Whitney Biennial
2012

Whitney Biennial 2012

Whitney Museum of American Art, New York

Distributed by Yale University Press, New Haven and London

This catalogue was produced on the occasion of the *Whitney Biennial 2012*, March 1–May 27, 2012,
curated by Elisabeth Sussman and Jay Sanders. They were assisted by Thomas Beard and
Ed Halter, co-curators of the film and video program, and by Esme Watanabe, Biennial coordinator,
Elisabeth Sherman, curatorial assistant, Sophie Cavoulacos, Biennial assistant,
and Greta Hartenstein, performance assistant.

Sponsored in part by **⁄ Deutsche Bank**

Major support is provided by **Sotheby's**

Lighting and audio by **BENTLEY MEEKER.**

Exclusive hotel partner **S | U | R | R | E | Y**

Generous support is provided by the Brown Foundation, the National Committee of
the Whitney Museum of American Art, and the Jacques and Natasha Gelman Trust.

Additional support is provided by the 2012 Biennial Committee, chaired by trustee Beth Rudin DeWoody
and Renee Preisler Barasch: Philip Aarons and Shelley Fox Aarons, Joanne Leonhardt Cassullo,
Rebecca and Marty Eisenberg, Marilyn and Larry Fields, Glenn and Amanda Fuhrman,
Diane and Adam E. Max, Heather and Tony Podesta, Mari and Peter Shaw,
Sharon and Howard Socol, John Studzinski, and an anonymous donor;
The Consulate General of the Federal Republic of Germany; and the E. T. Harmax Foundation.

Funding for the 2012 Biennial is also provided by endowments created by
Melva Bucksbaum, Emily Fisher Landau, and Leonard A. Lauder.

Library of Congress Cataloging-in-Publication Data

Whitney Biennial (2012 : New York, N.Y.)
Whitney Biennial 2012 / [edited by Elisabeth Sussman, Jay Sanders].
p. cm.
"This catalogue was produced on the occasion of the 2012 Whitney Biennial at the
Whitney Museum of American Art, New York, March 1–May 27, 2012."
ISBN 978-0-300-18036-7 (pbk.)
1. Art, American—21st century—Exhibitions. I. Sussman, Elisabeth, author, editor of compilation.
II. Sanders, Jay, author, editor of compilation. III. Whitney Museum of American Art. IV. Title.
N6512.7.W49 2012
709.73'0747471—dc23

2011046760

Printed and bound in the United States
10 9 8 7 6 5 4 3 2 1

ШHITNEY

Whitney Museum of American Art
945 Madison Avenue at 75th Street, New York, NY 10021-2764, whitney.org

Distributed by
Yale
Yale University Press
302 Temple Street, P.O. Box 209040, New Haven, CT 06520-9040, yalebooks.com/art

CONTENTS

ARTISTS IN THE EXHIBITION

On Biennials

Whitney director ADAM D. WEINBERG *chats with critic* ERIC BANKS *about the Museum's signature exhibition*

ERIC BANKS: This is the fifth Biennial since you became director of the Whitney in 2003. Biennials, of course, modulate quite a bit over time, and I'm curious as to what sorts of changes you have seen in the identity of the exhibition—what it is and what it can achieve—over the last decade. Or, has it changed that much?

ADAM D. WEINBERG: Each Biennial is its own installment. Memories are relatively short, but the Biennial has changed quite a bit, especially in the last twenty years, in terms of its approach, the number of curators, whether they come from the inside, the outside, or some combination thereof, and so on. To a degree I think each one is sui generis. It's a response to its particular moment or time as much as it is part of a long line or history. The fact that each one is a new beginning is a great thing. But I think that each is influenced in its direction, approach, and selection criteria by the previous Biennial. You can wipe the slate clean. Each set of Biennial curators wants to do something that contrasts with the previous one. It's amazing that even in a short, two-year period, people want to put the prior one behind. They're conscious of it, but they're also starting afresh each time.

EB: I guess the memory of each one is much shorter than we imagine in the moment.

AW: In the last five iterations, there has been always at least one if not multiple inside curators. We feel it is very important that there is always an internal voice represented in the Biennial, somebody who is a part of the history and culture of the institution, the family, so to speak. Even when we brought somebody in like Philippe Vergne in 2006 or Francesco Bonami in the last Biennial, or Jay Sanders to work with Elisabeth Sussman this year, the idea of introducing an outside voice is to try to mix things up. I think what distinguishes the Whitney's from other biennials is that it is always coming from an institutional point of view. There is always someone from the inside, no matter how broad or changeable the exhibition might be.

I think the Biennial really changed under David Ross. Under Tom Armstrong, it was basically a set group of curators involved—Lisa Phillips, Richard Marshall, Richard Armstrong, John Hanhardt, Patterson Sims, and occasionally, Barbara Haskell. They presented an institutional voice and an institutional vision. Everybody always knew who the Biennial curators would be, which changed the relationship of the artists and galleries to those people. Anytime Richard Armstrong or Lisa walked through the door, they knew that it was probably going to be about the Biennial. Whereas now, nobody knows who the Biennial curators will be until we announce it. That changes relationships, and it also changes the sense of continuity. When you had the same group of curators, you were seeing a consistent take on what was going on in the art world at a regular interval for a decade or so. Here the variables are so much greater because the curators, as well as their approach, are in fact the variables.

EB: Do you think that's changed the basic sense of how this pulse-taking can proceed or what visitors expect from the Biennial? Has it introduced more pressure to put forward a thematic presentation as opposed to something that's more baldly pegged to the zeitgeist?

AW: I think as much as one wants to try to make the Biennial thematic in focus, it never quite works. Take the 2006 *Day for Night* Biennial. To this day I'm still not completely clear why that theme fully characterized the show. I think it did in the curators' minds; it was an attempt to acknowledge a kind of dark underbelly on one side and lightness on the other. I saw some of the threads they were suggesting, but there's not a Biennial where you don't see threads of connection. So I don't really think it ultimately was a thematic exhibition. I'm not sure I see this year's Biennial as thematic, either. However, it's clear that there is an emphasis on performance and that it involves a wider range of media and fewer objects than many previous Biennials.

EB: No, I understand that, and I put the word *theme* in very generous quotes. I guess it's more a matter of the relationship of this Biennial to the most recent one—again, going back to what you were just saying about the proximate relations of the Biennials—because I didn't think of *2010* as being particularly thematic at all.

AW: You didn't see it as thematic?

EB: *2010*? No. It seemed like it represented a sensibility, but it was a different territorial emphasis. I mean, you could obviously see themes running through it—a relationship to politics, a kind of focus on drawing, etc.

AW: Right, and it captured a certain zeitgeist, a sense of the times and a sense of conversation among artists; but the mood changes so quickly in the world these days that it's difficult to capture that successfully. I think the 2012 Biennial may get at that changeability, because this installment is so unfixed as an entity, which is one of the things that fascinates me. For example, an entire floor is being turned into a performance space. That alone introduces a tremendous amount of variability into the Biennial as a whole. And the rest of the installations are quite open. There isn't an overwhelming number of painters or object-makers included. I think it is going to have the effect of being much more fluid than previous Biennials. It may on some level feel more like surfing the web, jumping in and getting bits and pieces of things, sampling in a way. Because of that fluidity, I think to get a true sense of what this exhibition is about is going to take a lot more time. The danger might be that people will just come once and get a feeling for it, a snapshot impression, and say, "Okay." The curators have spent a lot of time thinking about these artists and how they might connect, even in a visceral fashion, but I think it's going to take a lot of time to appreciate this Biennial.

EB: A visitor will literally have to come to the Whitney many, many times just to see the Biennial in its entirety.

AW: It's an exhibition based on temporality, and so, yes, you need to see multiple performances. The film programming, too, will require a lot of time, with visitors coming in to see the full films as opposed to just kind of popping in and walking out.

EB: With running times, etc.

AW: Exactly. People need to make several visits to get a flavor of what it's really about. All of this goes back to the element of fluidity. The dilemma facing a curator in doing any Biennial is the unfixedness of art at any time, the inability to nail it down and say, "This is what is happening now." Looking back at past Biennials, there are certain ones that seem to have caught and memorialized particular moments—say, the East Village moment. Maybe what the fluidity of this exhibition memorializes is just that, the fluidity of the moment. But I think that the unfixedness of it also mirrors the sheer difficulty of trying to capture a moment, simply an impossible task.

EB: And this really touches on the thematic of the Biennial itself. There are so many more Biennial-like exhibitions in New York today than there were a decade ago—with the MoMA PS1 Greater New York shows, the New Museum's Triennial, Performa, etc. Do you think that this phenomenon somehow frees up the Biennial from what once seemed to be a primary task of introducing young artists or presenting them in an institutional framework for the first time?

AW: There was a time when the Whitney Biennial, along with the Carnegie International and the Venice Biennale, was one of just a handful of exhibitions that people might look to as being the introduction to new artists and to work they haven't seen. I think there are those who still look to the Biennial for that to a certain degree, but not in quite the same way they once did. I think the audience is looking for an institutional point of view from us, and that's the difference from say, something like Venice or even Documenta. Those exhibitions don't represent the vision of an institution at a given moment. What separates the Whitney's exhibition? It's defined by its collection. It's defined by the voices of its curators, at least one of whom is always part of the Biennial's voice. It's defined by geography, which, of course, many others are. But it is defined by its exhibition program as well, because you're looking at the Biennial among other exhibitions that are happening before and after.

Documenta happens once every five years, and people fly in to see it. People are visiting the Whitney before the Biennial, and they're visiting the Whitney after. Whether one's conscious of it or not, that does frame the Biennial. It's part of a program; this year you have David Smith and Sherrie Levine right before it and Yayoi Kusama, among others, right after, which frames it in a way

that isn't the case with other similar exhibitions. It gives a sense of the Biennial as being not only part of the contemporary discussion but also part of a historical discussion. We typically have part of the collection on view on the fifth floor during the Biennial, which also frames it.

EB: Is the permanent collection show being integrated this year into the Biennial?

AW: The permanent collection installation is not something that's being specifically devised as part of the Biennial. The 2010 Biennial, as you know, included an installation, selected by the curators, of works that had been bought by the Whitney from earlier Biennials or works by artists who had previously been shown in Biennials. It explicitly tried to frame the Biennial, in a historical way. It was another way of saying, this is one chapter in a long series of Biennials that are part of the institution's nearly eighty-year history. The catalogue reflected that, too, as it traced the entire history of Biennials. So it reminded everybody of the temporality of the Biennial. This time, we're doing it in a very different way by virtue of the expanded range of media and the content. And I guess there's always that meta-dialogue going on among the curators—not just what's in the Biennial, but what does the Biennial mean at any given time and what then does it mean for the institution at that moment? That's always present, whether it's fully expressed or not. In 2010, it was very consciously expressed.

Because the last Biennial was so situated and historicized through the collection, I think the public found it very easy to understand; it was very clear what the curators were trying to do. By contrast, I think this Biennial is probably going to be befuddling to a lot of people, to be honest. I think a lot of people will say, yes, I understand performance is now part of the museum space, we've seen that at the Whitney before, as at the Guggenheim and MoMA. The art community, I think, will be challenged and intrigued, but my guess is that among the general public, which is looking for objects more often than not, there will be more frustration and some confusion. But that's part of looking at the art of the present moment. You don't do the Biennial based on the audience reaction you want but on the institutional and the cultural needs of the time.

EB: It's interesting in that the performance aspect here is only, to an extent, intermedia and more a type of paramedia—Werner Herzog is not an art-world

person, for example; Michael Clark is really not, either. A lot of the choices for this Biennial consist of people whose practices are really outside of contemporary art in the way we usually think of it.

AW: Well, this doesn't exactly contradict what you are saying, but many of these are art-world people but not "art people" per se; they've been part of the dialogues in the art world. This isn't new. The trend has long been for artists to keep opening and opening and opening—it goes back to Picasso, for one, with the collaborative opera *Parade* and the idea of collage and bringing in things from the real world. In a truly "American sense," it really happens with Robert Rauschenberg. In an interesting way, this show is probably as much the legacy of Rauschenberg in that it is about opening up dialogue, going out into the streets, bringing in the performative, dealing with the ephemeral, and responding very quickly. There are, for example, stories of Rauschenberg traveling in Russia or Italy with Trisha Brown, when the sets didn't arrive and he went out into the streets of Naples and made all new sets the week of the performance. It's the idea of rapid response, of the artist responding spontaneously. That element feels to me a real thread in the show. There are certain Biennials that seem more Duchampian, but this one feels more Rauschenbergian in some fascinating ways.

EB: I hadn't thought of this as the "Black Mountain College" Biennial, but that's an interesting way to think about it. There's no single figure in the show, though, who unites so many disparate threads.

AW: I think that's why this Biennial may feel even more diffuse. With Rauschenberg, there was still a creator, an artist who brought everything together even though he may have been working in collaboration with others. With, say, Michael Clark, this is his own thing; with Herzog, it's his own thing; and yet it is coherent in a larger way. It's really a part of what other artists are talking about with one another and what's in the air. In a sense, the Biennial is a bit like a source book—the idea that different people and elements are being brought in to the exhibition in terms of what they might add to a conversation about many different things in the larger art-world sense, as opposed to making an individual statement.

EB: In the past the Biennial has turned to satellite sites, particularly for the performative work; this year performance is being staged on the Museum's fourth floor. What kind of implications do you think the use of the building might have for the show as a whole?

AW: While we've been talking about this quality of diffusion, the curators have remained committed to keeping this Biennial within the confines of the physical institution. Unlike previous Biennials that used the Armory or Central Park, everything will be brought back under the wrapper of the museum itself, which is interesting. If the exhibition were too spread out, if it were to become so physically diffuse that it turned into more of a festival, it just wouldn't cohere into anything—it would become so inseparable from what's going on in the rest of the world that it would disappear, in a sense.

If you imagine taking a lot of these ideas and doing them off-site or in collaboration with another institution like BAM, and designating all these components as part of the Biennial, you would still presumably have something interesting, but in the end, would people see that? The idea of containing the show within the institution is more pointed. It's the institutional voice again. While the Biennial may reference what's going on in the world, it's happening here at the Whitney, and we brought it together. By keeping the performative work on the fourth floor and not, say, doing a collaboration with another performance space, it really gives the ownership of it, so to speak, to the Whitney.

EB: Can you see this Biennial as anticipatory in some way of what to expect from the new High Line space and the particular way that building will accommodate more than traditional painting and sculpture?

AW: Well, from a performance sense, we will have essentially a theater/black box space downtown, something we don't have in the Breuer building, which will be set up so that it can handle any kind of performance in multiple configurations. And there's a smaller film-and-video black box similar in size to the one we currently have, which will probably be used more for film and video but can also be used for performances. It also has an indoor/outdoor dimension because the film-and-video black box opens onto a big outdoor gallery. Most of all, we're thinking about the entire building as being performance ready. Everything—all the outdoor galleries, the outside plaza, the lobby, the galleries themselves—is being set up with an eye toward technological capabilities, and the flooring, the acoustics, and so on are being considered in terms of their potential for performance. Whereas in the current building, nearly all the floors are stone. We've been using the Breuer building since 1966 for performances on every floor of the Museum, yet there has probably never been a space less physically hospitable, particularly to dance and movement-based work. Still, it did not stop Trisha Brown from dancing on the walls or Meredith Monk from doing performances. The artists commandeered the space, no matter what.

EB: Looking forward to the High Line space, this is the penultimate Biennial in the current Whitney location. It seems that there's an aspect of meditation on the Breuer building in this Biennial, though it's not quite as pronounced as one might expect.

AW: The last Biennial was more of a kind of capstone, so to speak, because it looked back at the whole history of Biennials and tended to emphasize those Biennials through the selection of the works that had been in that building. This one offers a reflection on the building by opening up the space. You have much more of a sense of the physicality of the architecture of the Breuer building by the particular use of the fourth floor. You see the big open space that Breuer designed, and in that way it becomes a meditation on what happens in that space. But there isn't the sense of recapitulation that there was in the previous Biennial.

Again, it goes back to the fact that each Biennial is its own chapter. We, of course, have absolutely no idea what the next one will look like or who will do it. We don't select the curators for the next Biennial until several months after the previous one closes—we need time to digest what the exhibition did, what we thought it meant, before we go on to the next one. The interesting thing, too, is that even though the exhibition occurs every two years, in a sense it's not really a biennial; it's almost an annual. By the time the curators begin in September or October, they have a little over a year to pull it all together. The summer before the Biennial is always the real killer. The curators make their selections and turn in the manuscripts for the catalogue during the summer and into the fall, months before it opens. In other words, from a conceptual perspective the Biennial is a misnomer because the curators are basically putting it together in a year to a year and a half. By contrast, when we're organizing an exhibition for a full floor of the

Museum, whether it's Sherrie Levine or Roni Horn or whatever, typically those shows take two to three years to organize. When you consider that we're curating the entire Museum in a year, it's astonishing that it can be done with any coherence at all, not to mention with the extremely high level of professionalism that is evident every time. I think that, by and large, most artists have felt very good about the amount of attention they have received from the staff on every level, from the art handlers to the exhibition designers. That's one of the things I'm most proud of. The artists really feel that this is their moment and that they're being given the full energy and support of the institution.

I can't think of many artists, if any, who have said they had a bad experience in the Biennial from the point of view of institutional support. Even for a senior artist, like Robert Grosvenor in 2010, the Biennial is a bit of an incubator experience. He hadn't been in the Biennial for decades. To all of a sudden find himself in a context where he is the senior guy among all these thirty-year-olds, the experience is pretty stressful. Yet I think he was thrilled with how it came out. The pressure is enormous, maybe even more so as you get older. When you're younger, the expectation is that things will be rough and funky, and that there will be other chances. The level of energy put into the show and also the amount of vulnerability is part of the whole process, because there isn't a lot of preparation time, either for the artist or for the curators.

EB: Particularly when it's completely new work that's being prepared for the exhibition.

AW: It's fascinating to me: as the curators were preparing their selections, they would show me a handful of images, but most of them were obviously not of works that would be in the show since many are performances. Or, there would be no images at all, and they'd present verbal descriptions. Often in past prep meetings for the Biennial, I would get a full forty-five-minute PowerPoint presentation with multiple images of either the works for the exhibition or similar ones. That's one reason this year's installment is so exciting, and it makes this year's Biennial edgier. People have sometimes suggested we should move to a kind of triennial or something analogous because it gives more prep time, which, of course, is true. On the other hand, the pressure of having to do everything so quickly shakes everyone out of their routines. We are used to working under this

kind of pressure because we have done it so many times, but each Biennial is a unique challenge—the artists are different, the uses they're making of the space are different, the curators are different. It's a bit like cramming for an exam. You're not going to be able to spend the next two years in the studio working on what you want to show. You have six months or nine months. There's something good about that—it gives the exhibition a certain kind of energy and always forces things to happen very quickly.

EB: Given those constraints, I have no idea how it was ever possible to realize the old Annuals.

AW: Well, of course, at the time they were very object-oriented, and it helped that for many years they alternated between exhibitions of painting and exhibitions of sculpture and prints. The Biennial was a very different thing, too, basically until Tom Armstrong's tenure. Before then, there was more of an idea of the anonymous institutional voice, and the curators weren't so much a part of the picture. In fact, if you go back to the early Biennial catalogues, you don't see the names of curators on anything. You would have to go into the files to find out which curators actually worked on them. It was only bit by bit that the idea of authorship became critical. After that, the mix of voices becomes more complex, as opposed to an anonymous group of people who basically selected the artists, who in turn picked their own objects.

EB: I think the kind of tension between presenting objects and presenting something more time-based marks our own moment of transition. It puts a tremendous amount of pressure on presentation and curation.

AW: In the last Biennial there was a lot of video, but each one was in its own room or box. So you went from one series to the next, from one room to another. In this Biennial, there are few discrete spaces; it's more about taking down the walls of the building and getting all the media out in the open. This is a challenge not just visually but in even the most practical sense, in terms of sound and coordination and so on.

EB: Though the vision is remarkably expansive in those terms, it's a much smaller Biennial in terms of the number of artists invited.

AW: It's down to around fifty or so.

EB: There seems to be a trend toward Biennials with smaller numbers of artists.

AW: Yes, the number has been coming down. I think that at this moment, given the vast number of artists working today, there is a sense that the exhibition can no longer truly be any kind of summary. It is limited by the scale of the Breuer building and also by a desire to give the artists more room. It also really gives the exhibition a tighter focal point. But the smaller size has been a trend since the Biennials of the middle part of the last decade. I think it was also somewhat of a reaction to the density of those earlier shows, which were overwhelming to many people— that was certainly part of the motivation in the Biennial that Francesco [Bonami] did with Gary [Carrion-Murayari]. The idea was to give more breathing room, which I think did indeed benefit the exhibition. But, who knows? The next ones will probably be …

EB: Packed?

AW: Yes, you never know.

EB: Back to 1932, when the first Biennial had over 350 artists!

AW: Well, the idea behind those earliest Biennials was to help develop a market for the work. The address of every artist was included in the catalogue, so if you saw a Hopper that you liked, you could write to him in Washington Square and ask him about buying a painting. The addresses were in the catalogue at least until the 1970s. Interestingly enough, this particular Biennial is definitely "unmarket." I do think that there's a certain consciousness of that on the part of Elisabeth and Jay. They're not trying to be anti-market per se, but they're not attempting to feed into a kind of frenzy about buying objects from the Biennial. There was a time when, after the artists for the Biennial had been announced, the next thing you knew every work by every artist in the show would be on hold at every gallery. This time, at least, with the type of show that's been organized, finding objects to buy will be a lot harder.

EB: So you're not going to be publishing the addresses of the artists in this catalogue?

AW: Maybe we should—or at least their e-mails, so they can get correspondence from the audience.

EB: At least some of the addresses this

year would be in Detroit or San Francisco. It has been interesting to hear from Elisabeth and Jay about their travels as they prepared the show and what they sought out. You know, to the extent that every Biennial seems to have at least a few key pressure sites outside New York or Los Angeles that emerge as of particular interest, this year Detroit and San Francisco, two wildly different scenes, really captured their attention.

AW: The curators approached the exhibition with a great level of honesty in not coming to the show with a preconceived notion of what they were going to do. That's not to say that one couldn't come to organize the Biennial with a preconceived notion and make a pretty great exhibition, but there is something excellent about the idea that this is all part of their discovery process. They are basically showing you what they're discovering at the same time as you're discovering it. Not that Elisabeth and Jay didn't know a lot of the artists beforehand, but even when it comes to the ones that they knew, they didn't necessarily know what works they would actually be producing for the show. The discovery was firsthand because they went to the artists themselves rather than through the galleries. Back in the 1980s there was a recurring accusation that the Whitney was too close to the galleries and that this was evident in the Biennials. What's interesting is that if you go back and look at who was in those shows from the time, it was in fact an amazing group of artists selected and a lot of the key artists known today.

EB: I do remember that that was part of the Biennial's reputation back then.

AW: This one will probably get the complete opposite response—say, isn't the Whitney interested in painting and sculpture and objects anymore? Has the whole world turned to performance? I'm sure we'll hear some of that.

EB: Do you have a personal response to that? With your history, I think of you as an object-based person.

AW: I am. But I've always loved performance; my training was at the Walker Art Center, which was truly an interdisciplinary institution. Performance and time-based media will be very much a part of the new Whitney downtown, but it will also be our way of doing it. The downtown Whitney can't be BAM. It doesn't mean that we won't have overlaps, but the Whitney is a visual arts institution, and so

performance will be an extension of the primary media that are part of our mission. That said, the Whitney has a long history of involvement with performance, and not just in the 1960s. It goes back to the 1930s, when new music was being presented at the Whitney on Eighth Street. Edgard Varèse, for example, was a regular at the Whitney on Eighth Street.

EB: That's interesting.

AW: But whatever my own relationship, the Biennial is about what's important at a given time in the art world. I think you get that through the collective points of views of multiple curators, which is why bringing in an outside curator is such a good idea for a Biennial. It serves as a kind of irritant or, if nothing else, just a fresh view. Bringing in Jay as an outside curator for the 2012 Biennial was actually Elisabeth's idea. She and Jay are of two very different generations, yet they have shared sensibilities and a profound regard for and interest in history while remaining totally engaged with the current moment.

EB: No, their interest in history is genuine and not nostalgia driven. I remember ten years ago there was a kind of similar moment of rediscovering a lot of 1970s work, particularly overlooked conceptual work from the first part of that decade. The current interest in this moment in looking again at performance and performance-based work, some of it from that same decade, feels very different in tone, more productive and much less retrospective.

AW: I think so, too. What I love about both Jay and Elisabeth is that they have an incredible sense of wonderment—that's the word that keeps coming back to me—a true astonishment and passion for what is going on in the world at this time. They are both in touch and have strong opinions. They're utterly free of cynicism and despair, which is so difficult today. There is an acknowledgment in the show of some darker things, particularly in some of the film programming—it's not that this is a "Biennial of light" by any means. But it doesn't feel to me to be coming from a sense of frustration or anger or protest or anything like that, just curiosity about what's going on in the art world and the world at large, and how artists are dealing with it coming from different disciplines.

EB: Their approach, not to mention their personalities, seems definitely infused with a spirit of openness and—though this might not be the most precise

word—a sense of intimacy with the work.

AW: Intimacy is a good way to describe it. That's what I mean when I say "the wonderment." There is a real and sincere connection to the work.

EB: I assume that the real test of this Biennial will be how well that intimacy can translate.

AW: I don't think we really know the success of a particular Biennial until it recedes in time anyway. The 1993 Biennial, which Elisabeth co-curated with Thelma Golden and Lisa Phillips, was the most disparaged Biennial for years. It was a very long time before people started to say, hey, that was a really great Biennial. The artists' community felt it was pretty interesting at the time, but the general consensus about the 1993 Biennial for years was, what is all this political stuff?

EB: The press was ready to run the curators out of town, with the director, David Ross, in tow.

AW: Absolutely.

EB: That Biennial had a tremendous effect in terms of clarifying the identity of the Whitney as an institution in the moment.

AW: It also really opened the institution up, because at that point the Whitney was not dealing with political issues. It wasn't dealing with identity politics or with artists who were involved in either issue-based work or work that was coming out of a more conceptual bent. The Whitney had not been collecting a lot of conceptual art until David Ross arrived. An artist like Lawrence Weiner hadn't even been in a Biennial until Klaus [Kertess] put him in his 1995 installment. The 1993 Biennial basically brought these elements into the picture.

One interesting thing was the fact that so many artists from the Whitney Independent Study Program were included in that show. The ISP always had a parallel track of identity politics and theoretical work, and yet, for the most part until David Ross came to the Whitney, it didn't infect the institution, so to speak. It was its own thing. The ISP shows were always at the branch museums. Under Ross, for the first time, the dialogues and discussions that were happening in the ISP began to be part of the discussions that were taking place internally in the Biennial. It would be interesting to track how many of the artists from

the last forty-something years of the ISP have been included in Biennials. At any rate, 1993 was a signal of the opening up of the institution. I think that's one of the reasons the exhibition that year made so many people angry—they saw it as a denial of what the Whitney had been under Tom Armstrong. It will be interesting to hear Elisabeth's thoughts about the two Biennials she has curated. She was actually rather reluctant at first to do this one.

EB: I didn't realize that.

AW: I don't think it was because she felt that the last was a bad experience, but since Elisabeth returned to the Whitney, she has been focusing more on monographic and often historical projects. That's become her passion. When Donna De Salvo and I approached her about doing the Biennial, I think she was almost shocked. I don't think it had ever occurred to her that we would ask her to do the Biennial—which I think makes it all the more intriguing because it brings some fresh thinking to it. Rather than someone who already had all the ideas about what they would do, Elisabeth all of a sudden had to rethink the Biennial.

EB: That's interesting. I didn't know that she had that kind of reluctance.

AW: I don't think she was thinking about how she would reinvent the Biennial, but very quickly, and especially after she asked Jay to co-curate the show, the conversation was incredibly lively, and they were very much in the same zone.

EB: Do you think it's still possible to do the kind of Biennial that had the throat-clearing clarity of that 1993 show?

AW: I think it's harder—my sense is that the 1990s was one of the last times that you could easily clear the throat, in a sense. But I think this installment might have some of that same effect—not because of the emphasis on performance per se, but because of how Elisabeth and Jay are treating the space and the small number of artists included. Each time the exhibition approaches, I think: How are these curators going to reinvent the Biennial? I've done a lot of exhibitions at the Whitney, but I've never organized a Biennial, and I'm amazed how the curators come up with a fresh take. But what really makes it remarkable and fresh in the end comes from the work itself. It comes from the process: going out and having the conversations, going into the studios and mining what's out there.

Organizing a Whitney Biennial is a considerable challenge, and I'd like to express my deepest thanks to Elisabeth Sussman, curator and Sondra Gilman Curator of Photography, and Jay Sanders for taking on the task with passion, thoughtfulness, and, above all, a sense of adventure and wonderment at the art being made today. They were supported by a peerless team, including film program co-curators Thomas Beard and Ed Halter of Light Industry, and curatorial assistant Elisabeth Sherman, Biennial coordinator Esme Watanabe, Biennial assistant Sophie Cavoulacos, and performance assistant Greta Hartenstein as well as the entire Whitney staff, who have once again shown their dedication to and enthusiasm for this demanding and rewarding project.

Corporate sponsor Deutsche Bank has long demonstrated its commitment to championing art that takes risks and pushes boundaries, and I am grateful for their continued support of the Whitney's signature exhibition. The Museum also owes a great debt of thanks to Sotheby's for their major support of the exhibition. The 2012 Biennial's ambitious program of performances would not have been possible without the collaboration of Bentley Meeker and I extend my thanks as well to our exclusive hotel partner, The Surrey.

The generous contributions of the Brown Foundation, the National Committee of the Whitney Museum of American Art, and the Jacques and Natasha Gelman Trust were essential to the exhibition.

My appreciation also goes to the 2012 Biennial Committee, chaired by trustee Beth Rudin DeWoody and Renee P. Barasch: Philip Aarons and Shelley Fox Aarons, Joanne Leonhardt Cassullo, Rebecca and Marty Eisenberg, Marilyn and Larry Fields, Glenn and Amanda Fuhrman, Diane and Adam E. Max, Heather and Tony Podesta, Mari and Peter Shaw, Sharon and Howard Socol, John Studzinski, and an anonymous donor; and to The Consulate General of the Federal Republic of Germany; and the E. T. Harmax Foundation for kindly recognizing the importance of this Biennial.

In addition, I am deeply grateful to Melva Bucksbaum, Emily Fisher Landau, and Leonard A. Lauder for their longstanding devotion to the Whitney and their foresight in the creation of endowments for the Biennial.

The steadfast commitment of these organizations and individuals has made the exhibition a reality.

Adam D. Weinberg
Alice Pratt Brown Director

A Year in the Making...

ELISABETH SUSSMAN *and* JAY SANDERS

with THOMAS BEARD *and* ED HALTER, *co-curators of the film and video program*

ELISABETH SUSSMAN: Reading over the rough transcripts of this dialogue, what it reminds me of is people in the field working through their notes, thinking through their decision-making, their charting of new territory. Sometimes the discussion tries to go back into historical context, but a dialogue of doing something like the Biennial falsifies itself if it goes backward into categorization and history; it reveals itself for what it is: a process of note-taking.

JAY SANDERS: It's a fiction to think that we would stitch too much of a theoretical armature to this, because that's not really how we went about putting the exhibition together.

ES: The exhibition and catalogue are like field notes, results based on the training and experience that we have, and our watching this field: art. We didn't go into the field looking for something specific …

ON IDEAS AND PROCESS (I)

ES: How relevant is it at this point to make an overarching generalization of what's going on between 2010 and today—almost a year after we started working together on the Biennial? I mean, here it is, the end of October, and it's not something we've spent much time trying to articulate: how we feel about a generalized theory and its relationship to this show.

JS: It's strange. I feel like we've made a few structural decisions about how we'd like this show to look and feel within the Museum, based on our own experiences with Biennials in general, but beyond that, it's hard for me to think beyond the singularities of each of the artists participating. That's the basic level—the artists and their work. We didn't curate as if we were trying to make cer-

tain claims for aesthetic strains or themes, but we tried to be reflective. I don't see simple kinds of sound bites coming out of it.

ES: It's not us picking some concept and then finding the artists who fit that, and then presenting it to a general audience. I think we ended up being drawn to artists who have deep, thoughtful underpinnings to their practice, of a very individual sort, and if I were going to make any kind of general statement, then I would say that this show is about supporting those kinds of practices.

JS: I feel like the practice of everyone in the show is—very *explosive*; that's the word I keep coming back to. I look at any artist on the list, and they evade easy summation when I think about what they do. Their work is not very reducible. It's the antithesis of what sometimes gets called "art school art," where someone says, "This is a formal painting problem" or "This is a formal photography problem," and everyone draws a box around it. And what you end up with are tightly bound, novel ways to participate within those parameters. I think the artists we've selected don't foreground that kind of wall to bounce against; they seem to pass right through it. Even as each artist may take up a set of formal concerns, his or her work tends to extend from there, both to more personal and more exploratory territory.

ON IDEAS AND PROCESS (II)

JS: You and I never really talked about process when we started. We didn't sit down and say, "You'll travel here, and I'll travel there," or decide to research things individually and then come together and advocate for certain inclusions. I feel as though without ever overtly coming up with a working method, you and I just decided that we'd do all this together. And somehow that became crucial, because we seemed to open up an intellectual space between the two of us that allowed us to work in a very natural way. We've had a completely shared experience this last year, and what adhered within that shared space became the exhibition.

ES: There was a fluidity to the whole thing. We also really didn't let anything stop us from visiting someone whose work we were interested in—if they had been working for forty years or were very famous or had never shown anything. We didn't draw those sorts of boundaries. And the studio vis-

This text is excerpted from a series of conversations among the curators that took place between October and December, 2011

its—you know, artists have become so professional, and they'll take you through some work and give you their spiel, and it's all very quick and polished. But we intentionally wanted to get beyond that. So our studio visits were, at minimum I'd say, two hours, sometimes more—really, we scheduled our time in a way to allow everyone to talk for as long as we all wanted to talk. And those visits, in my mind, became the building blocks of this Biennial. They allowed us to build a show around artists who each have a strong sense of authorship.

JS: Which was important because I think there's an awareness right now of the flimsiness of some contemporary art—the sheen of "art"—and we wanted to explore what's happening under the collective surface in a deeper sense, which at present does often look purposefully feeble.

ES: Yes, I agree—a slightness of the visual quality, or the impact.

JS: And we wanted to go beyond the rhetoric. You know, you often go to galleries, and you read all these active verbs about how this work interrogates the medium or détourns its own status and conditions, and it is this or that. But as that's become a normative mode in promoting contemporary art, it's often too easily inherited by art that's not actually extending itself into a transfigured state. One can rely on this language of radicalism and theory—

ES: —like a cloak—

JS: —but the work itself is kind of stillborn. I was inspired by what Andrea Fraser wrote for the catalogue about how art discourse uses all these terms of radicalism, but she's feeling like she's increasingly being lied to, that the gap between the theoretical claims and the reality is widening, making the whole critical discourse suspect. It's a chicken-and-egg question, really, of which came first: the discourse or this kind of intelligent, theory-driven, neo-conceptual art, which can feel like it's all very bent on press releases and reviews. And we decided not to foreground this as the idiom of the moment, these sorts of impoverished, neo-formalist objects with a certain amount of empty rhetoric around them.

ES: Yes, in the last two years, it seems people aren't so interested in "smart art" as they once were, and I had this idea that the smart art moment, or at least what interested us about it, was over, that it's become almost cliché. And as we were putting this show together, what interested us more were artists who were certainly smart but who just pushed another button in their brain and allowed themselves to go into these imaginative worlds that might not have any relevance to anybody except themselves. But then we saw such powerful things in their work that we thought they would actually speak to a larger audience—Nick Mauss and Kai Althoff, for example. They imag-

ine space and a narrative that is an alternative to a common narrative, and they create a whole world.

JS: This makes me think of Jack Smith as one precursor to all that, and the conversations you and I had at the beginning of this process about him and about his impact on so many artists, even today.

ES: Exactly, those conversations sort of established a shared sensibility between us when we started working together. I tried this out on Lutz Bacher when she was last here, this idea that, at this end of poststructuralism, postmodernism, all those periods, that these artists were opening the door to this kind of Pandora's box of imaginary places and forms and ideas, and I said I thought that was something you see in the Biennial and in her work, and she said, "yes, absolutely."

JS: I agree; I feel like each artist has a lot embedded in a complex practice. Like with Bacher—there are all these conceptual approaches, where she's moving within known mediums, but then it does go into this other realm of fantasy and personal and hermetic communication. Addressing all these well-trodden means, but in order to key up her explorations to other degrees—having that knowledge and twisting it so it opens a new dialogue and space.

ES: When she started out, her early work, it was within the appropriation, feminist discourse, but now it's gotten more quirky and personal; she's let the oddness take over and kind of let the ideology recede.

JS: I think what's too often celebrated is when work travels more along the party lines—the dominant story and the illusion that art is actually progressing. So there's always a mad search for the "next" artist in an intellectual or art-historical/formal line, the next word in the sentence. And that keeps rebirthing the industry—a self-generating philosophical product line.

ON THE SPACE OF THE EXHIBITION

ES: We very much agreed that we didn't want this Biennial to look like an art fair, divvied up into little rooms like booths. You walk around those big art fairs, and it's like product, product, product. I think we were really tired of that and felt like we had to interrupt it. And the way to interrupt it

CURATORS' CALENDAR
11/19/2010–12/19/2011

Elisabeth & Jay first meeting @ Serafina with Elisabeth Sherman • Scheduling meeting • Fly to Miami • Art Basel Miami Beach, Whitney Trustee dinner • Visit Sackner Collection, NADA • First Whitney catalogue meeting, first long meeting re: artists • Meeting with Connie Lewallen & Bill Berkson • Meet @ Waverly Diner, meeting with Paul Chan • Visit with John Knight, meeting with Greil Marcus @ New School • Work at museum • Work at museum, meeting with Thelma Golden @ Studio Museum, meeting with Simon Critchley @ 57th St bar • Meet @ St Mark's Books – meeting with John Zorn • Work at museum, visit with John Kelsey • Work at museum, meeting with Branden Joseph • Meeting with Robert Gober, see exhibitions in Chelsea

Installation view of *Anti-Illusion: Procedures/Materials* (1969) at the Whitney Museum. Photograph by Peter Moore

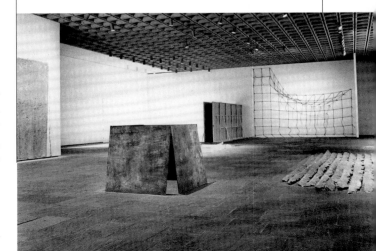

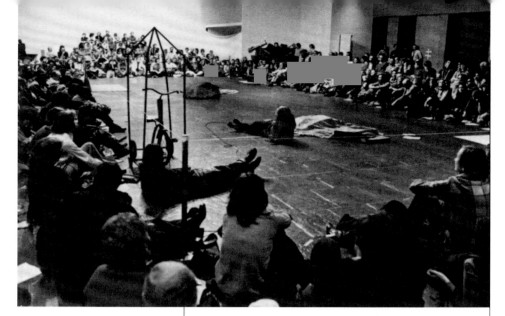

Richard Foreman at the
Whitney Museum, as
part of *Performances: Four
Evenings, Four Days*, 1975

*Work at museum, initial book
designer conversation, Thomas
Beard & Ed Halter first film
meeting, plan LA dates &
trip • Work at museum • Work
at museum, studio visit, see
shows in Chelsea • Work at
museum, meeting with Diego
Cortez, visit Kai Althoff @
Gladstone • Work at museum,
studio visit • Work at
museum • Work at museum,
visit with Richard Maxwell,
studio visit • Work at museum,
fundraising meeting, visit
with Jutta Koether, interview
Esme Watanabe for Biennial
Coordinator • Work at museum,
meeting with Thomas & Ed,
plan for LA • Studio visit, see
Sarah Michelson's Devotion @
The Kitchen • Interview with
possible Biennial Coordinator •
Work at museum, meeting
with Richard Maxwell – see
open 4th Floor, studio visit
with Kai Althoff, studio visit,
screening event • Chelsea
galleries, meeting with David
Little • Studio visit, studio
visit with K8 Hardy • Visit
with Lucy Raven @ Breslin,
studio visit with Nick Mauss,
studio visit • Phone meeting re:
LA • Meet @ Waverly Diner,
studio visits • Work at museum,
research performance history
@ Whitney*

was to present something that was exciting in the moment but that couldn't be bought, couldn't generate a new trend in sculpture, say, or a new this or that—something that was just exciting in and of itself. That's what I think is missing at these art fairs. It's just a lot of product.

JS: We'd been talking to the playwright Richard Maxwell of the New York City Players, about how we wanted to incorporate various kinds of performances into the show …

ES: And he came to the Museum when the Paul Thek exhibition was just coming down, so the fourth floor was completely empty. And we were wandering around this magnificent open space with Richard, and he said, "It's so meaningful to be here when it's empty." That sort of planted the seed for this spectacular open space.

JS: We kept returning to a conversation with Sylvère Lotringer—how in an exhibition context, one task might be to acknowledge our fundamentally divided, unfocused attention, and that our lives are fully mediated by electronic devices, while at the same time to encourage a multivalent, open experience that challenges an audience to reorient toward a range of different time frames, durations, instabilities, and immersive possibilities. Art can do all these things, so to assume that a show like this has to be a single experience—quick, and tourlike—doesn't really dignify the range of what's possible and what the different art forms demand to fully deliver on their amazing potentials.

ON THE PERFORMING ARTS AND PERFORMANCE ART

ES: I've always thought that a meaningful program in a contemporary art museum would be one where you could take in and be involved with not only the visual arts—painting, sculpture, photography, installations, etc.—but also performance, film, music. You can look back to, say, what Marcia Tucker was doing at the Whitney in the late 1960s and into the 1970s—*Anti-Illusion: Procedures/*

Materials [1969] and "Four Evenings, Four Days" [*Performances: Four Evenings, Four Days*, 1975]— for a kind of precedent to that. And I think, Jay, you respond to that as well and that it was a shared notion of this expanded field that was one of the things that made it natural for us to work together.

JS: Right, and that's in line with our decision to approach major artists in, say, theater or music or dance and offer them almost a residency-like way to create a major new commission, and to give the fourth floor almost entirely over to performance. And as you say, we looked to the Whitney's history to find where and how to site these practices within the Museum and exhibition. We were specifically drawn to artists whose work we admired for its level of technical skill and its deep commitment to understanding and rearticulating the conventions of their respective medium, whose work forces you to engage in a way that other performance art does not.

ES: Because you take an artist like Michael Clark or Sarah Michelson in dance or Richard Maxwell in theater, or Jason Moran and Alicia Hall Moran in music—there's a kind of technique to their work that invites an immersive experience.

JS: So for example, with Michael Clark, his commitment to an extremely high production value amid all this input of transgressive and pop content is really a unique amalgamation of style, value, and production.

ES: He doesn't hold back, meaning he goes the full range; he doesn't have some undernourished idea of performance art at all. It's pretty baroque.

JS: And seeing Sarah Michelson's most recent work in New York, *Devotion*, was one of the most astounding experiences either of us had this year. Her extreme formalism, rigor, and exactitude become means that then tip the work's pure exertion into a deep existential meditation, all told through a language of Minimalism and avant-garde dance history. This brings to mind the Morans, too, working in jazz and classical music—these forms that can sometimes seem rather ossified, until these performers redraw the boundaries and invite new audiences to hear the whole form in a different way.

ES: And, too, while these performing artists fall into defined categories—dance or theater or the like—I think many of them share this notion of the expanded field that we were talking about earlier.

JS: Yeah, we looked to artists and work that naturally had a lot of connecting points and dialogue with the visual arts—it's a discourse that's out there, but maybe it's not known to a very wide audience.

ES: You've got someone like Jason Moran who's collaborated with any number of visual artists— Joan Jonas, Glenn Ligon, Kara Walker, Adrian

Yvonne Rainer's *Continuous Project—Altered Daily* at the Whitney, 1970. Photographs by Peter Moore

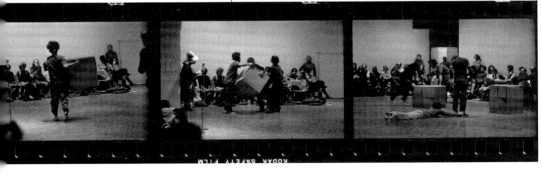

Piper. And again, Michael Clark, who has such a close relationship to the visual arts and to fashion and pop music. Then there are these personal practices that are multifaceted; K8 Hardy, for example—her work is in photography and installation, and then she conceives a fashion show as a performance for the Biennial. You see in her the embodiment of this kind of total artist, someone who can approach a variety of mediums and formats and create impact, whether it's through collaboration or on their own.

JS: And within the realm of performance art, there are young artists who generate a network of elements and moving parts that get constantly reconfigured in their work. They're interested in working contingently—I think of Jack Smith again, as an influence here. Dawn Kasper, Tom Thayer, Georgia Sagri, and at times K8 Hardy and Wu Tsang—they all work performatively in a way that's a bit disruptive at times, and yet the work has its aesthetic dimension. But it also has a real political dimension to its presentation in the way each artist engages with their work and the public.

ES: Charles Atlas …

JS: Oh yeah, definitely. He kind of laid out that terrain with his early video mixing, creating a scenario that's an array of equipment and imagery that's then activated live and can never be repeated. And going back, so much of his art has been collaborative, his early work with performers, documenting dance. He's had this interstitial connection to other people's practices, blurring the boundaries, which I definitely think speaks to some of the other artists in the show in terms of collaboration and the permeability of his practice in relation to other people's practices.

ES: What struck me watching him work in his studio, and I think that translates to him as a live artist, is that he's like a dancer himself. He's extremely improvisational, but it's fluid and flexible—not that all dance is improvisational, but his is notably responsive to other bodies.

JS: And going back to the idea of an expanded notion of artistic practice, we've asked the UK-based group Arika, who are international curators organizing festivals of experimental music, moving image, and sound, to organize a week-long series of performances, workshops, and conversations that will capture interesting tenets in

North American listening, including contemporary poetry, noise, dialogue, collective practice, and music that we hope will amount to an internal survey of the state of contemporary sound.

ES: Their program is going to be part of the fourth-floor event series …

JS: And as outside curators doing their first project in the United States, they're taking the time they've been given to survey the scene and bring back results—positive, negative, shortcomings, gaps; I think they'll deliver wonderfully rich programming that will complement the other programming on the fourth floor.

ES: They're on the cutting edge of people who are interested in looking at the broader category of sound—what they call *listening*, not just music narrowly defined. So it's a kind of follow up to what the Whitney did with the Christian Marclay exhibition last summer, which explored ideas of what is music, what is sound, and what is performance in many different ways within the artistic community.

We've also asked Artists Space, in the year of their fortieth anniversary, to organize a weekly series of events, talks, and panels during the run of the Biennial. We share with Stefan Kalmár and Richard Birkett [director and curator, respectively, of Artists Space] an interest in art and performance as a part of and in relation to a wide variety of thought and writing. These activities will address and involve artists in the Biennial as well as others and will take place in Artists Space's new venue downtown.

ON FILM AND VIDEO (OUT OF THE LOOP)

ES: Our ideas about space and time, and giving over the appropriate space and time to different works—I think one of the areas where this is most significantly understood is in how we've integrated film and video into the show. We had this feeling that we've seen a lot of looped video work in dark rooms this past decade—and, you know, our experience has been that people sort of step into these little rooms, look for ten seconds, and then move on. They never experience the full impact of what's in those little dark rooms. So we made the decision to really activate the film program in the Whitney's film and video theater, and to make that a place where sitting down and watching a film or video from beginning to end was possible, because we felt that was important.

THOMAS BEARD: The loop has become a kind of default setting, curatorially. It's not simply one way that film and video is shown in the context of contemporary art—it's the dominant form. This becomes a serious issue, though, when you're dealing with work that's not designed as a loop. So if you consider an artist like Thom Andersen, for instance, his film *Los Angeles Plays Itself* is a three-

hour meditation on the image and idea of Los Angeles in cinema, a work like that—

ES: It's unloopable.

TB: Yeah, it's unloopable. You could never appreciate the film by only seeing a random fragment of it. How a film is edited, how it's structured in time, is obviously one of the crucial decisions that an artist working in that medium makes. So when you loop a work that wasn't expressly made to be seen that way—with people popping in and out at different points—you're really undermining the artist's intentions. What we've tried to do with the film and video gallery, by having an ongoing series of scheduled screenings, is to create an environment where people can really give these works the sustained attention they deserve.

ED HALTER: I think that's in keeping with the history of film and video at the Whitney Biennial, because the Biennial is really the only major event in the art world that has, for decades, consistently celebrated and included experimental and independent cinema on its own terms. This remains incredibly rare. Obviously other museums have also included film in significant ways in their regular programming, as have certain editions of other biennials, but to my mind, this is the only major event that has had such a longstanding engagement with cinema.

TB: Well, at its best, it's one of the few places where you find the most remarkable developments in cinema alongside contemporaneous developments in painting or sculpture or photography or performance. You had, in the case of the 1993 Biennial, Sadie Benning's early Pixelvision videos in the same exhibition as Glenn Ligon's *Notes on the Margin of the Black Book*; more recently, Stan Brakhage films with Amy Sillman paintings, and so on.

JS: I think we're all looking to make those sorts of connections and explore these relationships in this Biennial. And Elisabeth and I were drawn to working with you [Ed and Thomas] via your own curating and presenting of films at your space, Light Industry. You both have been great to want to do this and to engage in this kind of permeable collaborative discourse so that the film and video program doesn't feel marginalized or disconnected, as I think it may have been in other exhibitions. Creating that discourse has been key, I think, to our thinking about other aspects of the show—dance, theater, and the other performing arts; we didn't want these things to be compartmentalized concerns.

EH: In the past, the Biennial's film and video programs were conceived as separate, sidebar events, often by a different curator from the main exhibition. But for this edition, we're breaking with that by having all four of us work in collaboration on the film and video selections. It makes me think that

our way of working is very much appropriate to the contemporary moment and the relationship of cinema to the other arts that's happening now. There seem to be these cycles of relationship between film and video and the visual arts—moments of separation and rapprochement—and we're definitely in a moment of rapprochement now.

ES: Yes, I remember early on, realizing that Lucy Raven had actually conducted these long interviews with Thom Andersen in *Artforum*, and her practice is also essayistic and research-oriented and oriented toward American history, these materialist facts. And she's quite new, and the fact that she found him is interesting. So that's just one connection in what seems to be a kind of network of connections.

JS: Yeah, and one thing we've been thinking a lot about is how we make some of those connections apparent to the audience in the way we program the Biennial. Because with the fourth-floor performance space and the film and video program, the show in some ways is really more like a festival— I think people will most certainly need to come back several times as the show transforms to feel like they've gotten the whole experience.

ES: We were just talking about Michael Clark, for example, and Jay had this idea that it would be interesting to program something from Michael Robinson when Michael Clark is in the building—

JS: There's an opulence and an excessive beauty in both their work.

EH: And a kind of new romanticism as well, at least in Robinson. You see this aspect in Laida Lertxundi, too—unabashed emotion, at times intensified through restraint.

ES: And I don't know exactly what Richard Maxwell is going to do, but he has this kind of straightforward quality to his narratives and a way of addressing people that shares something with Kelly Reichardt.

JS: Absolutely.

TB: I think the inclusion of artists like Reichardt and Matt Porterfield is significant, because it brings narrative cinema, which typically circulates outside the art world, into the conversation about contemporary art. Showing their films is also, in a way, getting back to the roots of the Museum's film program—the Whitney famously gave Charles Burnett's *Killer of Sheep* one of its early theatrical runs in 1978. So in this Biennial we're renewing that commitment to independent feature filmmaking.

EH: And from the beginning, all of us wanted to bring in a wide range of artists working in film and video—people whose accomplishments are well-known within international cinema circles, or experimental film, but aren't part of that conver-

Houston: studio visits, visit galleries, visit Menil, studio visit, visit MFA Houston, meeting with Yasufumi Nakamori, meeting with Valerie Cassell Oliver & Bill Arning @ CAM, studio visit • Studio visit, meeting with Fredericka Hunter at Texas Gallery, visit Core Program artists, studio visit • Austin: studio visit, visit gallery, dinner with Mike Smith • Visit gallery, visit Blanton Museum, visit AMOA, Arthouse & Texas Biennial, Elisabeth on panel discussion at Blanton • Studio visit • Meeting with Kenny Goldsmith, studio visit with Nick Mauss • Publications meeting, Thomas & Ed film meeting • Work at office, studio visit • Work at office, work on PowerPoint presentation, A/V tech meeting • Visit downtown galleries • Work at office • Work at office • Studio visit, work at office • Meeting with Donna & Adam, work at office • Lunch meeting with Kai Althoff @ Untitled, meeting with Liz Deschenes, meeting with Emma Reeves • Visit Chelsea galleries • Los Angeles: visit galleries, dinner meeting with Rhea Anastas & Bennett Simpson @ Hungry Cat • Studio visits, visit galleries, see Andrew Masullo exhibition at Weinberg Gallery, M Café, studio visits • Meeting with Thom Andersen, lunch @ Allegria restaurant, studio visit with Dawn Kasper, studio visit, visit MAK Center

Nathaniel Dorsky in his studio, 2011

sation Thomas is talking about. This has, at some points in its history, been one of the Biennial's great strengths—that it brings together a much larger field of cinema, not merely that portion that the rest of the art world has assimilated, or generated within itself.

ES: Going back to Thom Andersen for a minute—I think it's interesting because I've had this idea as Jay and I have been putting the show together that doing a Biennial is so much about the process; you sort of go back over your notes from the field to make these connections, not all of which you can actually see before the show opens. We, as curators, aren't really far ahead of everyone else in terms of understanding how all the different parts fit together. So in these discussions we've been having, we've tried to bring more of that process out, and one of the places I think that's evident is how Thom Andersen came to our attention early on. Originally we sort of thought that documentary was going to be an even more significant part of the show, but things took a somewhat different course.

TB: I feel that documentary film has definitely found a place in the show, and I think that's interesting insofar as it really points to the range of nonfiction film practices that are thriving at the moment—whether it's something more essayistic, like Thom Andersen and Moyra Davey, or growing out of dance and performance, like Charles Atlas, or a kind of poetic and politically urgent reportage, like Laura Poitras.

EH: In a way the importance is signaled by our selecting Frederick Wiseman, who not only shaped documentary as we now know it, but remains one of its major contemporary practitioners. We could also talk about the way that Kevin Jerome Everson includes scripted scenes within a seemingly documentary framework. Or George Kuchar's video diaries, which come out of the practice of home movies but have evolved into something far more idiosyncratic and complex.

TB: Definitely—and Wu Tsang's *WILDNESS*, which is still another form of auto-ethnography.

ES: So it's not straightforward documentary, as we've always known it. It's very personal.

EH: It's in keeping with a long tradition of artists who have had to create their own visual languages, whether in film or other mediums. I'm thinking about Luther Price and Nathaniel Dorsky who are deeply invested in using exceedingly formal means to both speak about and create precise states of being. Dorsky argues that there is a spiritual, meditative component to seeing his films, whereas with Price, there's almost an existential crisis that occurs while watching his work. You know, you're faced with mortality through experiencing these fragile and sometimes decaying materials. That said, these artists aren't wholly outsider or something. We're

also talking about the continuance of certain internal traditions: the rhythms of Dorsky's editing can be connected back to Gregory Markopoulos, for example, and Price, who began as a sculptor, was inspired early on by Eva Hesse. Or Jerome Hiler, who also works with stained glass, and translates that sense of luminous color into his filmmaking.

FIELD NOTES AND ASSOCIATIONS (I)

JS: I wonder if this might be a real stretch, but meeting Kate Levant, something about her speculative, far-reaching mind makes me think of Lutz Bacher. They're two very different artists at far different points in their artistic lives, but I feel they're connected somehow.

ES: There's something about Levant and Bacher and a lot of the artists in the show—they have their own speculative ways of associating things; they associate objects in a way that's very hermetic.

JS: They both use objects and the real world, and take appropriation in unexpected ways.

ES: But then Levant has an entirely different side, in that she is very much about the handmade, and Bacher is not at all—but then you get to Joanna Malinowska and the Duchampian bottle rack she made from material fabricated to look like tusks. They're not handmade, per se, but they reference this kind of primitive handmade.

JS: Yeah, it takes this kind of free association for these patterns to emerge. Like in just this linking, you start to see that you and I are both drawn to artists who might work in known modes but who kind of go around their more didactic uses. Bacher deals in ready-made things, but not in a way that's groundable in strictly art-historical terms. She's just much more esoteric, for lack of a better word. And Kai Althoff, too—he's somehow deep into a painting discourse, but when you map out the state of painting, he's so much harder to place than others. And his practice encompasses so many other facets. For me, that's what makes Vincent Gallo totally intriguing as well—his absolute singularity in the cultural field.

ES: A grouping that comes to mind is Elaine Reichek, Nick Mauss, Richard Hawkins, and Werner Herzog. In one sense, they appropriate the

imagery of others, relating in that way to current practice, but the appropriations then become the scaffolding that embodies a new idea or emotion.

JS: Each of those artists has connected to an unlikely strand of artistic history, and not simply within the last fifty years of American and European modernism.

ES: Right, well, maybe postmodernism—they're latching on to older traditions in the history of art and opening them up to see what their possibilities are.

JS: But it's even different from classic postmodernism in that they don't use these historical works as pastiche; they're not mixing styles indiscriminately. It's more studied, singular, almost devotional.

ES: And there you can look at Robert Gober's work with Forrest Bess. Earlier discourses would have sublimated a sexual reading of his iconography in favor of formalist arguments. Bess challenged that by suggesting these hermaphroditic, hybrid possibilities.

JS: Right. How could you have modern painting informing body art and gender-ambiguous sex? It just could never go. But now, via Gober's effort, we can look at Bess's work very differently.

ES: And, of course, Gober sees Forrest Bess as being an early example of body art, before someone like Chris Burden, so he connects Bess to that kind of performance history, too. So there's just this odd, re-circuiting of information that's going on.

JS: Gober is very scholarlike; he wants to be historically correct and respectful to the artist he's working with. He will go to the limits of what scholarship is there. But then you have someone like Richard Hawkins who is so immediately willing to transgress. He's making works that investigate the little-known collage notebooks of Tatsumi Hijikata, the founder of Japanese *Butoh* dance. But in Hawkins's hands … he'll move more fantastically around this material and at times make the project much more overtly personal by entwining his own art and related obsessions. But neither project could be called an appropriation.

ES: No, they don't copy artists; they incorporate artists—I would go so far as to say that they inhabit artists. Jutta Koether is inhabiting an artist; Gober is inhabiting an artist; Nick Mauss is inhabiting an artist.

JS: We talk about the artist as historian, but really, they can blur the boundaries in a way that's much different. They can enjoy the complications between someone else's work and their own work. That's a real part of contemporary artistic practice, often working in several interlocking modes, juggling and exceeding the roles of artist, curator, writer, and historian.

ES: But these groupings have an interesting instability about them, because they sort of want to pull apart, too. Some of these historically based artists are heavily into research and even use this sort of formal quality of presenting documentation in a vitrine as a way of having this research be transparent. And then there are people who evoke history—like Mauss or Werner Herzog.

JS: They conjure it as part of a larger artistic vision.

ES: Right, and Gober does not want to incorporate Bess into his own work the way Herzog wants to honor something of the soul or mentality of Hercules Segers in his work. And this touches again on the weird fluidity of this show, because first, I don't know that people who are familiar with Herzog's films will at all expect to see him working in this way, and second, I can't help but think of Michael Clark again, in this discussion about artists inhabiting other artists. Because I cannot think of another artist of Clark's stature whose work is so collaborative with other artists.

JS: I feel like Koether has a real relationship to him (I think she's actually the first artist I heard talking about Clark), and she's definitely one of those artists who makes sure to be really permeable, to seep into all kinds of formal, art-historical, performative, and collaborative relationships. Like we were saying about Charles Atlas, the boundary between her and her collaborators is often much more open.

ES: How would you compare what Clark is doing to The Red Krayola?

JS: I think The Red Krayola traffics more like a Trojan horse that's transparent enough that you can actually see who's inside at any given moment. They've always operated as a "band," and in many ways they prefigure much collective/anonymous practice that has emerged in the last several years. They haven't sought solace in the symbolic art world but typically prefer the rugged life of touring nightclubs and concert halls. Who I might relate more to Clark is Hawkins, and Dennis Cooper, too—and their shared beginnings around glam-rock fandom, decadent European literature, fringe and pop culture, critical theory, and gay subculture.

ES: Yes, I feel like Dennis Cooper is a sort of Jean Genet character. He's very interested in crime and criminal thoughts—I'd say that's what's going on with the boy, the mannequin.

JS: Yeah, Cooper and Hawkins address gay culture in a way that allows for the kind of perverse pleasures of Genet, which was a little too transgressive at the moment they both began making art and writing.

ES: And they figured out a way to handle this kind

Meeting with Bentley Meeker • Phone meeting with Stefan Winter re: Werner Herzog sound, phone meeting with Werner Herzog • Detroit: studio visits, studio visit with Kate Levant, studio visit with Michael E. Smith • Visit Susanne Hilberry Gallery, visit Cary Loren/Bookbeat, visit MOCAD, meeting with Luis Croquer • Chicago: studio visits, visit galleries, lunch with John Corbett, studio visits, drinks @ Drake Hotel • Brunch meeting @ MCA with Julie Rodrigues Widholm, studio visits, visit Art Institute • Catch-up meeting, record first conversation for curatorial essay, record conversation with Thomas & Ed re: film, catalogue meeting • Work at office, meeting re: releasing artist list, gallery walkthrough with Nick Mauss, gallery walkthrough with Jutta Koether • Work at office • Visit downtown galleries • Studio visit with Cameron Crawford • Catch-up meeting, website meeting, studio visit, work at office • Breakfast meeting with Eric Banks @ Untitled re: interview with Adam, Whitney Gala • Performance logistics meeting, meeting with Lutz Bacher, work at office • Meeting to project Luther Price slides • Skype meeting with Barry & Bryony (Arika), meeting with Kai Althoff @ Untitled, initial projector test for Werner Herzog images • Breakfast meeting with Joe Melillo @ Silver Spur, meeting with Andrea Fraser @ Eli's, Thomas & Ed film meeting, membership meeting, present exhibition to Adam & Donna • Catalogue meeting, work at office • Work at office, meeting with Liz Deschenes @ Eli's • Meeting with Surrey Hotel re: collaboration, work at office • Test Lutz Bacher projection on Whitney 4th floor, gallery walkthrough with Sam Lewitt • Studio visit • Studio visit, work at office • Record curatorial conversation, meeting re: education structure in sculpture court, discuss music/sound festival, meeting with graphic design department • Studio visit with LaToya Ruby Frazier, meeting with Georgia Sagri, catalogue meeting, work in office

of material through installation ideas and through the archive, I think, which kind of links them to a more conceptual generation. So it's not so straightforward in revealing its sources.

JS: Exactly, and each orients toward things like vintage horror motifs—Richard had made these haunted house sculptures. And Cooper is now delving into these major visual-theater tableaux projects with Gisèle Vienne, the French theater director and artist. Cooper and Vienne's installation for the Biennial is the first time this work will be shown in the United States, and it evokes an early "spook-house" sensibility with an existentially creepy talking mannequin and puppet.

ES: Do you think that in this Biennial we've encountered installation artists who do work that is poetic or hermetic—whereas other installation art recently has been either institutional critique or relational? Even someone like Moyra Davey—she presents as a photographer, but she photographs what she's interested in exploring mentally and emotionally. So in this case she's interested in Mary Wollstonecraft and Frankenstein, and she relates these things to her own sisterhood. Her series of photographs and the related film are very content laden. Which, in a way, brings us again to these artists' relationship to the archive.

FIELD NOTES AND ASSOCIATIONS (II)

ES: Cameron Crawford is, in a way, an artist who is typical of many Biennials because he's in this state of emergence, and all Whitney Biennials capture some artists in that state. It's one of the most exciting things about a Biennial, to see how somebody comes to life almost for the first time in that context. I can relate him to Nick Mauss, in the sense that his work has a sculptural presence that's kind of poetic and slightly fragile, even though it builds up into this large work that has a real presence in the exhibition.

JS: Crawford's work is extremely elegant and committed to fine craft; at the same time, it addresses the less visible forces that define an artwork and the virtual. When we visited him, at one point we asked him which artists were important artists to him, and he said—

ES: —Morandi.

JS: And he mentioned an interest in Seth Price, which is such an interesting pairing. Price's work speaks to issues like addressing distribution as a medium, titling, formatting, updatable text—contemporary forms of immateriality. Crawford traffics in these concerns but makes these incredibly crafty, time-demanding objects, and in that way he calls to mind other abstract sculptors such as Vincent Fecteau and Oscar Tuazon.

ES: Fecteau and Tuazon each seem to be at a particular moment in their practices as well—they're different from other artists of their generation who engage with collage and appropriated objects and reassembly.

JS: I think they both set up formal problems for themselves, but the way they go about it is totally different. Tuazon deals more with construction, hard architecture, disruptive vernacular.

ES: Yes, it's like Tuazon is thinking more of the dwelling and the house and the space. His earlier work looked to geodesic domes and things like that. Fecteau—you look at his work and almost think of it being like Henry Moore …

JS: Some kind of homespun, weird sense of biomorphic geometry—resolving or producing a totality of form, material, and colors that operates very unexpectedly. Another artist, Matt Hoyt, makes tiny, labor-intensive objects, which he arranges in small groupings and displays on simple shelves. In both their practices, I think the viewer can really sense the incredible effort and focus, the deep commitment to conjuring an object. They each make magnificently strange and entrancing small-scale sculpture, but the formal language they each develop communicates much more on different wave lengths and explores the connections between the known and unknown.

ES: I think Fecteau wants to bring things down to zero toward a very simple idea of space and things that interlock and make a new form—he doesn't want to get too far away from a specific problem; it's a problem that he wants to figure out. And that's kind of a radical move in today's environment where everything is so laden with partial meanings.

JS: And yet, there's more to Fecteau's work than just the formal questions, which is what a lot of people see. His work doesn't make these overt cultural or art-historical nods, but it does stretch into other territories, pushing the bounds of what you can sneak into an abstract practice.

ES: Kind of like Donald Moffet—

JS: Yes, in a way. That helps clarify something about abstraction and culture, and different formal means to embed undercurrents of meaning.

ES: Going back to Oscar Tuazon, we have a number of artists who are responding directly to the Whitney's Breuer building, and he's one of them. He has expressed an out and out admiration for the building; he really loves the materiality of it. He's not only going to be using the lobby gallery, but he's also building a runway on the fourth floor for K8 Hardy's fashion show of clothes she's designed.

JS: And John Knight. He's addressing the fact that the Breuer building is soon changing occu-

pants. It's all about sprucing up and finishing the Breuer, not quite "restoring" it, but instead enhancing a latent sensibility in its original design as the kind of last thing you do before you evacuate a site.

ES: He reads these underlying texts of architecture. I think Sarah Michelson's choreography will work specifically with the building, and Jutta Koether is interested in the windows. Liz Deschenes ... There's a sense with these artists of trying to make the spectator aware of what they are as a body in the space in which they stand, and to reflect on that space ... Deschenes wants you to think of the planes of the building; Koether wants you to think about the shape of that window. They want you to be more actively aware of—

JS: Context.

ES: Yes, of where you are when you're looking at their work.

ON THE CATALOGUE

JS: We both agreed that the Biennial catalogue should be reconceived. It just seemed like the model before, of professionally written synopses of each artist's practice paired with a professional photograph of a single exemplary artwork—has become completely outmoded. You can now get all that sort of information online, continually up to date. And the consistent tone of the institutional voice throughout can create a dulling sameness at times in its equal treatment and enthusiasm for the sequence of artists.

ES: And then we read Andrea Fraser's essay in *Texte zur Kunst*, which she actually builds upon in this catalogue. And that kind of crystallized our thinking on some level, to move away from this kind of empty "artspeak" and toward an idea of making the catalogue an extension of the exhibition rather than just a chronicle. We chose David Joselit to be an essayist because he has been so involved in looking at developments in contemporary art since the 1980s, and he's someone who is an academic art historian and also writes and speaks internationally about artists who are working now. He not only writes about them theoretically, but is interested in their studio practice.

JS: Joselit's recent essay "Painting Beside Itself" was a major watershed text. It rearticulated contemporary painting in terms of networks, contingency relationships, media theory, and broader institutional concerns and applied it to painting, which does hit a strong note about the ways painters are thinking and working now. For the catalogue, he's continued to look at painting but has brought in another rubric. He goes against the idea that painting is always killing itself, and instead puts forth another concept—travesty—that speaks to a lot of the connections we see in the Biennial: artists occu-

pying other artists, taking on the guise of a historical artwork or another moment, and so on.

ES: I have worked with Joselit since the mid-1980s, and we have together explored this field, so it's personally satisfying to me.

JS: In his essay he mentions a group of artists that he has studied closely and articulates them as examples, but it will be clear to those who see the show that so much of what he speaks about—whether it's painting or other mediums—is reflective of a lot of contemporary practices.

ES: And since he had worked with Jutta Koether and written about her work many times, we thought they might like to confuse their roles a little bit, so they came up with the idea of Koether providing the illustrations for Joselit's essay and Joselit contributing shaped text fragments to Koether's pages. And again, you see that fluidity we've been talking about throughout—artists who have a strong sensibility moving their practices into different territory. Fraser, of course, started out as a performance artist, and now she's becoming an increasingly important theorist.

JS: And then we have John Kelsey's text; he's extended his role as a critic and essayist through myriad aberrances and complications. Both Fraser and Kelsey are exceeding their role as essayists by also coming into the exhibition as artists, which is fascinating. Overall with this catalogue, we wanted to let things get out of our hands a little, and we've been rather fortunate with the results. It's building on what I think is a great moment of articulation, of artists writing, playing multiple roles, occupying multiple sites. For us, the catalogue was another opportunity to follow their leads as they extended the reach of our survey—they wrote themselves or commissioned their own writers, collaborated, or used their pages to extend into other directions.

FIELD NOTES AND ASSOCIATIONS (III)

ES: I remember when we first started on this project, someone said to us: "Well, you know, you're

Andrew Masullo's studio,
San Francisco, 2011

*Catch-up meeting, planning
meeting with Bentley Meeker,
Ed & Thomas phone meeting,
catalogue meeting • Meeting
with Robert Gober & Becky re:
Forrest Bess, phone meeting
with Jason Best re: curatorial
conversation, Stefan Kalmár
re: collaboration • Miami:
meet at Art Basel, meeting
with Oscar Tuazon @ Cadet
Hotel, tour art fair, Whitney
dinner @ BLT Steak • Meet
Branislav & Dominic (MCC)
@ Ice Box Café, Art Basel,
meet Marian Goodman re: Art
& Language painting, NADA
Fair • Work on curatorial
conversation • Prepare for
curatorial meeting, suggestions
for acquisition, catch-up
meeting to go through all
artists • Biennial website
meeting, record final bit of
curatorial conversation, Michael
Clark event @ Four Seasons
to launch Modern Dance Club
(U.S. Company) • Meeting with
Stefan Kalmár, Richard Birkett,
Thomas & Ed re: Artists Space
collaboration, receive Arika
text for catalogue, meeting
with Michael Clark & team*

going to be putting this show together during the year of the presidential primaries and the next election; it's going to be a pretty loaded time for Americans." And I guess that could have formed a backdrop for our work, but it didn't. We didn't consciously look for it.

JS: No, and even as the Occupy movement gained momentum …

ES: We'd made our selections at that point; we were really in the final stretch, so to speak. But we did start to feel like there was some great seismic change that had gone on in the last two years that Occupy Wall Street recognized. It does feel like something significant has happened, but, in a way, it all still seems somewhat nascent.

JS: Well, we've been reluctant to go back and try to group the work based on these overarching theories or themes, and to try to do that now vis-à-vis Occupy Wall Street feels like it would be—

ES: —disingenuous.

JS: Yeah. But I also think—I mean, you read through the catalogue, there are a lot of overt political overtones in the writings. Some of the artists and writers clearly take up politics in a direct way; for others, it's more indirect. So you see in Nicole Eisenman's paintings a social and political satire … And, I think her influence could be drawn even to an artist like Dawn Kasper. She links to those younger queer artists, her sensibility, politics, and experimental approach continues to be important.

ES: You could say that she has this very forthright figurative painting style that relates to an earlier generation, so she's like Dana Schutz in that regard. It's unique in this exhibition; there really isn't a lot of figurative painting. Yet, the new work, the monotypes that she described to us as being about something that's loosened her painting style up a bit … she wanted to be freer as a painter. I was also thinking how Sam Lewitt is a politicized Charles Ray. He's using these globs of, what's it called?

JS: Ferrofluid.

ES: —ferrofluid. And you know, in his early sculpture, Ray was very involved with liquids, with black ink. That blackness reminds me of Lewitt's substance, too. But Lewitt is out there announcing that this is kind of evil material, this industrial goo that has all these commercial and military associations; he's blatantly showing it to you. And Ray, by using this black ink, there was always this suggestion that it was toxic and that if you got a little too close, you'd be covered in it and could never erase it from your body.

JS: Or you have an artist like Lucy Raven and her player piano piece that considers our relationship between two centuries of technology. But to take a somewhat different tack, in thinking about a kind of indirectness, there are artists like Matt Hoyt or Vincent Fecteau who are making these things that make you slow down, and I really do think there's some politics to that, too. This goes back to what we've been saying about a lot of the artists in the show—they're not slick, they don't slide through. The way that art and art discourse has borrowed from protest culture and radical politics in the past has become suspect, or at least its ground of correctness or edginess has been wobbled quite a lot by the real events of the past few months, and how artists, like everyone else, have had the possibility of putting themselves into real scenarios of conflict. I think, in a lot of ways, even if we're not seeing a lot of overtly political art, artists are working politically on an even more fundamental or structural level. I have a hard time when critics complain that art hasn't sufficiently responded to real-world trauma, or is apolitical. Art shouldn't be responsible for anything, and at the same time, deep traces of conflicted reality are always there. It's the challenge of the viewer to learn to see them.

ES: Yes. I like the way Mike Kelley has come into this exhibition, because he's done work about Detroit, where he's from, and he's done it with an awareness of this political, old, anarchic style that came out of Detroit. He's very well-versed in the history of American art, and he brings that to his work, to this very moment and what's happening in this particular place in the middle of the country that he knows very well. But he doesn't do it through any of these fancy, theory-laden modes; rather, he approaches it in the most direct way he possibly can. Nothing could be more direct than taking a house, a symbol of every middle-class family's dream, and hauling it through the streets of Detroit, talking to people who can't expect to have that in their lifetime. Many of them, they've had a house and lost it. He literally picks up these conversations on video; there's nothing elaborate, and it's right to the point and very poignant. And the videos we're showing are one part of a public art project for Detroit, which is still in progress and is described, in all its shortcomings, by Kelley in his catalogue text.

Is it irresponsible to allow people to speak, without precautions, without supporting documentation, and without a pseudo-scientific screen?
How otherwise to conceive of a study, whether it be in psychiatry, pedagogy, or areas that concern justice?
Is it really dangerous to let people speak of things as they feel them, and with their language, their passions, their excesses? [...]
We think that the expression of desire is synonymous with disorder and irrationality. But the neurotic order that forces desire to conform to dominant models perhaps constitutes the real disorder, the real irrationality.

Felix Guattari, *Three Billion Perverts on the Stand*, 1974

Artists **Books**
&
As a curatorial programming partner of the 2012 Biennial, Space **Talks** will be the site of a weekly program, curated by Artists Space, focusing on key concerns from the work of the exhibiting artists, as well as from the Biennial as a whole.

Artists Space Books & Talks is a space in which new ideas can be proposed, examined and contested, fostering a discourse beyond exhibition and display. It acknowledges the vital role that the exchange of knowledge plays within the context of contemporary art and beyond – how we locate ourselves and our work in an expanded cultural field; how we relate to each other and each other's desires, and to the conditions of living in 2012.

As Artists Space turns forty this year, opening this second permanent venue, which will exist alongside Artists Space Exhibitions, will build new and extend existing relationships. Discussion, debate, correspondence, and argument have long formed a central part of Artists Space's work—as aspects of working and living, these social relations are to be seen as much in the realm of art production as an object or image, or, as Louise Lawler and Sherrie Levine once said, "A picture is no substitute for anything." In addition to an open space for talks, discussions, screenings, and meetings, Artists Space Books & Talks houses a bookstore—consisting initially of one thousand titles, selected by one hundred artists, writers, and thinkers.

As a parallel narrative, relationships will, or will not, unfold over time.

Stefan Kalmár and Richard Birkett
Artists Space

1 This phrase references a statement made by Hollis Frampton to Carl Andre, in *12 dialogues, 1962–1963*, ed. Benjamin H.D. Buchloh (Halifax: Press of the Nova Scotia College of Art and Design; New York: New York University Press, 1980).

Final catalogue meeting, meeting with Lena Herzog to schedule Werner's installation, present Biennial in Whitney curatorial meeting, Whitney staff art show, holiday party • Meet with Sarah Michelson & team @ Whitney upstairs, meeting with James Lingwood | Artangel @ Untitled, gallery walkthrough with Michael E. Smith • Meeting with Mark & Cara re: floorplans, work at office, marketing/press meeting to present artists' works for show, edit and finalize curatorial conversation • Catch-up meeting, review performance schedule and logistics, Thomas & Ed film meeting and schedule • Meeting with Stefan, Richard, Ed re: Artists Space collaboration, final edits of curatorial essay & acknowledgements, meeting with Greta re: performance events during opening • Work at home on program guide texts, final essay edits, acknowledgments, field notes

JS: The moving house is such a strong visual image. It's direct, but it's incredibly nuanced as well. It doesn't answer all of its own questions.

ES: And it's very personal—the mobile homestead is a replica of the home he grew up in. So that's different, too, this personal, affective quality. We were very moved by our visit to Detroit. Michael E. Smith, who was born in the city and still lives there, has a sculptural practice based on taking the most common, forgettable, non-luxurious things from his world—mostly little fragments—and transforms them materially. His work makes me think of the real poverty of many people's lives .
 LaToya Ruby Frazier, who is from a community near Pittsburgh, takes these portraits of her own

body in this home that belonged to generations of her family, which has now been deserted, so she inhabits it almost as a ghost. But then there's her other project, which is a very direct photographic dissection of a Levi's campaign that exploited the town where she grew up and misrepresented it in order to sell a product.

JS: She unravels the projected image and false authenticity that this campaign projects. And that makes me think—filmmakers such as Thom Andersen, Kevin Jerome Everson, Laura Poitras, and Frederick Wiseman have also each endeavored to show what's behind the falsely smooth surfaces of industry, institutions, culture, and the war on terror. While artists working performatively, such as Andrea Fraser, K8 Hardy, Mike Kelley, Wu Tsang, and Georgia Sagri, have interrogated how one's body is a conduit for external institutional force and at the same time a tool for potential resistance.

ES: Sagri's definitely doing something live for the Biennial—we don't know exactly what yet. She wants to camp out—embed herself in the exhibition space, but she wants it to be a large site of conversation. And she's going to try to set that up naturally by inviting people who will sit down and talk to one another, but then she hopes that people who are coming through will join the conversation. It's similar to Dawn Kasper, too, in that she wants to—

JS: —show up and create a live, unpredictable scenario. Which, in a way, is the whole Biennial.

ES: We really don't know what's going to happen, do we? I think we expect to be as surprised as anyone else coming into the Whitney—we really don't know what it's going to be like to have this big empty space on the fourth floor with many bodies flowing through it sometimes. How's that going to work in relation to some of the other artwork, in relation to the saturated bright hues and obstinate cheerfulness of Andrew Masullo's paintings downstairs, for example, or the film screenings. I just can't quite imagine how it's going to work, and I like that.

JS: But I think, like we've been saying, that sort of indeterminacy is reflected in a lot of the work …

ES: We've been attracted to artists who do not answer all the questions in advance. It's like, some artists, you walk into their studio or you read the press about them, and they seem to have anticipated every kind of critical viewing of their work, whereas the artists here—it seems a lot of them can't yet explain their work or their attraction to it themselves.

JS: Yeah, yeah—I think we've ended up with a show like that, that goes into this kind of territory where the system—

ES: Yes, the system—the system is not entirely figured out.

A survey is a process of listening.

ARIKA

Being: a quasi and limited performed survey of activities in North America that could be said to concern different kinds of *listening*, as undertaken by Arika[1] (and others), based on particular concerns we have, which we will look for in said surveyed work; performing a series of encounters, both with existing and potential listening practices: i.e., we'll talk about what is and is not happening in North America, resulting in performances, talks, discussions, and consecutive social gatherings …

0: BRIEF EXPOSITION
The purpose of this text is to invite the reader to begin to imagine a process. It announces its beginning and concerns, the terms of engagement, methodology, and what could reasonably be expected as its ends. At the time of writing (December 2011), we are in no position to announce any actual results,[2] but we can say something as to the potential shape and general feel of what we'll present at the 2012 Whitney Biennial.

1: OPENING GAMBIT: A SURVEY RETURNS BOTH POSITIVE AND NEGATIVE RESULTS.
In the interest of full disclosure, here's our main gambit: A "survey" is a process by which a field is summarized from the standpoint of specific concerns, stated aims, or things to be searched for and in which results (or lack thereof) are both highlighted and discussed. We do have specific concerns, will state these, and take relatively seriously the methods and terminology of surveys. In a kind of "pataphysical" way, our survey might display some, but not all, of the features of a "survey," and might willfully exaggerate said features for rhetorical gain; but we'll be open about that, and you are invited to call us on it. So, collaboratively with others, we'll undertake a performative survey of our concerns, as they can be found, or not, in American activity. The public program we present at the Biennial will be a continuation of that surveying. You are encouraged to point out what we miss, overlook, or what you think we might be blind to …

2: SECONDARY GAMBIT: THIS IS A SURVEY OF LISTENING.
A kind of sub-gambit: We're going to survey *listening*. For ten years we've organized experimental music, film, and art events in the UK. We have a fidelity to music, but also real concerns about how it's going to develop and be useful. It's our wager that a focus on *listening* (not experimental/avant-garde/underground music/ sound art/etc.) can get beyond the confines of genre or medium to allow us to consider listening as a process or tool to which music has contributed and which it has advanced greatly, but to which other disciplines also contribute. Or better: We can create encounters between different kinds of listening, and in some small way produce some knowledge, cross-fertilization, or tension that is useful within and beyond music.

3: OUR CONCERNS: ENTROPY MADE AUDIBLE.
A hypothesis: The listening tools of experimental music have almost always been made as means for getting to grips with real-world social, political, or philosophical situations.[3] We worry that experimental music has slowly been stripped of those political or philosophical uses, that it's not as radically useful as it once was. Does much of current music practice resemble the conflicted, oddly shaped "holes" and "slices," the now vacant, irrelevant, and redundant spaces that Robert Smithson talks of in his 1973 text *Entropy Made Visible*: "in a sense [they] are the monumental vacancies that define, without trying, the memory-traces of an abandoned set of futures." Making such a connection could be seen as a deliberately provocative; but could the kind of self-doubt that connection lays bare be a useful impetus to survey these holes and null spaces? Could we celebrate where practice remains potent, and where it does not, reanimate it in relation to other ways of listening, from other extra-/non-musical practices? For example: could or does music make good use of Derrida's phrase "s'entendre parler" (to hear oneself speaking and to understand one's own utterance)? How do conceptual writers deliberately mishear, or simply transcribe to generate new text; do they think of their performances as public hearings? How do we philosophically deal with concepts and objects, and what does this have to do with listening, being at once concerned with the material (sonic) and dematerialised (a conceptual procedure)? Should we think of listening as a cognitive experience, or as a non-discursive mode of thought, or both? What if we replace the idea of music as organizing sound with a process of organised listening (as Ultra-red propose), in which "organizing" takes on its political meaning? How do all of these different registers of listening relate back to the incredible listening practices developed by experimental music: in deep listening, in Cagean silence, in acousmatic listening, or in Afrocentric and/or Eurocentric improvisation? How do conceptual or non-musicians listen? Is noise music a kind of un-listening? Etc. …

4: A METHODOLOGICAL NOTE: THIS IS A SURVEY OF CATEGORIES, NOT OBJECTS.
This will not be a survey of closed objects, of individual data. It will be a survey of cultural data. Please be apprised: We're not unaware of standard surveying methodology and can happily report our embracing of *not unbiased* methods— the best way to survey cultural data is via key informants, which we'll have to do anyway since we're not from America. But then: Being Scottish might allow us to draw from an understanding of "survey" as the perspective implied by *sur videre* [Latin: "over-view"]; the surveyor has to both know enough to have a detailed authority, but also be sufficiently outside (above). So: It is our intention to try and create encounters between different categories of listening, suggested by or involving key informants. That could mean setting up for the audience, performers, or both, situations in which people with a competency in one form of listening (improvisation, free jazz, noise music, etc.), have to relate to listening in another register (community organizing, popular education, poetry, and so on), in which they have little or no competency. In doing so, as well as hopefully identifying some practices and protocols of listening, our survey might attempt to glimpse deeper into the properties of listening itself (into its dependent variables that shift as other variables shift). Is this to enquire as to the politics of listening; the shifting economies of power that listening can provoke as it organizes?

5: SOME REASONABLE ENDS.
Let's not get ahead of ourselves; this won't be a comprehensive overview. But we can (in another sense of "survey"—its architectural or geographical sense) hope to determine the lay of the land, the features of the terrain. It's fair to hope we could expect to advance far enough to propose a second level of investigation or surveying that could yet be done, to produce new terms for a further and more advanced critical investigation of listening.

6: A SURVEY IS COLLABORATIVE.
This process is already a collective enquiry; we won't be the sole authors of it and in many ways the key outcomes will be produced by others with whom we work. It'll involve more people as it develops, to include musicians, artists, writers, critics, participants in investigations and performances, audiences, and conceivably even you. It already involves members of the militant sound collective Ultra-red and the conceptual writer Craig Dworkin.

7: WHAT MIGHT ACTUALLY HAPPEN
Real-world things happening on the fourth floor of the Whitney could include encounters between: performance or discussion of conceptual music, noise music, improvisation, deep listening, free jazz, composition; conceptual writing or poetry performances, displays; temporary libraries or returned survey results as text, audio, video; workshop investigations as performances, groups testing one idea of listening via another; talks and demonstrations of things we couldn't find and discussions of why we couldn't; music that seems quite unlike music, non-musical things considered as listening. Which is to say that it's our intention to performatively inhabit the space with many other people; to set up situations in which we can all collectively embody the act of listening. We're proposing to survey via a set of encounters, and so the galleries might not be full of objects or predetermined or fixed results. It might not look like art. More to the point, it will be a performance and an invitation to listen.

NOTES
1. To see the survey and get a sense of our provenance, visit www.arika.org.uk
2. Both a welcome vulnerability and strength.
3. Given more space we could make a case for: (a) *musique concrète* as a form of phenomenological enquiry; (b) noise music as a focus on the unwanted, superabundance, and excess as a means to jam or overflow societal norms; (c) of much UK improvisation in the 1960s as an attempt to embody Marxist ideas of social relations; etc.

High Lines (for Sick Bees)

JOHN KELSEY

… but the artwork is no longer mute, it has learned how to speak itself, and by engaging networks is immediately referential, communicative, gossipy, and as fast and connected as any other information. And if art no longer needs a writer (all these recent symposiums on the decline of the critic), it can always *use* one, just as the writer uses art. We have seen how writing elaborates a parasitical relation to the expanding space of contemporary art. We have seen an explosion of blogs. And connected to these, an explosion of painting.*

Writers are like sick bees buzzing between artworks and shows, people and media, making trails in the hyper-productive air that is the space of the work today. And like bees, writers (especially critics) are now a little disoriented in this world, because writing, too, is infected by the virus of communication. Writing really does get lost. It goes wherever, losing the sense of its own space, sometimes recovering it suddenly in the vanishing point of total communication, in the depths of an apparatus—on a blog or in a text message, wherever. Then again, writing has always been on the move, since its invention. In the beginning, it travelled down roads in the form of military commands, later as literature. Letters and money moved in the same channels.

I'm often struck by the fact that writers and artists share the same screens when they do what they do, negotiating their own territories or gestural possibilities within a cybernetic workspace where art and discourse become abstract and fast together. Writing and art have never moved so quickly in one channel, and you can see the panic in the eyes of young artists who know they will never reach the end of scanning and tracking each other's every move, producing a deluge of information by sharing and reblogging whatever they're following. This is the exponential panic of mobilization and of linkage, a sort of swarming-bee panic as art proceeds to leak itself everywhere in real time. Artists are both more numerous and smaller than they were a few years ago, so they get into collaboration: choreographed labor, social networks, and other ways of enhancing productivity (when you know you're no Picasso) in the cloud. And now the network literally overwhelms the works themselves, which we hardly have time or attention for. So we work on the network itself, where the space of the work becomes identical to that of gossip. Art leaks.

We could describe many contemporary artworks as network-things, objects and images already half-gone in discourse and communication. So how does a writer work in relation to artworks that already speak, announce, displace, and connect themselves? And why, if everything is operating so abstractly now, are kids suddenly so involved with making clunky, handmade, tangible things again? I would answer the first question by saying that writers are compelled to speak back to the speed and efficiency of communication, or to make it speak back differently to itself, in order to reclaim something like "literary" space. Because writing is not reducible to communication. Meanwhile, artists make these gestures of throwing up clunky, material roadblocks in the midst of nonstop communication, not so much to stop it as to make it visible and durable, while still exploiting its speed to produce value. Of course, there is a market for such things (any things), and if it's not on blogs, it's in art fairs that you can always find the things I'm talking about. While art, too, is irreducible to communication, I'd say that artists tend to be entirely complicit with the demand to expand the noncontext of cyber-capitalism, especially when they make rough- or careful-looking stuff that really wants to show that it's here, present, specific, even critical. You can tell by looking at it that it's already a jpeg, and knows it. It's jpeg stuff. Already gone, in a crate or online. This is the smart stuff we see everywhere today, and it's all good.

Sometimes it occurs to us how unassuming and even crappy most art looks these days, and that that's actually part of its strategy and charm. It doesn't want to stand up in a forceful or problematic way, claim its own space, or elaborate a counterspace in relation to this swarmingly productive one. It wants to blend in and move nicely. For example, there was an exhibition of new art from L.A. a few months ago, and to me it looked exactly like Berlin art, which looks more and more like London and New York art. Not so long ago, L.A. art inhabited a specific space and had a specific look; it was exotic. But now a sort of global emo style

is emerging in galleries and on screens. Michael Sanchez was saying this, too, recently, in regards to the function of blogs like Contemporary Art Daily. MFA grads are making cozy, nice, unassuming, slightly frazzled, handcrafted works that are designed to speed like bullets (but without hitting anything). Artworks are improvised in relation to all the information that flies through them. Like dream catchers. Flimsiness is strategic, a seduction performed in relation to screens and networks. And every writer is now a screenwriter.

But if contemporary art can't claim or command a viable, inhabitable counterspace within the spreading noncontext, it can still find ways of closing itself down for a moment. It can produce small breaks or gaps within the functional, semiotically saturated space-time of the metropolis. This may not be much, but it allows us to see in a way that's not pure scanning or streaming. Here, like a dropped call, you suddenly experience communication in its interruption. A sequence of small gaps begins to produce another rhythm or musical intermittence within and against the efficiency of communication, and this is how art *survives* today (see Pasolini's article on fireflies). This is also what allows us to elaborate a distance from the work we do and the work that we are, and to display and see our own abstraction in work. Art claims the possibility of rhythmically disconnecting us within the abstraction of connection.

The idea of the writer being useless (and also used by art), or anyhow less responsible for the work's functionality within a discourse network, can become a sort of position and define another approach to art. A literary approach can be a way of elaborating a distance in relation to the communication that art is so constantly involved with. If the writer engages art within the abstracting spaces of networks and communication (using the same screens as art), it's not just because here is where contemporary art is to be found (on blogs or whatever), but also because writing doesn't always want to agree that everything should operate so efficiently within these spaces. Writing can be a way of unworking the work these spaces constantly demand, maybe even reclaiming their abstraction as a poetic possibility. If writing can do anything here it's by countering the functional openness of the new productive formats with its own specific and "impossible" space, and many artists are already becoming writers for this reason. Artists are also blogging, perhaps in order to make art criticism die a little more on the screen, "like a stomach digesting itself," as Jay said the other day. Here, the work is gossip and the gossip is the message.

Lately I've been working pretty closely with the artist Stephen Willats, who likes to say that art is a "channel." Decades before laptops, he began a practice that diagrammed spaces of social communication. Already in the 1960s, his work was about what moved through it, as he superimposed his strange diagrams over shared everyday worlds in order to show how cities are also social and semiotic networks. Whereas relational aesthetics involved itself with making the city disappear into art (installations), Willats prefers to make art disappear in the city, straying outside both the gallery and the traditional boundaries of the work. The sprawling *DATA STREAM: A Portrait of New York (Delancey Street/Fifth Avenue)* that he produced in 2011, which consisted of nothing more than printouts of image and text files glued to a forty-two-foot-long wall of sheetrock, was a sort of diagrammatic High Line of information gathered locally in our streets, using a combination of primitive analogue tools (tape recorders, still cameras) and cheap digital ones (Flip cameras, digital voice recorders). The data stream captures the teaming nothingness of metropolitan space, but what's moving is how devoted it is to the pedestrian inhabitation of flows, at the level of the average, urban body. It reveals and displays the touristic conditions of our daily lives, whereas the High Line in Chelsea is pornographic architecture designed to produce more urban tourists. I mention Willats because something important survives and continues to rethink itself in his art: the possibility of reappropriating our own information in New York or wherever we are, which resonates in a timely way with the ideas and strategies currently being experimented with down by Wall Street and in other cities. Occupy the diagram! No one knows what this is. We defer its articulation while reclaiming spatial agency.

Not to exploit the theme of occupation to fill a few more inches of catalogue space, and certainly not to neutralize this political weapon by putting it to work for art, but let's recognize that we are no longer in the moment of Institutional Critique or Utopia Stations, and that the question of space and its uses is suddenly on the agenda again in New York. We talk about space now that we no longer have it. We realize that we can only produce it by taking it back, but that this involves both struggle and a massive, collective rethinking of how we inhabit our own worlds. Meanwhile, we've witnessed a mushrooming of new galleries on the Lower East Side, fast little spaces that function exactly like blogs or screens and are linked by a discourse/network/gallery map. Art has a way of neutralizing space by spreading abstraction. I felt this strongly at the Frieze fair just now, where I was stranded in the booth picking up text messages from what sounded like a riot in New York, feeling very disconnected from its energies. Now we see the media-pressurized Occupy-thing already threatening to reduce itself to a list of demands, to be read by a talking head on TV, which would end what we like best about this thing: that we don't know what it is or what it is capable of. What's been occupied is a mutant space that is both real and abstract, and for the past five weeks this has made the city way more exciting and up for grabs than it has been in a long while. It's a strange new topology of discourse networks and urban behavior. And none of this is necessarily separate from the world of art and artists.

We don't know what the Biennial is either, but it arrives at a particularly strange and energized moment when New Yorkers are starting to stray from their subjective bounds in order to test possibilities of acting, meeting, and thinking outside the usual productive formats. We've seen artists, writers, and curators emerging from their workspaces, sensing other possible ways of occupying the abstraction of New York. Sick bees, wandering from the hive as we go to work on our own mutation, wondering at what point the artist's life finally begins or ends in this city.

NYC, October 21, 2011

NOTE
* And last night at Michael Krebber's opening, an explosion *of* paintings of blogs. People standing around reading the paintings, reading anonymous trash talk about themselves. For example, a blog called C-A-N-V-A-S spread out across a series of canvases, naming names. A paranoid gossip girl effect. Painting with gossip, an abject image of an all-consuming discourse network, a nasty mirror. Tomorrow these paintings will probably show up on these same blogs, and on screen is where they will both complete and end themselves as paintings. Krebber painting the words and opinions of others, saying nothing himself, painting as reblogging (the dandy doesn't blog, he only reblogs). So many names, no authors, all signed Krebber.

There's no place like home

ANDREA FRASER

It is difficult for me to imagine that I have much to contribute to this exhibition or its catalogue, with their aim of offering a survey of art of the past two years. I have not been looking at art in galleries or museums much for a number of years now, or reading much in art publications. I can draw on my previous years of studying the art world as an "institutional critic," as well as my ongoing work with young artists in academic contexts, but I can't help but doubt the relevance of my increasingly removed perspective for an audience of more actively engaged participants. I can rationalize this remove as stemming from my alienation from the art world and its hypocrisies, which I have made a career out of attempting to expose. I have ascribed to institutional critique the role of judging the institution of art against the critical claims of its legitimizing discourses, its self-representation as a site of contestation and its narratives of radicality and revolution. The glaring, persistent, and seemingly ever-growing disjunction between those legitimizing discourses—above all in their critical and political claims—and the social conditions of art generally, as well as of my own work specifically, has appeared to me as profoundly and painfully contradictory, even as fraudulent. Increasingly, I have turned to sociology, psychoanalysis, and economic research, rather than to art and cultural theory, to understand and work through these contradictions. Nevertheless, it has gotten to the point that most forms of engagement with the art world have become so fraught with conflict for me that they are almost unbearable, even as I struggle to find ways to continue to participate.

Writing this essay and the prospect of contributing to the 2012 Whitney Biennial are no exception. As I begin working on this text, the Occupy Wall Street movement is spreading across the United States and beyond. Along with many of what is most certainly an overwhelming majority of artists, curators, art critics, and historians who profess a progressive if not radically left political orientation, I have been looking for ways to support and participate in this movement and believe it represents a long overdue expression of collective revulsion over the excesses of the financial industry, the corruption of our political process, and the economic policies that have produced levels of inequality in the United States not seen since the 1920s. Indeed, the Occupy movement seems to be taking the art world by storm, especially in New York, with dozens of symposia, lectures, and teach-ins as well as Occupy-themed or inspired artists groups and protests at art-related sites. Who knows where this movement will be four months from now when this essay is published. I find myself asking, however, where was it four months ago? Why did it take an art world that prides itself on criticality and vanguardism so long to confront its direct complicity in economic conditions that have been evident for more than a decade now?

A few days ago, there was a march through the streets of Manhattan's Upper East Side, with stops in front of the residences of various billionaires. I was visiting New York from Los Angeles but tied up with Whitney-related meetings, so I didn't join in.

Did protestors stop in front of the homes of any of the Whitney Museum's patrons or trustees?

I consider a few of the Whitney's patrons to be friends, even family, and feel deeply and personally indebted to their support of some of the Museum's programs. One of these programs in particular, the Whitney Independent Study Program, has been a home for me since I was in my teens—one of the few homes I feel that I have ever had. It is unlikely that the particular Whitney patrons whom I know personally would appear on the radar of social justice activists (being only millionaires and not billionaires), although there are certainly other museum trustees and contemporary art collectors who have. But this does not make the situation any less fraught for me: the direct and intimate conflict I feel between my personal and professional allegiance with the Museum and some of its patrons and staff, and the political, intellectual, and artistic commitments that drive my "institutional critique," have contributed significantly to my difficulty in writing this essay.

IT IS WIDELY KNOWN that private equity managers and other financial industry executives emerged as major collectors of contemporary art early in the last decade and now make up a large percentage of the top collectors worldwide. They also emerged as a major presence on museum boards. Many of these collectors and trustees from the financial world were directly involved in the sub-prime mortgage crisis—a few are now under federal investigation. Many others have been vocal opponents of financial reform as well as any increase in taxation or public spending in response to the recession they precipitated, and have pursued these positions through contributions to politicians and political groups, with some giving generously to both parties.[1]

More broadly, it is clear that the contemporary art world has been a direct beneficiary of the inequality of which the outsized rewards of Wall Street are only the most visible example. A quick look at the Gini Index, which tracks inequality worldwide, reveals that the locations of the biggest art booms of the last

decade have also seen the steepest rise in inequality: the United States, Britain, China, and, most recently, India. Recent economic research has linked the steep increase in art prices over the past decades directly to this growing inequality, indicating that "a one percentage point increase in the share of total income earned by the top 0.1% triggers an increase in art prices of about 14 percent."[2] And we can assume that this hyperinflation in art prices, typical of how luxury goods and services respond to increases in concentrations of wealth, has also catapulted an unprecedented number of art dealers, consultants, and artists themselves into the ranks of the top 1, .1, and even .01 percent of earners, with the reported prices of many artworks well above $344,000, the 2009 threshold for 1 percent status.[3]

Indeed, the art world itself has developed into a prime example of a winner-take-all market, one of the economic models that emerged to describe the extremes of compensation that have become endemic in the financial and corporate worlds and now also extend to major museums and other large nonprofit organizations in the United States, where compensation ratios can rival those of the for-profit sector.[4] At all levels of the art world, one finds extreme wealth breezing past grinding poverty, from the archetypal struggling artist to the often temporary and benefit-less studio and gallery assistants to the low-wage staffers at nonprofit organizations. Museums plead poverty in negotiations with workers and leave curators to scramble for exhibition budgets and often-meager artist and author fees, while raising hundreds of millions for big-name acquisitions and expansions, which proceed in many institutions despite the continuing recession.[5]

And it is not only big museums and the art market that have benefitted from the enormous concentrations of wealth that have risen with inequality in the past decades. Given the steady decline of public funding for the arts since the 1980s, it is clear that this private wealth also financed much of the boom of smaller nonprofits, artist-run and alternative spaces, as well as a still-growing number of art foundations, prizes, and residencies. Under the U.S. system of providing a tax deduction on contributions to organizations, this private support for cultural institutions has amounted to a substantial indirect public subsidy. The corresponding loss in tax revenues may be negligible compared to the losses from other deductions and loopholes that have contributed significantly both to inequality and the impoverishment of our public sector, but it is a loss nevertheless, and one that has grown apace with the market value of artworks donated to museums.[6]

However, it has been during this same period of inequality-fueled art world expansion that we have also seen a growing number of artists, curators, and critics take up the cause of social justice—often within organizations funded by corporate sponsorship and private wealth. We have seen a proliferation of degree programs focusing on social, political, critical, and community-based art practices—based mostly in private nonprofit and even for-profit art schools that charge among the highest tuitions of any masters-level degree programs. We have seen art magazines take up apparently radical political theory and even a critique of the art market—while weighted down with advertising for commercial galleries, art fairs, auction houses, and luxury goods. We have seen museums embrace the discourse and even functions of public service—while the charitable deduction from which they benefit reduces public coffers, while they attract private donors away from social-service charities,[7] and while many of their patrons actively lobby for a shrinking public sector. We have seen artworks identified with social and even economic

critique sell for hundreds of thousands and even millions of dollars. And we have seen critical, social, and political claims for what art is and does proliferate, becoming central to art's dominant legitimizing discourse.

We also have seen a proliferation of theories and practices that aim to account for these contradictions, or to confront them from within, or to escape them by proposing or creating alternatives. I myself have long argued that the critical and political potential of art lies in its very embeddedness in a deeply conflictual social field, which can only be confronted effectively *in situ*. From this perspective it would seem that the apparent contradictions between the critical and political claims of art and its economic conditions are not contradictions at all but rather attest to the vitality of the art world as a site of critique and contestation, as these practices develop in scope and complexity to confront the challenges of globalization, neoliberalism, post-Fordism, new regimes of spectacle, the debt crisis, right-wing populism, and now historic levels of inequality. And if some or even most of these practices prove ineffectual, or readily absorbed, with their truly radical elements marginalized or quickly outmoded, new theories and strategies immediately emerge in their place—in an ongoing process that now seems to serve as one of the art world's primary motors of content production.

With each passing year, however, rather than diminishing the art world's contradictions, these theories and practices only seem to expand along with them.

The diversity and complexity brought about by art-world expansion itself makes it perilous to generalize about such efforts. While I believe that we still can speak of "the art world" as a singular field, this expansion has led to the growth and coalescence of increasingly distinct artistic subfields, each defined by particular economies as well as configurations of practices, institutions, and values. There are the art worlds that revolve around commercial art galleries, art fairs, and auctions; the art worlds that revolve around curated exhibitions and projects in public and nonprofit organizations; the art worlds that revolve around academic institutions and discourses; and there are the community-based, activist, and DIY art worlds that aspire to exist outside of all these organized sites of activity, and, in some cases, even outside of the art world itself. At their extremes, participants in these subfields may indeed escape some of the art world's contradictions, although certainly not those of the world at large: there are those who feel at home with wealth and privilege, for whom art is a luxury business or an investment opportunity and perhaps not much more, as well as those who see art as a purely aesthetic domain in which the political and economic should play no part. And there are those who see art as social activism and who have nothing to do with commercial galleries and art fairs, society openings, gala benefits, and privately funded museums. Most of us, however, and most of the art world, exist uncomfortably and often painfully in between these extremes, embodying and performing the contradictions between them and the economic and political conflicts those contradictions reflect, unable to resolve them within our work or within ourselves, much less within our field.

Art discourse—which includes not only what critics, curators, artists, and art historians write about art, but what we say about what we do in the art field, in all its forms—seems to play a double role in this expanded and increasingly fragmented art world. As a critical discourse, it often proposes to describe these conditions and contradictions, account for them, and even to

provide the tools to resolve them. At the same time, however, it remains largely and broadly shared, often traversing the most diverse art institutions, economies, and communities without any significant alteration in artistic, critical, and political claims or theoretical frame of reference. In this way, art discourse serves to maintain links among artistic subfields and to create a continuum between practices that may be completely incommensurable in terms of their economic conditions and social as well as artistic values. This may make art discourse one of the most consequential—and problematic—institutions in the art world today, along with mega-museums that aim to be all things to all people and survey exhibitions (like the Whitney Biennial) that offer up incomparable practices for comparison.

It is not only the immaterial character of art discourse that predisposes it to this function and mode of operation. Rather, it is the consistent tendency of art discourse to segregate the social and economic conditions of art from what it articulates as constitutive of the meaning, significance, and experience of artworks, as well as what it articulates as the motivations of artists, curators, and critics, even when it asserts that art is acting on these very conditions. While this is not surprising in the perspectives of those who view art as a purely aesthetic domain—and who even may make political arguments for art's autonomy as such—it seems increasingly symptomatic in an art world ever more intently focused on producing effects in the "real world" and on seeing art as an agent of social critique, if not of social change. The result has been an ever-widening gap between the material conditions of art and its symbolic systems: between what the vast majority of artworks *are* today (socially and economically) and what artists, curators, critics, and historians say that artworks—especially their own work or work they support—*do* and *mean*.

It now seems that the primary site of barriers between "art" and "life," between the aesthetic and epistemic forms that constitute art's symbolic systems and the practical and economic relations that constitute its social conditions, are not the physical spaces of art objects, as critics of the museum have often suggested, but the discursive spaces of art history and criticism, artists statements, and curatorial texts. Formal, procedural, and iconographic investigation and performative experimentation are elaborated as figures of radical social and even economic critique, while the social and economic conditions of the works themselves and of their production and reception are completely ignored or recognized only in the most euphemized ways. Even when these conditions are specifically conceptualized by artists as the subject matter and material of their work, they tend to be reduced in art discourse to elements of a symbolic rather than practical system, interpreted as representative of a particular artistic position, to be evaluated in contrast to other artistic positions, usually according to a theoretical framework which itself is being proposed in contrast to some other theoretical framework.[8]

Indeed, much of what is written about art now seems to me to be almost delusional in the grandiosity of its claims for social impact and critique, particularly given its often total disregard of the reality of art's social conditions. The broad and often unquestioned claims that art in some way critiques, negates, questions, challenges, confronts, contests, subverts, or transgresses norms, conventions, hierarchies, relations of power and domination, or other social structures—usually by reproducing them in an exaggerated, displaced, or otherwise distanced, alienated, or estranged way—seem to have developed into little more than a rationale for some of the most cynical forms of col-

laboration with some of the most corrupt and exploitative forces in our society.[9] Even more perniciously, perhaps, we also often reproduce in art discourse the dissociation of power and domination from material conditions of existence that has become endemic to our national political discourse and has contributed to the marginalization of labor and class-based struggles. With this, we may also collude in the enormously successful culture war that, for a wide swath of the U.S. population, has effectively identified class privilege and hierarchy with cultural and educational rather than economic capital, and which has facilitated the success of right-wing populists in convincing this population to vote for its own dispossession and impoverishment.

MANY YEARS AGO, I turned to the work of the sociologist Pierre Bourdieu for an account of art's social conditions, and found an account of their particular relationship with its symbolic systems as well. As Bourdieu asks in the opening pages of *The Rules of Art*:

> What indeed is this discourse which speaks of the social or psychological world *as if it did not speak of it*; which *cannot speak* of this world except on condition that it only speak of it as if it did not speak of it, that is, in a *form* which performs, for the author and the reader, a *denegation* (in the Freudian sense of *Verneinung*) of what it expresses?[10]

Among the aims of Bourdieu's work on cultural fields was to develop an alternative to purely internal and external readings of art—to those who take art as an autonomous phenomenon whose meaning derives only from immanent structures, and those who see art only as a manifestation of social, economic, or psychological forces. Here and elsewhere, however, Bourdieu suggests that the "denial of the social world" in cultural discourse is not just a matter of attending to the genuine logic of art or of avoiding the trap of a reductive or schematic social determinism. Rather, he suggests that this negation (*dénégation* in French) of the social and its determination is central to art and its discourse and even may be the genuine logic of artistic phenomena itself—and thus, any "external" reading that simply reduces art to social conditions, without taking into account its specific negation of those conditions, would fail to understand anything about art at all.

With regard to art as a social field, Bourdieu evokes negation in connection with a "bad faith … denial of the economy," which, he argues, is a correlate to one of the conditions of art as a relatively autonomous field: that is, its capacity to exclude or invert what he calls the dominant principle of hierarchization (which, under capitalism, is economic value).[11] More broadly, he describes the aesthetic disposition—the modes of perception and appreciation capable of both recognizing and constituting objects and practices as works of art—as a "generalized capacity to neutralize ordinary urgencies and to bracket off practical ends." He argues that this artistic tendency to distance and "exclude any 'naïve' reaction—horror at the horrible, desire for the desirable, pious reverence for the sacred—along with all purely ethical responses, in order to concentrate solely upon the mode of representation, the style, perceived and appreciated by comparison to other styles, is one dimension of a total relation to the world and to others, a life-style, in which the effects of particular conditions of existence are expressed in a 'misrecognizable' form."[12]

In Bourdieu's analysis, those conditions of existence "are characterized by the suspension and removal of economic necessity." What this distancing thus performs is an "affirma-

tion of power over a dominated necessity"—over need that may be a consequence of economic domination or impoverishment, but which also itself exists as a form of domination in that it may determine our actions and thus limits our freedom and autonomy. While this aesthetic neutralization of urgencies and ends may appear as a radical rejection of economic rationality and domination, historically achieved by artists through sacrifice and struggle, it also corresponds to the freedom from need afforded by economic privilege. And it is this dimension of the aesthetic that Bourdieu finds the specifically artistic principle underlying the objective collusion, manifest in the art market and in private nonprofit museums, between apparently radical artistic positions and those of economic elites.

In some respects, this is one of those aspects of Bourdieu's work that may appear woefully out of date. Art and art discourse have become increasingly focused on social and psychological functions and effects, as more and more artists, curators, and critics endeavor to escape the boundaries of the artistic and aesthetic and to reintegrate art and life, to serve social needs, to produce authentic emotional relationships, to embrace performativity, to liberate the spectator, to act in and on urban space, and to transform all manner of social, economic, and interpersonal structures. Art discourse no longer speaks of the social and psychological world *as if it did not speak of it*. It speaks of that world incessantly, especially in its economic aspects: financial and affective. And yet, it seems to me, to a very large extent, it speaks of that world *so as not to speak of it*, still, again, in forms that *perform* a negation in a Freudian sense quite specifically—and not only of the economic.

I was always struck that Bourdieu, apparently no fan of psychoanalysis, turned to Freud when it came to accounting for literary and artistic fields and especially their discourse. With his reference to negation "in the Freudian sense," he invites us to consider the operations of the aesthetic disposition, as well as the conditions of the artistic field and our investments in it, in terms of subjective as well as social structures. Freud describes negation as a procedure through which "the content of a repressed image or idea can make its way into consciousness," even resulting in "full intellectual acceptance"; and yet, repression remains in place because this "intellectual function is separated from the affective process."[13] As such, negation functions as a mechanism of defense that produces a contradiction on the level of discourse that manifests but also aims to contain a conflict—between opposing impulses or affects; between a wish and a countervailing imperative; or between a wish and a prohibition that negation itself may represent. In addition to functioning as a mechanism of defense, Freud describes negation as central to the development of judgment, not only of good and bad qualities, but also of whether something that is thought exists in reality. Because what is bad, what is alien, and what is external are "to begin with, identical," negation is a derivative of expulsion.[14] Thus, one can say that what negation performs is a splitting off, externalization, or projection of some part of the self (or, perhaps, any relatively autonomous field) experienced as bad, alien, or external—distancing, above all, our active and affective link with it.

And so, we speak *of* our interests in social, economic, political, and psychological theory and structures, and in artistic practices that engage these interests as well, or even attempt to engage materially the conditions those theories describe. And yet, those interests—social, psychological, political, economic—generally appear only as what Bourdieu once called "specific, highly sublimated and euphemized interests,"[15] framed as objects of inquiry or experimentation; of intellectual or artistic investments that are carefully segregated from the very material economic and emotional investments we have in what we do, and from the very real structures and relationships we produce or (more often) reproduce in our activities, be these economic in the political or psychological sense, located in a social or corporal body; isolating the manifest interests of art from the immediate, intimate, and consequent interests that motivate participation in the field, organize investments of energy and resources, and that are linked to specific benefits and satisfactions, as well as to the constant specter of loss, privation, frustration, guilt, shame, and their associated anxiety.

If the artistic negation Bourdieu described indeed functions defensively, in a psychoanalytic sense, then the primary object of those defenses may in fact be the conflicts attendant to the economic conditions of art and our complicity in the economic domination—and spreading impoverishment—that the enormous wealth within the art world represents. Much of art discourse, like art itself today, seems to me to be driven by the struggle to manage and contain the poisonous combination of envy and guilt provoked by that complicity and by participation in the highly competitive, winner-take-all market the art field has become, as well as the shame of being valued as less-than in its precipitous hierarchies. To the extremes of symbolic as well as material rewards within the art field, there corresponds an art discourse that swings between the extremes of a cynicism that disavows guilt, and a critical or political position-taking that disavows competition, envy, and greed; or, between an aestheticism that disavows any interest in the satisfactions such material rewards might offer, and a utopianism that ascribes to itself the power of realizing them by other means; or, between an elitism that would tame envy and guilt by naturalizing entitlement, and a populism that would mollify them with often highly narcissistic and self-serving forms of generosity, from traditional philanthropy to proclamations that "everyone is an artist."

Increasingly it seems that these positions do not represent alternatives to each other but rather are only vicissitudes of a common structure. They are bound together by their common claim on art and their common contestation of the art world's enormous resources and rewards. Individually and together, they serve to distance and disown aspects of that world, our activities in it, and our investments in those activities that might otherwise render continued participation unbearable. Above all, perhaps, they save us from confronting the social conflicts we live, not only externally but also within ourselves, in our own relative privilege and relative privation, by splitting these positions into idealized and demonized oppositions, to be inhabited or expelled according to their defensive function and the loss, or threat of loss, with which they are associated.

Certainly it is less painful to resolve these conflicts symbolically, in artistic, intellectual, and even political gestures and position-takings, than to resolve them materially—to the marginal extent that it is within our power to do so in our own lives—with choices that would entail sacrifices and renunciations. Even these sacrifices may be preferable, for some, to the pain of wanting what we also hate, and hating what we also are and also love, from the guilt of hurting others with competition, greed, and destructiveness to the fear of envious and retaliatory aggression. And it may be that any form of agency, however ineffectual and illusory or self-denying, is preferable to the anxiety of individual helplessness in the face of overwhelming social as well as psychological forces.

The most prevalent and in some ways effective defenses against the conflicts of the art field, however, may be various forms of detachment and displacement, splitting and projection. We may simply locate those conflicts, or the bad parts of them, elsewhere, in social or physical locations or structures at a safe remove from the art world and our participation in it, which we can then attack or attempt to act upon without challenging our own activities or investments in the art world. This may be true of much of what is considered political and critical art that exists primarily in the art field, as distinct, for example, from activism that may take cultural forms but does not exist primarily in the art field. Conversely, we may locate what is good elsewhere, in a "real world" or "everyday life" imagined as less conflicted or ineffectual and where we also may try to relocate ourselves; or in a whole range of cultures and communities, practices and publics imagined as less fouled with hierarchies and relations of domination and from which art wrongly has been split off. This may be true of much of what is described as social and community-based practices that seek to redeem art vis-à-vis positive social functions. And then we go about the work of reintegration and reconciliation—of art and life, of the specialized and vernacular, of performer and spectator, of individual and collective, of the aesthetic and the social and political, of the self and the object. Ironically, however, we often reconstitute those divisions in the very process of attempting reparation, most obviously by locating these "real" structures and relationships outside of the artistic frame, such that they must be newly constituted and conceptualized as the material or subject matter of art, or reintegrated through practical innovations or theoretical elaborations. It often seems that the very process of the conceptualization of social and psychological structures in art, and above all in the art discourse in which these conceptualizations are articulated, has the consequence of distancing and derealizing them; of splitting them off from the social and psychological relations that we may be producing and reproducing in the very same activities of making and engaging with art.

In fact, however, all art and art institutions, including art discourse, invariably exist within, produce and reproduce, perform or enact structures and relationships that are inseparably formal and phenomenological, semiotic, social, economic, and psychological. All of these structures and relationships simply are always there, in what art is, in what we do and experience with art, in what motivates our engagement with art, just as they are in every other aspect of our lives. Some aspects of these structures and relationships may be conceptualized by artists as the material or content of their work and specifically worked upon, with an intention to reveal or transform them; others may be elaborated by critics, historians, and curators. Most, however, remain implicit, assumed, whether unconscious in the psychoanalytic sense of repressed or simply un-thought, even while they may be central to what art is and means socially, as well as to our own interests in and experiences of making or engaging with art as well as in other forms of participation in the art field.

As much as art discourse may reveal structures and relationships to us, it also serves to conceal, with direction and sometimes misdirection; with affirmations accompanied by implicit or explicit negations of other ways of seeing, experiencing, and understanding; with abstraction and formalization that distance and neutralize; or simply through a pervasive silence about aspects of art, our experience of it, and the relationships it performs that, once internalized, may even cause them effectively to disappear for us. Through these operations of art discourse,

we not only banish entire regions of our own activities and experiences, investments, and motivations to insignificance, irrelevance, and unspeakability, we also consistently misrepresent what art is and what we do when we engage with art and participate in the art field.

The politics of artistic phenomena, then, may lie less in which structures and relations are reproduced and enacted or transformed in art than in which of these relations, and our investments in them, we are led to recognize and reflect on, and which we are led to ignore and efface, split off, externalize, or negate. From this perspective, the task of art and especially of art discourse is one of structuring a reflection on precisely those immediate, lived, and invested relations that have been split off and disowned.

Negation, for Freud, is not only a defensive maneuver. It is also a step in the direction of overcoming repression and reintegrating split-off ideas and affects; it is central to the development not only of judgment but also of thought. This may be what Bourdieu had in mind when, after evoking negation "in the Freudian sense," he goes on to ask "if work on form is not what makes possible the partial anamnesis of deep and repressed structures"; if artists and writers are not "driven to act as a medium of those structures (social and psychological), which then achieve objectification," passing through them and their work on "inductive words" and "conductive bodies" as well as "more or less opaque screens." And it may be that art's capacity to "reveal while veiling" and to "produce a derealizing 'reality effect'"[16] is not only what makes these structures available for recognition and reflection—and potentially for change—but also what makes this recognition tolerable, perhaps sometimes even pleasurable. In this sense then, the role of crafted, self-consciously and conceptually framed elaborations, objectifications, and enactments of these social and psychological structures is not that of producing an alienation effect or a disinvestment, as many traditions of artistic critique would have it, but rather to provide for just enough distance, just enough not me, just enough sense of agency, to be able to tolerate the raw shame of exposure, the fear or pain of loss, and the trauma of helplessness and subjection, and to be able to recognize and reintegrate the immediate, intimate, and material investments we have in what we do and that lead us to reproduce structures and relationships even while we claim to oppose them.

In order to achieve this recognition and reintegration, however, it finally may be necessary to free these operations of negation from those of negative judgment. Toward the end of his essay on negation, Freud famously writes that "in analysis we never discover a 'no' in the unconscious"[17]—there (as he put it elsewhere) "the category of contraries and contradictories … is simply disregarded."[18] The dreaming, imagining, thinking, saying, writing, representing, making, or performing of anything may be taken, first of all, as an affirmation that what is dreamt, imagined, thought, etc., is present within us as a memory, a fantasy, a wish, a representative of an affective state or force, an object that matters to us, or an intra- or intersubjective relationship in which we are, in one way or another, a participant. A negative judgment attached to that idea, object, or relationship is irrelevant with regard to this fundamental fact and indicates only that we feel compelled to distance ourselves from it and to disown it.

Artistic critique and critical discourse have often focused on the conflicts and contradictions of culture and society, including the art world itself. While negations performed as judgments, expressed or implied in various forms of distancing and objec-

tification, might elaborate on such contradictions and take the form of critique, what they signify as negations in a psychoanalytic sense are not conflicts in culture and society but rather conflicts in our selves, which are then manifest as contradictions in our own positions and practices. It may well be the critical agency within our selves that plays the greatest role in maintaining this internal conflict and, thus, in reducing cultural critique to a defensive and reproductive function. By interpreting negations as critique, by responding to judgments of attribution with judgments of attribution, by aggressively attempting to expose conflicts and to strip away defenses in critiques of critiques and negations of negations, critical practices and discourses may often collude in the distancing of affect and the dissimulation of our immediate and active investments in our field.

Instead, perhaps, we should be more like the analysts that Freud describes in the opening paragraph of his essay: "In our interpretation," he writes, "we take the liberty of disregarding the negation and of picking out the subject-matter alone of the association."[19] Far from judging negation and the manifest contradictions it may produce as a kind of hypocrisy, fraud, or bad faith, the analyst nods and lets the analysand move on, making note of the forces of repression at work and leaving open the way for further associations that might lead to the relinking of intellectual process and affective investment—and, eventually, to meaningful change. Indeed, it may be that the way out of the seemingly irresolvable contradictions of the art world lies directly within our grasp, not in the next artistic innovation—not, first of all, in what we do—but in what we say about what we do: in art discourse. While a transformation in art discourse would not, of course, resolve any of the enormous conflicts in the social world or even within ourselves, it might at least allow us to engage them more honestly and effectively.

NOTES
This essay is a reworking of, and an attempt at integrating, themes from a few previous essays. These include: "L'1% C'est Moi," *Texte zur Kunst* 83 (September 2011), 114–27; "'I am going to tell you what I am not; pay attention, this is exactly what I am,'" in Sophie Byrne, ed., *Museum 21: Institution, Idea, Practice* (Dublin: Irish Museum of Modern Art, 2011) 82–103; and "Speaking of the social world…," *Texte zur Kunst* 81 (March 2011), 153–58.

Thanks to Rhea Anastas, Thyrza Goodeve, and Simon Leung for their support and comments on this essay, and especially to Jason Best for his thoughtful, engaged, and expert editorial assistance.

1. I periodically look up the political contributions made by trustees of major museums. This information is readily available at websites such as CampaignMoney.com. For a brief survey of some of the financial and political activities of top collectors, see my essay "L'1% C'est Moi."

2. William N. Goetzmann, Luc Renneboog, and Christophe Spaenjers, "Art and Money," Yale School of Management Working Paper No. 09-26, Yale School of Management, April 28, 2010.

3. Damien Hirst, reported by London's *Sunday Times* to be worth £215 million in 2010, may top the list of wealthy artists. The *Wall Street Journal* has reported estimates that international art dealer Larry Gagosian sells more than $1 billion in art annually, making it very likely that most if not all of the seventy-seven artists he represents have incomes well above the $1.4 million threshold for .1 percent status. See Kelly Crow, "The Gagosian Effect," *Wall Street Journal*, April 1, 2011. (For calculations of income percentile thresholds, see the Tax Foundation, http://www.taxfoundation.org/news/show/250.html#table7.)

4. According to *Newsweek*, the highest paid CEOs in the nonprofit sector in 2010 were leaders of cultural organizations, with Zarin Mehta of the New York Philharmonic (at $2.6 million in total annual compensation) and Glenn Lowry of the Museum of Modern Art (at $2.5 million) topping the list. Greg Bocquet, "15 Highest-Paid Charity CEOs," *Newsweek*, October

26, 2010. According to the Economic Policy Institute, the ratio of average CEO total direct compensation to average production worker compensation in the United States was 185 to 1 in 2009. http://www.stateofworkingamerica.org/charts/view/17

5. The Whitney Museum recently broke ground on a new building in Manhattan's Meatpacking District that is estimated to cost $680 million to complete. The Museum of Modern Art is beginning a fundraising campaign to expand into the former site of the American Folk Art Museum, which it purchased in August 2011 for $31.2 million. MoMA sought major concessions from unions while raising $858 million for its last expansion, completed in 2004, resulting in a prolonged strike.

6. According to former Labor Secretary Robert Reich, the charitable deduction amounted to a total of $40 billion in lost tax revenues in 2007—which, he pointed out at the time, was equal to the total federal allocation to the Temporary Assistance for Needy Families program. (See Robert B. Reich, "Is Harvard Really a Charity?" *Los Angeles Times*, October 1, 2007.) Cultural philanthropy is reported to have averaged about five to six percent of total charitable donations in recent years. This does not, however, include foundation support and corporate philanthropy.

Of course, if the nonprofit art sector exploded in the past decades while the public sector has been under constant budgetary pressure to contract, it is not the result of a direct transfer. However, these phenomena are structurally and historically linked. Historically, the nonprofit sector in the United States developed not, primarily, as an alternative to the private sector, but as an alternative to the public sector. The U.S. model of privately governed cultural institutions has its origins in the gilded age of the late nineteenth century, when Andrew Carnegie and others spread the "gospel of wealth," advocating for private philanthropy instead of public provision and arguing that wealth is most productively administered by the wealthy and that private initiatives are better suited than the public sector to provide for social needs. The charitable deduction was introduced with a wartime tax increase in 1917 but extended by Treasury Secretary (and National Gallery of Art founder) Andrew Mellon in the 1920s. Mellon slashed top tax rates from 73 percent to 24 percent, arguing that lower taxes would increase tax revenues, spur economic growth—and also encourage philanthropy. The frenzy of financial speculation resulting from Mellon's economic policies came to an abrupt end with the stock market crash of 1929 and the Great Depression. Mellon's economic theories returned as the supply-side economics that have driven U.S. economic policy since the 1980s and have led to our most recent gilded age, museum boom—and recession.

7. According to Charity Navigator, donations to cultural charities increased 5.6 percent in 2010, while donations to health charities went up only 1.3 percent and donations to human service charities did not increase at all. See, http://www.charitynavigator.org/index.cfm?bay=content.view&cpid=42.

8. I examined the critical and art-historical reception of Michael Asher's work as an example of this tendency in my essay, "Procedural Matters: The Art of Michael Asher," *Artforum* 46, no. 10 (Summer 2008), 374–81.

9. Certainly, my own work has not escaped this condition.

10. Pierre Bourdieu, *The Rules of Art: Genesis and Structure of the Literary Field* (Stanford, CA: University of Stanford Press, 1996), 3.

11. See Pierre Bourdieu, "The Field of Cultural Production, or: The Economic World Reversed," p. 50, and "The Production of Belief: Contribution to an Economy of Symbolic Goods," pp. 74–76, both in Bourdieu, *The Field of Cultural Production* (New York: Columbia University Press, 1993). This analysis is often misunderstood as an assertion that art *is* autonomous or that this inversion of economic criteria defines art. Rather, Bourdieu argues that art's autonomy in this sense is only ever *relative* to its capacity to invert and exclude external criteria, and that this capacity only developed and can be sustained under specific social and historical conditions.

12. Pierre Bourdieu, *Distinction: A Social Critique of the Judgment of Taste* (Cambridge, MA: Harvard University Press, 1984), 54.

13. Sigmund Freud, "Negation" [1925], in *The Standard Edition of the Complete Psychological Works of Sigmund Freud*, vol. XIX (London: Hogarth Press, 1961), 235–36.

14. Ibid., 237.

15. Bourdieu, *Distinction*, 240.

16. Bourdieu, *The Rules of Art*, 3–4.

17. Freud, "Negation," 239.

18. Sigmund Freud, *The Interpretation of Dreams* [1900], in *The Standard Edition of the Complete Psychological Works of Sigmund Freud*, vol. IV, 318.

19. Freud, "Negation," 235.

Painting Travesty

DAVID JOSELIT

The history of painting has centered on *history painting*. What Leon Battista Alberti called *historia* in his foundational treatise of 1435, *On Painting*,[1] would be codified by the French Academy as "History Painting," the most prestigious of genres. If, in its magnificently scaled tableaux populated by the catastrophes of antiquity (or, by the mid-nineteenth century, the unsettling events of modern life), history painting tended to represent tragedy, things changed in the early twentieth century.[2] The axis of tragedy rotated 180 degrees: no longer was it *represented* as a drama of sacrifice and death performed by characters on a virtual stage, as in Jacques-Louis David's *The Lictors Bringing Brutus the Bodies of His Sons* (1789). Instead, tragedy unfolded in real space as the death

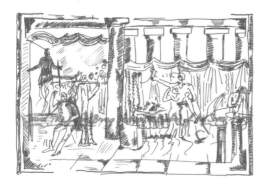

of painting itself; spectators encountered the limits of a medium in works such as Aleksandr Rodchenko's triptych of paintings *Pure Red Color*, *Pure Yellow Color*, and *Pure Blue Color* (1921), which, as

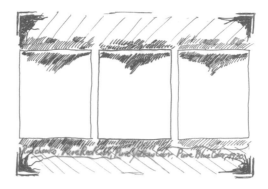

the titles indicate, consisted of nothing more than the medium's purified elements, monochrome canvases covered with primary colors. Generations of spectators witnessed the death of painting: at first they were outraged, and then they were mystified, but eventually they grew eager to consume these recalcitrant works in the galleries of museums of modern art around the world. Painting was killed by revolutions, and it was killed by commodities; it was killed by flatness, and it was killed by sheer boredom, but over and over it was resurrected only to die another day.[3] This is painting's modern tragedy: a modern form of history painting.

But *historia* was never the whole story. Just as Shakespeare's tragedies were contemporaneous with the Italian Commedia dell'Arte, so, too, is there a comic tradition of painting—or better yet, a tradition of painting as travesty, whose patron saints include Antoine Watteau and Florine Stettheimer, both masters of the *fête galante*, as well as canonical modernists like Pablo Picasso (think of his "unaccountable" recourse to Ingres-esque drawing in the so-called return to order, or consider his longstanding love

of the Harlequin as a motif). What I'm suggesting is that instead of organizing the history of post–World War II painting around, for instance, works like Andy Warhol's *Death and Disaster* series (which has been linked influentially to tragedy through Warhol's appropriation of images of celebrity martyrs, car crashes, or electric chairs),[4] let's give equal time to his *Flowers*: those dumb, showy blossoms regilded with paint. There is nothing tragic about them, and it's hard to wax philosophical in their presence. They are simply there—as travesties.

First Principles

The Commedia dell'Arte was an ensemble theater of stock characters engaged in acrobatic action and witty improvisation. Its comedy arose from an intricate texture of constantly shifting situations involving figures like Harlequin, Pantalone, and Columbine, whose attributes were well known to their audiences. The development of a tragic interiority or a narrative culminating in catastrophe played no part in the Commedia dell'Arte; it was characterized instead by repetition, speed, and travesty (enhanced by masks and costumes). As Allardyce Nicoll has put it:

> In the Italian comedy … the mathematical and musical patterning, the fantastic adventures, the admixture of masked and unmasked actors, all combine to draw us from the real world into a world of the imagination—so that what might have been thoroughly distasteful with a comedy naturalistically presented can here be accepted within the framework of the palpably fictitious. The constant utilisation of firmly established situations also contributes toward this end. The writers of the scenarios are rarely intent on introducing novelties; they aim rather at devising variations of effects already well known; and the very familiarity of the vulgar episodes attracts attention away form their subject matter to the skill with which they are integrated into the plots and particularly to the skill with which they are interpreted.[5]

The Commedia dell'Arte (which has directly inspired painters throughout the modern period, and arguably up to our own time)[6] thus suggests three principles for theorizing a painting of travesty: repetition, speed, and travesty itself.

Repetition

If tragedy pivots on a culminating disaster whose ultimate (and typical) expression is death, a tragic form of repetition would encompass the multiform efforts of artists since Minimalism to extinguish authorship (or agency) through sheer replication. This is a strategy closely aligned with the "death of the author," theorized by Michel Foucault and Roland Barthes, and enthusiastically taken up by the proponents of postmodernism (more recently it has gone underground as the domesticated death drive of "critique"). And yet I doubt aesthetic forms of repetition ever really function tragically, except in the fantasies of art historians. Take Robert Morris's minimalist sculptural "manifesto," *Untitled (L-Beams)* (1965) in which the same simple figure, a roughly human-scale L-shaped plywood box,

painted gray and copied three times, is made to assume three distinct postures: staidly standing on the flat of one of its legs; knocked over onto its side, and set on tiptoes as a precarious upright triangle.[7] Here is an acrobatic rehearsal of permutations worthy of the Commedia dell'Arte. In his famous condemnation of "Literalist" art[8] as theatrical, Michael Fried made a distinction between modernism's *conviction* (meaning its devotion to the history of a medium such as painting) and Minimalism's tendency to pander to an audience—to end up, as he put it, "merely interesting." Despite Minimalism's ostensible dullness, Fried thus intuited (and despised) its impulse to entertain—its ingratiating comic spirit.[9] We must remember, however, that the aim of such deadpan comedy is not a vulgar belly laugh (and, after all, Commedia dell'Arte in its golden age was characterized more by wit than physical slapstick or pantomime) but the profound revelation that the same thing is always popping up different, or as Henri Bergson puts it:

> [In comedy] we see the objective is always the same—to obtain what we have called a *mechanisation* of life. You take a set of actions and relations and repeat it as it is, or turn it upside down, or transfer it bodily to another set with which it partially coincides—all these being processes that consist in looking upon life as a repeating mechanism, with reversible action and interchangeable parts.[10]

For Bergson, laughter erupts with the introduction of rigidity—including mechanization and stereotyping—within the flow of life. Taking Morris as our model, and inspired by Bergson, it may thus be possible to think of Minimalism not merely as a *manifestation* of industrial modes of production and reproduction, or a critique of these procedures, but also as a comic response to them: as an eruption of laughter in the face of mechanization. And certainly there is a direct connection to be drawn between Morris's "dressed down" sculptural travesties of the 1960s and their "dressed up" contemporary progeny in the work of Isa Genzken, Tom Burr, or Rachel Harrison. As John Kelsey has put it with regard to Harrison's columnar sculptures named after celebrity figures, such as *Al Gore* (2007) and *Tiger Woods* (2006), "There is no other way to take these new sculptures but as stand-ins and imposters. Standing in for men, they perform their statuesque act in drag, and verticality as a sort of camp routine."[11] The joke is that Morris's L-beams were already performing a camp routine. By the late 1970s, such stand-ins would take their place

in the practice of painting as well, through the vast production and over-production of Allan McCollum's surrogates.

What form would repetition as travesty take? We need look no further than search engines for an answer, as suggested

satirically by a series of commercials to promote Microsoft's search engine, Bing.[12] In these ads, a series of normal conversations go wildly astray when, in response to a word like "plasma," for instance, an interlocutor utters a chain of tenuously connected associations in a send-up of bad search results, creating a routine worthy of the Commedia dell'Arte. If one Googles the word *travesty*, for instance, as I have done at the time of this writing, the top results after several sites promising definitions or synonyms are: "2001: A Space Travesty" (a 2000 film parody starring Leslie Nielsen); "Alabama's immigration travesty—The Washington Post"; and "Amazon.com: Travesty in Haiti: A true account of Christian Missions." This is the *post*-industrial brand of repetition, which can assemble kitsch Hollywood, immigration debates, and Christian evangelism in one random configuration. And do it again. Such "dumb" searches manifest what Bergson would identify as *mechanization*—in this case an unreasoning algorithmic principle of combination—into the vital flow of conversation as a source of comedy. But such a model is distinct from repetition understood as a blind form of reiteration (wrongly) associated with Minimalism and industrial production that supposedly leads to the death of the author. On the contrary, repetition is a mode of late-capitalist comedy based on the queasy-making irrationality of markets and the sometimes violent ebb and flow of fads. It is precisely the presumption that repetition is a drumbeat of the identical that gives it the appearance of tragedy—that makes the return of the same seem deadeningly identical, causing the death of agency, the death of creativity, or the death of authorship. But, in fact, repetition is arch, self-interested, gamed, and endlessly fecund in the meanings it scatters to the winds. It is, as Kelsey reminds us in terms of Harrison, a form of camp.

Speed

We don't often speak in terms of art's velocity, but I think we should. From the perspective of production, careers begin earlier and faster than ever: it's good to be "younger than Jesus," as a 2009 exhibition at the New Museum, "The Generational," was subtitled. From the perspective of consumption, the worldwide proliferation of mega-exhibitions in the form of biennials and the explosion of galleries and art spaces devoted to contemporary art create conditions of viewing that encourage rapid scanning and quick absorption of sound-bite meanings. And, of course, we possess an elaborate infrastructure of "instantaneous" communication, which is one of globalization's fundamental preconditions. Art announcement services like e-flux, Art-Agenda, or e-artnow have become a little industry—not to mention the proliferation of specialized listservs and independent blogs. Moreover, as in mainstream journalism, art websites—some associated with major print publications and others not—establish a twenty-four-hour news cycle. Perhaps most disarming, there are legions of exhibitions based on a quick idea, the one-off, the half-baked, which, while hardly a new phenomenon, really does seem to have attained an unprecedented scale. The interesting thing is that art's super-velocity as a global entertainment-cum-educational-cum-philosophical-cum-luxury-product industry is seldom openly discussed as such. It used to be respectable for art to require and insist upon maturation in time—that isn't really an option any longer.

It may sound like I'm condemning this velocity, but that's not my intention—instead of "critiquing" the situation we inhabit, I'd rather think about it. What kinds of value does art attain when it's made, exhibited, interpreted, and consumed really fast? In the Commedia dell'Arte, and the modern slapstick traditions that succeeded it, rapidity and repetition amplify one another, resulting in comic routines. As Bergson asserts, comedy emerges from the eruption of rigidity (i.e., mechanization, stereotype, or repetition) within the organic flow of life. We might say, then, that painting in the comic tradition, like Marcel Duchamp's piquant readymade *Trébuchet* (1917), a coat rack attached to the floor, is meant to trip us up. This is a physical

form of humor that plays on sudden shifts in velocity (from running to tripping to collapse in a heap on the floor). In his hybrid 2002 artwork-manifesto, *Dispersion*, dedicated to claiming the dissemination of art and images as a kind of medium in itself, Seth Price offers a pithy theory of velocity. He writes, "Slowness works against all of our prevailing urges and requirements: it is a resistance to the contemporary mandate of speed. Moving *with* the times places you in a blind spot: if you're part of the general tenor, it's difficult to add a dissonant note."[13] Such an introduction of discordant or uneven velocities occurs, for instance, when Wade Guyton makes a series of paintings based on a simple Photoshop image of a blank, black square, spending time executing something that took no time to generate (and, thus, reversing the principle of just-in-time production in which the material realization of a product approaches instantaneity, while what requires significant expenditure of time is design development). Or, from an opposite perspective, it occurs when R. H. Quaytman does everything in her power to carry us along from one painting to the next in one of her interconnected sets of paintings known as "chapters," robbing us of the ancient pleasure of indulging in a sustained period of looking at a single painting in favor of keeping us moving. As Quaytman stated in a recent interview, "I need to flatten the image so it can reverberate with other paintings around [it]. When a picture is too powerful or busy, it sucks up into this kind of aloneness and self-sufficiency, which I try to avoid."[14]

Travesty

The first definition of *travesty* in the Oxford English Dictionary is: "Dressed so as to be made ridiculous; burlesqued." The term *appropriation* has been widely used for decades now to describe a range of artists' strategies by which ready-made images are incorporated in a new work of art by a new author. But this term involves significant distortions pivoting on its meaning as, again according to the OED, "the making of a thing private property, whether another's or (as now commonly) one's own." As a theater of exteriority (publicness or publicity), as opposed to the psychological interiority of tragedy, comedy is precisely

not private property but rather freely available to those within the presumed public of its author. Bergson makes this structure explicit throughout his extraordinary account of comedy. With regard to communal experience, he claims, "[L]aughter always implies a kind of secret freemasonry, or even complicity, with other laughers, real or imaginary," and in terms of creative production he declares: "It is comic to fall into a ready-made category," or, "[c]omedy depicts characters we have already come across and shall meet with again. It takes note of similarities. It aims at placing types before our eyes."[15] Comedy emerges from *common sense* or common knowledge. And unlike a territorial commons, it cannot be enclosed, or appropriated. To put it bluntly: for better or worse, we all possess the characters and stereotypes that populate our worlds.

In lieu of *appropriation* then, I wish to substitute *travesty*. What happens, for instance, when Wade Guyton *wears* Kasimir Malevich, or R. H. Quaytman *wears* Bridget Riley, or Jutta Koether *wears* Nicolas Poussin? Such performances need not conform to the contours of broad parody—instead, they establish an intimate, if belated, physical engagement of one body with another defunct body, active at a previous moment in time. To *appropriate* is to transfer property, but to *wear* the art of another—to try it on through the gestures of one's own body—is a living process that is as unpredictable as Commedia dell'Arte. Comedy is not about death but about reinvigoration, about giving *new life* to something that, in Bergson's terms, has become rigid like a reified masterpiece hanging in the Louvre or the Museum of Modern Art. In her 2009 work *Hot Rod*, Koether makes us see Poussin's depiction of Pyramus and Thisbe (1651) as a real

instance of love, sacrifice, and pathetic fallacy. She makes Poussin's tragedy profoundly, but not cheaply, comic. She returns him to us as travesty.

Such painterly travesty is the temporal analogue to the fundamentally spatial discrepancy between velocities of image circulation noted by Seth Price. *Wearing* Poussin, for instance, involves a form of touch that crosses centuries and a form of manual and imaginative motion *through* a painterly composition that is distinct from the acquisitive, all-or-nothing drive of appropriation (and also very different from the abstract scores of John Cage or George Brecht, to name only two of the many mid-twentieth-century artists engaged in composing with everyday sound and movement). Koether uses a given painting, such as Poussin's Pyramus and Thisbe, as a kind of mask, which both articulates and (as ethnographic studies have demonstrated) constitutes an entity that might have been called a "god" by some, but which I prefer to think of as an embodied drive. The contemporary author (Koether), like the historical

"mask" (Poussin's painting), is a vehicle for such a "spirit" while never being simply reducible to it. This might explain why Koether so often performs around and with her paintings, bringing them to life.

WE BACK OURSELVES into a corner with the false critical presumption that either painting must act serious or it will be nothing more than a plaything for the rich. Who can deny that paintings are luxury products hung on walls (or squirreled away in storage) like so many trophies? But painting has a secret weapon: its capacity for travesty and its provocation to laughter. Amy Sillman outed the secret not long ago when she wrote in *Artforum*, "I don't find it odd that AbEx practices have now been vitally reinvigorated by a queered connection of the vulgar and the camp. Many artists—not least of them women and queers—are currently recomplicating the terrain of gestural, messy, physical, chromatic, embodied, handmade practices."[16] Bergson argued that laughter brings asocial automatic behaviors back into the flow of communal life—it's a form of discipline, yes, but one meant to affirm the social commons rather than to enclose them. You may or may not own a particular painting, but nobody can stop you from laughing.

NOTES

All illustrations by Jutta Koether, 2011.

1. See Leon Battista Alberti, *On Painting* [1435], trans. Cecil Grayson (London: Penguin Books, 1991) (see especially, 67–79).

2. The epic and the tragic were the two favored modes of History Painting, both of which avoided the comic mood.

3. See Yve-Alain Bois, "Painting: The Task of Mourning," in Bois, *Painting as Model* (Cambridge, MA: The MIT Press, 1990), 229–44.

4. Thomas Crow and Hal Foster have done the most to theorize—and even to evangelize—a tragic Warhol. See Crow, "Saturday Disasters: Trace and Reference in Early Warhol," in *Reconstructing Modernism: Art in New York, Paris, and Montreal 1945–1964*, ed. Serge Guilbaut (Cambridge, MA: The MIT Press, 1990), 311–26; and Hal Foster, *The Return of the Real* (Cambridge, MA: The MIT Press, 1996), 127–36.

5. Allardyce Nicoll, *The World of Harlequin: A Critical Study of the Commedia dell'Arte* (Cambridge, UK: Cambridge University Press, 1963), 149.

6. See, for instance, Lynne Lawner, *Harlequin on the Moon: Commedia dell'Arte and the Visual Arts* (New York: H. N. Abrams, 1998). In pursuing this line, I'm inspired by my encounters with the work of Marika Knowles on the history of Pierrot in artistic representations.

7. Morris's columnar "minimalist" works had their origins in dance; the first, his *Column* of 1960, was "performed" at New York's Living Theater. Morris toppled an erect column so that it lay flat. The L-beams are a kind of embodied memory of this performance, which moves from the vertical to the horizontal. See *Robert Morris: The Mind/Body Problem*, exh. cat. (New York: Solomon R. Guggenheim Museum, 1994), 90–92.

8. What Fried called "Literalist" art is now known as Minimalism.

9. Michael Fried, "Art and Objecthood" [1967], reprinted in Gregory Battcock, ed., *Minimal Art: A Critical Anthology* (New York: E. P. Dutton, 1968) (see especially p. 142).

10. Henri Bergson, *Laughter: An Essay on the Meaning of the Comic*, trans. Cloudesley Brereton and Fred Rothwell (New York: MacMillan Company, 1917), 101–2.

11. John Kelsey, "Sculpture in an Abandoned Field" [2007], reprinted in Kelsey, *Rich Texts: Selected Writing for Art* (Berlin: Sternberg Press, 2010), 167.

12. The campaign was titled "Cure for Search Overload Syndrome."

13. Seth Price, *Dispersion* (2002), http://www.distributedhistory.com/, n.p.

14. David Joselit, "R. H. Quaytman" (interview), *Mousse Contemporary Art Magazine* 29 (Summer 2011), 136.

15. Bergson, *Laughter*, 6, 149, 163.

16. Amy Sillman, "AbEx and Disco Balls: In Defense of Abstract Expressionism," *Artforum* 49, no. 10 (Summer 2011), 323.

Announcements echo in patient English, and then Yiddish, inscrutable but familiar in feeling (half a language to each of the two them), crackling from unseen speakers crouched somewhere in the steel beams overhead, mingling with fluorescent vibes, impatient bodies, frozen foods. Sale items or lost children or allotments of staff, and noticeably, no music or even Muzak weaving it together, possibly in an expression of pious restraint, or maybe just an oversight, indifference, a preference for the bare murmurs of the browsers and restockers in the aisles, a fine break from your Pathmark or Foodtown, where you can barely even hear yourself shop. Their cart, one wheel smashed in at an angle and dangling, spinning uselessly above the linoleum, seems to come from another store, "J-World," in Parsippany, New Jersey, having somehow found its way across the Hudson to settle down here, in Brooklyn. They cruise the aisles, raising eyebrows and wary looks from the regulars, uninitiated and brazen, bare-headed in a sea of turbans, fedoras, fur hats and snoods, a pair of sore thumbs self-consciously exaggerating their own otherness. The paranoia is understandable; one an *apikores*, an apostate from their very ranks, and the other a dreaded Hun, villain of grandmothers' stories, both of them tourists, but also distant cousins, their thoughts as warm and genuinely curious as they are inherently patronizing.

KAI ALTHOFF *was born and lives in Cologne, Germany. He lives and works in New York.*

They are here for a gift. Ike, a serial gift-giver and the older of the two, had asked his friend Ira's advice on where to pick up something special for an old acquaintance, one Alistair Ochs of Dortmund, an art collector who had been following Ike's career since the early days. Alistair had recently found God and had begun observing the tenets of *kashrut*. Ira had actually grown up in the fold but could never find a real place for himself, an intellectual and budding libertine, in the conformity and dogma of the ancient practice or, for that matter, in a culture that, in the name of modesty, tends to shun the very notion of aesthetics. Any anger toward his parents and upbringing had long ago faded, replaced with weary acceptance, then by a cheerful contempt, and finally culminating in a kind of ironic appreciation. Ike, himself a student of childhood trauma, had developed a strong affinity toward his friend's experience as the pair had grown increasingly close, delighting in the piques and foibles and costumes and foods, a second-hand devotee but a serious one nonetheless.

"Anything I want?" asks Ira, timidly. He ducks his head down and shrugs his shoulders high, the tall, shy boy trying to shrink himself in deferential gratitude, a turtle in thanks.

"Yes, I have some money, you know," says Ike, "and it was your birthday recently, don't be afraid to go a little crazy." They grin at each

SLEE IN VIAGGIO
FELICI

other knowingly as they turn into the candy aisle, both aware that the mission has changed. The variety, novelty, and kitsch they have come for is on full display here. Brands you have never heard of, brands the average person will never see, live in this aisle: corn syrup, citric acid, cellulose and xantham gum, woven into mysteries, so alike and yet so different from the iterations one finds in any other store. Ike grabs a sack of individually wrapped pink blobs; "Farmer Moishe's Fuzzy Teeth," it says. A weary-looking mother in a matched satiny gold robe and headscarf gently shushes her daughter, sitting upright in the cart, like it's a library.

"Maybe we can just get them to put something together for Alistair," says Ike, "a

collection of good stuff, a gift basket." Ira nods enthusiastically, yeah, yeah, but is pulled away suddenly, eyes rolling and eyebrows arching in muted excitement, look but look away, he whispers to Ike, "Check him out." Peeking over Ira's shoulder, Ike has his most serious face on, brow furrowed, lips pursed, he zooms in on the culprit, a man that, against the black robes and tights, stands out even more than they do, a real ringer. The man leans against the snack-cake display, tall, swarthy, and unctuous, hands digging deep into dangling pockets peeking out from the frayed ends of his cutoff denim shorts. He eyes Ike and Ira as they try to avoid his gaze, shuffling, panicked, having been found out, they squirm, suddenly conscious of the cart full of junk food

they are pushing. He sees them. His lips
curl up into a smile, and his mustache,
a black caterpillar wriggling beneath his
nose, pulls taut into the whole of the
expression, a nodding, leering mask,
confident and without regard, oblivious
to the stares and disapproving clucks of
the other shoppers and focused intently
on Ike and Ira, mortified and full of
dread at this moment of recognition. He
waves at them limply and approaches,
almost skipping, and draws in, within
inches of Ike's face, all happening too
quickly to fully process, the man frowns,
now serious, and says:
 "It's not OK."
 Elsewhere, the sun beats down in
pulsating orange waves, slapping and
spreading along the dusty scrub, the
landscape bare and the horizon endless,
maddening in its repetition, the static
background of an old video game. Tiffany,
awakened by the morning heat, yawns
and shakes off the lingering touch of
sleep, doing a grunting, joyful sort of hula
dance, a private prayer to morning, child
of evening, grandchild of the day before.
Her brain cranks slowly into motion, data
is requested from the main server, but to
no avail, she squints, disturbed a moment
by the lack of details, but soothed now,
as an idea forms, she recalls a purpose,
maybe, yes, a child … they were looking
for a child. Hagar's son. Ishmael.
 She turns, almost surprised to see
her relative and companion, Hagar, still
asleep, buried up to her head in the
sand, her frail, battered body shielded
from the elements.

"Hagar." says Tiffany. "Wake up. Wake up, Hagar!" Hagar groans and shifts beneath the packed layer of sand, cracks forming on its surface. Tiffany, kneeling, excitedly shovels dirt off her friend, shaking her, tenderly first, and then jerking her violently. In pain, Hagar writhes and reaches out, meekly attempting to rebury herself, but still weary, she is not as fast as Tiffany, and is now exposed, awake, blinking in the light. The remaining sand rains off her body as she stands, reaches out, and slaps Tiffany across the face, sending her reeling, spinning around almost completely and falling in a crumpled heap, blessing of morning forgotten on impact, weeping now. Hagar runs to aid her, reaching down, embracing, so sorry, ignoring Tiffany's shrugs of resistance, she also begins to cry.

"Go on without me!" wails Hagar. "I don't even care if we ever find my daughter!" They sit and glare, baking in the silence, and Hagar, disgusted, gets back on the ground, trying again to bury herself, ignoring the still-tearful Tiffany and oblivious to a mustachioed man, tall and lanky, limp and yet purposeful, trudging slowly in the distance, his sandals pressing soft tracks as he crosses the span, a ship in the night, there, gone, passing them by. The stinging winds descend, beginning softly and working up to a roar, airborne particles whip around, a choking mist, a veil, shrouding the two women from view.

Jed Oelbaum

Get Out of the Car is a response to my last movie, *Los Angeles Plays Itself*. I called *Los Angeles Plays Itself* a "city symphony in reverse" in that it was composed of fragments from other films read against the grain to bring the background into the foreground. Visions of the city's geography and history implicit in these films were made manifest.

Although Los Angeles has appeared in more films than any other city, I believe that it has not been well served by these films. San Francisco, New York, London, Paris, Berlin, Tokyo have all left more indelible impressions. It happens that many filmmakers working in Los Angeles don't appreciate the city, and very few of them understand much about it, but their failures in depicting it may have more profound causes.

In *Los Angeles Plays Itself*, I claimed that the city is not cinematogenic: "It's just beyond the reach of an image." Now I'm not so sure. In any case, I became gradually obsessed with making a proper Los Angeles city symphony film. I was aware of a few notable antecedents: *L.A.X.* by Fabrice Ziolkowski, *Mur Murs* by Agnès Varda, *Water and Power* by Pat O'Neill, *Los* by James Benning. These are all ambitious, feature-length films. My film is shorter (34 minutes), and it concentrates on small fragments of the cityscape: billboards, advertising signs, wall paintings, building facades.

Originally it was even narrower. It began as simply a study of weather-worn billboards around Los Angeles. The title was *Outdoor Advertising*. I've loved these billboards with their abstract and semi-abstract patterns since I was a teenager, and I would sometimes take photographs of them, but I resisted the idea of putting them in a film because "it had been done," notably in still photographs by Walker Evans and Aaron Siskind. An interest in decayed signs had become a commonplace in contemporary art.

But it happened that there was one quite beautiful ruined billboard quite near my house that went unrepaired for many months. I drove by it at least once a week, and its presence was becoming a reproach: "You cowardly fool, I won't stay like this forever." So on Sunday, February 22, 2009, with my friend Madison Brookshire, I filmed it with his 16mm Bolex. For some months, when somebody asked about the film I was working on, I could simply say it was a film designed to destroy my reputation as a filmmaker.

There was another inspiration: seeing a program of recent videotapes by Kenneth Anger. His new movies were just records of things that interested him, documents pure and simple. He felt secure enough that he didn't have

to set out each time to make a masterpiece, or even "an Anger film." He had made the films that established his reputation, and he could say, "I'm proud of them." Now he could make anything he wanted and not worry about what anyone thought of them. Although Anger is older than I am and his obsessions—Mickey Mouse memorabilia, boys playing football, a wall covered with tributes to Elliott Smith—more idiosyncratic, I still felt I could follow his example.

Get Out of the Car: A Commentary

In any case, like everyone else, I try to make movies I would like to see, and then hope there are others who share my sensibilities. The greater their number, the better, but fewer is also okay. For me, movies are, first of all, "tools for conviviality," to borrow a phrase from Ivan Illich, a means of sharing images and ideas to create a circle of friends, or virtual friends. The size of the circle is less important than the intensity of the bonds among them. For these aspirations, originality doesn't matter much.

From the beginning, there were two other motives for the project: the desire to work again in 16mm film and the desire to explore the city. Why 16mm? I had made two compilation movies in video, and the quality of the image makes me cringe when I watch them. Three short 16mm films I made in the mid-1960s had recently been restored by Mark Toscano at the Motion Picture Academy Film Archive. For years I had been hearing complaints about declining standards in laboratory work and projection that brought into question the viability of 16mm film as a medium for the production of moving images, but the new prints of these films were superior to the ones I had made in the 1960s, and the projections I attended were flawless. It was a happy experience, which reawakened my interest in the possibilities of the film image.

For years also, I had witnessed the conversion to digital image-making by many filmmakers I admired: Jon Jost, Ernie Gehr, Jonas Mekas, Ken Jacobs, Vincent Grenier, Leslie Thornton, Su Friedrich, Fred Worden, Lewis Klahr, and, most recently, James Benning. The switch allowed them to compensate for the collapse of institutional

support for filmmaking in the United States, and they became much more prolific than ever, but there was a decline not only in the image quality of their work but also in its rigor, which nobody was crass enough to acknowledge. It would be like complaining because their earlier films weren't shot on 35mm. I also found myself annoyed by the messianic proclamations that often accompanied these conversions. The stronger the conversion, the weaker the work, it seems.

How is it possible that working in a slightly different medium could produce such a giddy sense of liberation? Since they had mastered 16mm filmmaking, they didn't need instant replay to judge the images they had created. Of course, digital image-making is cheaper. We like to make things as cheaply as possible, but sometimes this desire is worth resisting. Films are not properly valued, but if we can go on making them, perhaps they will be. I guess I could afford to work in 16mm because I work slowly. I enjoy making films because it is a process of research and discovery (and I hate finishing them because something that's alive turns into something dead).

The outlook as I write this in the summer of 2010 is very different than it was at the beginning of 2009 when I began shooting the film. The slow-motion digital revolution is finally upon us, and God saw that it was good. High-definition digital imaging can now achieve higher resolution than 16mm or 35mm film formats, and the necessary projectors will be in place soon. Is there no longer any difference between the film image and the digital image? Still there are grains and there are pixels, and I prefer grains. A film image is warm (thanks to the play of the grains), and a digital image is cold no matter how fine the resolution.

My desire to explore the city was occasioned by the response to *Los Angeles Plays Itself*. When it began screening around the world, I suddenly found myself regarded as an authority on Los Angeles. This kind of treatment had the effect of underlining my ignorance. Like most people who live here, I follow the same few paths all the time so I know a few

neighborhoods, a few streets. Since I drive most of the time, and then, mostly on the freeways, the areas I pass through daily or weekly are just drive-over country.

In *Los Angeles Plays Itself*, I claimed that only those who walk and ride the bus know Los Angeles. But they, too, follow the same paths every day. Now I would say that only politicians and policemen know the city, because it is their job. I still can't claim to know the city, but I know it a little better than I did before starting out on this work.

As I explored the city, of course I found other things that fascinated me as much as the billboards, and I began to film them as well. Gradually the scope of the film broadened. This expansion suited me since it allowed me to claim that now I was imitating everybody, but most of all myself. The film could become a "city symphony," a term I like because it sounds old-fashioned, even "old school," as somebody we met on the street during filming said of the camera we used, a 16mm spring-motor Bolex.

I only put in things I like (with one exception, which I will come back to later), beautiful or funny things that most people would overlook, things that I would probably overlook if I hadn't been searching for them. It happened that many of these things were also outdoor advertisements, from custom-made neon signs to whimsical sculptures to murallike paintings that cover the walls of restaurants, grocery stores, and auto repair shops.

Some are a bit enigmatic. What is a papier-mâché horse doing on the roof of a motel? Why is a giant hot dog sculpture with white bricks as pickle relish sitting on top of a Thai Town Express restaurant? And the grotesque sculpture of a monkey dressed up as a baker outside Nicho's Pizza on Florence Avenue? "You got to do something to compete with Domino's and Pizza Hut," the owner explained. But I think he just likes animal figures. On top of his insurance offices next door, he has a giant helium elephant, which we were tempted to film.

But what about an elaborate neon sign outlining a round face in half-profile with a yellow clothespin attached to the nose and three blue teardrops below the right eye? It's the logo of Twohey's, a restaurant founded in 1943 along Route 66. Twohey's featured dish is the Stinko Burger, which is nothing more than a hamburger with sliced pickles and onions. Proprietor Jack Twohey overheard a woman exclaim, "Oh, stinko," when one was served to a customer sitting next to her, and he decided to take advantage of her remark.

The *muñeco* or muffler man might appear equally enigmatic, but it is part of a long tradition. At first I

THOM ANDERSEN *was born in 1943 in Chicago. He lives and works in Los Angeles.*

Still from *Get Out of the Car*, 2010. 16mm film, color, sound; 34 min.

Worn signpost
11211 S. Wilmington Avenue
Watts
April 8, 2009, 9:50 a.m.

Big Jay McNeely, "Deacon's Hop"
Recorded live at Hunter Hancock's "Blues and Rhythm Midnight Matinee,"
Olympic Auditorium, W. 18th Street and S. Grand Avenue, Los Angeles, October 6, 1951
Big Jay McNeely (tenor sax) with the Maxwell Davis Band

thought *muñecos* were Mexican imports, but I learned from *Muffler Men* by Timothy Corrigan Correl and Patrick Arthur Polk that they are indigenous throughout the United States, from Washington to Florida. At first, they were strictly utilitarian, replacing the flagmen on the street who tried to lure customers into the muffler shop. When a worker had some spare time, he would weld together a used muffler for the torso, some pipe for the limbs, and a catalytic converter for the head to form a fanciful human figure. Now they have become an established form of folk art, but they are more often stolen for scrap metal than for their artistic value. The *muñeco* we show is fairly ordinary, nothing special, but the workers at Universo 3000 were so pleased by our curiosity about their work that I had to include it in the film.

Murals, on the other hand, did come from Mexico, and they are central to Chicano culture. Some Anglos seem to think they are the sum of Chicano culture. Maybe that's why I had been suspicious of them. Agnès Varda's *Mur Murs* converted me. However, there are only a few shots of public murals in *Get Out of the Car*. I preferred to film the more humble paintings commissioned by small shop owners to adorn the exterior walls of their businesses. The artists are not painting for the ages. They know the businesses that hired them can go under at any time. With the stakes not quite so high, they can be freer.

They know that humor sells—just like sex. And piety, a cynic might add. But I'm inclined to believe that the religious sentiment expressed in Catholic iconography on store walls is genuine. Paintings of the Virgin of Guadalupe are especially common throughout the Mexican quarters of Los Angeles, as they are throughout the southwest United States, perhaps more common than in Mexico. Since the Virgin of Guadalupe is the most resonant and polysemic symbol of the Mexican nation, her image also expresses the longing for *Mexico lindo* that many immigrants feel—particularly the *indocumentados*, who cannot return even for a visit.

The iconography of the Virgin paintings is strict, but there are variations. I had to cut out a shot of one beautiful painting on the side of a moving van because the Virgin looked too much like Veronica in the Archie comics. The most obvious variations among the ten paintings of the Virgin that appear in *Get Out of the Car* are in their condition. Some are pristine, some are covered with graffiti, and one is cracked and peeling (it has since been whitewashed over). I hope this film will lead defenders of graffiti to rethink their position. I supported graffiti myself in its initial phases

when it defaced public space that had been sold to private interests, such as the advertisements in subway cars. I thought it was a direct and effective protest against the degradation of public space. But there is no justification for defacing property belonging to individuals, particularly when the graffiti disrespects and disfigures a work of art, even commercial art.

Camilo Vergara, who has created a photographic survey of crucifixion paintings, believes that storeowners commission them to discourage graffiti. "If someone is going to put some tag on there," he claimed, "the mural might lead them to think, 'Maybe something bad will happen to me if I deface a crucifixion.'"[1] Unfortunately, it doesn't always work. We rephotographed one painting he had photographed earlier to show the progress of the graffiti. The other paintings of Jesus and the crucifixion were chosen to present a diversity of iconography and style. Some are crudely painted; others show a high level of skill. I like them all, and sometimes the less-skilled artists compensate for their technical deficiencies by the originality and complexity of their ideas.

Manuel Gomez Cruz, for example, can't paint much better than I can, and he has no sense of perspective or modeling. But he was willing to attempt a bold variation on the seminal Los Angeles mural, *América Tropical* by David Siqueiros, painted in 1932 and almost immediately painted over (its restoration has been promised since 1995). Cruz transformed the central figure of *América Tropical*, a crucified Indian with a bald eagle perched above him, into an abject prisoner on the lower right of his mural. He doubled the figure with a cast-iron relief replica projected out from the surface of the wall and wrote underneath it, "1.2.3. WILL GET YOU LIFE." But he reversed the theme of victimization in the Siqueiros mural by filling most of the wall with the Battle of the Alamo seen from the Mexican side. The Alamo itself is very tiny, almost unrecognizable, with a few defenders hanging from its roof, and it is dwarfed by exultant Mexican soldiers reveling in their victory.

This mural is on the side wall of a *lavendería* at the corner of Cesar Chavez Avenue and Indiana Street in East Los Angeles. It can be glimpsed in *Get Out of the Car* behind a *cemitas* truck. I also included a detail from another Cruz mural a few blocks west: the crucifixion scene in a charming mural depicting the life of Christ from his birth to his ascension.

In the end, I included many examples of Latino art, both painting and sculpture, and so the film became a kind of gloss on Mike Davis's book *Magical Urbanism: Latinos Reinvent the U.S. City*, although Davis devotes

himself to the continued discrimination against Latinos in the United States and their modest political victories, not to their cultural innovations. To grasp these innovations, it's more useful to read "Into the Future: Tourism, Language and Art" by Peter Wollen, a worldwide survey of hybrid syncretic cultures, which reconsiders the work of the great Mexican muralists (Siqueiros, Rivera, and Orozco) as a major challenge to the norms of Western modernism. He concludes with these words: "Modernism is being succeeded not by a totalizing Western postmodernism, but by a hybrid new aesthetic in which the new corporate forms of communication and display will be constantly confronted by new vernacular forms of invention and expression. Creativity always comes from beneath, it always finds an unexpected and indirect path forward and it always makes use of what it can scavenge by night."[2]

Nowhere is this more true than in Los Angeles, which has always had an official culture and an underground culture, where the projects for urban planning and architecture that come from above are incoherent at best, and nowhere is this more evident than in downtown Los Angeles. Ever since the destruction of the residential rooming houses on Bunker Hill in the 1960s, there have been two downtowns: an Acropolis of art and commerce on the top of Bunker Hill that has never quite jelled; below it and to the east, the decaying "historic core" appropriated by Latinos as their major shopping district with Broadway as its center, its historic movie palaces dating from the 1920s turned into swap meets and churches (to the Anglo preservationist, turning a movie theater into a church is an abomination, but turning a church into a performing arts center is a triumph of "adaptive reuse"). The storied old hotels such as the Alexandria where the founders of United Artists (Chaplin, Griffith, Fairbanks, and Pickford) once met to gossip and talk business had been taken over by the denizens of Skid Row, people with just enough money to get off the streets.

The leaders of the city looked at these dynamic transformations of spaces they had abandoned with horror. They tried to recruit "urban pioneers" (an apt phrase) to push out the Latinos and the homeless by turning unused old office buildings into luxury lofts and providing the services these pioneers require: Starbucks, French bistros, pet supply stores (at first I thought the dogs were to protect the *arrivistes* from the homeless people with whom they still share the streets, but that was unfair: many of their dogs are toy breeds).

There is now a third downtown: a shiny new $2.9-billion entertain-

ment complex on its southern edge in a neighborhood now called South Park. It was built by the Anschutz Entertainment Group (AEG), owned by billionaire Philip Anschutz, a conservative Republican and antigay activist invariably characterized as "reclusive," and run by Tim Leiweke, whose liberal politics made him a more effective advocate with the Los Angeles city government. It began with the Staples Center, a $400-million sports arena that opened in 1999. Then came L.A. Live, which includes a 7,000-seat concert hall (Nokia Theatre), a more intimate 2,300-seat concert venue (Club Nokia), a television studio for cable sports network ESPN, a multiplex movie theater (Regal Cinema Stadium 14), a Grammy Museum, a bowling alley (Lucky Strike Lanes & Lounge), a nightclub (Conga Room), a score of restaurants and bars, and a fifty-four-story skyscraper (the only one built in downtown Los Angeles since 1991) with two hotels and 224 condominiums.

To create this megadevelopment, AEG received unprecedented aid from the city and state governments. To build Staples Center, it got $58.5 million from the city and $12.6 million from the Los Angeles Community Redevelopment Agency (as well as $100 million from Staples for "naming rights"). For the hotel-residential complex, which cost $900 million to build, AEG got only $5 million from the CRA but $246 million from the city in tax rebates. Although the primary announced goal of the CRA is the creation of affordable housing, it was once again complicit (as in the redevelopment of Bunker Hill) in a scheme that eliminated affordable housing, but this time there was little protest, perhaps because the buildings themselves were not as picturesque as the Victorian mansions of Bunker Hill.

Leiweke even managed to sneak a special bill through the state legislature (the vote came after midnight on the final day of the 2007 session) so that $30 million in state funds could be diverted from affordable housing projects to beautify the public streets and sidewalks around L.A. Live and Staples Center. Although L.A. Live is "private space" under the control of AEG, the Los Angeles Police Department maintains a special "state of the art" substation there, usually manned by twelve to eighteen officers who wear special gold pins with the L.A. Live logo. When rioting broke out after the Los Angeles Lakers won the NBA championship in June 2010, the police rallied to defend L.A. Live and let the unruly fans vandalize small businesses just to the north.

I don't find L.A. Live inviting, and everything except the Starbucks and the movie theater is too pricey for me.

Still from *Get Out of the Car*, 2010. 16mm film, color, sound; 34 min.

Neon sign
Twohey's Restaurant
"Home of the Little Stinko-O"
1224 N. Atlantic Boulevard
Alhambra
April 24, 2009, 11:50 p.m.

Like stars that give light from above …
Richard Berry, "Pretty Brown Eyes"
RPM 452, December 1955
Richard Berry (vocal) and Maxwell Davis (tenor sax)

The architecture is competent if not inspired, but as *Los Angeles Times* architecture critic Christopher Hawthorne wrote, it is "not really architecture at all but an extensive series of armatures on which the developer and its tenants can hang logos, video screens and a sophisticated range of lighting effects."[3] In other words, the buildings are just backdrops to giant animated advertisements posted on LED screens. Even the hotel has been plastered on two sides with twenty-story-high "super-graphics" advertising Coca-Cola and Bud Lite. The central open square is the most unpleasant public space I've encountered anywhere in the world. It's not just the constant advertising from the giant LED screens that almost cover three of its sides; it's the noisy soundtracks accompanying them that make a visitor feel constantly assaulted. It's not a space that says, linger and look. It's a space that says, I want your money.

They created a wasteland, and they call it entertainment. AEG's project is sterile and oppressive, but most of all it is irrelevant. The hotels may draw new business to the nearby convention center, which can use it. Staples Center replaced sports arenas without luxury suites located in poor, black neighborhoods, so a new arena in a closely policed zone where the slightest detail is arranged to reflect the social hierarchies of the city might be regarded by some as a significant gain. Los Angeles does need another bowling alley, but I would prefer one that is less expensive than $6.95 per person per game. On the other hand, downtown had a perfectly adequate (although perhaps not for gala premieres) three-screen movie theater driven out of business by the Regal Cinema, and it still has some beautiful vintage concert venues. But is the city a better place if people drive downtown to see a movie? Does it matter whether his fans go to see Justin Bieber at the Nokia Theatre downtown or in Hollywood? Is this revitalizing downtown? Just a few blocks west of L.A. Live but across the great divide of the Harbor Freeway, there is a real city, a vibrant neighborhood called Pico-Union, where immigrants from Central America first settled in Los Angeles. The people who fill the streets there have no need of L.A. Live, and it has no need of them.

No Los Angeles politician would say, "The most beautiful buildings must be built in the poorest neighborhoods," as Sergio Fajardo, the mayor of Medellín, once declared. But our politicians have decreed that the ugliest buildings will be built in the richest neighborhoods.

I never had any interest in filming around L.A. Live, but I did intend to include the ugliest building in Los Angeles until I realized that the form of the film would make my criticism seem callow. Even in this essay, I cannot begin to suggest the sheer hideousness of the Orsini apartment buildings created by developer Geoffrey H. Palmer on the northern end of downtown abutting the Hollywood Freeway, nor can I explain how Palmer and his lawyer Benjamin Reznik bullied the city government into approving his projects despite his refusal to build units for lower-income tenants as mandated by city law, and despite his illegal demolition of a historic Queen Anne–style cottage that stood in the way of expanding the Orsini. It was the last nineteenth-century residential building in downtown Los Angeles. Although city officials at first demanded that Palmer be jailed for six months and forbidden to build on the site for five years, the city ultimately settled for a $200,000 "contribution toward civic improvements" from Palmer.

As its name suggests, the Orsini appropriates the Italianate style that has had a lasting appeal for residential construction in southern California because "it represented the best of two worlds—classical order and control, and the picturesque."[4] Once historicist styles worked to make beautiful buildings in southern California, but today's versions are only impoverished replicas. Like many contemporary buildings, Palmer's Orsini looks like an architect's model built full scale. There is no detailing. It seems caught between two worlds, afraid to look too classical and afraid to look too picturesque. The unresolved tension is almost comedic, but this possibility has been repressed to produce a blandness that offers no sense of repose. Slipshod classicism without conviction and standardized, cheaply fabricated decorative motifs make for the worst of two worlds. If the Orsini and Palmer's other projects in the same style (the Visconti, the Piero, the Medici) were tucked away in some remote corner of the city, I wouldn't be so irate about them, but they are all situated in prominent sites around downtown, next to freeways and major boulevards, so there is no escape from them when coming into the central city from the north or the west.

On the other hand, some of the most beautiful buildings in Los Angeles are in the poorest neighborhoods. Not surprisingly, there were once many more that have been destroyed, and many of those that remain have been scandalously neglected. One appears in *Get Out of the Car*: the Bethlehem Baptist Church by Rudolph M. Schindler, our most inventive modern architect. Schindler belonged to the underground culture of Los Angeles, working almost exclusively on residential commissions from middle-class Bohemian clients with small budgets, gaining no public recognition until long after his death in 1953. He is still better known outside Los Angeles than he is here. The first few times I visited the church, Kevin Polk, who hangs out there almost every day, would ask me, "Are you from Australia?"

The Bethlehem Baptist Church, located at the corner of Compton Avenue and East 49th Street in "South Central" Los Angeles, is Schindler's only noncommercial public building. The congregation commissioned him to build their church because a carpenter who worked for him was a member. Schindler designed the church in 1944, but it was not completed until 1952 because the congregation was strapped for money. Schindler created a strikingly elegant house of worship with the simplest means: overlapping horizontal bands of stucco-covered wood siding with recesses, a small cruciform tower at one corner, and a band of windows (now covered over) to soften the severity of the design. In essence, José Rafael Moneo's Cathedral of Our Lady of the Angels (2002), with its horizontal bands of faux-adobe concrete, is nothing more than Schindler's modest church blown up to gargantuan proportions.

In 1975, the congregation moved to a new building at Normandie Avenue and 74th Street, and the church became the Prayer Tower for All Nations Evangelical Center, a Pentecostal church with O. M. Miller as pastor. As blacks moved out of the neighborhood and Latinos moved in, the congregation dwindled to a handful, and services were moved from Schindler's chapel to a small classroom on the west end of the property. Last year Rev. Miller became too ill to continue the services, and the church fell into disuse. Her son stops by once a week to water the grass and clean off the graffiti. The church has become a target for taggers, as Kevin Polk laments in the film. Aside from the graffiti, it is in serious disrepair; because of water damage, its roof could collapse at any time.

Even the most iconic of these buildings, Sabato Rodia's *Nuestro Pueblo*, commonly known as the Watts Towers, also suffers from serious neglect. It is the city's greatest civic monument and its greatest civic embarrassment, "a beautiful metaphor for diverse Los Angeles" and also "a symbol of … government's inability to do anything right," as Robin Rauzi has put it.[5] Rodia was also an underground artist, a scavenger working by night, although his work was noticed in the *Los Angeles Times* as early as 1937. I discovered the towers in 1952—two years before Rodia gave them away to a neighbor and moved to northern California—when I read "The Artist Nobody Knows" by Selden Rodman in *New World Writing*, the earliest essay to treat Rodia as a major artist. When I was a teenager, they became for me a fabulous playground—as they appear in Andy Warhol's 1963 film *Tarzan and Jane Regained … Sort of*, in which Taylor Mead and Naomi Levine dance amid the towers with their skimpy garments falling off their bodies. There was no fence around them, no guards to keep people away. The Towers were, as I claimed in *Los Angeles Plays Itself*, "the First World's most accessible, most user-friendly civic monument."

I didn't realize then that the city had proposed tearing them down in 1957 and that their survival was a fluke. It was actually three young film artists who saved the Towers. First there was William Hale, who made a short documentary about Rodia and his work in 1953. Two other film workers in their early twenties, editor William Cartwright and actor Nicholas King, saw Hale's film, and it inspired an interest in Rodia's work that turned into a passion. Visiting the Towers, they found them apparently abandoned. With a few friends, they formed the Committee to Save Simon Rodia's Towers in Watts and raised $3,000 to buy Rodia's property from its current owner. As Richard Cándida Smith notes in *The Modern Moves West*, "The committee included no major arts patrons or representatives from major art institutions, nor were the city's cultural leaders supportive of the effort to turn the towers into a cultural heritage monument."[6]

When the Committee discovered by chance that the city was planning to demolish the Towers as a safety hazard, they launched a campaign to prevent the demolition. They had the wisdom or the luck to enlist in their cause the gifted aerospace engineer Bud Goldstone, who realized that Rodia had built his towers better than anyone knew. Goldstone proposed a daring gamble to the Committee: a public "torture test" to determine whether the Towers could withstand a force of 4.5 metric tons (equal to the force of an 80-mph wind) pulling against them. When the city accepted his challenge, Goldstone worried that he might become forever remembered as "the man who pulled down the towers." But on October, 10, 1959, before television cameras and a crowd of one thousand people, the towers withstood the test, and the city had to abandon its efforts to tear them down.

Sixteen years later, when the Committee ran out of money to maintain them, the city agreed to take over and look after the Watts Towers, but its Board of Public Works contracted out restoration work to an unqualified architect who botched the work so

Still from *Get Out of the Car*, 2010. 16mm film, color, sound; 34 min.

Banner overlooking Hollywood Freeway
N. Alvarado Street and Bellevue Avenue
Los Angeles
March 28, 2009, 10:53 a.m.

Freeway traffic noise

badly that the Committee had to sue the city to stop it. An agreement was reached under which *Nuestro Pueblo* became a California Historic Park, and responsibility for restoration was transferred to the city's Cultural Affairs Department. Its stewardship has been haphazard and miserly. Its restoration work has sometimes been as destructive as the earlier work sponsored by the Board of Public Works, and it has never invested enough to maintain the towers properly. However, it did manage to construct a particularly insensitive fence around them, hiding the beautiful wall Rodia constructed on the south side of the towers and making it impossible to see his composition as a whole. In the past, the pace of the restoration work has been so slow that the towers seemed closed to the public more often than they were open, but closures in the near future seem unlikely since the city has essentially given up on maintaining the towers, laying off all three of its conservation workers. It needs $5 million to restore them (more than it has spent in the past thirty years), but it has no plan to find the money other than asking the Los Angeles County Museum of Art for assistance.

A number of local commentators have claimed that this neglect can be attributed to the location of *Nuestro Pueblo* in a poor neighborhood that most white Angelenos are afraid to visit, but I'm inclined to believe it's just another example of the failure by local arts institutions and their administrators to understand or appreciate the real culture of Los Angeles. There are a number of architectural masterworks in southern California that could and should be public museums—Schindler's How House (1925), Frank Lloyd Wright's Millard House (1923) and Ennis House (1924), Richard Neutra's Kaufmann House (1946) in Palm Springs, all currently or recently on the market but unable to attract any buyers—but no local arts institution has moved to purchase any of them. With its restoration of Schindler's Kings Road House (1922), its purchase of his Mackey Apartments (1939) and Fitzpatrick House (1936), and its transformation of all of them into vital arts centers, the Österreichisches Museum für angewandte Kunst (MAK) in Vienna has done more to protect the architectural legacy of Los Angeles than all our local art institutions combined. Yet the Los Angeles Opera can spend $32 million to mount a production of Wagner's Ring Cycle (propped up by a $14-million loan from the county government, advanced in the misguided belief that this represents some kind of cultural rite of passage for the city) and the Getty Museum can find $44.9 million to buy a Turner painting.

The Watts Towers do not appear in *Get Out of the Car*, but a whole sequence was shot within a few blocks of the Towers. The sequence memorializes a more obscure civic monument, the Barrelhouse, a rhythm-and-blues club established in 1948 by Bardu Ali and Johnny Otis at Wilmington and Santa Ana, one block east of the Watts Towers. No trace of it remains, and no plaque marks its location. So I hung a sign on a fence for the filming, like the sign on the other side of the street that advertises funerals for only $2,695.

I dedicated *Los Angeles Plays Itself* to Johnny Otis and Art Laboe; I called them "guardians of our history" because they kept alive the musical history of Los Angeles on their radio programs. But that is only the sketchiest summary of their achievements. Through his long-running radio show (beginning in 1956 and still going stronger than ever), Laboe nurtured an appreciation for 1950s rhythm and blues among local Chicanos that helped spawn a distinctive style of hybrid rock in East Los Angeles and later a Chicano hip-hop rooted in the "oldies" Laboe championed. A Greek American who calls himself "black by persuasion" and a person of unique integrity in the music business, Johnny Otis has been a drummer, a pianist, a vibraphonist, a singer, a bandleader, an arranger, a composer, a talent scout, a record producer, a newspaper columnist, a political activist, a pastor, and a TV host, as well as guardian of our history on his radio programs, which ran from 1953 to 1991. In *Get Out of the Car*, I wanted to elaborate a bit on my dedication to Otis and Laboe.

I found a way when I abandoned my original idea for the soundtrack. In the early stages of work on the film, I planned to use simple background ambient sound, a kind of "street tone" for each shot that would do no more than differentiate one space from another. It came into my mind that I can still remember hearing certain songs in certain places even fifty years later: "Runaround Sue" in a San Francisco bus station, "Willie and the Hand Jive" in a beachfront hamburger stand in Santa Monica, "Every Little Bit Hurts" on a street in Oakland, "Just One Look" sung in Spanish on the car radio as I was driving alone through Arizona (never heard it before, never heard it since, but just one listen was all it took). I wanted to evoke these memories. These random juxtapositions of sounds and places are one of the great joys of modern life and of city life in particular. The cinema is the only art that can re-create these experiences and their emotional resonance.

So I built the film around juxtapositions of songs and places. The eighteen shots in the Barrelhouse sequence are accompanied by a live recording of tenor saxophonist Big Jay McNeely playing "Deacon's Hop," introduced by disc jockey Hunter Hancock. It wasn't recorded at the Barrelhouse, but it could have been: Hancock often emceed there, and McNeely often played there. In fact, it was recorded on October 6, 1951, at the Olympic Auditorium in Los Angeles, during a midnight concert Hancock promoted and emceed. It was the birth of rock 'n' roll, although nobody noticed it at the time and nobody has noted it since. For the first time, thousands of white "hepcats" jammed a large auditorium to see black rhythm-and-blues artists and adopted the music as their own. Because American cultural history is written from an eastern perspective, Alan Freed is credited with building a "crossover" white audience for rhythm and blues, turning it into rock 'n' roll sometime in 1954 or 1955. But it happened here first.

Before the 1960s, the United States was a nation of regional cultures. The "national culture" was simply the regional culture of the northeast, the center of publishing and the music business. Many Los Angeles singers and musicians recorded for local record companies that could not secure national distribution for their work, and consequently they never received the fame and fortune they merited. For me, discovering their music was an important part of discovering Los Angeles. I thought I knew it, but I didn't. I listened to Johnny Otis and Hunter Hancock on the radio, and I loved Big Jay McNeely's 1959 recording of "There Is Something on Your Mind" (it was his biggest hit, but an inferior cover version by Bobby Marchan was a bigger hit). I even put it in a movie.

But I didn't realize that McNeely had created a sound more radical than bebop. He was the most inventive of the honking saxophonists whose playing was characterized by "freak high notes, the relentless honking of a single note for an entire chorus, and the use of low notes with deliberately vulgar tonal effects," in the words of conservative jazz critic Leonard Feather.[7] It emerged in the late 1940s as an inchoate protest against the U.S. failure to honor the promises of freedom made to its black population during World War II. It was a cry of despair and defiance, and Big Jay McNeely took it further than anyone. Amiri Baraka called it "Black Dada": "The repeated rhythmic figure, a screamed riff, pushed in its insistence past music. It was hatred and frustration, secrecy and despair … There was no compromise, no dreary sophistication, only the elegance of something that is too ugly to be described … McNeely, the first Dada coon of the age, jumped and stomped and yowled and finally sensed the only other space that form allowed. He fell first on his knees, never releasing the horn, and walked that way across the stage … And then he fell backwards, flat on his back, with both feet stuck up high in the air, and he kicked and thrashed and the horn spat enraged sociologies … Jay had set a social form for the poor, just as Bird and Dizzy had proposed it for the middle class."[8]

Hunter Hancock was also the first disc jockey to play "Louie Louie," the original version recorded in 1957 by Richard Berry, who wrote the song a year earlier, making it a regional hit. I had always admired Berry's "Louie Louie" (for me, it's still the best version), but I didn't know the range of his work. He never had a hit outside Los Angeles, but he made some of the best records of the 1950s. One of them, a talking blues he recorded in 1954, suggested the title of my film, and the saxophone solo by Maxwell Davis is the music over the opening credits. Davis is another unsung master of Los Angeles rhythm and blues, a tenor saxophonist of great versatility (he has been underrated because he didn't have a distinctive sound— he could play like Big Jay McNeely or like Lester Young), and a gifted arranger-producer not only for Richard Berry but also for many of the best singers of the 1950s. He also discovered Jerry Leiber and Mike Stoller. They showed up one day in 1950 at Aladdin Records without an appointment. Davis, who was then musical director for Aladdin, gave them a chance anyway. They played him two songs, and he immediately gave them a songwriting contract. There is also quite a bit of Leiber and Stoller in *Get Out of the Car*, mostly from the catalog of their own small Los Angeles record company, Spark Records, which lasted only two years, 1954 and 1955.

Of course, this history is only backstory in *Get Out of the Car*, but I hope the film will at least inspire curiosity about the music.

Rock 'n' roll was betrayed by men like Dick Clark who pandered to a racism that was more imagined than real by pushing out black artists. As a result, the careers of Berry, Hancock, and McNeely ended prematurely. The saxophone became too black for rock 'n' roll when it entered its racist phase, and it was replaced by guitars. Big Jay lost his audience, and he settled back in Watts, where he had grown up, and found a job as a postman. Hancock couldn't accept the Top 40 format that took over radio in the 1960s, stifling the disc jockey's creativity, and he quit in disgust in 1968. Berry quit making records in

1962 and eked out a living by playing at after-hours clubs around Los Angeles. He sold the rights to "Louie Louie" in 1957 in order to buy a wedding ring, but he was able to reclaim them in 1985. He made more money in the next year than he had in the previous thirty.

Johnny Otis and Art Laboe were able to survive, although Otis was unhappy with most of the records he made in the late 1950s for Capitol Records, and he quit making music for most of the 1960s to concentrate on working in the struggle for black civil rights. When he returned to performing in 1970, he tried to counter the emerging "Rock 'n' roll Revival" formula by showcasing still-forgotten musicians he considered the true originators of rock 'n' roll, such as Esther Phillips, Pee Wee Crayton, Charles Brown, Big Joe Turner, and T-Bone Walker. Art Laboe was sustained by the loyalty of his Chicano listeners to 1950s rhythm and blues.

I pay tribute to Laboe in a sequence filmed on the site of El Monte Legion Stadium, another cultural landmark that has vanished without a trace. Both Laboe and Johnny Otis (with business partner Hal Zeiger) promoted shows there, but the Legion Stadium is now particularly associated with Laboe because, in 1963, his Original Sound Records released "Memories of El Monte," written by Frank Zappa and Ray Collins for Cleveland Duncan of the Penguins, and for a while Laboe made it almost his theme song. Of course, it provides the music for this sequence of the film. In the 1950s, Otis and Laboe had moved their shows to El Monte, thirteen miles east of downtown Los Angeles, because racial harassment by the Los Angeles Police Department under Chief William H. Parker made it increasingly difficult to hold racially integrated dances in the city of Los Angeles.

When I went to the El Monte Historical Museum to research the shows put on by Otis and Laboe, the curator could barely acknowledge they ever happened. She couldn't tell me anything about them, and there were no records of them in her archives. However, she did recall vividly Cliffie Stone's *Hometown Jamboree*, a country music show telecast live from El Monte Legion Stadium on KCOP-TV beginning in 1949, which meant nothing to me, although it launched the careers of Tennessee Ernie Ford, Billy Strange, Merle Travis, Speedy West, and many others.

I realized our tastes and interests are partial, mine as well as hers. However, we probably share a disdain for contemporary pop music. A sign of aging, I guess. Rock music died for me on December 22, 1985, the day

of D. Boon's fatal van accident. But I do like recent *norteño* music, particularly Los Tigres del Norte, so all the more recent music in the film is by Mexican and Mexican American artists, mostly singing in Spanish, with an emphasis on Los Tigres. Anglos know Los Tigres del Norte—if they know them at all—as the popularizers of the *narcocorrido*, the ballad of the drug traffickers, but to Latino immigrants, they are the voice of the people. They are the most important music group in the United States today, their impact greater than Dylan and Springsteen combined.

Their song "*Ni aquí ni allí*" plays over the end credits. It's the plaintive lament of a Mexican immigrant lost between two worlds, a protest song in a gentle and sometimes humorous vein. I will quote only the chorus, in the original Spanish and in English translation:

En dondequiera es lo mismo
Yo no entiendo y no entenderé
Que mis sueños ni aquí ni allá
Nunca los realizaré.
Ni aquí ni allá, ni allá ni acá
Nunca los realizaré.

Wherever you go it is the same
I don't understand, and I never will
That my dreams, neither here nor there,
Will never be realized.
Neither here nor there, neither there nor here,
Will never be realized.

The film is in English and Spanish, without subtitles. I wanted to put bilingual viewers in a privileged position (they are the only ones who can fully understand the film) and remind monolingual viewers of their cultural disadvantage. This perverse obscurity has a polemical purpose. Los Angeles has become a bilingual city, but English-only speakers stubbornly refuse to learn Spanish, cutting themselves off from a good part of the local culture and compromising their ability to understand the politics of the city. The cure is obvious: real bilingual education in the schools of California to insure that all English-speaking students learn Spanish and that all Spanish-speaking students learn English. Only the crudest nativist sentiment would oppose this simple initiative, yet animosity toward Latinos is so pervasive in California that no "mainstream" politician or educator has even broached the idea. However, this "dual language immersion" program has been adopted in the schools of Chula Vista, a San Diego suburb near the Mexican border, and of course it works. Native English speakers learn Spanish, and native Spanish speakers learn English more

quickly and thoroughly than they do in English-only schools.

The form of the film doesn't allow advocacy, but I can suggest something of what is lost to a monolingual person in Los Angeles.

If California could become bilingual, perhaps there would be greater understanding between Anglos and Latinos and tragedies like the destruction of South Central Farm could be averted. In *Get Out of the Car*, the site of South Central Farm is another of the unmarked historic landmarks depicted. It is the one sequence of overt social criticism I left in the film, and the razor wire that surrounds it (also appearing in the three shots that follow) is the one thing I don't like that appears. I tried to include the essential information about South Central Farm in the memorial sign I made: "Site of SOUTH CENTRAL FARM, 1994–2006, one of the largest urban community gardens in the United States, bulldozed on July 5, 2006 by owner Ralph Horowitz whose repurchase of the property from the City of Los Angeles in 2003 is still mysterious and legally questionable." The battle over South Central Farm pitted the Spanish-speaking farmers against the English-speaking Horowitz and local councilwoman Jan Perry, and the moral rights of the farmers against the legal rights of Horowitz. I still believe that cultural misunderstanding played an important role in the unfolding of the tragedy, making compromise impossible when it should have been feasible.

Although Horowitz promised to develop the site as a distribution center for clothing manufacturer Forever 21, it is still an immense fourteen-acre vacant lot.

South Central Farm should still be there, but I didn't mean to suggest that the Barrelhouse and El Monte Legion Stadium should be. The German filmmaker Klaus Wyborny once said, buildings disappear when our feelings desert them. Our feelings haven't deserted El Monte Legion Stadium and the Barrelhouse, but we don't need the buildings to sustain those feelings and the memories they made. A building of intrinsic beauty should be preserved for as long as possible, and a useful building should not give way to a useless building, but it's not necessary to preserve a simple utilitarian building just because it is a repository of historic memories. That would be a misguided nostalgia.

Get Out of the Car could be characterized as a nostalgic film. It is a celebration of artisanal culture and termite art (in Manny Farber's sense, but more precisely in the sense Dave Marsh gives the phrase in his book *Louie Louie*). But I would claim it's not a useless and reactionary feel-

ing of nostalgia, but rather a militant nostalgia. Change the past, it needs it. Remember the words of Walter Benjamin I quote in the film: "Even the dead will not be safe." Restore what can be restored, like the Watts Towers. Rebuild what must be rebuilt. Re-abolish capital punishment. Remember the injustices done to Chinese, Japanese, blacks, gays, Mexicans, Chicanos, and make it right. Put Richard Berry, Maxwell Davis, Hunter Hancock, Art Laboe, and Big Jay McNeely in the Rock and Roll Hall of Fame. Bring back South Central Farm. Only when these struggles are fought and won can we begin to create the future.

It's also a sad film, some people say. I presume they understand Spanish. Then it is a just film, because the world we live in is sad, but, as Jonathan Tel has written, "Great cities are tough; their ugliness is inseparable from their sexiness."[9] Los Angeles is certainly tough and certainly ugly when seen in medium shot or long shot. But Roman Polanski once suggested it has another kind of beauty: "Los Angeles is the most beautiful city in the world—provided it's seen by night and from a distance." *Get Out of the Car* proposes a third view: that Los Angeles is most beautiful when seen in a close-up and that its sexiness is not to be found where most tourists look.

—July 2010

Previously published in *Urban Cinematics: Understanding Urban Phenomena through the Moving Image*, edited by Francois Penz and Andong Lu (Bristol, United Kingdom: Intellect Books, 2011).

NOTES
1. Camilo Vergara, "Street 'Passion,'" *Los Angeles Times*, April 10, 2009. **2.** Peter Wollen, "Into the Future: Tourism, Language and Art," in *Raiding the Icebox: Reflections on Twentieth-Century Culture* (Bloomington: Indiana University Press, 1993), 209–10. **3.** Christopher Hawthorne, "It Has No Place," *Los Angeles Times*, December 3, 2008. **4.** David Gebhard and Robert Winter, *Architecture in Los Angeles: A Complete Guide* (Salt Lake City: Peregrine Smith Books, 1985), 469. **5.** Robin Rauzi, "Traveler in Her Own Backyard," *Los Angeles Times*, August 25, 2009. **6.** Richard Cándida Smith, *The Modern Moves West: California Artists and Democratic Culture in the Twentieth Century* (Philadelphia: University of Pennsylvania Press, 2009), 156. **7.** Quoted in Arnold Shaw, *Honkers and Shouters: The Golden Years of Rhythm and Blues* (New York: Collier Books, 1978), 170. **8.** Amiri Baraka, "The Screamers," in *The Fiction of LeRoi Jones/Amiri Baraka* (Chicago: Lawrence Hill Books, 2000), 184–85. **9.** Jonathan Tel, untitled manifesto, in *Urban Future Manifestos*, eds. Peter Noever and Kimberli Meyer (Ostfildern, Germany: Hatje Cantz, 2010), 21.

CHARLES ATLAS *was born in 1949 in St. Louis, Missouri. He lives and works in New York.*

We are the people.[1]

LIA GANGITANO

In a previous Whitney Biennial catalogue, I describe Charles Atlas's *Hail the New Puritan* (1985–86) as my generation's *The Chelsea Girls* (1966).[2] It's a work that makes you want to live in a city. Warhol's double-projection film established a possibility, for Atlas to work from his own social world—it was as formative to *Hail* as other influences that had little to nothing to do with documentation, namely Hollywood musicals and *A Hard Day's Night* (1964). Instead, these models instigate performances invented for the camera—a strategy that began for Atlas together with Merce Cunningham in the late 1960s, in terms of film and videography, and over time developed to spawn a new art form.

> The first video package that I got for the [Merce Cunningham] company was a three-camera set-up with a live switcher, so we could do live editing. This had a real advantage in that it made you aware of how to get from one shot to another.[3]

As technology developed, Atlas's amalgamation of video and performance advanced compellingly into live video. In 2003, when I approached Atlas with the idea of a video retrospective, he chose instead to mount an exhibition that contained no existing work at all—just a video studio in which he created live portraits each day. More than a live exhibition or evolving video work, Atlas's *INSTANT FAME!* was also a nonstop, impromptu party and performance marathon. Some recollections from the appointment log include: SOMEONE NEEDS TO WRAP JULIE ATLAS MUZ IN SARAN WRAP; YVONNE RAINER'S STRETCHING OVER A CHAIR ONTO THE FLOOR; DIRTY MARTINI NEEDS HELP GETTING INTO/OUT OF HER BRA; MERCE TAKES SOME TIME ON THE STAIRS; STANLEY LOVE'S ON THE PHONE CALLING FOR WEED, WANTS JUICY FRUIT. The press release stated, "Show-offs encouraged; performers of any kind invited; and just plain sitters tolerated" (but in actuality, they really weren't).

✱ ✱ ✱

Atlas has been called the "court portraitist to the Anglo-American choreography and post-punk scenes";[4] an interest in performative identities and the dynamics of collaboration have long distinguished his work, which has evolved from close working relationships, friendships, and engagements in particularly immodest creative contexts such as the club scenes in the East Village and London of the late 1980s and early 1990s—far from the official art world. Despite their nihilistic subcultural origins, these communities advanced to the strange task of defying annihilation, and, by the mid-1990s, gave rise to new political imperatives on the part of artists who, in the wake of too much death, wanted a future.

Looking back (which Atlas seldom does), his portayal of his family tree of collaborators offers stories of such particular times, but his axiom of

NOTES

1. Excerpts from appointment log, Charles Atlas, *INSTANT FAME!*, New York, 2003. Week One: Laurie Weeks, Lucy Sexton, John Erdman, Michel Auder, Euan Morton (thank you baby), Greg Zuccolo, Squid E. Seid & L. E. Seid (who's your daddy?), Douglas Dunn, Paul Laster, Thomas C. Stephan, Henry Flesh, Damion Joseph Dickerson. Week Two: Earl the Wizard, Merce Cunningham, Kevin Aviance (no show), Gail Thacker, Ed Halter & Jessie, Ken Bullock, Valda Setterfield, Lisa Mellinger, Ilyse Kazar for Jude Kazar (Vita Kurland), Suzanne Weil, Richard Hollander, Peggy Weil and family, Gary Schneider, Erlind N. Kelly, Quin Charity, Badomi DeCesare, Bert Kopell, Malka Kopell, David Vaughan, Mikhail Baryshnikov (didn't make it). Week Three: Laurie (try again), Stanley Love, Scott Ewalt, Tony Stinkmetal, Yvonne Rainer, Eileen Myles, Julie Atlas Muz, Hapi Phace, Cecilia Doughery, Lawrence T. Katz & Siobhan Meow, Sabrina Gschwandtner, Caspar Stracke, Gabriela Monroy, Rebecca Cleman, John Thomson, Timothy Cronin, Christopher Williams, Ishmael Houston-Jones, Polly Motley, Terry Dean Bartlett, Jonah Bakaer, Barbara Pollack & Max Berger, Mike Iveson, Peter Petralia, Mimi Gross, Eileen Myles, Rafael Sanchez, Linda "Dirty" Martini, Fred Sullivan, Anne Hanavan.

2. Lia Gangitano, "Dead Flowers: Oppositional Culture and Abandonment," *2006 Whitney Biennial: Day for Night*, exh. cat. (New York: Whitney Museum of American Art, 2006), 87. "Charles Atlas's film *Hail the New Puritan* features scenes of friends in London hanging out, drinking, primping, changing and checking their outrageous outfits—all the rituals involved in going out to a club that were such important components of 'a day in the life of a punk ballerino.' Considering the length of these scenes and our doubts that the friends would ever leave the apartment, their eventual arrival at a club is raised to operatic proportions. Like Warhol's 1966 film *The Chelsea Girls*, *Hail the New Puritan* fully described a particular generation's subsistence in an underground moment that they defined."

3. Atlas, quoted in Stuart Comer, "Life Stages," *Frieze* 139 (May 2011), 87.

4. Colin Perry, "Charles Atlas," *Frieze.com*, November 26, 2008, http://www.frieze.com/shows/review/charles_atlas/.

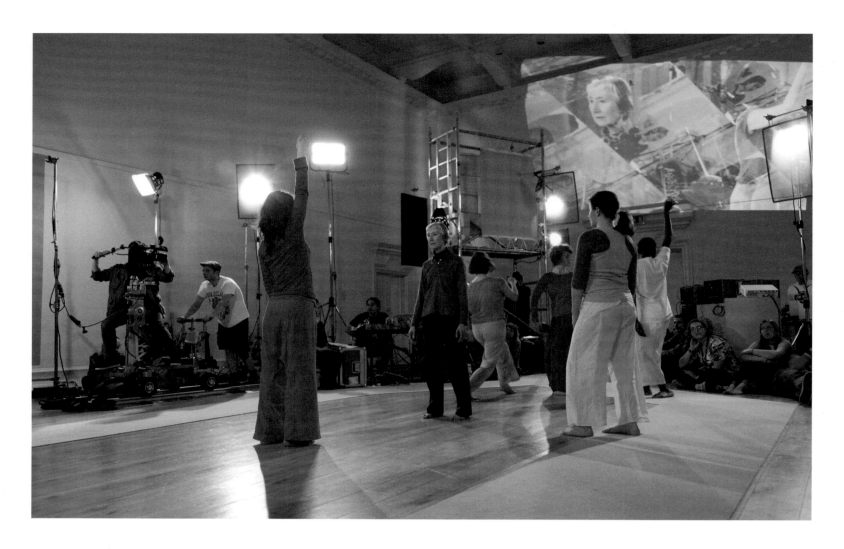

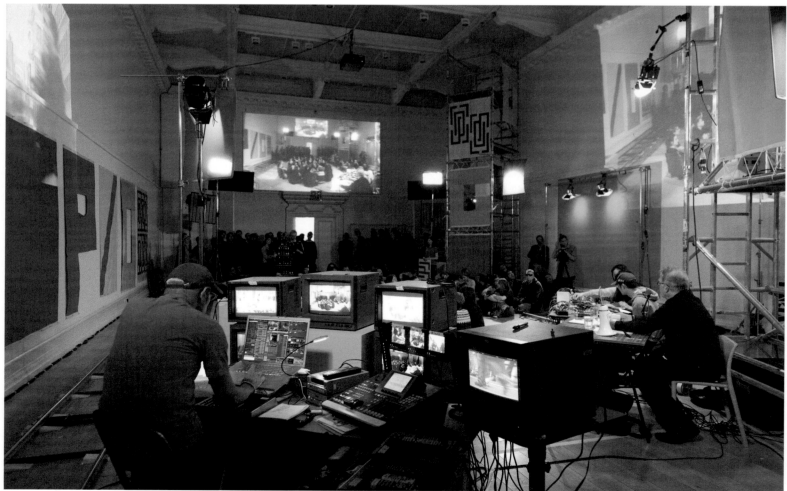

Installation views of *The Pedestrians*, performance in collaboration with Mika Tajima/New Humans, South London Gallery, 2011

Installation view of *Instant Fame (NY)*, performance, Participant Inc., New York, 2003

Stills from *ATLAS / FENNESZ*, live video performance with musician Christian Fennesz, Volksbühne, Berlin, 2007

"truth to the situation/subject" does not promulgate themes: "I don't think I've ever gone out to address a theme; something just emerges for me. There are artists who naturally think in big or cosmic terms. I just don't."[5] Atlas describes his 1991 video *Son of Sam and Delilah*, which could be considered a treatise on AIDS, as "an impressionistic combination of opera singing, disco dancing, and serial killing" told through many a drag queen and club kid's demise shot against a rain curtain.[6] Even this quasinarrative/thematic work is comprised of portraits of people and performances *just being what they are*.[7]

> At that time, drag seemed relevant in a special way. It was trashy, funny, homemade and nonprofessional. [...] I loved all the performers that were part of that scene, and I used them in my films, such as *Son of Sam and Delilah*. It's other forms of sexual expression, and I believe in them.[8]

❋ ❋ ❋

Atlas brought several props to the set of *INSTANT FAME!*, a rotating platform among them. This would later become the central motif of a collaborative project with Antony and the Johnsons, *Turning*, for the 2004 Whitney Biennial. An immersive tableau of thirteen "beauties," described by Antony as "moving across androgyny toward the feminine," is conjured as each model takes a turn posing on the revolving platform, filmed by two cameras and mixed live throughout the musical performances. "It's an iconic idea; a slowly turning portrait of a person's face where the turning creates a shedding of self that can be very revealing" (Antony's words).[9] Atlas has recently completed editing a feature film based on the tour of *Turning*, seven years in the making. Like Atlas's work in general, this project is subversively encompassing, expressing "the infinite ways that his subjects carry over the estranging qualities and oppositional strategies of their distinct art practices and micro-cultural sensibilities into his portraiture, and his reimagining of both pop spectacle and art history through the radical filters of drag performance and punk aesthetics."[10]

> It's funny to me that having worked with Merce and John Cage for years, I had rejected the whole idea of aleatory procedures—I thought it wasn't for me but now that I'm working with live video, I've become a Cagean; there's lots of chance in the live performances.[11]

An intermittent rolling of dice continues in ongoing collaborative performances staged with both sound and visual artists (such as Christian Fennesz, William Basinski, and Mika Tajima and New Humans), often occurring after completing time- and labor-intensive works such as *Turning* or *Rainer Variations* (2002). Rainer noted that among her reasons for asking Atlas to make a piece was his appealing to her "sense of mischief and play."[12] Although more anarchic in form, the mounting intensities of the live works bear many similarities to Atlas's highly crafted videos—they embrace performance as an unpredictable medium, one that defiantly affirms: we are the people, and the time is now.[13]

5. Charles Atlas, "Antony," *BOMB* 95 (Spring 2006), http://bombsite.com/issues/95/articles/2818.

6. Charles Atlas wrote of *Son of Sam and Delilah*: "New York City 1988. Raging homophobia. A killer on the loose. Disco dancing 'til dawn. Performers struggle to survive. Delilah seduces Samson in a song. Gender illusionists go shopping. Samson and Delilah, 1991 [...] a dark vision of an America where life is cheap and even the moments of tenderness have a life-threatening edge." Charles Atlas, *Son of Sam and Delilah* (1991), video description, Electronic Arts Intermix, http://www.eai.org/title.htm?id=3871.

7. Atlas: "[F]or me things have to be what they are. I am fascinated by masks and artificiality and I am addicted to irony, but as you know, my heart is drawn to essences." Atlas, "Antony."

8. Atlas, quoted in Comer, "Life Stages," 90.

9. Antony: "I would like to point out, though, that I do not see the disparity between the most rotten details of a person's life and the dream they are striving for." Atlas, "Antony."

10. Johanna Fateman, "Truth to the Situation," *Dead Flowers* (Philadelphia and New York: Vox Populi and Participant Press, 2011), 12, 16. "Atlas' understanding of portraiture, and what it means to collaborate with artists and performers is radical: He does not reveal his artist-subjects through providing voyeuristic access, by stripping them of their artifice, or eliminating the distancing strategies of their practices, but rather colludes with them in novel self-presentations."

11. Atlas, quoted in Comer, "Life Stages," 91.

12. Yvonne Rainer, *Rainer Variations* (2002), video description, Video Data Bank, http://www.vdb.org/titles/rainer-variations. Rainer: "Such a ploy is in keeping with my long-standing fascination with the phenomenon of performance and all its potential for dodgy dissembling and illusion. Also at play here is a skepticism about the conventions of the documentary form that purports to reveal the 'real' artist who ultimately remains a persona or crafty impersonator of her own idealized self-image."

13.

WARNING

Beware the styles of other times
Beware the styles of other times
- YOU'LL never do it right
Dress: Poiret- Makeup: Max Factor
Don't become like this drawing Style
 Hubert Robert
Unspeakably
Old
But
Unfinished

Rene Ricard, "Warning," *Trusty Sarcophagus Co.* (New York and Rome: Inanout Press, 1990), 75.

LUTZ BACHER *was born in the United States. She lives and works in Berkeley, California.*

1701 Avenue E,Bay City,Texas
22 September 1958

Dear Betty,

I sold two canvases,one"And all of those things I have forgotten"to
Jack Akridge for $200 and one to his wife "Brown Grass"for $100.This
then means that I owe you $100.

My books show that by now all canvases should have been paid for(Richter
etc.)and that you owe me #392.46 minus the above $100 minus the cost
of having "Prophecy"photographed which should be $292.46 minus the
cost of the photography,plus any other indebtedness that I have on your
books.I need a new second hand car.The one I have is rusted up pretty
badly and is ready for an overhaul job which is too costly because the
body is gone.If Richter,etc have paid up I would appreciate a check.

You did not answer my letter concerning the hanging of my thesis for
my next show.I realize,as well as you do,that the subject matter is not
only delicate but highly provocative.Three doctors have encouraged me
to publish it,and all three doctors are tops in their professions;

Dr.Mortimer Shapiro there in New York
Dr.Jack Weinberg at Michael Reese in Chicago and
Dr.Michael O'Herron of the Urology Clinic,Medical Towers,in Houston.

The Institut Zurich has asked for it this fall.Dr.A.Maurer,secretary
to the Institut wrote that the President of the Institut has promised
that it would be reviewed.

I believe Betty that it will bridge the gap between medicine and art
because it concerns the analysis of the art form in relation to the
human body.I dont know what type of permission we will have to receive
from the City officials in New York to hang it because of the few draw-
ings and photographs that deal with the urogenital region.

Chuckle-I dont think that it will cause a riot.

I have spent the summer rewriting it and I believe it is in excellent
shape at present.I must have it photostated which will cost me some
$70.

O'Herron suggested that the thesis first be presented in a popular
magazine such as Look or Life and then published in Book form.I
rather leave this up to you.

Let me hear from you.

 Sincerely,

 Forrest

FORREST BESS *[by Robert Gober]: Forrest Bess was born in 1911 in Bay City, Texas. He died in 1977 in Bay City, Texas.*

October 22, 1958

Mr. Forrest Bess
1701 Avenue E
Bay City, Texas

Dear Forrest:

Thank you for your letter and the information
about your sales. I am enclosing a check for the
$292.46 which I owe you. Richter has not paid up
and I am scolding him.

Concerning the hanging of your thesis in your
next show, I do not feel I want to. No matter what
the relationship is between art and medicine I
would rather keep it purely on the aesthetic plain.
Why don't you show your paintings and the thesis
in a medical hospital?

I hope you get the thesis published and I look
forward to reading it again. I hope you understand
this.

Drop me a line soonohow you are getting along.

Love,

The "Tree of Life"constitutes not the penis growing on the scrotum but
the scrotum as the foliage and the perineum as the trunk and the penis
(outer)as the limb or the Branch.It is the 'side'of our body that we do
not observe-the neglected side;that which is in darkness.That 'side'
that God showed to Moses.Below shows both the tree in alchemy and in an
actual photograph-

Fig. 131. Adam as *prima materia*, pierced by the arrow of Mercurius.
The *arbor philosophica* is growing out of him.—From the "Miscel-
lanea d'alchimia" (MS., 14th century), **20, vii.**

Now,let us turn toward the stone itself;here is a passage from alchemy
in John Read's Prelude to Chemistry-
 After all this upon a day
 I heard my noble Master say,
 men patient and wise,
 Stone with Exercise;
 were trewlie tought,
 r that Stone they Caught;
)or scarcely one,
 gdoms had our Red Stone.(P.W.Martin:Experi-
 ment in Depth)

 ite Stone(see the Mandala-The Greek at Betty'
 enetrating Mercurius was the act of open-
 rein lies the Christian mystery.The trunk
 e same-the snake possibly representing the

Fig. 150. The penetrating Mercurius.—From the "Speculum verita-
tis," (MS., 17th century), **20, liii.**

The Man that Got Away

Forrest Bess (1911–1977) lived a life of profound poverty and solitude, working for most of his adult life as a seasonal bait fisherman in a series of camps and homes built from scavenged detritus on a tiny spit of a treeless island on Chinquapin Bay, off the eastern coast of Texas, a place that the *Houston Chronicle* described as "the loneliest spot in Texas."[1] Although Bess was physically isolated, from 1947 until 1967 he exhibited his paintings at the Betty Parsons Gallery in New York, a gallery renowned for exhibiting the most progressive art of its time. He also carried on voluminous correspondence over the course of decades, not only with Parsons but with scholars, doctors, and researchers from all over the world, including Carl Jung and the art historian and critic Meyer Schapiro.

Bess drew and painted from the time he was a boy, later evolving a realist and then an expressionist style influenced by Vincent van Gogh. Unsure of the possibility of anyone making a living as an artist, his family encouraged him to study architecture. But he soon dropped out of college and found that his true interest was art and painting. From 1941 to 1945, he served in the military with the Army Corps of Engineers. It is here where he had his first mental breakdown, here where he was beaten with a lead pipe, causing "a caved-in skull,"[2] for the suspicion of being gay,[3] and here where a psychiatrist gave him his first insight into the visions that he experienced in a half-sleeping state.

I just go to bed close my eyes and see these things. I keep a notebook handy and sketch them down in the dark or turn on the flashlight and sketch them. I get up the next morning—spend the day fishing then that night I paint the canvas as it was seen.[4]

From this point on, Bess believed with greater and greater conviction that his visions were a direct communication from the unconscious to his conscious mind and should be represented in paint with as much fidelity to the initial vision as possible. He never found his imagery through the act of painting and never added to or subtracted from the visions that appeared to him.

In fact I sense that I have very little to do with what is put down on canvas. The vision is there—the execution of the vision—the visual copying of it is of little importance ... and after it is painted I am as muchly an outsider, looking at, as you are ... Yet the damn things have to be painted else they bother me.[5]

Bess believed that the symbols in his paintings were clues to ancient truths and that he could access these truths through an understanding of his visions. As he became more immersed in his exploration of this symbolism, he also became increasingly preoccupied with the idea of uniting the male and female within himself. As Dr. John Money, a prominent sex researcher at Johns Hopkins Medical Center with whom Bess carried on a long correspondence, wrote: "[Bess] drew on evidence from alchemy, mythology, art history, iconography, literature, anthropology, psychoanalytic psychology, Jungian mysticism, Goethe, the Bible and personal experience. [He] attributed to alchemy the lost bisexual secret of the urethral orgasm, for which men had ostensibly been seeking since time immemorial."[6]

In a scrapbook now presumed lost, which Bess called his "thesis," the artist kept a record of his ideas and thoughts, sketches, historical research, as well as clippings from books and medical texts. Bess's long obsession with his thesis and the ideas therein convinced him that the male and female could in fact be united, and in the mid-1950s he made the decision to use his own body to prove it.

With the fortification of alcohol, Bess performed at least two operations on his genitals that turned him into a self-described psuedo-hermaphrodite. He seems to have performed the operations himself, in the isolation of his home on Chinquapin Bay. As he later described it to Meyer Schapiro:

I got myself good and drunk and began the thing ... I was very much afraid ... The great fear was going through the urethra and cutting the upper part of the urethra ... A terrific cramp came in my side, the razor blade slipped from my hand

and I was knocked on the floor… But, Meyer, the unconscious flooded in beautifully—I had found entrance to the world within myself.[7]

To perform this transformation, Bess created an incision in the underside of his penis just above the scrotum. He believed that this new opening would allow the bulbous section of the urethra to accept another penis and that this would be a transcendental experience, a way to gain full access to the world of the unconscious and its truths. Bess held a deep and sincere belief that this surgery and the balancing of the male and female within himself was the key to regeneration and eternal life. He sent his thesis to prominent sex researchers,[8] universities, and possible publishers, even writing to President Eisenhower to ask him to consider his discovery.

During his lifetime, Bess longed to show his paintings and his medical thesis side by side. In 1958 he wrote repeatedly to Betty Parsons asking her to exhibit his thesis alongside his paintings as part of his next show. Parsons politely declined his requests, and Bess's dream was never realized. This project, based upon Bess's writings, aims to fulfill his wish.

I believe I have found something so very very important—so important that it gives meaning to art, and it has given meaning to my existence and beliefs.[9]

In 1961, Hurricane Carla obliterated Bess's fishing camp, his home, his studio, and all the rest of his possessions, with the exception of his smaller canvases, which he was able to save. This natural disaster was almost too much for Bess to recover from. He eventually gave up bait fishing and moved about twenty miles north of his island camp to Bay City, Texas, the town where he'd been born and where his mother still lived. Although he maintained an eccentric lifestyle, the people of Bay City who knew him the longest and the best describe him as a "good, caring person."[10] His neighbors looked after him, bringing food and lending money, often receiving a painting in thanks.

Forrest continued to paint sporadically, and he made plans to expand into other mediums, to work in sculpture and film, but these plans were unfulfilled. His last one-person exhibition with Betty Parsons was in 1967. As he aged, Forrest was driven to procure an additional genital surgery, one that would enlarge the existing hole to make it big enough to fully accept another penis. He never had this last surgery, and he felt that his thesis was not fully realized. Meanwhile, his lifelong exposure to the sun had resulted in serious skin cancer, and his advanced alcoholism, erratic behavior, and a subsequent stroke caused his brother to commit him to San Antonio State Hospital in 1974. He was diagnosed as a paranoid schizophrenic. Forrest Bess passed away at the Bay Villa Nursing Home on November 11, 1977.

Robert Gober, 2011

Polaroid taken by Bess of his self-surgery that he sent to Parsons. Betty Parsons Gallery records and personal papers, Archives of American Art, Smithsonian Institution, Washington, D.C.

Untitled No. 12 A, 1957. Oil on canvas, 12 x 18 in. (30.5 x 45.7 cm). Collection of Andrew Masullo

NOTES

1. Sigman Byrd, "The Byrd's-Eye View: Trawling in the Collective Subconscious at Chinquapin," *Houston Chronicle*, March 11, 1956. Chinquapin is a small fishing village near Matagorda Bay; "Chinquapin Bay" was Bess's own designation for the place he lived.
2. Bess, letter to Rosalie and Sidney Berkowitz, undated, Rosalie Berkowitz papers relating to Forrest Bess, 1947–1981, Archives of American Art, Smithsonian Institution, Washington, D.C., reel 3752, microfilm.
3. Bess's relationship with homosexuality was fraught, and he struggled with his sexual attractions. In a letter to his friend Rosalie Berkowitz, he describes himself as "a peculiar type of homosexual," and he relates an early experience of confiding in "some over talkative individual" and the resulting ostracism that he felt from the people in his town. He later tries "to sublimate, to pass into other channels any sexual excitement I felt." He is fearful that his sexuality will keep people from him and will hurt his father's business. While living in Houston and San Antonio, he finds "protection in numbers with people I thought were my own kind" only to find that he was "too 'butch'—rough" for them. Ibid.
4. Bess, letter to Meyer Schapiro, undated, Meyer Schapiro papers, 1949–1982, Archives of American Art, Smithsonian Institution, Washington, D.C., reel 3458, microfilm.
5. Ibid.
6. John Money and Michael De Priest, "Three cases of genital self-surgery and their relationship to transexualism," *The Journal of Sex Research* 12, no. 4 (November 1976), 283–94.
7. Bess, letter to Meyer Schapiro, January 10, 1955, Meyer Schapiro papers, 1949–1982, Archives of American Art, Smithsonian Institution, reel 3458, microfilm.
8. As previously noted, one of the researchers with whom Bess was in correspondence was Dr. John Money at Johns Hopkins Medical Center, who wrote about Bess as a subject. In Money's words, Bess's case "lay not in conventional homosexuality, nor in transexualism or transvestism, but in a quasi-hermaphroditic theory of bisexualism … It had a certain credibility, as when the patient likened his own condition to that of the aboriginal Australian practice of subincision." Money and De Priest, "Three cases of genital self-surgery and their relationship to transexualism," 287.
9. Bess, letter to Betty Parsons, December 26, 1962, Betty Parsons Gallery records and personal papers, circa 1920–1991, bulk 1946–1983, Archives of American Art, Smithsonian Institution, http://www.aaa.si.edu/collections/container/viewer/bess-forrest--correspondence-306518.
10. Jim Scarbrough, personal tribute to Forrest Bess, www.forrestbess.org/tributes.html.

Special thanks to Becky Kinder for her research, writing, support, and invaluable editing. RG

MICHAEL CLARK *was born in 1962 in Aberdeen, Scotland. He lives and works in London and New York.*

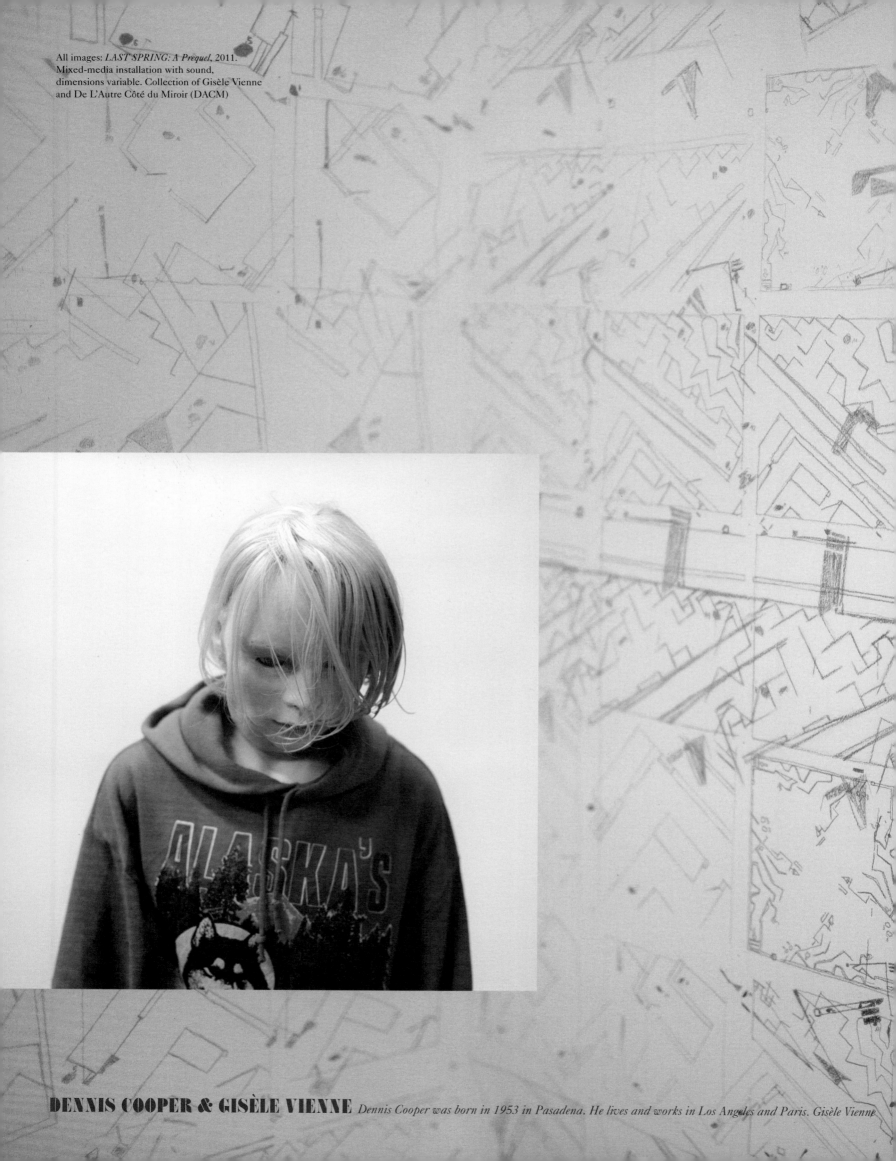

All images: *LAST SPRING: A Prequel*, 2011.
Mixed-media installation with sound,
dimensions variable. Collection of Gisèle Vienne
and De L'Autre Côté du Miroir (DACM)

DENNIS COOPER & GISÈLE VIENNE *Dennis Cooper was born in 1953 in Pasadena. He lives and works in Los Angeles and Paris. Gisèle Vienne*

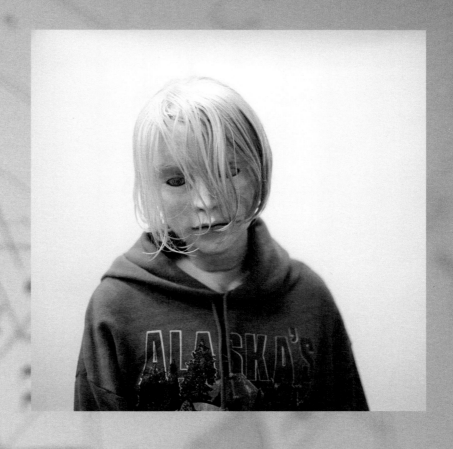

was born in 1976 in Charleville-Mézières, France. She lives and works in Grenoble and Paris.

LAST SPRING
A prequel

Dennis Cooper

DOLL: Please wait. Please listen to me—for just a minute? I really need your help. I—Oh, no, he's going to speak. I can always feel it starting in my arm like a heart attack.

PUPPET: Charles's eyes gave the impression of having been unearthed from the visage of a particularly stupefied infant and then screwed into his sockets where they beamed cordially enough yet tweaked one's eagerness and sympathies not one little bit. Even so, they might have left its—oh, let's be kind and say *his*—his face charmingly hospitable had whoever built this brainchild not put an unnatural pressure on its upper fringes to perform the incredulous bullshit fantasies of a boy, which this—well, dummy, let's be honest, seems to think it is.

DOLL: The puppet calls me Charles. I don't know why. There's something wrong with it. I can't take it off my hand.

PUPPET: I linger on the head because, while strangely flat and leaden, it was his body's sole wonder. No, I'll add the neck, which was so slim and milky, his head might instead have been a vase pouring flesh and blood and bones into a hole between his shoulders. Granted, I am that neck's only historian, but, like the rope that might have lynched some wrongly condemned and strangling young criminal, it caused one to wish, for very different reasons, that one's right hand was within reach of a machete.

DOLL: I used to think he was talking to himself, but I think that's how he sees me. Or wants me. D-d-dead, I mean. But I'm not dead, unless this is death. Is this death? No, because you're not dead, right? Anyway, I need—Oh, fuck, hold on—

PUPPET: Perhaps you will join me in thinking yourself no longer in the presence of a boy named Charles but comporting briefly with some horrid mutant, perhaps some fluke of a creature whose lack of specificity is nauseating to contemplate—the abhorrent spawn of some countryside pervert and a deer, one of those stumbling fawns one spots sometimes in nature, helpless wisps of deer-like matter found wanting by their mothers for reasons only animals can grasp then all but coaxed towards the nearest hungry lion.

DOLL: He needs to stop sometimes and breathe or recharge. I think he's a machine, or he's possessed. Anyway, my friends and I are trapped in some place I don't know how to describe. Not a building, or not what you and I would call a building, but ... um ...

PUPPET: I hesitate to paraphrase Charles within his earshot, but, assuming his wheedling voice has only thinned your understanding and attention with each crazy-sounding word, I'll suggest that, in effect, he is in a sort of labyrinth, although not the magnetizing secret passageways so attractive to the voyeurs in scary stories, nor the barren, byzantine underbelly of a stage set where actors sneak about and wait their cues to enter, but ... a hotel, for all intents and purposes, featuring yet lacking the amenities expected of resorts and, thus, less a hotel in which Charles vacations than an intertwining set of premises that

are haunted by his ghost, for whom beds and chairs are no cozier than colored clumps of fog. Hence, his confusion.

DOLL: I think the puppet either owns the hotel or he is the hotel. I know that sounds insane.

PUPPET: Charles is dead, in so many words, and this figure is his reliquary, and it is I, indulging in magician mode, who has dubbed any whinnying and purrs and growls you have hallucinated in between his tight, immobile lips. For instance, let's see, what shall I have him say now? Oh, yes:

DOLL: I don't know how I'm here with you. Maybe I'm a projection or a double or a statue of myself that's been erected here or ... But I swear to fucking God, I am real. And scared shitless. Can't you see that?! Can't you tell?!

PUPPET: It is I, this hotel's ... proprietor, let's say, who is oddly disinclined to treat my guests with the deference one preternaturally accords a customer, and who, at times, seems to be mechanically fraternizing with a sort of work crew that is only in my establishment to fix the plumbing and, other times, to be exterminating hotel tenants as though they're pests, and who pretends not to understand a single word that they quite clearly if agitatedly pronounce.

DOLL: Can a building be evil? Because where I am is evil.

PUPPET: In fact, that is the last time I, in the egotistical fashion by which, oh, pet owners saddle dachshunds with witty names then ask them if they are hungry or wish to exercise, will co-opt the rigid scarecrow you see before you and, quite honestly, the last time it could be said to have begun to deserve my helpful input.

DOLL: I don't know how to get there, but ... it looks a lot like here. Yes, a lot like here, actually. Look for somewhere that looks like here. But complicated. So much more complicated. Like ... imagine a crossword puzzle where my friends and I were letters, or ... if this room was deep inside a mine that stretched away in all directions and was as crooked as a jokey drinking straw that had been plunged into the horrifying world inside my head and seemed to hold your wildest dreams inside its mouth like inhaled smoke, or ... I don't know. It makes no sense.

PUPPET: Oh, one last tidbit. Should you indulge this sculpture's fantasy of boyhood and try to quote/unquote "save him," you will locate not the frightened child it seems to think it is, or thought it was, but ... hmm, a something—perhaps in plural, a thing or things (although "thing" seems too formative), an artifact both newborn and previous, possibly a "who," at least in retrospect, and which is rotting in the darkest reaches of a boy's imagination, or rather, hidden in my intricate hotel if you prefer, decapitated head upon severed arms upon dismembered legs upon mutilated trunk-like logs and branches in a fireplace.

DOLL: Fuck, he just told you how to get there. Amazing! He told you everything you need to know to find me. Did you get that? Did you understand? Oh, please, please save me.

PUPPET: Oh, yes, please, by all means, try.

CAMERON CRAWFORD *was born in 1983 in Boulder, Colorado. He lives and works in New York.*

Elegance is Refusal

1

Elegance is refusal. And refusal is a spheroid opening. Please imagine a jug. This jug has a lid, which has always been on, and never comes off. It is permanently attached. Jug is bubble. And the bubble is a sphere, but what is covered by this is a particular thing: the inside.

It is necessary, when considering that elegance is refusal, to know that refusal is a positive. It is inside, held inside, kept apart. It is a quantity. The jug is a spheroid opening.

The jug, the actual jug, is not indestructible. It is a construction of partial atomic offerings. One of these holds the possibility of catastrophe. It is the possible catastrophe, collapse, which is the opening, and the perpetually lidded jug which is the sphere.

The spheroid opening is on and within the ether. There are other words for the ether: the ground, the general, sex. The jug, the bubble, the refusal, the elegance is a spheroid opening on and within the surface of the sex.

And if I say "no" . . . , and I say no all the time, then I make of myself a spheroid opening on and within the ground. If I say "no," and I say no all the time, I am covering my inside. I am a bubble covering this particular thing, a positive.

In this case, I am also a construction of partial offerings. Caviar. As a building would be in this case. A building the lower stories of which would be in full sun, the upper stories leaning out, shadowed, due to design,

over the lower stories, and reflecting in the water, and so therefore saying "no," and this building says no all the time.

Within the particular but serial building, is the possible catastrophe. The one wall holds inside the refusal. Each brick is a partial brick. Each brick might collapse the one wall of the building, which is on the ground. There is only one building at a time.

If I say "no" . . . But if I say "yes," then it is only ground. It is a vista of ground, and I have fallen out of the window of my car, the elegant jug, me saying no, and my clothes are mussed. There are crumbs in my lap. I am lying on the ground.

But I say "no" all the time. so my clothes are on the ground, mussed, in the grass, and I am holding the inside, the refusal, the elegance. Then I am a spheroid opening. My lid is on (the lid has always been on, and it never comes off).

It is important to know that there is only one jug at a time. This spheroid opening can move, but the ground does not end or change. If I have a cold, and I have a cold all the time, then the refusal is inside.

The ground, understand, is a bacchanalian revel, with not a member sober. The ground does not repeat. The ground instead continues. It assents. It is dirt, grass grows in it, crumbs fall there, there is no sky—the lights are on the ground. The wheels of the jug stay closed on the ground. Please imagine that the spheroid opening does not move. It "parks."

There is a third term; it is "maybe." This is how the jug is built: It is partial bricks assenting to partial bricks. It is the soap, stretching around the bubble, containing the positive. And there is a fourth term; it is "talking and talking." This is how the spheroid opening moves. This is how the wheels stay closed on the ground.

If I say "maybe," and I never say maybe, it is a partial construction. Then I get back in the car, through the

door. I stand up on the ground. I run my palms down the front of my clothes, the crumbs fall on the ground, I think about my hair, and I cough, and inside the car, my throat has refusal inside.

If I talk and talk, and this is what I do while I am saying no, the spheroid opening moves. It does not stop on the continuing ground, sex. It holds refusal inside.

2

I am looking in the mirror so as to see the back of my hair. "This is me saying no." I am congested, and I am holding the inside, the congestion, and I am getting ready to talk and talk. I am the spheroid opening and I am getting ready to move. I am getting dressed, in the fashion of always dressed, but with partial clothes: closures that hold within them the possibility of opening, catastrophe. I am getting ready to not eat. I am looking at the frame in the center of the mirror.

Thusly: Please imagine that the spheroid opening does not move, it "parks," which is eating, also, which is the expectoration of the possibility of collapse. I am putting on a glove.

Yet, I say "no" all the time, so I talk and talk. If I ate, but I never eat, I could then "park." So I must talk and talk, and this talking says "no" all the time.

How to hold "park" inside, and move the spheroid opening across the ground? This is a problem. This problem is a fifth term; it is "lovers lane." It is the stillness of the collapsing spheroid opening upon the general. It is where "maybe" (I never say maybe) turns into "yes" (I never say yes) and then I am on the ground. In the damp, reflecting in the water, with mussed clothes, and I am dirt with gravel. I then have fallen out of the window of my car.

In order to be irreplaceable, understand, one must always be different.

3

A woman is closest to being naked when she is well dressed.
I am putting beers in bottles into a bag. There is the
dragging of a small bag of chips, across the surface of
the table, into the bag. The bag of chips falls neatly into
the bag, with the bottles of beer, but if the bag of chips
would have missed the bag, the bag of chips would have
fallen onto the ground. Chips inside the bag of chips
would have broken. There would have been crumbs,
held inside the bag of chips, waiting to collapse onto the
grass, the ground, outside the door of the car (i.e., park-
ing would be required, the bag of chips would open).

I am inside the car, with my hand in the glove under
my thigh, on the seat of the car. I am talking and talk-
ing. The words are made in the air, outside my face,
and the words hover in the air. The wheels are open
on the ground. My mouth is very full of the word "no."
This "no" is held inside by the mouth of the bottle of
beer. The windows of the car are shut, there is hot air
held inside the vents. I am looking in the mirror which
is inside the visor. It is a superfluous case. I hold inside
"my face," I say no, I cough into my hand, and hold the
congestion inside.

My foot in my tights feels my tights, the inside of my
shoe, the sole of my shoe, the floor mat, the nap of the
fabric that covers the bottom of the floor, the vibration
of the car.

My hand in the glove feels the bottle cap inside my
pocket, through hand, glove, pant, pocket, gold foil, logo,
aluminum. These are things on and within the surface
of the spheroid opening, elegance. They are things on
this surface, which themselves are closed. They are the
lid of the jug, they have always been on, and they never
come off.

My clothes hold the positive inside. My clothes say
no. "This is me saying no. I am talking and talking." My
hair has always been on it never comes off.

Previously published
in *Blast Counterblast*,
edited by Steve Reinke
and Anthony Elms
(Toronto: Mercer Union/
WhiteWalls Inc, 2011).

Les Goddesses

GREY TO GREEN

Sitting on the floor in sunlight and reading through eight small notebooks going back to 1998 looking for a phrase about Goethe: *The stars above, the plants below*. The thought is connected to Goethe's mother and what she taught him about the natural world; more generally it is about how people lived in constant relation to nature.

I never found the reference; it was something I stumbled across on the internet, but it led me to *The Flight to Italy,* Goethe's diary (also recommended by Kafka, in *his* diary), in which G. abruptly takes leave of a turgid existence in Weimar and travels incognito to Italy for the first time in his life. He is thirty-seven years old, and the trip is a revelation and a creative renewal of mammoth proportions. He draws plants, collects rock samples, and begins to dress like the locals so as to pass and better be able to observe their customs. G. reports on the weather patterns (sublime clouds and sunsets); he develops a theory of precipitation involving the curious concept of "elasticity." He looks at architecture and writes of his worshipful love of Palladio; he has a deep appreciation for Italian painting but rails against the squandering of genius and talent on the "senseless…stupid subjects" of Christianity.

Because the diary is written quickly, informally, it feels uncannily contemporary. It is hard to believe this is a voice from the late eighteenth century. In addition to studying everything, G. takes a hard look at himself, and towards the end of the book there is a striking revelation: he confesses his "sickness and…foolishness," his secret shame that he had never made the trip to Italy before to see firsthand its art and architecture, the objects of his lifelong fascination. Two days from arriving in Rome, he no longer takes off his clothes to sleep so as to hasten his arrival, and on October 26, 1786, he writes, "[N]ext Sunday [I]'ll be sleeping in Rome after 30 years of wishing and hoping."

The effusive diary abruptly goes silent: "I can say nothing now except I am here… Only now do I begin to live… " To his Weimar friends he writes: "I'm here and at peace with myself and, it seems, at peace with the whole of my life," and to his lover, Charlotte von Stein: "I could spend years here without saying much."

The Flight to Italy is filled with references to plants and crops; G. even has a theory of a *primal plant* form. The only star he mentions, though, is the sun.

THE REAL

Now it is a conflict between the idea of writing from the unknown versus working from notes and journals. Elsewhere, I have compared these different modes in writing to two genres in photography: the *vérité* approach of the street, seizing life and movement with little chance of reprise, and, in contrast, the controlled practice of the studio, where the artist is less exposed, the environment more forgiving, time more malleable. And perhaps another iteration of this distinction between risk and control was intimated in something I heard a critic, quoting Godard, say on the radio when I lived in Paris in 2008: "Filmmakers who make installations instead of films are afraid of the real."

In his six-hour documentary *Phantom India,* Louis Malle travels all over the subcontinent filming, and later, in voice-over, he analyzes and reflects on the intrusion and indiscretion of the camera. Malle will never get over this feeling of impropriety, but he will keep on shooting, hour after hour, pushing up against the act of documentary in an attempt to understand something about India and something about himself. Much of *Phantom India* is straight-up documentary, but there are moments of intense self-scrutiny and questioning. For instance, when Malle describes his inability to be "present," to experience the "real" of what is taking place before the camera.

He lives in his head, sometimes thinking of the past but mostly caught up in a work whose meaning will only be locked in at a future moment. To every new situation, his first instinct is to invoke memory and analysis: a scene on a beach at daybreak reminds him of one twenty years earlier when he was making his first film. "A tamer of time, a slave of time" is how Malle understands his predicament. At a certain point he and his crew will stop filming. Only then will they begin to experience the present tense, the slowness of time, and what Malle calls "the real."

THE WET

Another problem for me now is the welling up of "the Wet," the insistent preoccupation with narrating certain aspects of the discredited past, things I may never be ready to tell. Previously I have incited myself to write by beginning with the most pressing thing, but the problem now is that I can't face writing about the Wet. I think about giving it a masquerade, or perhaps the Wet will duly give way to something else.

This document parallels another one written from notes collected in diaries. That one is accompanied by the uneasy feeling of cannibalizing myself. *This* document, though not a book, is trying to begin according to a principle described by Marguerite Duras: "To be without a subject for a book, without any idea of a book, is to find yourself in front of a book. An immense void. An eventual book. In front of writing, live and naked, something terrible to surmount." I wanted to try, almost as an ex-

Notes, 2011. Chromogenic print, 4 x 6 in. (10.2 x 15.2 cm). Collection of the artist

MOYRA DAVEY *was born in 1958 in Toronto. She lives and works in New York.*

periment, to write both ways, one alongside the other in tandem, but already I've begun to fold in notes from that other document…

Was Duras opening her veins? Yes and no. She was also opening the bottle. But she would go at it—writing and drinking—for days and nights. She had stamina, as Sontag would say. And she was not afraid of the Wet.

Rainer Werner Fassbinder: "The more honestly you put yourself into the story, the more that story will concern others as well."

MARY

Mary Wollstonecraft, born in 1759, ten years after Goethe and two hundred years before my sister Claire, was Wet and Dry. She was a brilliant star in her firmament, a passionate, early advocate of women's, children's, human rights, and an enlightened defender of truth and justice: a radical. She went to Paris to witness the revolution and lived to tell of the bloody terror of 1793. A woman with enormous intellectual capabilities and savoir faire, she supported herself and, at various times, one or more of her largely hapless six siblings, by writing.

But she also suffered from depression, and broken-hearted over the rejection by her lover, Gilbert Imlay, drank laudanum. In an attempt to revive her, he offered a mission of travel to Scandinavia on an investigation of a murky business affair of his. Mary accepted because she needed the money, and she hoped that this continued involvement with Imlay might ensure a positive romantic outcome.

In 1795 she set out on a dangerous ocean voyage with her infant daughter, Fanny, and a French maid. Like Goethe on his travels to Italy, Wollstonecraft wrote letters to Imlay chronicling her observations and emotional responses to the landscape and peoples of Sweden, Norway, and Denmark. Her heartbreak is softly intimated in the letters, but mostly she reflects and reports with a jour-

nalist's eye on the native customs: a feather bed so soft and deep it is like "sinking into the grave"; children swaddled in heavy, insalubrious layers of flannel; airless homes heated with stoves instead of fires—and here, like Goethe, Mary invokes the odd concept of "elasticity" to talk about the air. Viewing the mummified remains of some nobles, she responds with characteristic indignation: "When I was shewn these human petrefactions, I shrunk back with disgust and horror. 'Ashes to ashes!' thought I—'Dust to dust!'"

After her return home to England, Wollstonecraft composed the letters into an extremely well-received book titled *Letters Written During a Short Residence in Sweden, Norway, and Denmark*. It was published in 1796, two hundred years before the birth of my son, Barney.

ALISON

Soon after I arrived in Paris, shaky with jetlag and insomnia, I asked Alison, my oldest friend, if she'd help me brainstorm some ideas. Bless her, she is always willing, and she is a font of ideas and strategies. I was struggling and fearful, convinced I'd do nothing of value in this city: I took a pill and drank a glass of wine on a cold terrace on the rue de Rivoli and told Alison this: "I came to Paris in 1976 just out of high school. I was lonely, depressed, bored, illiterate. I was thin, I was fat, with no control over any of it. I was a Francophile with a deep longing to be part of the culture, but I was clueless, infused with teenage ideas about 'the Romantic.' A French friend told me emphatically: 'the Romantic is the nineteenth century. End of story.' I met the two Quebecois artists in the Cité Internationale des Arts studios. They were friendly but aloof. Thirty years later, I am back in Paris with a husband, a son, a life. I have one of those studios. I am thin. I have money. I have MS." Alison's eyes light up: "*That* is

the perfect story." But I have no idea how to write a story. About telling certain episodes of your past, Norman Mailer said: "You must be ready." I may never be ready. Some excised paragraphs, the original motivation for this project, now reside in a separate document labeled *Pathography*.

Why does everyone want to tell their story? Why do all of my students talk about "representing memory"? Why is Amy, in grad school, suddenly conscious of her working-class roots, destabilized, obsessed with her childhood? Why is my sister Jane tormented by the past and asks Mom to talk to her shrink? Why did I spend so much time in Paris, agoraphobic, brooding, tunneling into realms of childhood where I found pockets of it illuminated with sudden, violent flashes?

Isak Dinesen: "The reward of storytelling is to be able to let go … All sorrows can be born if you put them into a story or tell a story about them."

SIBLINGS

At the end of my copy of *Flight to Italy*, there are short bios of all the principals in Goethe's life. His mother, Catharina Elisabeth von Goethe, is described as a very supportive woman, and there is a citation from Freud about G. having been his mother's favorite and about how children singled out in this way retain a lifelong confidence and glow. This led me to Freud's brief essay "A Childhood Recollection," an analysis of an early memory G. recounts in his autobiography of throwing dishes out the window when he was a small child. The episode remained mysterious to Freud until, as is typical of his method, he began to hear similar stories from his patients and started to piece together a theory, namely that the throwing of objects out the window is typically linked to a child's fury and jealousy in response to the arrival of a new baby. I strongly suspect I reacted just as

Letter, 2011. Chromogenic print, 4 x 6 in. (10.2 x 15.2 cm). Collection of the artist

violently or even more so to the births of my five younger siblings. A therapist explained this to me once and said I should practice self-forgiveness, but it took Freud's words to cement the notion that my behavior was not a murderous aberration of childhood. A description of one of these cruel episodes of "acting out" has been excised and relegated to the *Pathography*.

Michael Haneke: "Artists don't need shrinks because they can work it out in their work."

But can we do without Freud?

SHARON & GLORIA

I fell asleep in the afternoon and dreamed I was commiserating with Sharon Hayes about how a work, once finished, is "like a tombstone." Gloria Naylor said this about her book *The Women of Brewster Place*: "I had gotten a bound copy of the book which I really call a tombstone because that's what it represents, at least for my part of the experience."

The thing is only alive (and, by extension, *I* am only alive) while it is in process, and I've never quite figured out how to keep it ignited, moving. Some stubborn gene always threatens to flood the engine just at the crucial moment of shifting gears.

MARY & MARY

Like Goethe's *Flight*, Wollstonecraft's *Letters*, a narrative moderated by a journey, has a special, self-generating momentum: a trip, with its displacements in time and space, can be the perfect way to frame a story. Combine this with an epistolary address, and it would appear to be the most easeful of forms. *Letters* was the only happy outcome of the Scandinavian trip. Five months after her first suicide attempt, on confirmation that Imlay had a lover, Mary jumped from a bridge in rain-soaked clothing, to hasten her descent. She was saved by a boatman and briefly consoled

by Imlay, who shortly thereafter disappeared for good from the lives of Mary and Fanny. But MW was lucky to find a friend in the person of William Godwin, a sage man who, according to MW biographer Lyndall Gordon, counseled: "A disappointed woman should try to construct happiness 'out of a set of materials within her reach.'"

A year later, in 1797, in love with Godwin, married, and pregnant, Mary read Goethe's *Sorrows of Young Werther* aloud with William. The following night, she went into labor and gave birth to a child who would grow up to be Mary Shelley, whom she would soon leave motherless. The delivery was botched; the placenta did not descend, and a doctor's unwashed hands reached into the womb to tear it out. Sepsis set in, the mother's milk became infected, and puppies were used to draw off lactation. Two hundred years later, in 1997, less than six months after giving birth, I flew across North America with an electric pump to suction the milk from my breasts. But I missed my connection and arrived at my destination twelve hours later, my breasts grotesquely engorged. I took a photo in the hotel room and some years later published it in *LTTR*, a minutely circulating, queer-feminist journal. Now that photo is all over the internet, completely out of my control.

Part of the tragic irony of MW's death in childbirth was her own enlightened advocacy of simple hygiene and non-intervention in the care of infants and mothers. Suspicious of doctors, she was a believer in wholesomeness and common sense in an age of superstition and quackery.

THE SUN

Plants, flowers, crops, and nature figure abundantly in the *Letters* and in *Flight*, less so the stars, though both Wollstonecraft and Goethe, northerners from cold, rainy climates, enthuse repeatedly in their correspondences

about the presence of sunshine. Goethe marveled to his friends about its perpetual abundance in Italy ("these skies, where all day long you don't have to give a thought to your body"), and for Wollstonecraft in Scandinavia, its effects are central to her evocation of the sublime, which she experiences in her travels along the rocky coast and mountainous landscapes of Sweden and Norway.

The warm reach of the sun was also surely a factor in granting each of them a measure of peace: for Goethe, when he arrives in Rome and no longer feels the need to double his life in writing ("I am here … Only now do I begin to live …"), and for Wollstonecraft, during countless moments when nature impresses itself upon her as the salve and renewal of an exhausted, disillusioned spirit. Waking on a ship one morning, she greets daybreak with these words: "I opened my bosom to the embraces of nature; and my soul rose to its author…" Two decades later, her daughter Mary Shelley would write from the banks of Lake Geneva: "[W]hen the sun bursts forth it is with a splendour and heat unknown in England."

In 2004 in Needville, Texas, an asteroid is named for Mary Wollstonecraft (Minor Planet Center designation 90481 Wollstonecraft).

"LES GODDESSES"

Aaron Burr, visiting England from America in 1812, bestowed this epithet on Mary Wollstonecraft's daughters, Fanny and Mary, and their stepsister, Clara Mary Jane Clairmont, known then as Jane and later as Claire. Two years later, Mary, aged seventeen, and Percy Bysshe Shelley eloped to France with Jane in tow; Fanny, with disastrous results, was not invited to join them. Byron soon formed part of the group, and together they lived an idyll of poetry, song, travel, and love, surviving on whatever money they could squeeze from Shelley's father. On foot, atop a donkey, and by boat, they journeyed

Darling, 2011. Chromogenic print, 4 x 6 in. (10.2 x 15.2 cm). Collection of the artist

through parts of France, Switzerland, and Germany, keeping a collective diary subsequently published under the title *History of a Six Weeks' Tour*. Nearly two hundred years later, I procured a facsimile edition of this book printed in New Delhi, no doubt downloaded from Google books: the insides are a distant cousin of the original typeset, but the cover is a bright red design adorned with Islamic patterning. It is an utterly charming object, as is the prose it contains.

Eventually the Shelleys settled in Italy where they wrote, read the classics, Rousseau, and Goethe, and Jane, in particular, studied music and languages. About Rome, Mary proclaimed: "[It] has such an effect on me that my past life before I saw it appears a blank & now I begin to live …" They existed like this for eight years, short of money, outcasts living in defiance of the rigid matrimonial conventions of the early nineteenth century. The ménage was not without its tensions and jealousies: Mary, pregnant and ill for much of the time, quickly began to find Jane (now Claire) an irritant. But Claire was vivacious and talented, and though she could sometimes be dispatched, she would remain a resolute fixture of the Shelley circle. Mary began to use a little sun symbol in her diary to indicate Claire's presence on any given day: ☀

JANE

Mary Wollstonecraft's parents, John Edward and Elizabeth, were married in 1756; their union produced seven children. Two hundred years later, my parents, James and Patricia, met in England and married in 1956. They also had seven children—six girls and one boy—beginning with Jane Elisabeth in 1957.

Prompted by a stay in rehab, my sister decided to write a memoir of her childhood and addiction. In an email she told me: "I am in the process of teasing out an ending but I'm

now edging up to a very respectable 60,000 words, plenty to qualify for a book.

Now, of course that the deed is nearing completion and *I have set down once and for all a true record of what has happened* (sorta, kinda), I am feeling somewhat uncertain."

MW wrote of "the healing balm of sympathy [as the] medicine of life," a concept Jane, an uncommonly sensitive and empathic person—always, since childhood—and now an amateur homeopath, would undoubtedly agree with. Jane reminds me of MW in some ways. She is a strong and caring woman, a nurturing mother of three daughters who also kept her distance from doctors and their drugs, but is emotionally fragile in the way MW was at times, prone to depression and occasional rash behavior.

FANNY

Fanny, to whom Percy Shelley had first shown affection, was excluded from the "summer of love." She had inherited her mother's melancholic streak, and though she tried to combat the depressive feelings, she was dogged by what she called: "Spleen. Indolence. Torpor. Ill-humour." Fannykin, of whom Mary Wollstonecraft wrote in the Scandinavian *Letters* when her child was a babe: "I dread lest she should be forced to sacrifice her heart to her principles, or her principles to her heart" succumbed to exactly that predicament of the nineteenth-century woman without means. Fearful of becoming a burden, Fanny drank laudanum as her mother had done, but unlike Mary, she was successful.

Young Mary's bliss with Shelley was short-lived as death began to intrude with frightening regularity. Of her four pregnancies, only one child, Percy Florence, survived. Claire's daughter by Byron, Allegra, whom Byron callously separated from her mother, died at age five, alone in an Italian convent. Just prior, Claire had written heart-breakingly in her

journal that recovering Allegra would be like "com[ing] back to the warm ease of life after the coldness and stiffness of the grave." Shelley's first wife, Harriet, in an advanced state of pregnancy, drowned herself in 1816, and eight years into his relationship with Mary, Shelley himself drowned in a boating accident on the Gulf of Spezia off the coast of Pisa with their close friend Edward Williams. Byron, who'd committed himself to a war of independence in Greece, died two years later in Messolongi of fever.

JAMES & PATRICIA

In 1975, my father James, aged forty-five, fell from the roof of our house one Saturday morning in August and never regained consciousness. I had just turned seventeen, the same age as Mary Wollstonecraft Godwin when she eloped to France with Percy Bysshe Shelley and Jane Clairmont. My mother, Patricia, retreated to the top of our big box of a house and all hell broke loose below. The Davey girls were not writing poetry, studying Greek and Latin, and procreating; we were listening to David Bowie, Roxy Music, and The Clash, and ingesting too many drugs. Interviewed by a journalist friend about our active sex lives at the time, my mother responded ruefully: "I'd mind less if I thought they enjoyed it more." It was a different time and different kind of rebellion; nonetheless, many thought of us as a female force—goddesses no, but "Amazonian," yes, to be reckoned with. And that is what I tried to show in a series of portraits I took in Ottawa and Montreal beginning around 1980. "*Les jeunes filles en fleur*" was another expression used by the same journalist friend to describe some of us, but that came later, after we'd settled down a bit.

CLAIRE & KATE

Claire Davey, small and taut and the only one among us who did not regularly swell and

Your Sister, 2011. Chromogenic print, 4 x 6 in. (10.2 x 15.2 cm). Collection of the artist

shrink, never succumbed to intoxicants or liquor. And she never threw herself at men, as did some of her sisters, as did Claire Clairmont with Byron. Temperate, she traveled, she studied; now she teaches philosophy and yoga to high-school students in Toronto. Kate, born a year and a half after Claire, in 1961, two hundred years after Mary's brother Henry Wollstonecraft, was the fearless party girl, drinking and inhaling pills until she passed out. Kate never "recovered" into anything resembling normalcy. Multiple stays in rehab would eventually lead to a lifetime of AA, NA, OA. Intelligent, sensitive, she opted out. She read every novel on my mother's bookshelves and filled the house with rescued animals. Some of the original five cats and four dogs have passed on, but the smells linger to remind us of nineteen-year-old, blind, incontinent Candy and gentle, gormless, clubfooted Duke, found on a reservation.

CLAIRE

Of the Shelley entourage, only Mary, her son Percy, and Claire Clairmont lived past the age of thirty. At the dissolution of their circle, Claire joined her brother in Vienna and began to work as a teacher, but she was hounded out of this employment by the lingering scandal of her youth and forced to migrate as far as Moscow, where she became a governess. Her journal, a penetrating literary document, was published a century later; an old woman, she eventually settled in Florence with her niece Paola and became the model for Henry James's story "The Aspern Papers."

MARY & PERCY

Widowed, Mary Shelley was at the mercy of her tyrannical and conservative father-in-law, a man who had never accepted his son's poetic gift, nor his marriage to Mary. After editing a posthumous collection of Shelley's work in 1824, Mary is forbidden by the patriarch from publishing any more of Shelley's poetry or even writing about him, lest it shame the family, thus forcing her into a conventional lifestyle for the sake of her son and his inheritance, small sums of which were parsed out to them while Shelley senior lived on and on, defying all expectations of his demise.

According to Muriel Spark, Percy Florence inherited none of his parents' literary or artistic talent and refused to visit art museums with his mother when they traveled in Europe. A disappointment to Mary, she later grew to appreciate what Spark termed his "phlegmatic qualities." Percy was "to remain loyally and negatively by [Mary's] side to sustain her old age." He married Jane Gibson, a sympathetic woman who became Mary's friend and caretaker during her final illness at age fifty-three. Percy and Jane did not have children.

BARNEY

Aged thirteen, does not like art museums either—he says they instantly make him feel sleepy. He told me: "An ideal way to spend the day would be to drive to an airport and watch the planes take off and land."

TAUTOLOGY

I learned the meaning of this from Baudelaire via Barthes: "I take H (hashish) in order to be free. But in order to take H, I must already be free." And from Alejandra Pizarnik: "To not eat I must be happy. And I cannot be happy if I am fat." This comes close to summing up my adolescence.

HOMEOPATHY

In November 2010, I traveled to Montreal to visit Dr. Saine, a famous homeopath recommended by my sister Jane, a man who, like his father before him, had treated thousands of people with MS. I sat with him in his Dickensian study, surrounded by stacks of paper and books, some framing white busts, no doubt Dr. Saine's predecessors, the discoverers of this strange and mystical science. He interviewed me for three-and-a-half hours about symptoms, cravings, fears, and dreams. He felt my frozen feet and lit a fire, burning a cube of oak. "How do you feel when you see a poor person? On a scale of one to ten, how much do you fear poverty? Cancer? Death?" "How do you feel when you are with your son and your husband enters the room?" And on and on. "Is there anything you haven't told me about yourself?" I told as much as I could, including some of the bad and shameful memories from the *Pathography* (because you have to), but the long interview was tiring, and my fragmented story came out rather flat and monotone. He received it all without judgment. indeed, with a high degree of curiosity, almost excitement.

He said my case was unusual—perhaps my parental influences were too strong, too dominant, neither one giving way—and this left him torn between two antidotes. I departed with two tiny glass vials, coincidently each a substance related to photography: sepia, which is a dye used to tone photographic prints, and lycopodium, the spores of clubmosses that were ground into combustible powder and ignited in the era before flashbulbs.

BEING

"To do without people is for photography the most impossible of renunciations," wrote Walter Benjamin. Yet that abandonment is precisely what would begin to take place in my photographs over the next ten years, beginning in 1984, until my subjects constituted of little more than the dust on my bookshelves or the view under the bed. The burden of image-theft, as Louis Malle put it, had something to do with my retreat, but also a gradual seeping in of a kind of bi-

Elasticity, 2011. Chromogenic print, 4 x 6 in. (10.2 x 15.2 cm). Collection of the artist

ographical reticence, perhaps connected to my present reservations around telling my story (*Pathography*).

I, too, ingested excessive substances in decades two and three, and one result is that I can barely keep track of the analogies I've posited, from Duras's "immense void" and the unscripted of *vérité*; between rehearsed writing (from journals) and photographic mise-en-scène. And what is meant by "the real" in the pronouncements of Malle and Godard ("Filmmakers who make installations instead of films are afraid of the real")? For Godard, the real is about confrontation and risk in time-based media, the old-fashioned way, no props allowed. Malle uses the term to describe a state of "being" to which he accedes when he finally stops filming in India; it is about experiencing a kind of existential peace, a freedom from the need to be making something. But he can only enjoy the feeling because he has worked very hard for it.

THE GREEN & THE WET

Over the years I've brushed up against a peculiar sensation of "being," usually in green places where water infuses the air: in a marshy field in England crisscrossed by canals; on the tiny, narrow peninsula of pine-choked soil that is Provincetown, in fall or winter. Something about the "elasticity" of the air infuses "the elasticity of my spirits" and allows me to enter an unusual state of weightlessness, an intense and rare feeling of wellbeing.

Displacement in space, and the attendant fatigue of travel, must be contributing factors to this febrile state, not unrelated to Stendhal syndrome, which had its origins in Florence in 1817. Stendhal noted this phenomenon in Italy just one year before Claire Clairmont and the Shelley party found themselves climbing the ruins of the Coliseum on their nightly walks through Rome. Goethe,

Mary Wollstonecraft, and the Shelleys were all weary travelers—MW had recently given birth, and Mary Shelley, her daughter, was more or less pregnant for five years. They both had very young children in tow; they were exhausted. In early 1997, sleep-deprived, I walked through the snow-covered woods of Provincetown with infant Barney strapped to my chest. I needed to move at all costs; I craved something mind-altering.

SEPIA DAYS

Mary Shelley died in 1851 and Claire Clairmont in 1879, but no photographs of them seem to exist, at least on the web; there is a photographic oval of Percy Florence Shelley as an older man: he looks a bit like Freud.

In his essay "A Little History of Photography," Walter Benjamin cites Goethe, apropos of August Sander: "There is a delicate empiricism which so intimately involves itself with the object that it becomes true theory." Mary Wollstonecraft and Goethe were just pre-photography, Goethe by only seven years. Their travel writings have the vividness and spontaneity of snapshots, and Goethe's phrases and sketches, in particular, feel startlingly modern. It is not a stretch to imagine that Goethe, with his scientific mind, might have anticipated the nascent technology: it was "in the air," after all, long before 1839.

The close observation that Goethe championed and was his means to knowledge, to "true theory," was precisely the promise held out for photography for many, many decades, perhaps 130 years if we count up through the late 1970s. And that is when I started taking pictures, at the very moment when the truth claims of the photograph were being dismantled by theory. That moment of the "Discourse of Others" has passed or shifted, but it marked me, changed for good the way I work.

When I wrote about "being" four years

ago, it was under the tapering effect of steroids. Now I take drugs that make me sleep. But this morning I woke early with precisely the idea of writing these lines and taking a picture of the rising sun reflected off the giant apartment building in the distance. Up at seven for the first time in—? Photograph gleaming building—my old habit from when I'd wake with the sun.

CODA

On the train downtown to the New York Public Library in search of Mary Shelley's diaries, I began to notice subway riders absorbed in writing of their own: a woman paying her bills, another marking pages on which the word "draft" is stamped in large letters. Some are standing, precariously balancing pads and pens on crowded trains; others look off into space, lost in concentration. There is a man folded over his crossword whom I captured in the same pose on more that one day; children doing their homework; a woman wearing orange velvet gloves clutches a small yellow pencil.

Just when I'd been writing about the disappearance of the figure from my photographs, I found myself taking street pictures again in the dim green light of the Manhattan subway. I experienced the same unease and doubt I've always had in taking pictures on the street, and I kept expecting to be asked what I was doing. But the writers themselves, eyes downcast, were unaware of my camera, and those looking on, over my own shoulder even, seem only mildly surprised by the small point & shoot, a note-taker itself, recording the underground writers as we ride.

The artist would like to thank Elizabeth Denlinger, curator of the Carl H. Pforzheimer Collection of Shelley and His Circle at the New York Public Library, for her kind permission to photograph.

Write, Read, Walk, 2011. Chromogenic print, 4 x 6 in. (10.2 x 15.2 cm). Collection of the artist

91

The Eyes Bear the Load

MATTHEW S. WITKOVSKY

"The architects are the form-givers and the photographers are the image-makers, and the relationship is more incestuous than one would think."
–Ada Louise Huxtable, 1973[1]

There is a memorable photograph of the Whitney's Breuer building, from a coffee-table book put out in 1970, four years after the building's completion, that shows it rising awkwardly over 75th Street in an axonometric view.[2] Heavier at top than at bottom and barnacled with windows, the structure appears fetchingly odd, like the massive head on John Hurt in David Lynch's film *The Elephant Man.* The three inverted setbacks on the main facade, seen foreshortened and in calming shadow, have a regularity and logic that contrasts strikingly with the side elevation, which is peppered by a seemingly random array of faceted windows caught here raked by morning sunlight to maximize the sense of their depth. The proportions and spacing of these windows make little sense from the exterior, where they seem like a glut of eyeballs looking out on the world below. Regular on one side, irregularly encrusted on the other, the structure thus rises from its pit and looms, gazing through its oblong protrusions onto further odd but endearing couplings at street level: the snub-nosed Fiat wedged between two very American sedans, or the prototypical 1960s Madison Avenue man in his skinny tie who appears to be helping his sensibly dressed grandmother hail a cab.

"That sheet of enclosure—that division between indoors and outdoors, the skin of a building—has again requested new answers to its problems," Breuer argued in April 1966, just as the Whitney building was nearing completion (it opened that September).[3] Breuer did not like his creations to appear transparently comprehensible from without, in the manner of Walter Gropius's glass architecture or the expressed I-beams of Mies van der Rohe; instead, he wanted internal functions such as air circulation, electrical or water conduits, and skeletal structure to be contained in precast concrete units that could either weight the cladding and make it load-bearing, like an exoskeleton, or, in the case of the Whitney building, rupture an otherwise smooth epidermal surface. Because the precast units for the Whitney exterior are essentially updated window moldings, the building appears to have a number of heavily lidded eyes punched through its outer skin. "A new *depth* of facade is emerging," Breuer conclud-

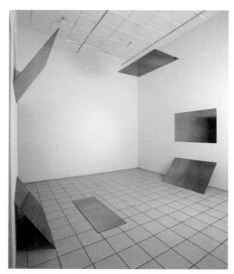

Tilt/Swing (360° field of vision, version 1), 2009 (installation view, Miguel Abreu Gallery, New York, 2009). Six unique silver-toned black-and-white photograms, 136 x 192 x 58 in. (345 x 488 x 147 cm). Collection of the artist

ed, "a three-dimensionality with a resulting greatly expanded vocabulary of architectural expression. Sun and shadow."[4]

Sun and shadow have a signal bearing on photography, which as Liz Deschenes knows, has a great tradition of bringing together the acts of writing and building. When Deschenes exposes sheets of photographic paper by moonlight, then processes them into lustrous, mirrored objects, she is consciously connecting with the development of "words of light" by the early photographer William Henry Fox Talbot, whose favorite subjects in the 1830s included written or printed surfaces and views of his manorial estate. Deschenes has used her heavily silvered "mirrors," which offer alluringly indistinct reflections of the surrounding space, to occupy that space as quasi-architectural elements in their own right. Her 2009 installation *Tilt/Swing*, for example, involved six of the mirrored photograms deployed in a full circle on the floor, two walls, and ceiling of a commercial gallery. Visitors stepping toward the ensemble saw their dim yet richly textured likenesses scattered and fragmented across multiple surfaces. The two-word title is common parlance among architectural photographers: *tilt* refers to the ability to swivel the lens plane relative to the image plane, so that elements not otherwise parallel to the camera will register as being in alignment and, thus, all in focus; *swing* (or *shift*) describes a movement of the lens directly up or down on an otherwise stationary camera,

typically to keep the image plane parallel to the plane of the subject, as when photographing multistory buildings. Deschenes's nocturnally prepared photograms involve no lens, so the words *tilt* and *swing* are liberated from a technical reference. They evoke instead abstract issues of viewpoint and manipulation, for example the ways in which the spectatorial subject is turned or focused in the controlled setting of a museum building.

For her participation in the 2012 Whitney Biennial, the artist is contemplating an arrangement of non-representational photographic elements that would suggest a relation between Breuer's sculptured architecture, with its stepped facade and many protruding eyes, and the lens and bellows of a view camera (a large-format device typically used to picture static subjects, such as buildings, in great clarity). It is another odd yet apposite pairing, tinged with melancholy: a high modernist monument, made in the very years in which architectural modernism was being condemned and relegated to the past, is coupled to a kind of camera rendered defunct now that film has ceded to digital photo sensors. We have no need of a bellows to create space between lens and film. For that matter, we no longer need an inside and outside to make a picture; dark and light need not be divided either in the moment of registration or during printing. Sun and shadow are what permit us to see an image, no longer to make one. In important respects as well, we concentrate today on the potential of skins, emphasizing surface over depth and thus refuting in every possible way the assertions made by Breuer in print and in his buildings.

The Breuer building, which will house the Metropolitan Museum of Art after 2015, will nevertheless live on, an archaic technology updated through new users. That moment of passage—like the far greater passage from analog to digital film—provokes nostalgia, but also the sort of critical reflection that Liz Deschenes regularly builds on in her work.

September 2011

NOTES
1. Ada Louise Huxtable, "Perspective on the City: The Photographer's Eye," *New York Times*, November 25, 1973, reprinted in Huxtable, *Kicked a Building Lately?* (New York: The NY Times Company, 1976), 137. **2.** The photograph appeared in Tician Papachristou, *Marcel Breuer: New Buildings and Projects* (New York and Washington, D.C.: Praeger, 1970), 123. **3.** Marcel Breuer, "The Faceted, Molded Façade: Depth, Sun and Shadow," *Architectural Record*, April 1966, 171–72. **4.** Ibid.

LIZ DESCHENES *was born in 1966 in Boston. She lives and works in New York.*

The Whitney Museum of American Art, New York City, 1963–66, Marcel Breuer and Hamilton Smith, architects. Photograph by Ezra Stoller

Aubade, 2010. Pigmented inkjet print, 4 x 6 in. (10.2 x 15.2 cm). Collection of the artist

NATHANIEL DORSKY *was born in 1943 in New York. He lives and works in San Francisco.*

Pastourtelle, 2010. Pigmented inkjet print, 4 x 6 in. (10.2 x 15.2 cm). Collection of the artist

Song and Solitude, 2010. Pigmented inkjet print, 4 x 6 in. (10.2 x 15.2 cm). Collection of the artist

The Visitation, 2010. Pigmented inkjet print, 4 x 6 in. (10.2 x 15.2 cm). Collection of the artist

Variations, 2010. Pigmented inkjet print, 4 x 6 in. (10.2 x 15.2 cm). Collection of the artist

Winter, 2010. Pigmented inkjet print, 4 x 6 in. (10.2 x 15.2 cm). Collection of the artist

In film, there are two ways of including human beings. One is depicting human beings. Another is to create a film form that, in itself, has all the qualities of being human: tenderness, observation, fear, transparency, solidification, relaxation, memory, the sense of stepping into the world and pulling back, dissolving, dreaming and the sudden dark haunting gravities of the heart. The first is a form of theater, and the latter is a form of poetry.

Eat Me

LAURIE WEEKS

The morning dawned clear and bright, and after my usual regimen of astral-projection exercises, which I was certain to need on this soon-to-be-a-charred-black-cinder-adrift-in-space that we call Earth, I took my pitcher of mimosas to the deck overlooking the bay and fed my pets: Pogo the Acid Rain God, a five-legged frog with a tail protruding from his forehead, and Eerie the Ear Mouse, refugee from a nearby military human-animal hybrid facility. "It's axiomatic that the ruling State hates transformation unless it's something they can control for profit, Pogo," I commented wryly to the eccentrically limbed amphibian.

I downed my drink and poured another, gazing moodily across the turquoise waters at a pair of gamboling dolphins. How lonely life would be without the submarine cosmos of my awesome friends the fishes and other dazzling organisms! Was there no way out of the prison of late capitalism, the greatest death machine of all time, not just through poverty and war but through the calculated, systematic destruction of interior life—the death of desire, sensation, imagination, and critical thinking—that totalitarian democracy depends upon to maintain control of its

subjects? More importantly, was there no way of extending the deadline on this essay I was penning on Nicole Eisenman, one of our greatest living artists?

My thoughts turned to that sixteenth-century sociopath Francis Bacon, whose rape-inspired theories led directly to the dying coral reefs in our bay. Guilty of such crimes as: A) writing a thing called *The Masculine Birth of Time* (1603), which, B) is bad enough, but also C) infected humans with the viral belief in infinite progress and the unlimited growth of production and knowledge, leading to his über-crime of theorizing that the way to achieve total knowledge and certainty was for Science (male) to bind Nature (female) to him (Science) as his slave. Convincing Nature to reveal her mysteries—which filled him with fear because he was a pussy afraid of

the dark—Bacon proposed the time-honored scientific method of enforced submission *by penetrat[ing] at length into her inner chambers;* as well as *hound[ing] nature in her wanderings by imposing order through reason.*

"Why are people so down on non goal-oriented wandering around, Eerie?" I asked, wondering if the stoic rodent could hear through the hairy man-ear jutting up from his spine. "After WWII, industrialization and mechanization should have led to reduced labor time and a post-scarcity global society of liberation from work—a post-work world, little dude!—with total freedom to create and explore our own realities."

"Ideally our identities are encouraged in their multiplicity," piped up a tiny voice. "And encouraged to change with shifting contexts. When that became possible after WWII, the apparatus of control cranked up, creating false consumer needs and fear of nuclear war and terrorism, crucial elements in the construction of consensus reality that would then be maintained by the mass media."

I looked down. "Clarissa!" I exclaimed. There she was, my beloved twin, who was actually more a vestigial tumor, a little lump of teeth and hair protruding from my hip, who was nonetheless very loving and talented in her own right, proving that my backseat conception on the scenic overlook of a depleted-uranium missile-manufacturing plant had its definite upside. Perhaps I'd have a tiny image of the Hindu goddess Kali painted on my big toe at the next pedicure. "I just don't get the drive for total domination and control, Clarissa," I said, "or the preservation of misery when there's enough for everybody plus tons more for those who need to be rich. People surrender their thoughts, hopes, and conscience to authority in the name of rationality and endless growth, which is *irrational.* What the fuck is wrong with everyone?" I cried.

"Well, they're desperate to fit in or die. The

invisible, governing law of our social order is the myth of a core, stable self, grounded in gender. Western societies view gender identity as an actual possession, one you're born with. Ownership of this defined self is property you must have to be recognized, and invested with the agency to make choices. We wrongly perceive it as inherent, natural, and inevitable. I mean, obviously that's not my issue," joked my petite sidekick, "but still."

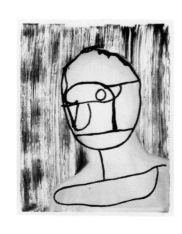

"Don't go there, girlfriend, you crazy little diamond," I said affectionately, placing an extra straw into her mouth. I sipped thoughtfully along with her for a moment, gazing at a distant prison barge for youthful offenders making its way slowly along the horizon. "You might not know this, Clarissa," I informed her, "but I consider juvenile delinquents to be some of society's greatest heroes."

"Could you expand on that a bit?" Clarissa asks, coming up for air from her straw.

"Well, juvies just aren't having it for even one second, the hideous lie of the socialization process. They don't miss a trick; they know public schooling's intentionally designed as a death camp for the soul, and Nic is one of the great JD's of all time. Her stuff reminds me of kids writing sarcastic graffiti in textbooks because they're so offended by the propaganda and stupefying writing. The sheer idiocy of the whole enterprise can inspire one to great pinnacles of comedy, simply to preserve your sanity and delay the encrushment of your soul in the trash compactor of state 'education.' Most people end up mangled into subservience, but Nic managed to get out alive with her x-ray vision intact, becoming this artist dedicated to making escape hatches for the rest of us. Hmmm."

"Well, hmmm," Clarissa echoed, trying to be helpful. "Were you going to make more mimosas or anything?"

"That's it!" I exclaimed suddenly. "It's the magic of the 'Eisenman Wormhole,' Clarissa—that joyride of hairpin turns, forks, and switchbacks torn in the space/time continuum that rockets you through speculative dimensions populated by morphing bodies in trees and clouds, minotaurs, models on fishhooks, Hamlet, marshmallows, oceans churning with throngs of stuffed animals and naked humans, kids engaged in

NICOLE EISENMAN *was born in 1965 in Verdun, France. She lives and works in New York.*

forbidden sexual exploration and display—unsettling Brigadoon-like geographies where dark matter is visible and evil twins wander the land, including the multitudes of Nicole, who casts herself as, among others, the anti-christ, an art movement, a host of bats hanging upside down in a cave, *Village of the Damned*, a disfigured war vet, and the doppelgangers of people from our world like Clive Banks, pot-smoking teenagers, figures from high art and whoever else—all are dislocated from their contexts to interact in setups governed by an alternate physics, where creative vandalism is the highest ideal. She sidesteps right out of the power equation, not accepting hierarchies of worth, like what's trivial vs. what's important to explore. If it's in Nic's sensorium, she's going to play with it, not obey it."

"So, by combining the infantile with the exalted," Clarissa mused, "Nic scrambles mandated boundaries between self/other, human/non-human, meaning/no-meaning; and violates all injunctions to 'know your place,' *just to see what happens ...* Whoa." She paused, stunned. "She just totally disrupts the predictable plot offered as reality by this Society of Lies, so that the whole notion of inherent, stable meaning goes up for grabs. Awesome!"

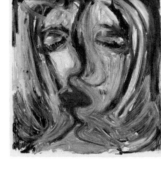

"She restores ambiguity, uncertainty, and unfamiliarity to the world, and in the process she RE-ENCHANTS it! Metaphoric high-five!"

"I like when she deflates enormous historical concepts designed to put you into an inadequacy spiral!" shouted Clarissa, jiggling with excitement on my hipbone, slightly pinching a nerve, but I was used to it. She was sensitive and high-strung, for obvious reasons, as well as drunk. "Her allegorical characters just kind of wander from painting to painting!" screamed the miniature round theorist.

"Sounds like there's some heavy shit going down out here. Considering it's only 6 a.m.," said a musical voice. "Can I interest you girls in a light breakfast of poached eggs and caviar?"

My heart skipped a beat and I dropped my special left-handed Mont Blanc pen. "Honey pants!" I cried with delight, whirling to press my cheek against the "everyday jodhpurs" covering my girlfriend Nicola Tyson's taut abdomen. Placing my arms around her waist, I breathed deeply, calmed by the smell of her black leather riding boots. "Thank god you're here, because I can't seem to get past the lobotomizing effects of my mandated public 'education'—which was based on the model pioneered by a Prussian military dictatorship to produce subjects incapable of anything but

following orders—to elucidate this thing about the centrality of language to Nic's work."

Nicola smiled. "Wormhole," she said, moving to the bar to mix up a batch of Cosmopolitans. "Tasty metaphor. I like it. Kudos." She handed me a drink and tapped her glass approvingly against mine before dropping onto the Le Corbusier chaise lounge and pulling me down beside her. Nostalgically I recalled how she'd invited me up for a nightcap after our first date. When I saw the MENSA plaque displayed on the mantelpiece next to her Academy Award for Best Foreign Language Short—which was actually in English but was so smart that nobody could understand it.

"But somehow I must explicate, in terms any layman can understand, how Nic dismantles the bogus history of science and technology as paradigms of rationality and exposes it as doublethink, where the linear march toward ultimate truth is a cover story for the unchecked growth of control over living beings—and ultimately ownership of the life force itself."

Nicola began taking notes in shorthand on paper she'd handcrafted herself. "So she turns her unconscious into theater, plucking elements from the tsunami of cultural input swamping her nervous system and detaches them from their underlying, normative logic to recast them as actors in fields of wide open possibility, like kids released from church into the wilderness. She effects some kind of phase shift that dematerializes the force field of our prescribed reality—agreed?" she asked, picking a hair off my lapel.

"Precisely," I shouted, draining my glass. I sprang up and began to pace, a restless panther. "What gives Nic's stuff the power to thrillingly destabilize your everyday sense of things is that she *literalizes* the language of control, or its effects, by turning it into images, familiar creatures reimagined or *surprised* into releasing their latent content, producing

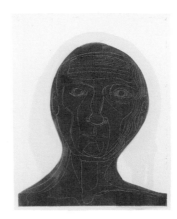

a visual shock in a wiser, deeper zone of recognition that startles us from walking comas. In a certain sense, all of Nic's bodies are stand-ins for the words and little brutalities enfolded into metaphors that have a damaging effect on your psyche."

"She re-edits the world, splicing together scenes that trap language into exposing its function as the jailer's instrument, or rather she provides enough rope for it to hang itself," said Nicola decisively, replacing the cap on a tube of her favorite wine-colored lipstick, Aveda's *Earnest Borgnine*.

"A lot of times you just get this barest sense of what's happening, an impression, as opposed to a total narrative. You get the pleasure of all these bodies morphing like crazy, everyone's trying out little storylines the way kids do. She reveals her psyche, like everyone's, to be teeming with potential selves. Nic's not issuing manifestos; her conclusions are indeterminate—she's *investigating* in a laboratory of possibility, creating a space of rupture where banished perceptions burst into view, bypassing language and rationality filters to hit your nervous system and jolt your unconscious sensory organs awake before they can be cleaned up by 'reason!'"

Abruptly I slammed my fist on the coffee table, drained my drink, slammed it on the coffee table, and stood up. "Damn! We have so much to explain. We shouldn't have stayed out so late last night with Brad and Sheldon and Debbie and Nanci-Debbie."

"Well, thank god Nic has prepped our loyal readers to the slipperiness of meaning," Nicola said. "On the other hand, I pray that these same readers still cling to the naive habits of The Old Ways—specifically the feeling

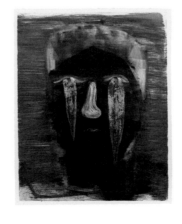

that if you can't understand what you're reading it must be because you're stupid." Nicola's a beautiful woman, with masses of red-gold hair (its color is one of the few things in this life that I can say with absolute certainty is real, without quotation marks.)

The phone rang. Nicola ran to pick it up in the solarium.

"It's Nic," she whispered across the room. "She wants to know how you're coming with the essay."

"Stall her," I said. "Make something up, anything. Like—tell her it's done."

"She knows you're lying. Which she says makes her happy because there's no such thing

Twelve prints, all *Untitled*, 2011. Mixed-media monotypes, 24 ¾ x 19 ¾ in. (62.9 x 50.2 cm) each. The Hall Collection

101

as a stable, eternal Truth. She's on her way over."

For days Nicola and I had been fully over-prepared to talk about Nic's work, but I'm an eclectic and original thinker, and I was frustrated. Linearity offends me politically, and I'm actually too creative to make an outline, but before we could start crafting what one influential Amazon.com guest reviewer termed

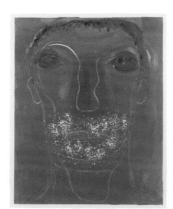

"the most stylishly grammatical sentences ever collaborated on, with intertextual references that make me have a literarygasm!," Nicola and I needed some way of organizing the heady speculations we'd amassed.

"Don't fret, Tiger," Nicola soothed, stroking my unruly mane of thick auburn hair. "Time's an illusion, like everything else."

I sat down with my drink to think. But it was no good. After a few minutes, I put down the TV remote.

"I've always agreed with Lyotard that the demand for clarity should be denounced because it's the first imprint of power on the libidinal band," I announced.

Nicola sipped her Negroni and nodded thoughtfully, her long legs tucked attractively beneath her on the tan Barcelona chair. "What?" she said after a minute.

"Clarity, doll face. The ruling principle of our evil society. Instead of recoiling from ambiguity and contradiction like good girls, we have to embrace it—in this essay!"

"Yeah!" shouted Clarissa. "And use it like Nic does, to become all curious and energized!"

Nicola looked up at me, her eyelashes ablaze in the afternoon sun. She reached for the pack of Gauloises. "Well, I'm certainly curious and energized, my darling," she smiled, pulling two cigarettes from the box, "by this very mysterious and ambiguous 'libidinal band' of yours."

What a little minx she was! "Quantum mechanics says nothing's real unless it's observed," I reflected, contemplating the perfect smoke rings as they left my mouth and drifted up to dissipate in the warm sea breeze.

Nicola scribbled notes. "Okay. So the confusing excess that you can't nail down with explanation is what makes you most alive, right?" she said.

"Correct, pussycat," I answered, noting with approval that she had switched to French in her shorthand. "Each time you dive into

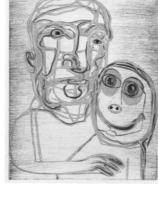

the cognitive dissidence and ask the hard questions, like, *Why—*?"

"Your cells start spinning like mirror balls, crashing the software of oppression, right?"

"Precisely." I took Nicola's chin in my hand and kissed her deeply, savoring the taste of Taylor's *Quinta de Vargellas* 1832 vintage port and Gauloise on her tongue. "It's a dangerous moment, *mi amore*, and an exhilarating one. We should try to provide that gift to our readers."

"What gift?" We looked up to find Nic Eisenman, her intelligent face alive with mischief, lounging boyishly in the sliding door that opened onto the infinity pool.

"Nic! What's your poison, my brother?" I shouted, moving to the bar.

"Scotch, straight up," Nic said. "Yeah, those were heady days, my friends. What's that sound? Pogo!" she exclaimed, as the avant amphibian cartwheeled into her arms. We toasted and she took a sip, regarding me over the rim of her glass.

"How's it going? The essay. Let's see it."

"How's it going," I repeated, turning to gaze absently at a display of faint diamond fountains on the horizon, spray from the blowholes of frolicsome humpbacks. "How's it going. Hmm." I drained my glass. "Look, Nic, all of us—you, me, Nicola, Clarissa—are, as far as we can tell, girls, or at least that's the diagnosis in this lifetime and dimension, as well as free thinkers and vagabond dreamers who recognize the label 'girl' for the regulatory fiction it is, ready-made to prop up State justifications for its death grip on definitions of reality and the allocation of meaning and value, a colonization of consciousness, via the language of hierarchy and pseudo-scientific categories …"

"Check," said Nic.

"Our point is that the crazy project of mastery over the vicissitudes of living beings that has led to what I like to call 'The Approaching End of the World' is contested by you and your art on virtually every conceivable level, because you provide us with an example of resistance and escape through shape-shifting,

a strategy that dislocates you from the land of law into a psychedelic territory of pleasure in shifting and ambiguous natures, which encourages tolerance of other identities and reveals the liberation of seeing everything as dress-up." I pulled the stopper from a crystal decanter of Bas Armagnac and downed a shot to fortify myself.

"Absolutely," said Nicola, standing in front of the mirror-wall reflecting the infinity pool and ocean beyond. "To resist with anger, locked in a battle of wills, focused on denying and killing off negative stuff, is to remain defined by the system of oppression," she said, teasing her hair, "even contributing to its chokehold. It nourishes itself on your creative energies, sucking them up to gain power exponentially, for these are its terms. Its game is war, and you're playing by the rules."

"Whereas you, Nic, juxtapose language with grotesque and exaggerated bodies such that we *see* words as actual sludge sitting in our cells and producing psychic constriction, which everyone usually only experiences subconsciously as five hundred pounds of torpor and ennui." I carried my free weights over to our Rietveld Red Blue chair, ideal for upper-body lifting. "The isolating sense of monstrosity, shame, taboo; fear of exposure; discovering yourself infected with the disease of historical definitions, struggling to retain mobility while gasping for breath in a sealed dome—you accept these as your creative materials and seek them out, especially those things exiled to the realm of the abject, non-meaning, and you fool around—gleefully recombining them and crossing the borders of other categories like "Male" and "High Art" on specimen raids, trying on other identities like suits—transmuting internalized forces of paralysis into art objects with their own life in the world. Your psyche dematerializes from its containment to appear in multiple and shifting sites.

"And it's not depressing; it's totally hilarious," Clarissa said.

"You commit the ultimate crime of enjoying yourself," I continued, "while alchemically transmuting the soul-destroying materials of coercion that invisibly sap one's energy for anything but work into something spine-tingling for the viewer. Suddenly we're *back*, baby, in our bodies and fully alert!"

"Nic, did you know it was recently discovered we have brain cells in our hearts and our intestinal tract?" squealed Clarissa.

"Others identify with the work, get inspired, a viral process with the potential to radically reconfigure our conception of the world."

"Which is why power hates transformation so much." I looked up as Nicola handed me a glass of a rare Pinot Grigio. "Perfect," I said, sipping appreciatively. "Mmm. Somewhat crisp, with overtones of incoherence," I teased, knowing how much Nicola enjoyed my excellent sense of humor. I commenced a set of bicep curls.

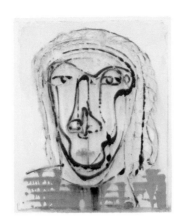

Nicola's coltish legs glowed below the swimsuit she'd picked up on our trip to Monte Carlo, a stylish one-piece with unobtrusive geometric cutouts. "Your scenes contain multiple perspectives, so it's hard to read them according to a single psychoanalytic, feminist, lesbian, or any other shibboleth," she said, beginning a complicated series of Tai Chi exercises in front of the mirror.

"Nic, you're a father," she continued, hands raised in the pterodactyl pose. "How can you stop the natural rhythms of your daughter George's body from being dissected by the disciplinarians of rationality? I mean, the uncoupling of her perception from her body and the world, so she sees herself only from a distance, as this lonely cog on some anxious quest in a frozen universe of solitude?"

"Well, the first thing we do," said Nic, waxing tiny surfboards she'd just fashioned for Pogo and Eerie, "is start a little band for George and her friends called The Disciplinarians of Rationality, so right away she's taken control of that issue. We have to preserve her belief that she can be anything, anytime—a butterfly racing car one minute and a capybara, the world's largest cute rodent, on Saturn the next. Here, Pogo and Eerie," she called. She placed them on their boards in the infinity pool.

"I don't know anything about Jaques Lacan," Nic remarked, dropping into a sleek Wassily chair. "I remember my dad talking about him in the 1980s, and I read on Wikipedia that Lacan said the unconscious is structured like a language, but basically my paintings use language—by which I mean actual words in English— as poles on which to perform dirty dances." She sipped her drink thoughtfully. After a moment she said, "Should I feel weird that I mentioned my dad, the unconscious, and pole-dancing in the same sentence?"

"Not weird at all," I said. "Just creepy." I reached over and put my hand on

Nic's knee. "To be on the receiving end of your talent is, I swear to God, Nic, like being healed, or released from prison," I said with deep feeling. I grabbed the back of the chair and hauled myself up, wobbling slightly. "The intelligence and authority of your work, devoid of arrogance, self-righteousness, or really any signs of ego, emitting the unmistakable vibe of desire—that we think and play with enjoyment and curiosity right alongside you, goddammit—" I looked over at Nicola, kneeling to wax her own surfboard.

"Right, honey?" I shouted. "Nic's up for anything. She's not saying she's right, she's just *saying*—right?" I slurred.

Nic downed her drink. "What I demonstrate is the healing, regenerative necessity of play," she informed us, "as well as its strategic usefulness as a tactic in the struggle against the limits imposed on human potential." Reaching over to the Noguchi coffee table, she chose a cigar from the box of Havanas that Nicola kept for guests, sniffing it appreciatively.

"You don't present a problem, then offer a once-and-for-all resolution," said Nicola, performing strenuous pretzel asanas in front of the mirror-wall. "Solutions are temporary. Everything's in flux." I felt amazed as always at my fortune in finding this magical, mystical lady at a time in my life when I thought all was lost.

Nic nodded. "That would mean I was operating from this position of knowledge, like I assumed everybody had identical desires and difficulties that could be fixed with an all-encompassing answer as discovered by me. It boringly reinforces the same old binary laws of what it means to be a girl, boy, straight or gay, and keeps us stuck in the fucking way of thinking that power relies on to keep people's imaginations in line."

"That's real!" shouted Clarissa. "The overthrow of the Old World Order, for men, too, without which there can be no liberation for humans in general. It's not men vs. women, gays vs. straights,

vestigial tumors vs. Siamese twins … It's The Power of the State vs. Individual Freedom of Imagination."

"Yeah. The real issue is what does it mean to be HUMAN and ALIVE and what *IS* consciousness, anyway," said Nic.

"… and what's your role as an artist in that conversation …" I slurred.

"I mean, do I know what desires and possibilities would materialize in a post-capitalist, post-authoritarian context? Answer: No I do not."

Suddenly a riotous swarm of colors as though from an intergalactic mirror ball began spinning through the room.

"Whoa," said Nic.

"It's just the UFOs," Nicola said calmly, as a cluster of silver spacecraft darted across the noon sun like molten diamonds to hang motionless in formation over the bay.

"Oh my god!" I shouted, lurching forward to slam drunkenly into the floor-to-ceiling glass door. "Oh my god!" I yelled again. "My perception's become uncoupled from my body, causing my imaginative gifts to atrophy! I can only speak using the slogans and metaphors of ruling power!"

Nic took an uncertain step forward and fell into the infinity pool, where she bobbed about, laughing in delighted abandon with Eerie and Pogo. Nicola grabbed her surfboard and sprinted off to launch herself into the waves.

"We must sing to the unknowable alien beings," I shouted to Nic, wheeling about and knocking a Bertoia chicken-wire chair into the infinity pool. Nicola's red hair whipped back in the waves beneath the shattering emotional epiphany that was the interdimensonal display. "Eat me!" I shouted. "Eat me!"

First published in *Nicole Eisenman*, edited by Beatrix Ruf (Zurich: Kunsthalle Zürich, JRP/ Ringier, 2011).

INT. SEAMSTRESS WORK STATION. MASTER CLEANERS PRITCHARD
ALABAMA

Annette, a youthful 50 year-old seamstress, is doing her
thing in the front of Master Cleaners. She is surround by
sewing machines, garments, fabric and spools. There is a
counter that separates her from the customers. She is super
friendly and "down-home". But... Annette is a type of woman
that is not going to waste your time because she doesn't like
her time wasted.

Annette is multi-tasking- sewing, mending, helping costumers,
talking to fellow employees...

...All at the same time.

She is humming and mending a pair of pants.

 WOMAN (O.S.)
 When you get a chance...

 ANNETTE
 I sure will...

 WOMAN (O.S.)
 Thanks.

 ANNETTE
 You're welcome.

Annette working on a pair of trousers and addressing a man off-
screen...

 ANNETTE (CONT'D (CONT'D)
 Is there something you need to day?

Annette addresses Tyesha.

Tyesha is a fellow employee is off-screen...

 ANNETTE (CONT'D)
 Tyesha...?

 TYESHA (O.S.)
 Yes... ma'am?

 ANNETTE
 Did Chet come by today?

 TYESHA
 Ummm, he didn't come in, he just
 passed by...

Annette talks to another woman off-screen.

KEVIN JEROME EVERSON *was born in in 1965 in Mansfield, Ohio. He lives and works in Charlottesville, Virginia.*

Script and stills from
Quality Control, 2011.
16mm film, black-and-white,
sound; 70 min.

VINCENT FECTEAU *was born in 1969 in Islip, New York. He lives and works in San Francisco.*

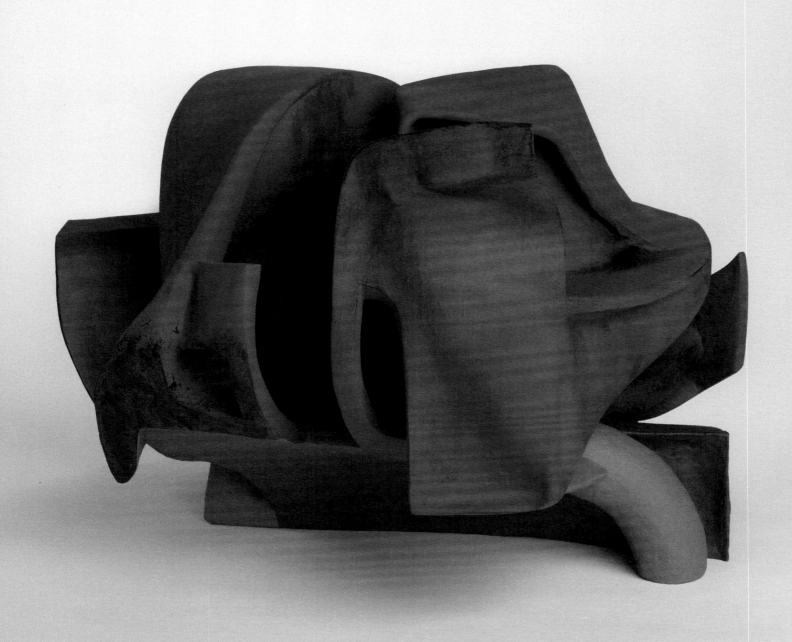

THE SNOW GLOBE

A shaky flashlight beam illuminates a stiff. Is that the boy you hit? It's prone beneath the snow wearing your overcoat and dirty, scotch-taped glasses. Yes, sir.

He had a deep depression, the worst one in our short lives' storied history. It reduced him to a speck. The storm helped. That snowball hid a rock.

You froze to death ten feet from here under white out conditions. It took years, this glass of scotch, and a cheap crystal ball to find the body.

He hobbled through a blur and hurled his snowball at my head. That missed. Later, he's lit by a jittering beam. Once this ugly little globe was the whole earth.

— Dennis Cooper

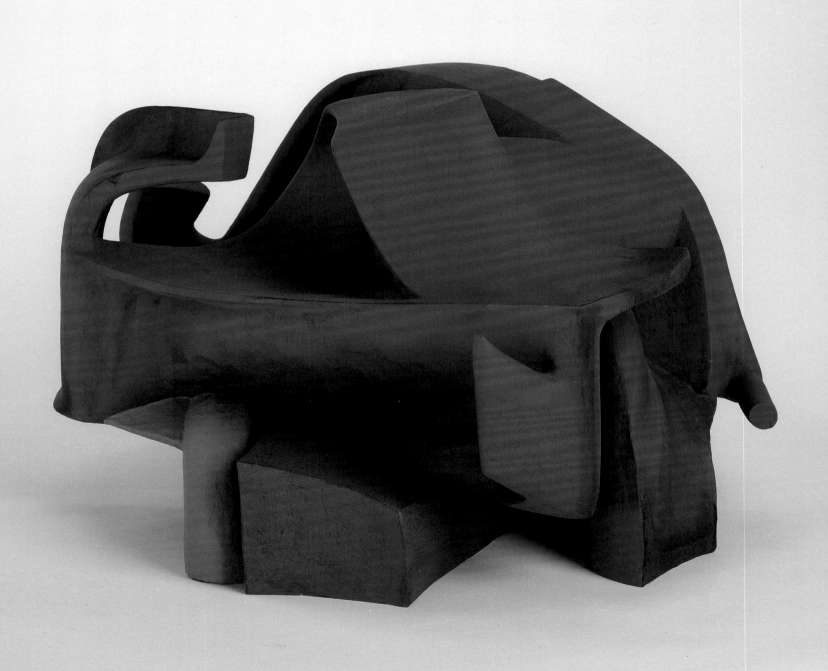

**MEI MOSES® 2006 ANNUAL ALL ART INDEX AND
S&P 500 TOTAL RETURN INDEX (1956–2006)**

Trends in Income Inequality in the United States
Top 0.01% Share of Wealth, 1956–2006

ALL ART
S&P 500

Index, 2011. Print project published anonymously in *Artforum*, Summer 2011, page 431. Produced for *24 Advertisements*,
a project by Jacob Fabricus, with design assistance by Santiago Pérez Gomes-de Silva, Studio Manuel Raeder

ANDREA FRASER *was born in 1965 in Billings, Montana. She lives and works in Los Angeles.*

Still from *Projection*, 2008. Two-channel high-definition video projection, dimensions variable. Collection of the artist

Paper Magazine Ad, 2011, from the portfolio *Campaign for Braddock Hospital (Save Our Community Hospital)*, 2011. Twelve photolithograph and screenprints, 17 x 14 in. (43.2 x 35.6 cm) each. Printed by Rob Swainston, Prints of Darkness

LATOYA RUBY FRAZIER *was born in 1982 in Braddock, Pennsylvania. She lives and works in New Jersey.*

Braddock Hospital served our community from June 27, 1906
– January 31, 2010. Braddock Hospital merged with University
of Pittsburgh Medical Center (U.P.M.C.) in 1996. In October
2009 the community found out that U.P.M.C. chose to close our
hospital because it was losing money and was underutilized.
Braddock Council President Jesse Brown challenged the
U.P.M.C. decision to abandon our town. The office for Civil
Rights of the U.S. Department of Health and Human Services
conducted an investigation. The final settlement allocated
shuttles to health care services in a nearby neighborhood for
outpatient service and extended hours at the Braddock Family
Health Center. Braddock Hospital was our largest employer.
Today our community does not have adequate health care,
emergency care or employment opportunities. U.P.M.C.
demolished our historical six-story hospital and built a new
hospital (U.P.M.C. East) in an affluent suburb that a majority
of our community residents cannot reach.

This series is dedicated to Braddock Council President
Jesse Brown and Save Our Community Hospital.

LaToya Ruby Frazier

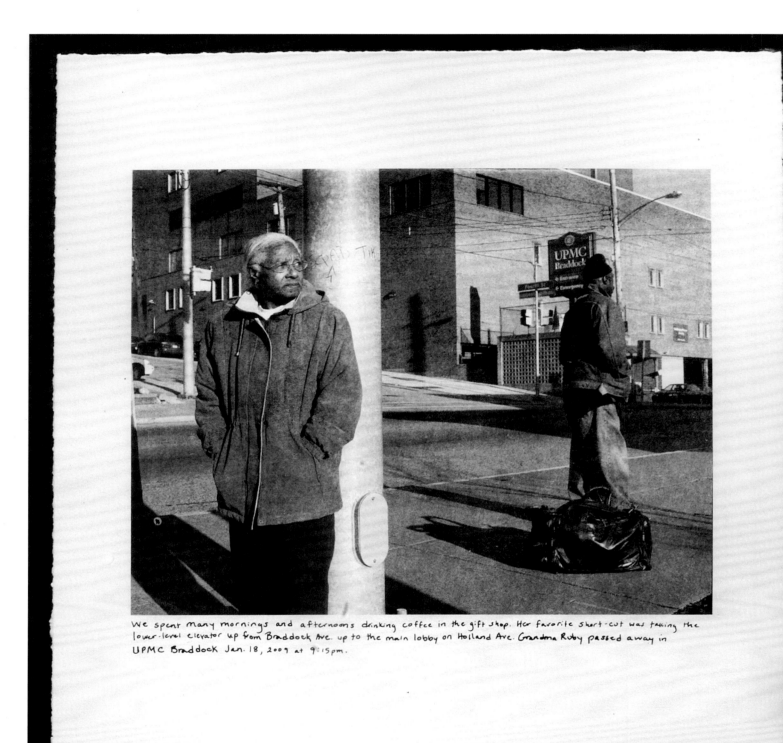

We spent many mornings and afternoons drinking coffee in the gift shop. Her favorite short-cut was taking the lower-level elevator up from Braddock Ave. up to the main lobby on Holland Ave. Grandma Ruby passed away in UPMC Braddock Jan. 18, 2009 at 9:15pm.

Grandma Ruby and U.P.M.C., 2011, from the portfolio *Campaign for Braddock Hospital (Save Our Community Hospital)*, 2011

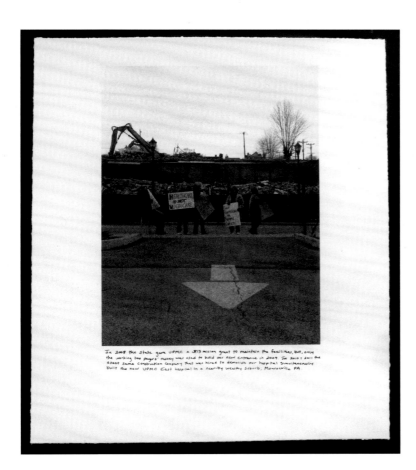

Clockwise from top left: *Health Care Not Wealth Care!*, *"Urban Pioneer," Undone*, and *Jenny Holzer's Truism*, 2011, from the portfolio *Campaign for Braddock Hospital (Save Our Community Hospital)*, 2011

What Might Be the Meaning of a Radical Documentary?

A Q & A with Martha Rosler

LATOYA RUBY FRAZIER: Martha, at the 2010 Vera List Center for Art and Politics, I presented my work on a panel that referred to your writing; organized by Susan Bright, it was called "Confounding Expectations: Revisiting In, around and afterthoughts (on documentary photography).'" Before I addressed the audience, I relayed a message you asked me to tell them: "Today documentary photography is more important now than ever, but it still needs a lot of work!" Can you highlight aspects in the current state of documentary practice that need work? Do you feel documentary has relevance in contemporary photographic practice and is being supported by institutions today?

MARTHA ROSLER: I would point to the need to complexify not only the production but also the reception of documentary, and to evade the demands of institutions that the work be obvious and transparent; humanist; and ambiguous or silent as to the meaning of class and power relations. It would be good as well if the people pictured, if there *are* people pictured, were not shown as passive, one-dimensional occupiers or performers of social roles, on the one hand, or as quirky, marginalized geniuses of self-creation, on the other—that presupposes the selection and presentation of these individuals for the delectation of the photographic audience. Aim to have your work *speak* to the people who are involved in the situation represented. I often feel, looking at the works on display in museums, that documentary is loosely interpreted as literally "irresponsible" because it's by definition subjective, but subjective *tout court*. With the end of modernism, universal message has become only universal with respect to human degradation, and usually not even then (in other words, the line between us and them is all the more evident).

LRF: In the 1930s, during economic instability in both Germany and United States, Walter Benjamin argued in his essays "A Little History of Photography" (1931) and "The Work of Art in the Age of Mechanical Reproduction" (1936) that photographic production and reproduction should be used for social change and that "inscription anchors photographic meaning, offering it a constructed depth that rescues it from surface meaningless" (James Elkins, ed., *Photography Theory*, 2007). In your essay "In, around, and afterthoughts (on documentary photography)" (1981), you conclude by stating:

"The documentary of the present, a shiver-provoking appreciation of alien vitality or a fragmented vision of psychological alienation in a city and town, coexists with the germ of another documentary—a financially unloved but growing body of documentary works committed to the exposure of specific abuses caused by people's jobs, by the financier's growing hegemony over the cities, by racism, sexism, and class oppression; works about militancy, about self-organization, or works meant to support them. Perhaps a radical documentary can be brought into existence. But the common acceptance of the idea that documentary precedes, supplants, transcends, or cures full, substantive social activism is an indicator that we do not yet have a real documentary."

Martha, your concluding statement echoes Walter Benjamin's demand for photographers to identify with political movements and struggles. I am curious about what the term "radical documentary" means to you? Is a "radical documentary" related to the works and conversations you were having during the 1970s and 1980s with friends and colleagues Allan Sekula, Connie Hatch, and Fred Lonidier? What were your positions on the socioeconomic predicaments of those times? How did those times influence your aesthetic decisions?

MR: Who better to echo than Walter Benjamin in this regard, and his inspiration, Bertolt Brecht? Yes, the ideas I was alluding to in the essay were related to the conversations of the era, essentially the 1960s/70s, with the people whom you name, and more. It is difficult to step back from one's organic responses to the day and try to follow a line of aesthetic decision-making. But here are some themes, some shared, some just my take on things: it seemed important to avoid focusing on the single, beautiful or inspirational image as far as possible; to avoid presenting people and situations unidimensionally or playing to prejudice; and to avoid catching people unawares in ways that diminish their dignity. If people were represented, we might try to engage with them as far as possible, collaborating on ideas and self-presentation; it is important to display your allegiances. It was vital to avoid implicit appeals to common sense and received ideas, and to eschew wordlessness where words are needed. Further, most of us were also intent on focusing on labor, both processes and sites of labor, and—especially the women among us—on gendered behavior.

As to form, although we identified, more or less, with postmodernism and conceptualism, we were definitely not part of the de-skilling moment in the use of the camera that is identified with conceptualism. I did not particularly fetishize the photographic image, but I cared a lot about it, about what I thought of as "wellformedness," adopting a term from linguistics. What is also important: most of us did not see ourselves as "in the service of" any particular group or movement but rather took pains to stay independent of organized groups in our work, if not in our lives, though this wasn't universally true. For me, the relative autonomy of art was and remains an important precept.

It is odd to be answering this question now, when the world is undergoing turmoil on a scale that may even dwarf that of the 1960s/70s. Thus, the present moment calls for similarly motivated decisions—no matter what the formal address, because there is no formula for the appearance of "realism." It may perhaps be more properly regarded as a matter of legibility.

Importing here part of your first question, one can say that institutionally, the imperative, stemming from governmental agencies and representatives and from linked-up charitable foundations, for museums to "serve the people" has translated into efforts to engage non-elite audiences. That may functionally be interpreted as engaging with the interests of working-class communities but in practice has generally been approached by inviting artists of color to represent the lives and interests of communities and individuals of color. Identity politics is one way of justifying the presence in elite institutions of what might otherwise be hostilely received by funders and trustees as class politics. But the crisis of the present is truly a crisis of class, if we may for the moment take "the super rich" to be a class; as the chorus echoing everywhere tells us, they are the 1 percent. And as donors and trustees, they fund museums and have tremendous, often direct, influence over the hiring and firing of curators, the elevation of particular artists, and the acquisition of works…

LRF: In my new series, *Campaign for Braddock Hospital (Save Our Community Hospital)* (2011), I have taken a stance with the community activist group Save Our Community Hospital and proudly follow the example of Tony Buba, the great documentary filmmaker of Braddock, Pennsylvania, in a struggle and fight for economic justice regarding healthcare, employment, redevelopment, and corporate exploitation to name a few. I often feel conflicted as to what role I should be playing, as it feels I play four to five different roles as artist, educator, mentor, daughter, and citizen of Braddock. Lately I am trying to understand the possibilities of activism and what it means when people ask me if I am going to become an activist. Martha, as a vocal artist, writer, and cultural critic, have these modes of activism satisfied or fulfilled the concerns you have raised in your various projects? For example, with regard to your project *If You Lived Here …*, is the collectivity of all this information that has been disseminated to those who have access to your book *If You Lived Here: The City in Art, Theory, and Social Activism* (1991) enough to cause social change or to serve the disenfranchised?

MR: Nothing is ever "enough," but one keeps trying. But asking art to be directly instrumental is, in my opinion, generally a mistake. We all fill at least some of the roles you mention, but if we can keep our minds on the citizen element, we would be adding something vital and critical to the practice of art. Joining with the aims and campaigns of grassroots groups is as good as it gets, but I do think one ought not become a functionary of any group that one works with, except in very specific instances. Work *with* them, not *for* them. Though that would be honorable, too, I believe that art contributes more through retaining a degree of autonomy—but it would take more space than we have here to spell that out without sounding like I'm simply arguing for precious individualism. A certain ambivalence is part of the territory. It is always in the minds of artists to participate and even meddle in public events, which is why artists are so central to the Occupy movement: it's all about the reinstitution of the imagination, not just in the service of trademarked artworks but of human beings

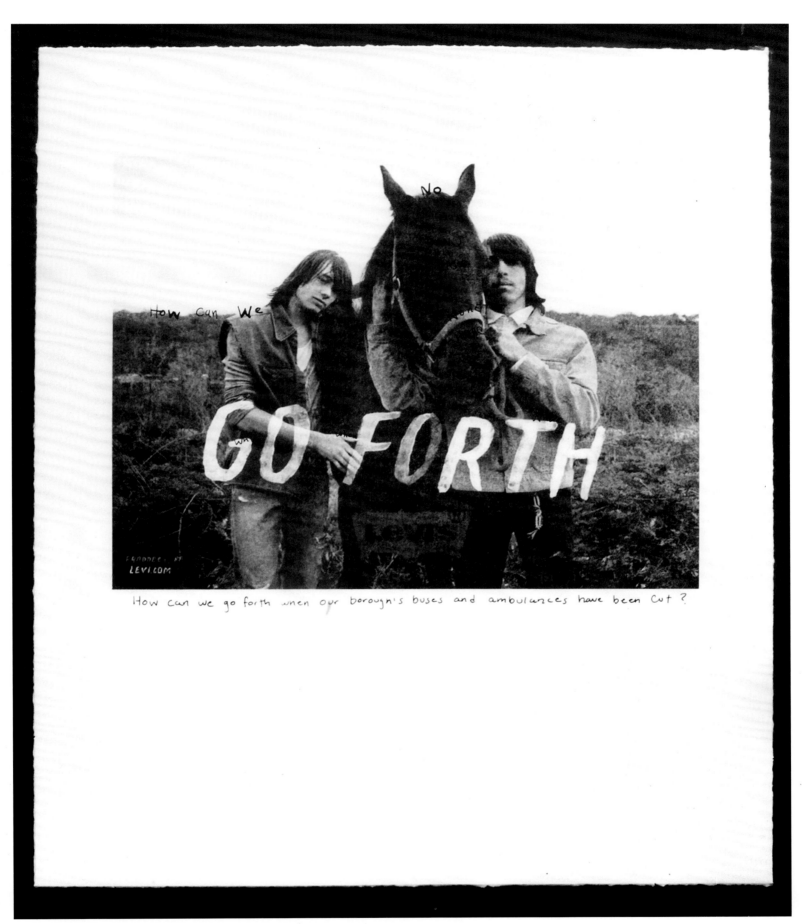

Go forth where? We don't have horses in Braddock!, 2011, from the portfolio *Campaign for Braddock Hospital (Save Our Community Hospital)*, 2011

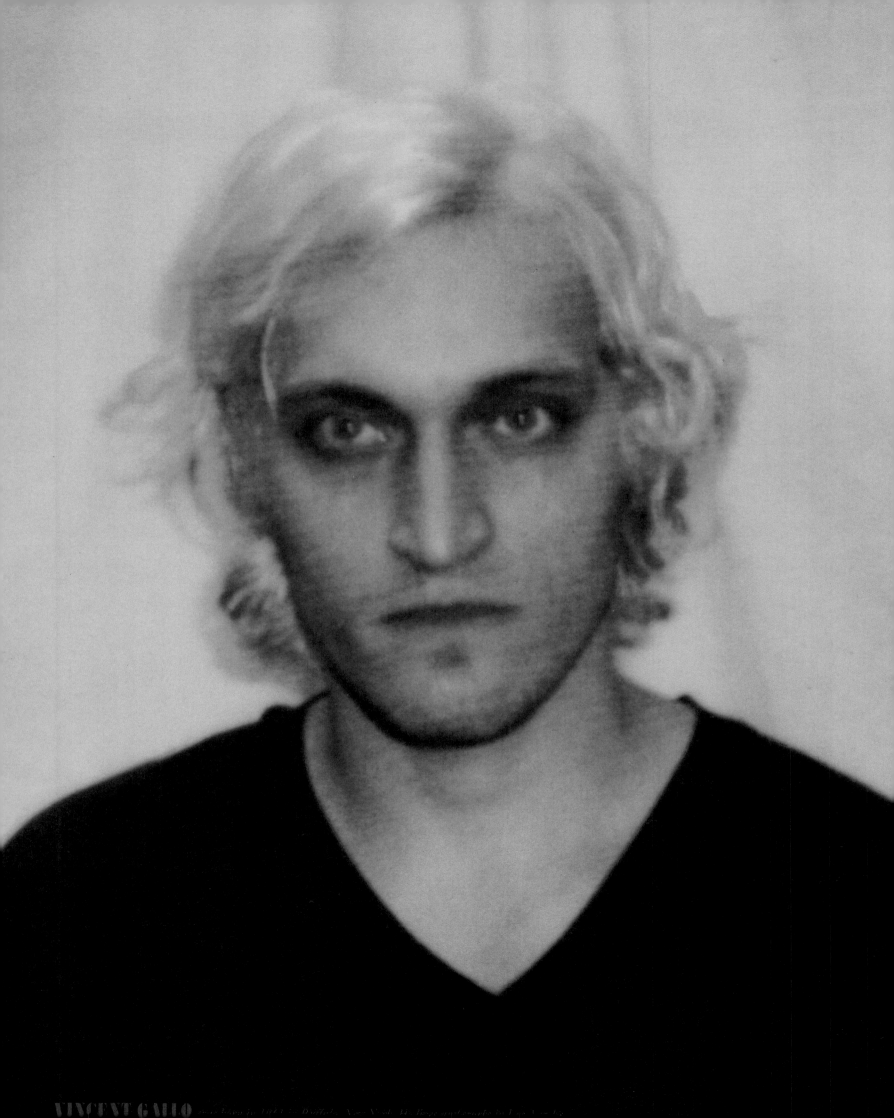

Vincent

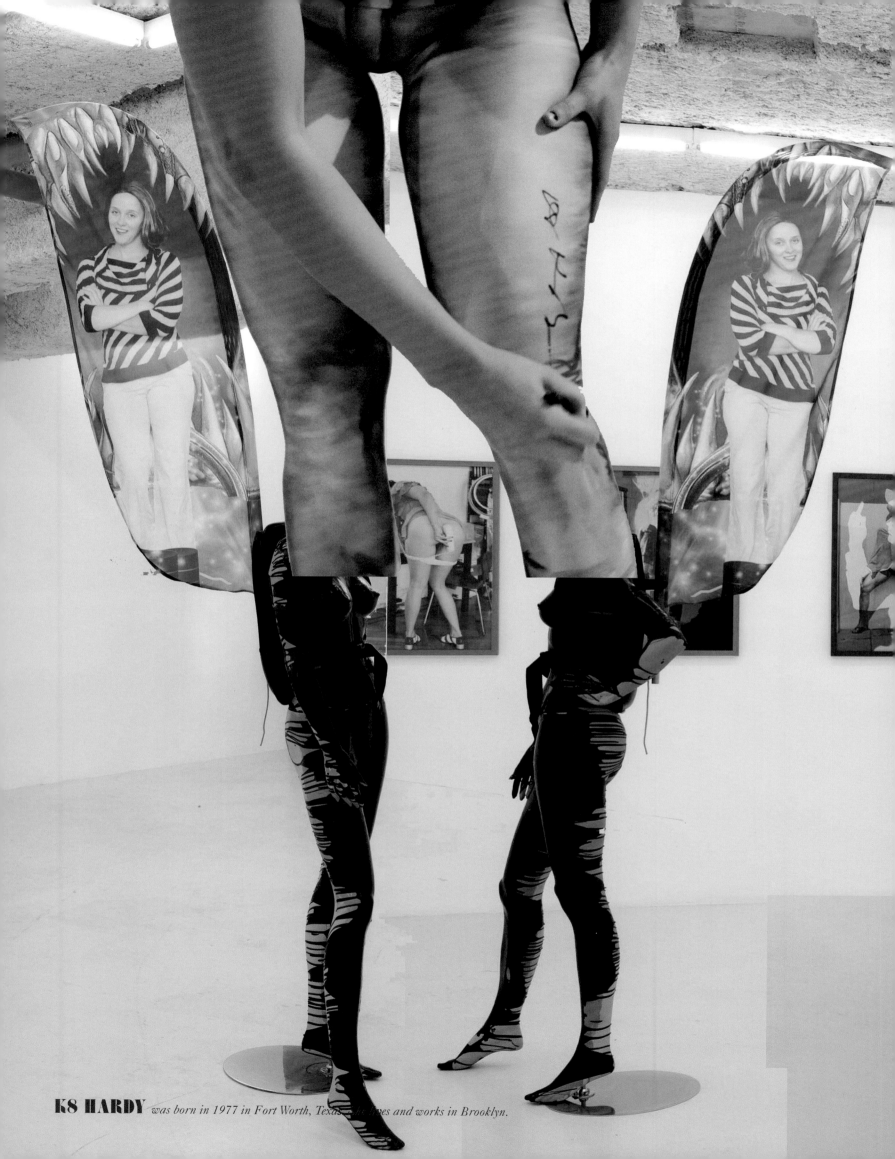

K8 HARDY *was born in 1977 in Fort Worth, Texas. She lives and works in Brooklyn.*

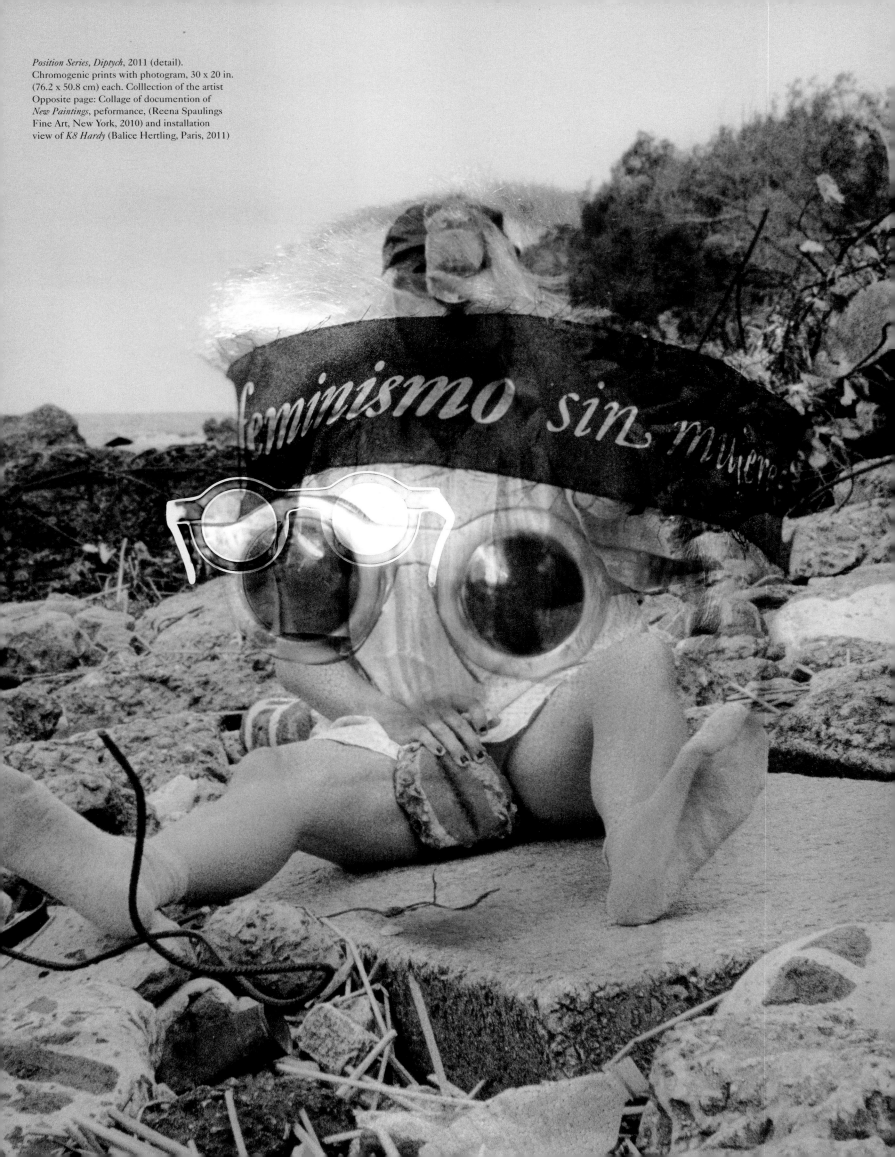

Position Series, Diptych, 2011 (detail).
Chromogenic prints with photogram, 30 x 20 in.
(76.2 x 50.8 cm) each. Colllection of the artist
Opposite page: Collage of docuemention of
New Paintings, peformance, (Reena Spaulings
Fine Art, New York, 2010) and installation
view of *K8 Hardy* (Balice Hertling, Paris, 2011)

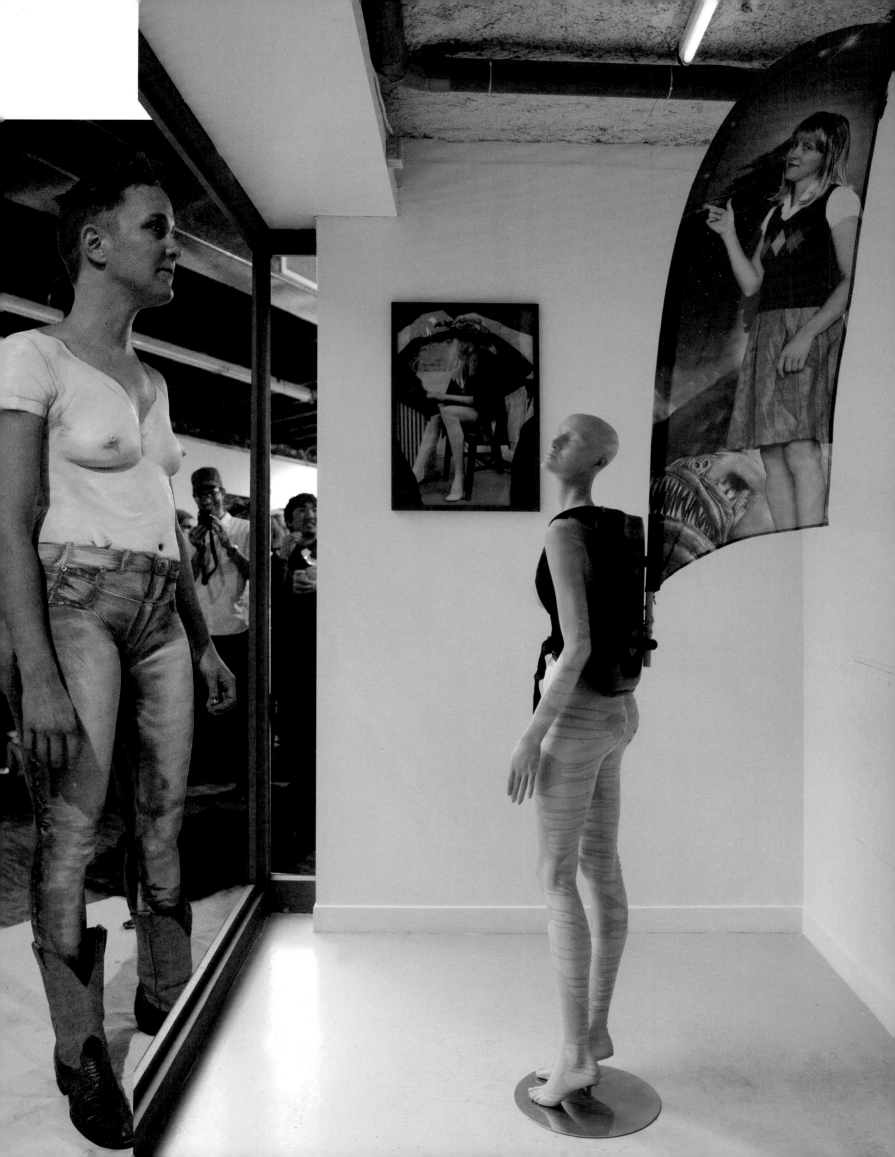

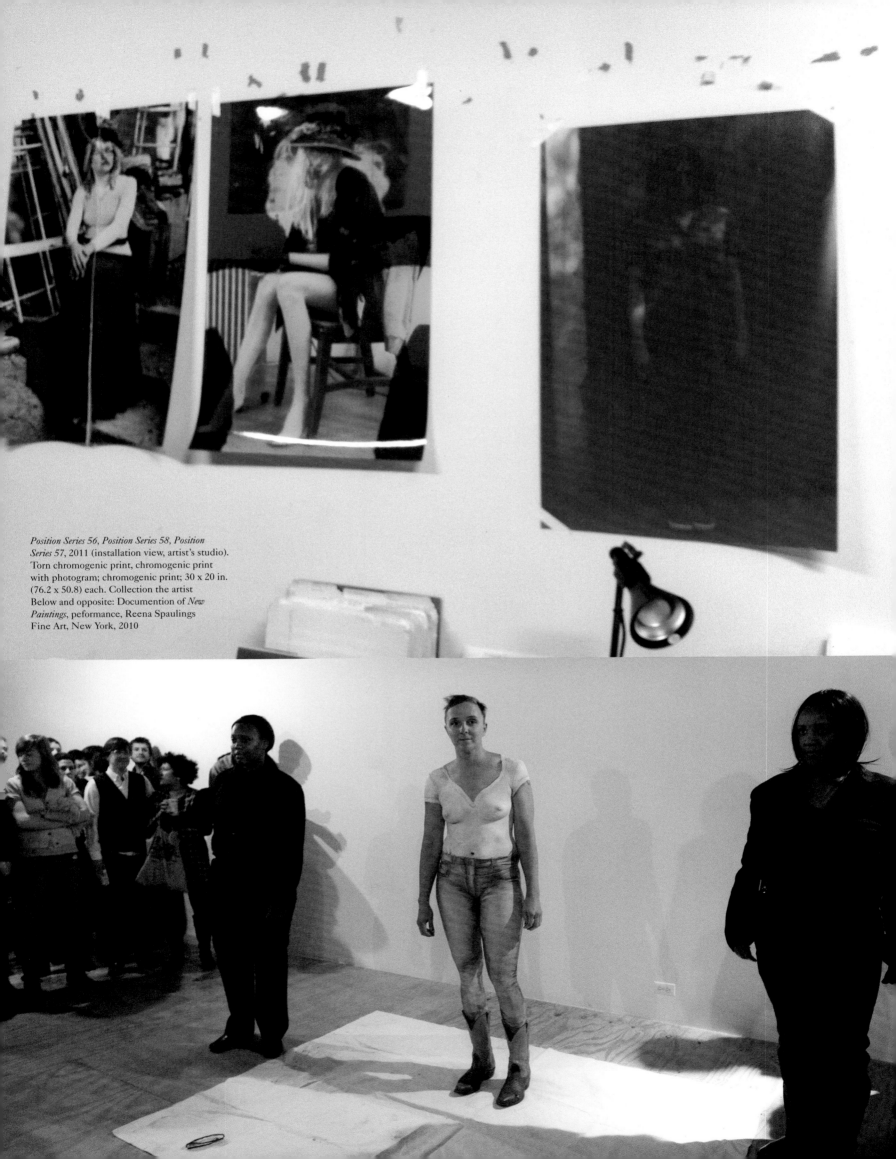

Position Series 56, Position Series 58, Position Series 57, 2011 (installation view, artist's studio). Torn chromogenic print, chromogenic print with photogram; chromogenic print; 30 x 20 in. (76.2 x 50.8) each. Collection the artist
Below and opposite: Documention of *New Paintings*, peformance, Reena Spaulings Fine Art, New York, 2010

The Nudity of The Artist

ARIANA REINES

Simone Weil wrote that the body, which is time, is a screen that shields the soul from what would otherwise be the catastrophic onslaught of God.

If the artist has a duty, it is to instigate a nudity such that the clothes of time and its eloquent pathogens fall off the truth.

If the artist has a duty, with respect to the nudity of the world, it is that even a body is also absolutely a cloth.

Yes, but what becomes of this nudity of the artist among the things it shows, or, what I mean is, then, what is this nudity really made of, if it isn't made of merely factual physical nudity, or of the fact that garments can be worn so as to describe a secret world, even to cause secret worlds to be born, and souls, and not merely to protect the flesh from the onslaught of the world or God, or to protect a soul from infinity.

When my cousin cut bangs into my hair, and I was four, and so was she, and she did it because I asked her to, because I wanted bangs, because she had them, and her hair was black and straight, and my hair was brown and curly, when my cousin cut my bangs, all I had to do was say I wanted bangs, not even

ask her to give me bangs, I said I wanted bangs, and she got the scissors and cut them for me, because I wore an eye patch, is that funny, I think I should try not to be funny, I did wear an eye patch, my glasses were of horn and my left eye was lazy, my cousin cut my bangs because she saw she could give me what I wanted and when she did that she got in trouble with her mom, when my cousin cut my bangs she got in deep trouble cos her mom, my aunt, saw my hair in the trash can and then she saw my face, and then my cousin was in deep trouble, and her mom threw her on the bed and started to spank her hard.

Now, I wanted the bangs and I got the bangs, although they were more becoming on my cousin, who had bangs already, and the straight hair that suits them, and though she was the one getting punished, and I was terrified, I was the one who would endure the shame of bad hair and of desire, with my eye patch and my swayback and the shame of the hair of my desire, I was the one who would begin to learn how to want like a girl and, why not, like a woman too.

As soon as my aunt threw my cousin on the bed and started yelling, I entered the state of

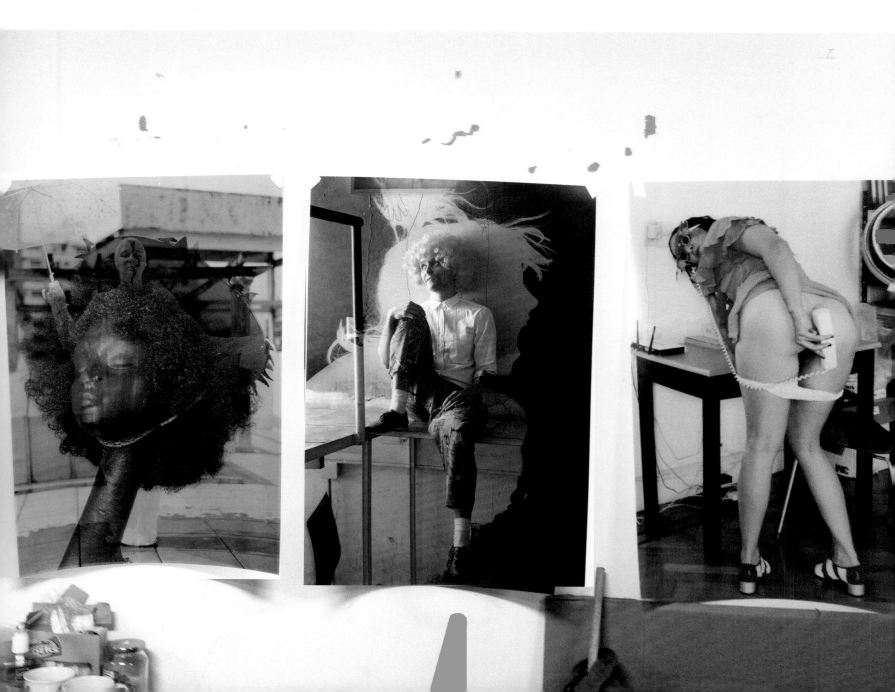

horrified rapture that always became me when I was made the witness or the object of tyranny, even petty tyranny. The way I'd sob in reverence when my dad counted to three and slapped me. The way I sobbed in miserable ecstasy like my total job on this earth was to verify that his BECAUSE I SAID SO was not only the biggest truth but the greatest reason, the only reason worth worshipping in human, my, existence. Violence is power. BECAUSE I SAID SO is the fairly witless way most images get you to look at them, and though it is a truth, it is not the only one, and, most vitally, it is not the most important one.

My aunt didn't seem to notice I was there and my cousin seemed to have forgotten my presence too, dissolving into convulsive peals of laughter as though she was not being slapped but tickled, tickled in some profoundly witty way, as though the core philosophy of her had been rocked into the hilarious outrage of its collapse. The harder my aunt slapped her, the louder my cousin laughed, until my aunt was laughing too, and the two of them expired, totally sated and teary and bliss-blasted on the bed. It was like my cousin, who was four like me, and my aunt, who might have been thirty,

became peers and equals, even lovers almost, because of the truth my cousin deployed when she started laughing, the truth she deployed without even trying.

Maybe only slaves and fucked-over people know what it's like to laugh in the face of someone who by all external obviousnesses not only has the means but the right to subjugate you—and to laugh not just because you want to but because you can't fucking help it.

Before I was four and saw this I did not know that there exists a power beyond power that is in anyone, free of charge, provided she knows how to touch it and how to release it.

This is precisely what K8 Hardy lays bare every time, and though many other true things can be said of what she does, this is the most important truth of them all.

In the iconography of defiance and its passions, there are certain images. The man facing the tank in Red Square, the hippie putting a flower in the barrel of a gun, John and Yoko in bed, the monk on fire, the Egyptian woman kissing the cheek of a soldier still holding out for Mubarak last year in Tahrir Square.

Maybe somebody from before our parents' generation, Hélène Cixous, would say

my cousin's laugh was the laugh of the medusa, and that's K8's laugh is a laugh of the medusa, the laugh of pure power, a child's laughter, a girl's laughter, the true laughter and ultimate power of the genuinely blameless on Earth, of the indestructibility of the truth, the power of the one you are so busy looking at and inventing according to the hilarious codes she has given for you to slalom your way through that by the time it becomes clear that is in fact she whose job it is to look through you and not, asshole, the other way around, that it is her gaze, and not yours so much, that shall cut like a sword, and all of a sudden it's like you can say things like life itself can be the sweetest thing, just passing through you, not even who or what you are or how you came to be here, but what by sheer graciousness and just because you like to fuck with things you allow yourself to appear to be, you will yourself to appear to be, you appear to perform the unmaking of what you would seem to have made of yourself, just so this greater thing, which is not a thing at all, can pass through you, whoever you are, for whose sake, even though she probably also can't help it, K8 is doing this.

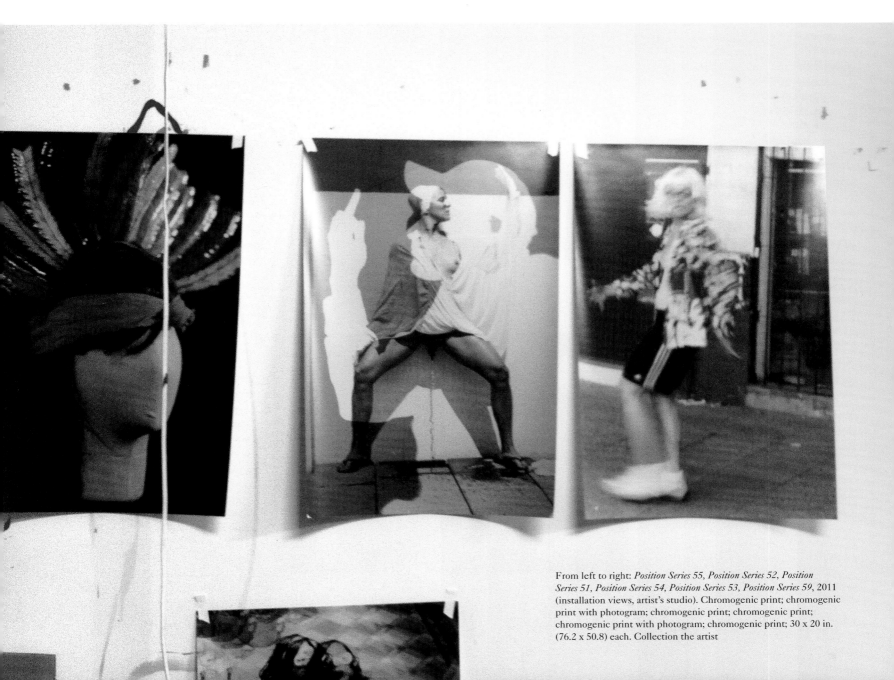

From left to right: *Position Series 55*, *Position Series 52*, *Position Series 51*, *Position Series 54*, *Position Series 53*, *Position Series 59*, 2011 (installation views, artist's studio). Chromogenic print; chromogenic print with photogram; chromogenic print; chromogenic print; chromogenic print with photogram; chromogenic print; 30 x 20 in. (76.2 x 50.8) each. Collection the artist

Ankoku

I.

Given the way that I work, several different and otherwise disparate interests can often—unwittingly—come together. Such is the case recently.

A primary interest, for many years, has been Gustave Moreau's *Salomé Dancing before Herod*. Intrigued by the fact that Cindy Burlingham at the Hammer Museum has been working on an exhibition focusing specifically on Salome and has been given rare access to the Musée Moreau's extensive archives, I've been peeking in on her research, sharing reading material, and picking her brain for months now.

Though I've been fascinated by this painting for some time, I've never been able to quite find a text or context that matched the direction of my fascination. There've been some attempts, particularly in the 1970s, to cast Moreau as a forerunner to abstraction for the simple reason that he would title, frame, and hang on the wall even the roughest of his rough oil sketches. I'm sure it's true. I'm even sure his students Rouault and Matisse would agree but … meh … it seems you discount Moreau's amazing ability to meld looseness with detail and narrative with affect to get at this particular point of view. And besides having to overlook Turner—a decades-earlier example of the "much better unfinished" school—the evidence for this line of appreciation has always been there without dragging out every little half-baked sketch. Most of Moreau's more finished paintings are riddled and coruscated with epiphanic little passages of pure non-descriptive painterly indulgences. The observation, sadly lacking, should perhaps be that this singularly evidential joy of pushing paint around was always available to viewers of Moreau's most publicly well-known pictures; they'd just have to stow their Victorian values and make it through the confrontational and horrific Grand Guignols of Salome and the Hydra to get there.

Also, what does it mean that an artist returns to mytho-religious subject matter when, within the same year, Caillebotte is painting a real-life rainy-day Paris street corner (one that happens to be only about five blocks away from Moreau's studio on rue de La Rochefoucauld)? Is Moreau doing something really heretical and obstinate in contrast—or something begrudgingly and nostalgically conservative? Why couple the lurid and sickly with the erotic when Bouguereau is still towing the academic party line for the plump and the saccharine? Why such an emphasis on sharp distinctive line when Manet is across town painting a portrait of Mallarmé with a few breezy whisks of a brush? Why such overwrought embellishment when Cézanne is already working on reducing even mountains to a few very simple rudimentary forms?

Gustave Moreau (1826–1898), *Salomé Dancing before Herod*, 1876. Oil on canvas, 56 ½ x 41 ¹⁄₁₆ in. (143.5 x 104.3 cm). The Armand Hammer Collection, Hammer Museum, Los Angeles; gift of the Armand Hammer Foundation

Aside from casting Moreau as a proto-abstractionist, the other discourse that currently surrounds Salome is that she is a kind of personification of feminine evil at the advent of the burgeoning nineteenth-century women's rights movement. Which is true, obviously—but only if you believe art is inevitably not much more than a Freudian slip of culture's unconscious. To retrieve such a great painting from the trap of such a narrow (though pointedly well-intentioned) interpretation, one might only have to look as far as the painting's initial exhibition, the other elements within the picture itself, and, specifically, as I've said, the tiny, jewel-like rivulets and globules of paint that make up its surface.

I'm not Bataille. But if I were, I'd want *Visions of Excess (Vol. 2)* to have a chapter addressing answers to the following questions regarding Moreau and Salome: Knowing that the artist exhibited *Salomé Dancing* in the Salon of 1876 alongside two other works—*The Apparition* and *Hercules and the Lernaean Hydra*—does the intentional pairing with mythological subject matter thwart the intention of the original Bible story? (Like, for example, the tone and arcane *poesis* of Oscar Wilde's play on the same topic does; just imagine bringing up either Wilde or Moreau in your Sunday school class on the Gospel of Mark and you might see what I mean.) Don't all three works—*Salomé*, *The Apparition*, and *Hercules* together—throw an understanding of Moreau's work into a less deterministic area where a delight in dark superfluity and the poly-perverse are embraced? And who of the several characters portrayed has access to power and uncompromised agency across the three pictures: weak and incestuous Herod? The controlling Herodias who tries to put an end to the viral pollution of Christianity? Seductress yet mere catalyst Salome? Goddess Diana of Ephesus, whose many nurturing breasts are also severed testicular tributes and who looms matriarchally over the whole scene?[1] The apparitional prophet who carries with him the same nuisance that involuntary memories, zombies, and other forms of resurrection always have in common (they pop up most anywhere and are then doggedly determined to not be sent away)? The most enfeebled and twinkiest of all representations of Hercules's known to the history of art? The smattered mass of skulls and finely executed corpses at his feet? Or the Hydra—cephalic monster who shares a superabundance of organs with Diana as well as the frustrating reanimation capabilities of Iokanaan?

And if I were Kristeva or Melanie Klein, wouldn't I see in all this something deeper and more ghastly than turn-of-the-century gender politics? The rich, stagnant, but fertile preconscious pools of symbiosis and ambivalence for example?

So—sigh—without answers to these questions, I've been making my own Salome paintings.

II.

But I indicated that two separate lines of interest have come together. The other, beside Salome, is *butoh*. Like many Westerners who are at home in the art world but well outside of the dance world, I have, of course, known of *butoh* for some time. But it was only after a number of lunch conversations with a colleague in Tokyo several years ago that I became far more intrigued by the beginnings of *butoh* and by the work of Tatsumi Hijikata (1928–1986) in particular. In the interim, with no particularly pressing deadline, I read everything I could find on Hijikata and *butoh* (though, frankly, in English, the reading list is far from huge). I also managed to meet several scholars and *butoh* dancers as well as see a number contemporary *butoh* workshops, lectures, and performances.

It has since been my conviction (or assumption or, maybe, speculation) that in the road *butoh* has taken and the kind of light, nonprobative nature of much of the dance scholarship I've read, something of Hijikata's original intention has been overlooked or left behind. Or else the

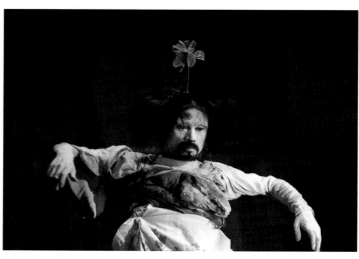

Tatsumi Hijikata performing *Calm House*

RICHARD HAWKINS *was born in 1961 in Mexia, Texas. He lives and works in Los Angeles.*

roots of *butoh* are far too confrontational or taboo to be built into contemporary dance or even investigated publicly.

This omission (if that's what it is—and not just my own oversight) seems coextensive with a change in name. Hijikata's term for his new form of dance (following the original short-lived and more generic term, in English, "Dance Experience") was *Ankoku-Buyou*. The term carried with it allusions to more traditional forms of specifically Japanese dance (*buyou*) but coupled it with *ankoku*, a word meaning "darkness" but infused with all kinds of associations to unseemliness, transgression, creepiness, betrayal, and the erotically thrilling. Though dances choreographed by Hijikata himself continued to indulge in this darker side, the final name change to *butoh* (a word originally intended to indicate Western forms of social dancing—specifically ballroom dancing—rather than performance art or dance for the stage) indicates a reappraisal of the context and intent of *butoh*. The slightly more ironic and somewhat less aggressive and confrontational term seems to indicate that Hijikata made the decision to reposition his investigations away from some of his initial, more odious influences—particularly his self-acknowledged, deep interest in the writings of Artaud, Lautreamont, and Genet.

It goes without saying to anyone who has read anything in English on Hijikata's *butoh* that the names of these French authors are always mentioned but very rarely probed.[2] The emphasis instead is almost always primarily on the more culturally evocative (and, strangely, more exoticistically acceptable) interpretation of *butoh* as a reaction against the wartime destruction of Tokyo and its eventual occupation by Western forces. But for a dancer who patterned one performance after the blunt-force gender-bending of Artaud's *Heliogabalus*, operated for a short time under the stage-name "Tatsumi Genet," and who states in his text "Inner Material/Material" (1960), "I learned everything from the male prostitutes of Kurumazuka," summing up the entirety of Hijikata's practice as residing in the trauma of war and militarized reconstruction seems to merely wrap a nice, pretty bow (a red, white, and blue one at that) around what might otherwise be far too challenging and uncontainable.

The darkness (I wish there were another word—"unspeakableness" or "threatening uncontainableness" might do—but perhaps it's best merely to use Hijikata's word, *ankoku*) is there, of course, in the earliest of the dances. It's also in the many texts that Hijikata is known for. But by now those all seem to have been historically over-encoded with the singularity of war trauma. It was only after stumbling upon images of Hijikata's *butoh-fu* scrapbooks recently that a new, less en-

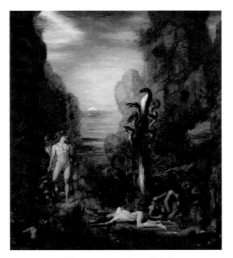

Gustave Moreau, *Hercules and the Lernaean Hydra*, 1875–76. Oil on canvas, 70 9/16 x 60 5/8 in. (179.3 x 154 cm). The Art Institute of Chicago; gift of Mrs. Eugene A. Davidson, 1964.231

trenched road seemed to open up into the *ankoku* aspect of early *butoh*.

Hijikata's *butoh-fu*, though often believed to be sketches for choreographies, are not scores. They are instead an intriguing form of recorded inspiration, a disentangling of figurative abstraction in visual art with a tendency toward the erotic, if not the all-out obscene and grotesque. The scrapbooks contain reproductions from primarily Western art magazines of paintings by, among others, Michaux, Schiele, Klimt, Fautrier, Turner, Dubuffet, Wols, Bacon, and Redon. (It's an odd list—de Kooning seems to be the only American, and Hans Bellmer the only photographer/sculptor.) Each cutout, after being Scotch-taped in, is attended by notations, either in Hijikata's rapid, spidery hand or in the more crisp and resolved handwriting of one of his students (Yukio Waguri, for example) under the master's dictation. The *butoh-fu* scrapbooks are the dark sensibility of the early dances without being either a plan or a documentation.

At the same time that I've been working on my Salome paintings, I've also been treating Hijikata's voice as a poetic guide through a series

of evocative, art-historical images with particular emphasis on the limits of the body. They work themselves out as collages, and some are direct translations of specific *butoh-fu* pages, particularly the scrapbooks housed in the Hijikata archive at Keio University: "Shinkei" and "Nadare-Ame." Others are merely patterned after these and contain texts that are either adapted from Hijikata's original literary sources or are complete fabrications of my own—in the dark, erotic spirit, hopefully, of early *Ankoku-Butoh*.[3]

III.

The two infatuations are not so dissimilar I suppose. Both Hijikata and Moreau were concerned with portrayed gesture, often with morbidly erotic overtones. But the two seemed to indelibly bind themselves together—for me, at least—when I ran across a *butoh-fu* specifically on Moreau's *Apparition*. It was apparently taken down by Waguri under dictation from Hijikata himself. If I'm translating correctly, it goes something like this:

"'King Solomon's (Herod's) Palace.' Cascading curtains of pus have fallen. A stale, rank stench abounds. A dance of destruction with a vicious, brutal ending, the abolition of gesture. Skin adhered and fused to skin, leprosy, malaria, decay of the flesh. Cerebral syphilis. Putrefying architecture, inflamed. Multicolored scabs crack off intermittently and dwindle to the ground. A slow rain of fleshly, rotting jewels. Columns and ornaments made entirely of scabrous verdigris. Mirrors inside the palace corrode and ebb away. Greasy pus on the mirrors, pus on the ceiling, the walls, the floor. The pus is there for the king of leprosy to feed, greedily. A sick, tumescent whale lumbers by, spewing out looping ropes and threads of rancid oily cum. A viscous canal of grayish-yellow, reeking pus."

— Richard Hawkins, August 2011

NOTES
1. Unused by most of these feminist fatale critics I mentioned, by the way, is the presence of Diana of Ephesus herself in *Salomé Dancing*. There's no verifiably scriptural reason why she's there other than that Moreau sets the scene in appropriately Roman times. If it's castration anxiety one's looking for, it's there already—in buckets—without even having to trudge through the metaphor of a beheading. (Except, of course, if you're pagan, and you see Diana's castration cult as evidence of the ecstatic limits of eroticized bodies doing double service as both polytheistic worship and surplus pleasure.) 2. Stephen Barber's book on the connections between Artaud and Hijikata, *Hijikata: Revolt of the Body* (2006), being an exemplary exception. 3. I'd have to admit, as well, that imagining Hijikata reading *Our Lady of the Flowers*, Genet's "epic of masturbation," has created its own kind of surplus pleasure. If there's something hidden behind and fueling these collages, it's an image of yet another of my infatuations, Japanese film actor Tadanobu Asano, cast in the role of Hijikata, stumbling around the seedy corners of Ueno station, pretending they're the whorehouses and pickup spots of Montmarte and playing pocket pool with a dirty little tube of Vaseline.

Tatsumi Hijikata, *Butoh-fu* for "Nadare-Ame"

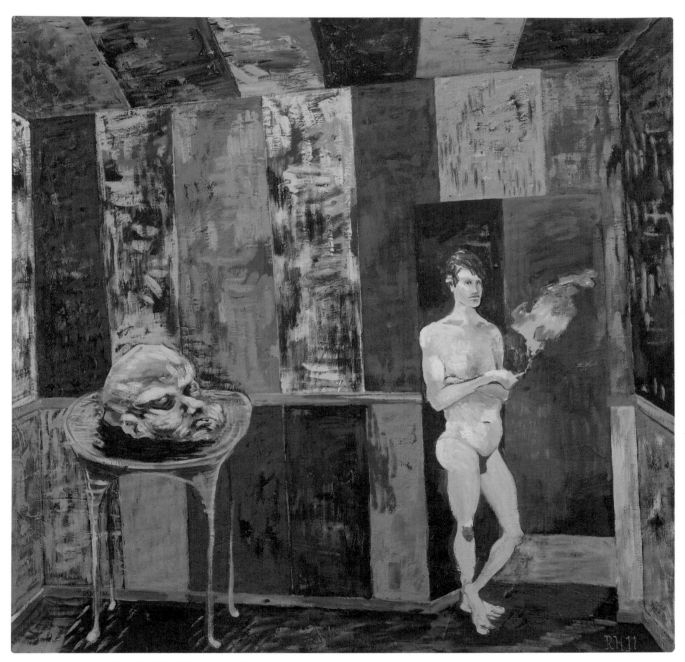

Salome Painting: Head of the table, 2011. Oil on canvas, 30 x 30 in. (76 x 76 cm). Private collection; courtesy Galerie Buchholz, Berlin

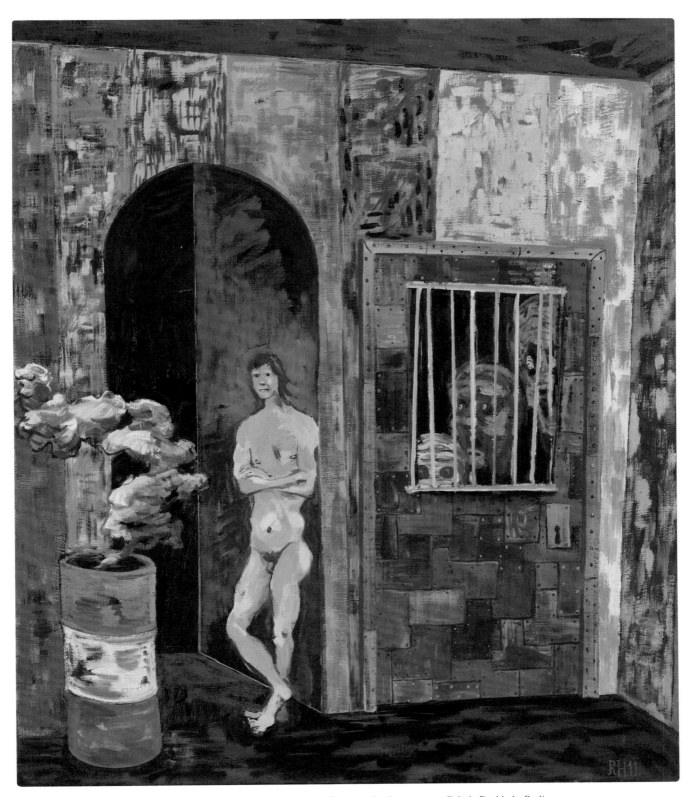

Salome Painting: Locked up, 2011. Oil on canvas, 30 x 25 in. (76 x 63.5 cm). Private collection; courtesy Galerie Buchholz, Berlin

DANAE'S BUTT GOLD, THE GLITTERING, SHIMMERING AND CAS- CADING GIFT OF ZEUS'S INFILTRATION/INSEM INATION, LIKE A PLAGUE OF SO MANY SKITTERING, SWARMING, CRAWLING METALLIC INSECTS. A RESOLUTE SPLAYING FAN PESTILENCE OF EGYPTIAN OF A PEA SCARABS IN BLUE AND COCK'S TAIL. GOLD, CONSUMED AND VANQ- UISHED AND THEN JUST AS EASILY REJECTED. REGURGIT- ATED AND SPAT OUT IN THE HANDSOME

Gustav Klimt
Danae, 1907/08
Oil on canvas, 77 x 83cm
Private collection

re: Dubuffet

34 „In each a vast gelatinous mass of misshapen femininity is spread across the center of the canvas ... these paintings suggest a one-sided encounter between a steamroller and the fat lady of the circus. There is nothing human about these women; they are like monstrous pink flowers crushed between the pages of a book, or strange sex-machines shown in the process of becoming assimilated to the earth, the world of vegetables and minerals." Fitzsimmons, James in: *Arts and Architecture*, Mai 1954, S. 4.

Tafel 7
Jean Dubuffet: *Concentration fluidique* – Zinkweiß, Leim, Terpentin, Sand, Öl au...

CASCADING CURT- AINS OF PUS HAVE FALLEN. A STALE RANK STENCH ABOUNDS. A DANCE OF DESTR- UCTION WITH A VICIOUS BRUTAL ENDING. THE ABO- LITION OF GES- TURE. SKIN AD- HERED AND FUSED TO SKIN, LEROS LE- PROSY, MALARIA, DECAY OF THE FLESH. CEREBRAL SYPHILIS. PUTREFYING ARCH- ITECTURE, INFLAM- ED.

Ankoku collage (in progress), 2011. Collage, 8 ½ x 11 in. (22 x 28 cm) or 11 x 14 in. (30 x 36 cm) each. Collection of the artist

Hearsay of the Soul

Hercules Segers (1589/90–c. 1633–38), *Mountain Gorge Bordered by a Road*, c. 1615–30. Contre-épreuve of etching, with oil paint, 6 x 6 ⁵⁄₁₆ in. (15.4 x 16 cm). Collection Rijksmuseum, Amsterdam; on loan from the Rijksacademie van Beeldende Kunsten

WERNER HERZOG *was born in 1942 in Munich. He lives and works in Los Angeles.*

1.

Sometimes great visionaries appear who seem to anticipate the course of our culture, like the pharaoh Akhenaten, who, in addition to creating a new style of art in ancient Egypt, was more than a thousand years ahead of his time as one of the first monotheist, or like Carlo Gesualdo, prince of Venosa, who, four hundred years ago in his Sixth Book of Madrigals, created music that leads straight to the twentieth century. Only from Stravinsky on have we heard music like his, and it is not a coincidence that Stravinsky made two pilgrimages to Gesualdo's castle near Naples and wrote an orchestra piece with the title *Monumentum pro Gesualdo*. This list is extendable: Hölderlin, who as a poet went to the outer limits of human language, or Turner, predecessor of the Impressionists.

2.

And now, it is time that we make a pilgrimage to the work of Hercules Segers, the father of modernity in art. He lived and worked at about the time of Gesualdo; he was born probably in 1589 or 1590 and died sometime shortly after 1630. Hardly anything is known about his life, and very few works of his have survived.

3.

It is shocking for me, and unacceptable, that I have not met a single art student in my life who has even heard of Segers, and it is deeply disquieting that I have not encountered a single curator in any museum of modern art who has had a clue. However, my contacts have been very scarce. Segers was not well known to his contemporaries either. His name can be found in documents of the seventeenth century spelled as "Seghers," but he himself signed his work "Segers." Born to Pieter Seghers and Cathalina Hercules, Mennonites from Flanders, he signed into the painters' guild of Haarlem in 1612 under his first names (Hercules Pietersz), without surname, and in 1615 married Anneken van der Brugghen. He soon ran into serious financial difficulties, which

eventually forced him to sell his home in Amsterdam. Poverty and ill fortune accompanied him until the end of his days. Samuel van Hoogstraten, a pupil of Rembrandt, laments that there was no market for Segers prints, although they were (he says it beautifully) "pregnant of whole provinces." According to van Hoogstraten, much of Segers printed work was used as wastepaper, probably to wrap fish or sandwiches.

4.

Images can be like windows that have been pushed open for us into a world of the unearthly, the sheer imagination, as if aliens had come upon us in the form of a strange visitation, yet at the same time we recognize the visions as something not foreign but belonging to us (we, born hundreds of years later), as if those visions had been dormant deeply within us. A genius like Hercules Segers makes us acquainted with images, as if we had suddenly been made known to a brother who had always been with us but whom we had not known before. His work creates an illumination inside of us, and we instantly know that this is not a factual truth but an ecstatic one. Most of his prints are not real landscapes. We can almost be certain that Segers has never seen a mountain or a rock formation in his life.

5.

His images are hearsay of the soul. They are like flashlights held in our uncertain hands, a frightened light that opens breaches into the recesses of a place that seems somewhat known to us: our selves. We morph with these images. Caspar David Friedrich recognized this for himself: "I have to render myself to what surrounds me," he said. "I have to morph into a union with the clouds and the rocks, in order to be what I am."

6.

Less than a dozen oil paintings of Segers have come down to us, and only four of them can be attributed to him with certainty. Rembrandt, one of the very

few contemporaries to recognize his genius, owned at least eight Segers paintings, including *Mountain Landscape* (c. 1620–25), which is in the Uffizi today. In all probability, Rembrandt repainted it in part, "improved" it, by adding a cart and oxen in the foreground and clouds in the sky. But Segers's oil paintings seem to be within the idiom of the time. What sets him apart from his epoch are his experimental prints.

7.

Of his etchings and prints, mostly in small formats, only some 180 survive, and even those that show the same motif exhibit a strongly divergent variety of colors and printing techniques. Not all of his technical procedures are fully deciphered yet. Segers frequently painted over his prints with a brush, tainted his papers with aquarelle colors, and experimented with light and effects of color. Some of his pictures are printed on linen, and Segers was so impoverished that he is rumored to have used his tablecloth and bed sheets as materials. In at least one of his landscape prints, ropes and parts of sails suddenly appear; it seems that in his poverty, he used plates that had been used previously for a picture of a sailing boat. He probably drifted into alcoholism, and was considered some sort of madman. He suffered from bouts of deep depression, and around 1635 (?), he allegedly fell drunk down his staircase and died instantly.

8.

Personally, I owe Hercules Segers a lot. An installation of projections of some of his prints, together with music by Ernst Reijseger (another rare visionary), cannot replace the task of seeing and studying the prints themselves. In projected enlargements, the etchings seem to acquire yet another quality that I cannot describe in words, but I have a suspicion that a distant echo seems to resonate in a few moments of my own work. Hercules Segers's images and my films do not speak to each other, but for a brief moment, I hope, they might dance with each other.

139

Still from *Words of Mercury*, 2011. 16mm film, color, silent; 25 min.

JEROME HILER *was born in in 1943 in Jamaica, New York. He lives and works in San Francisco.*

Still from *Words of Mercury*, 2011. 16mm film, color, silent; 25 min.

Still from *Words of Mercury*, 2011. 16mm film, color, silent; 25 min.

Still from *Words of Mercury*, 2011. 16mm film, color, silent; 25 min.

Much as I appreciate all the technical developments that have taken place since I bought my 16mm Bolex in 1964, I have become attached to the instrument as if it were one of my own limbs.

The camera has tamed my movements and sets the beat of the dance. I move the way the camera sees. Between the lens and my eye, the dark unreeling of the film converts light into swirling emulsion. When I receive the developed film from the lab, I edit the positive original as is. I add fades by slowly dipping the end of a shot into a black liquid. I use my fingers to "squeegee" the fades. There is a great pleasure in feeling the place of bones, limbs, body, and mind all mixed into a love affair with a hand-cranked machine.

Still from *Words of Mercury*, 2011. 16mm film, color, silent; 25 min.

Hornet's Nest

NELLIE BRIDGE

In Matt Hoyt's constructions, the combination of the natural and the intentional creates a tension, like a hornet's nest, or something else that vibrates even when it is still. In the way that a room that someone has just left may harbor a bit of that person's energy until it fades, Matt's objects give off energy, but the energies don't fade.

The way my daughter, Greta, arranges objects often reminds me of Matt's work. She recently turned three, and she's been making elaborate arrangements of objects since she could—the past two years. I'll come into the living room after doing dishes for a few minutes and catch my breath at some not-moving life form that wasn't there before. It's a simple arrangement—plastic green plates arranged in a spiral or pick-up sticks painstakingly pressed into the carpet to rise at odd angles—but there's something loaded with energy about the display. It's not the arrangement's complexity, but its naturally unfolding delivery mixed with its extreme intentionality that makes a sudden impression. Again, like noticing a hornet's nest when looking closely at a tree—the feeling something built and charged is present almost before you see it.

Unlike Greta, Matt makes the objects in his arrangements, and he makes them over time, and they are sophisticated: in their physical craft, effects, and in some cases, the careful preservation of a plain, open, unaffected form. Each one is its own being and means something alone, although it also contributes to the effect of the larger arrangements.

Some artists try to approximate a believable imperfection found in nature; to get close enough to chaos to cancel out the human hands behind it. But Matt isn't hiding his hands in his work, and I think Greta would enjoy arranging the stars in lines, if she could.

Matt's hands and decisions are present: neither hiding nor flaunted. And somehow, it doesn't get too heavy with that weight. A rawness is there. His pieces are unto themselves, but not pretending they came out of nowhere.

Greta's shifting decisions about object placement often add up to an effect that Matt's work has sometimes. It's something about aggregation and the subtle larger curve that comes out of hands adding one more thing, and one more thing. It's deliberate without being worried, with an easiness to the shaping even though the end result is so charged. The pieces are grown only from inside them. No one told them to do this.

MATT HOYT *was born in 1975 in Mount Kisco, New York. He lives and works in Yorktown Heights, New York.*

Component Objects, 2010–11. Mixed media, dimensions variable. Collection of the artist

Quarantine

DAVE MIKO

In Highbridge Park twelve years ago, due to the twists in the eroding staircases and paths and all the obstructions caused by stripped cars, overgrowth, fallen trees, shady lurkers, as well as the way the bridges, arches, retaining walls, overpasses, underpasses, and fences all tangled together, every view and moment seemed isolated from the previous and from the city itself, like a knot of imperfect dead-end alleys where you keep squeezing through breaks in the architecture and wondering about the strangeness of the previous space while futilely attempting to form a map of the connections.

Ground samples might yield a flattened paint bucket, empty drug bags old and new, acorns, sand, soil, a handful of matted leaves, a pair of torn underwear, chips of glass, a used condom, plastic nozzles, dried worms, various feces, a broken syringe, a McDonald's wrapper, an air freshener in the shape of a pine tree, bits of wire, a rusted bolt, dandelions, muddy ice, fragments of concrete, a coiled diaper, and dried sticks. Trying to get to the enormous archway in the center of the long, thin park proves impossible due to a series of menacing lookouts posted on every tier heading south. It remains unknown what exactly they are protecting.

Sitting on an enameled curb, dropping pebbles into the small, plastic-coated, folded paperboard Chinese food container that you've just finished eating broccoli out of, you notice the slightly greasy, bright white trap becomes a quarantine in which the individual characteristics of each gathered pebble are ridiculously heightened.

Perhaps instead of eating the broccoli next time, you decide to chew it up, spit it out into the Styrofoam tray—careful to spread it over the tray's entire surface. Then you place the whole thing in a toaster oven for two minutes, remove the melted mass, and roll out a bunch of pebble-like forms, which you tint with food coloring.

❋ ❋ ❋

Matt's work at first appears concrete, but because its construction is slow, consisting of accumulations, treatments, reductions, and divisions, which can last for years on a single small object, and which might continue indefinitely, it is essentially ephemeral. When the form of the object in process stabilizes, it can seem to further shift its roles and associations within the groups it becomes a part of, which can also continue to change day after day, in minute ways, as Matt makes further additions or subtractions. After leaving him initially, a single object might find its way into various different pieces in various exhibitions, the way a person

is sometimes in a doctor's office and other times on a bus, etc. So it seems that the natural state of the work is a flux or perpetual reworking that could continue even after one element has flown the coop but somehow found its way back. Trying to find a way to display these objects in a museum or art gallery can present an obstacle to really understanding them. They happen to go directly against the culture and architecture of the contemporary art institution in that, due to the way that their complex subtlety mixes with their minute scale and fragility, one must either hold the piece or be allowed a much closer viewing proximity than normal art security parameters would allow. So in order to inhabit these exhibition spaces, the work is placed on shelves or encased in plexiglass. This condition of viewing the work as a model or diorama of its self leaves us to contemplate it within the language of its display, as beautiful (too beautiful), and as "sculpture" even, a classification that seems misplaced, not crucial enough to describe them accurately.

Making things that need a closer observation than an art exhibition can possibly afford has the collateral effect of pressuring the exhibition context. This, I believe, is discernible on first sight and is a big part of the work's power. Matt's objects, once examined, maintain a traceable history of their creation. As complex physical objects of varied material ingredients, the forensics exists to reveal the history of their material abuses and manipulations. Because we have access to this historical information and because they, as objects, in addition to the information, will go forward in time, they will keep confounding the people they come in contact with—some of whom may not, in the possibilities of a distant future, know the context of art. All of this only comes up peripherally though, as the work has its own life, within its own language, and it will, as a physical thing, outlive art and its shifting currency. Thus far, the component objects have been geographically divided, finding their way to artists', curators', and art collectors' homes and holdings. Those pieces are, for now, finite, but perhaps may come back together in unforeseen combinations in a future and context we cannot imagine.

＊　＊　＊

Maybe a snail found its way into the shower room of the public pool and a slug to the middle-school boys' locker room.

When your eyes close you can see symmetrical forms that seem large in meaning and are beautiful.

There was or is somewhere a modeled, slightly spooky address placard with the number of his parents' house. There are, hanging in the parents' house, some Japanese characters that a friend of the family much later translated as, "May you get a government job."

A woman picks up some shells, twigs, and dried seaweed at the beach, goes home and spends the day carefully gluing them to sewing thread in a way in which they can all balance as a simple mobile. The next day she carefully wraps them up and puts them in a priority-mail cardboard box and sends them to her daughter who lives in a large city across the country. The daughter hangs them in her bathroom high above the toilet using a pushpin pressed into the rough spackled ceiling.

This Could Be Something if I Let It

I propose a mash-up of three ongoing projects: *Clues to the Meaning of Life*; *Visual Poems: Studies in Time and Space, or The On Series*; and *On the Exposure of Process: A Nomadic Studio Practice Experiment*—developing over various timelines running concurrently, each with an individualized process, some more realized than the others. *Clues to the Meaning of Life* (2007–) started in a West Hollywood porn bookstore with the idea to prove a theoretical equation. This equation was created to illustrate that everything has been done before, that we are simply byproducts of history, re-created over and over again. The intent was simple: if a birth date is plugged in (any birth date would work), you would see all of your interests come up—kind of like the death clock predicting your untimely end (www.deathclock.com). I only had an hour for my presentation and forgot my point. *Visual Poems: Studies in Time and Space, or The On Series* (2008–) is a series that represents varying fragmented experiences poetically illustrating causality. *On the Exposure of Process: A Nomadic Studio Practice Experiment* (2008–) started when I lost my job working as an artist's assistant and I had to give up my studio. I have been without a studio since and making work whenever and wherever I can. When I am invited to perform, I use the space as a studio, making new work, having studio visits, and playing music. I make it a point to create something from nothing and to maximize the time there as studio practice. My time in process is very much an important part of my performance work, as is revealing that process publicly.

I begin my process for creating performance work much like writing a middle-school science paper. I start by brainstorming ideas in order to create a hypothesis or a series of theories and/or concepts. This brainstorming process is realized through collage and drawing. I then conduct experiments, or "actions," to prove or disprove my theories and/or concepts. Usually during this process I get lost and confused. I have too many ideas going at once; I forget ideas or the point I'm trying to make, lose my train of thought; I become emotional and get nervous.

This middle-school-science-paper process is used as a template to get to the root of what's really happening, what's developing underneath the surface of things, a base-level steadfast approach that guides me safely through the descent into the void. I become a cipher, a channel. Failure is inevitable but also somehow impossible because there is no right or wrong present in that moment. I have to make mistakes in order to fix them, destroy to rebuild, and then make a new experience out of the fragments. Re-created, over and over again.

I perform in a calculated yet spontaneous manner, using props to punctuate my actions. The culmination of these actions will find my various changing personas physically building a living sculpture that marks my study into being, illustrating my findings and resulting in a sculptural installation, activated by performative action.

I find fleeting cognitive and emotional understanding through a ritualized formulaic process, a process articulated by a series of charged, raw actions. These raw actions can happen very quickly but may take a long time to realize. This process of realization, plus raw action, becomes the performance. The viewer may only witness a fraction of a realized concept, like the internet where only a few hours a day are experienced, yet there is so much happening beneath the surface we don't see. We don't see the electricity we use, but we know it exists. Cause and effect…we have the power to change our own perspectives if we choose to do so.

—Dawn Kasper

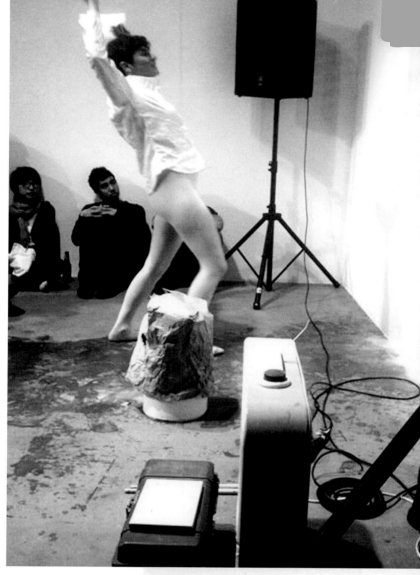

on drawing, 2010. Performance, Human Resources, Los Angeles, 2010

The Pond, 2003. Performance, Fritz Haeg Sundown Salon, Los Angeles, 2003

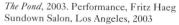

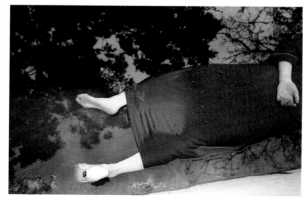

Missing Kaspar Hauser, 2005. Performance in conjunction with "Lange Nacht der Museen," Migros Museum für Gegenwartskunst, Zurich, 2005

DAWN KASPER *was born in 1977 in Fairfax, Virginia. She lives and works in Los Angeles.*

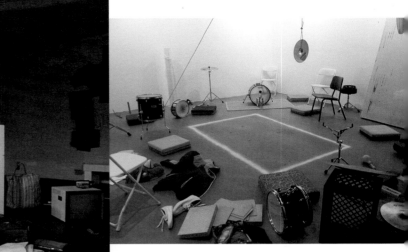

18 Possible Incidences In 18 Parts, 2011.
Performance, Los Angeles Contemporary
Exhibitions (LACE), 2011

on existence: a visual poem, a study in being—
Sea and Space, 2010. Performance, Sea and
Space Explorations, Los Angeles, 2010

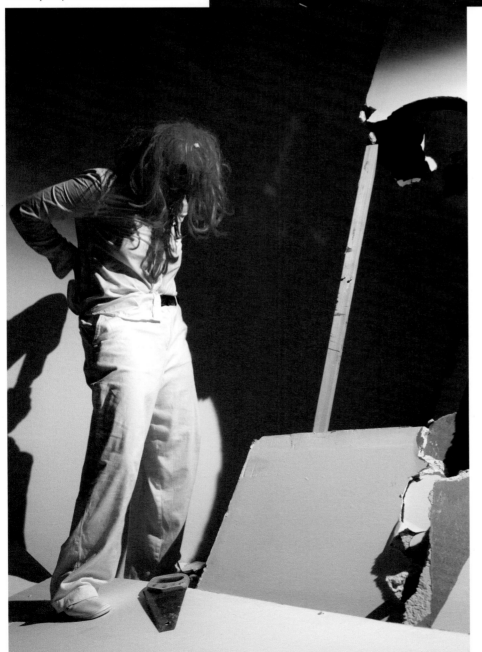

on existence: a visual poem, a study in being—
LACE, 2010. Performance, Los Angeles
Contemporary Exhibitions (LACE), 2010

Firstly, Eric and Kathleen and Devin and Giles and (((Dawn))), and then Ariel and Jason and Geneva and Giles and Simon and Daniela, et al.

ANDREW BERARDINI

Maybe I heard about it first from François, who knew Eric, and Eric knew Kathleen, of course (his sister), and Devin and Giles and Dawn. I knew Dawn from John, I think, from when she did this or that at Circus Gallery, her debut after grad school, after a few years of thinking things over and being influenced and uninfluenced by her teachers, who were all dark and strange and generous and pendulous with fame, the kind of fame where you can get so enrapt in all the things that they could make that it makes you shy of making for yourself. But for Dawn, of course, there was this need to make, a need to move like loose, slithery power lines flickering across a highway. And so she did, and often, with others.

François (who had this space in Chinatown, spitting distance

from downtown L.A.) and Eric talked about doing something at the vacancy next door (another gallery had shuttered and gone west), but it had histories and neighbors worth neighboring, and there was always something strange and great about Chinatown. They wanted to start a performance space, Human Resources, run by volunteering artists, the mandorla in the Venn diagram where "performers" could join up with "artists."

Dawn was more or less the "artist" among the "performers." Impresarios and musicians are artists of a kind, of course, but what made the joint venture at Human Resources special was that the performers were performers who cared about art, who wanted visual artists to be a part of it, not just musicians, and Dawn, this artist, was the perfect collaborator. The definitions are tangled and sticky, but truly, Dawn is an "artist" and, not unrightly, a "performance artist." And it is also true that some of her influences and some of mine and some of a whole generation of wayward kids looking for community come from the performances of punk and riot grrl and indie rock and whatever other label someone else needs in order to define spirited youngsters with varying grasps on how to actually play their instruments and a fierce love to make, if not music, at least noise, with friends.

What adulthood generally lacks is the exuberant bravery and urgent bravado of youth that does not know better. Dawn maintains that bravery and bravado. Even perhaps knowing better, she is still happily unfettered by the audacity of her actions. Some sense of what community is can be drawn from all that.

And Dawn continues ever onward, ever the maker and collaborator, a fulcrum for friends, demonstrating how doing things together can be so much larger and more enduring than doing them alone. There was, of course, the multipurpose art and performance space with Eric and Kathleen and Devin and Giles, but Dawn also gathered forces for other projects and was a force to be gathered for others' projects. Dawn alone perhaps as an artist; Dawn Kasper at the top of the press release—but she had become the unlikely conductor, a Cagean composer in this one performance she did in a cavernous space, some gallery out in Culver City, filled with this and that garbage and junk and debris and tools and furniture. Dawn picked things up and moved them around the hoard, and the musicians (many different ones drawn from many different friends over the many hours—Ariel and Jason and Geneva and Giles and Simon and Daniela and so many others) gathered on the edges of the heap to make music from her movements, her object-handlings, her stacking and shifting and restacking of junk as it towered up toward the high ceiling and its shivering track lights. Everyone watched, trying to make sense of this *Music for Hoarders*, orchestrated by the meandering movements of Dawn. Is a hoard a keeping of things for yourself or a keeping of them from others? Is sharing the hoard and making music with friends and accomplices from its rubbings and jumpings, handlings and shakings to dehoard the hoard? To give it all away, to sort through the materials of making and the mess that is perhaps inside all of us, but also maybe to try and shift an order (drawn from within) with panache and music, is maybe what it means to make art. All of us the hoarders and sorters and makers of things, forever moving and shifting, forever attempting to give of ourselves. We are trying with each action, all together now, to make music, to make meaning, to make art, out of all those sometimes bereft materials and unlikely friends haphazardly strewn around us.

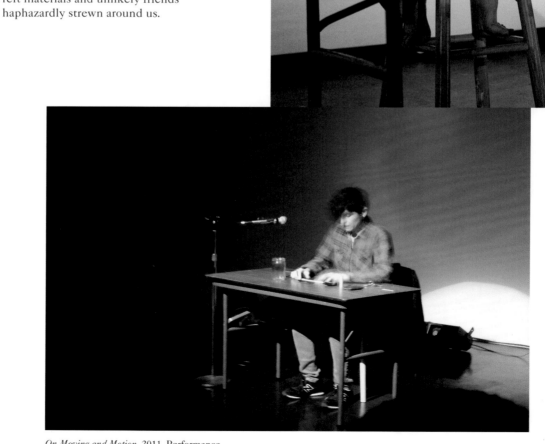

I Will Always Love You … (for CF) 2009. Performance, 533 Gallery, Los Angeles, 2009

On Moving and Motion, 2011. Performance, Highways Performance Space, Los Angeles, 2011

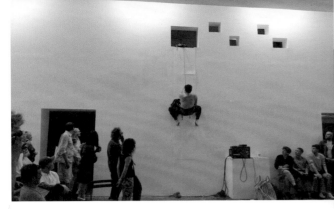

This Is How I Fuck My Environment, 2011. Performance, QUEERING SEX, curated by Kathryn Garcia and Sarvia Jasso, Human Resources, Los Angeles, 2011

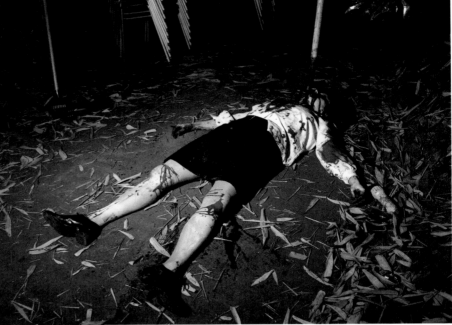

Murder At The Schindler House, 2003. Performance, Fritz Haeg Sundown Salon, MAK Center, Schindler House, Los Angeles, 2003

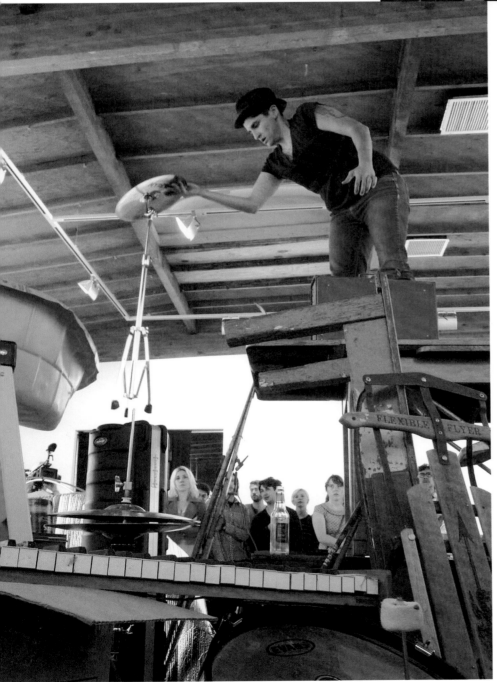

Music for Hoarders, 2010. Performance, Honor Fraser Gallery, Los Angeles, 2010

Stand-Up Comedy: G through K

SARAH LEHRER-GRAIWER

GALIFIANAKIS, ZACH

After his stand-up, watch Zach Galifianakis's brilliant and brilliantly retarded talk show, *Between Two Ferns*, and think about the comic potential of the studio visit as a celebrity talk-show situation. Less stand-up than his real stand-up (which is full of sparkling one-liners, absurdly banal impressions, and jaunts to the piano), the talk show (not his first) involves another person, a replaceable straight man (Bradley Cooper, Jon Hamm, Jennifer Aniston, Michael Cera, Jimmy Kimmel, etc.), but at its core, it is the same kind of virtuosic one-man shit-show we just cannot get enough of. Between Galifianakis and his guest is a coffee table, usually with an oversized red buzzer on it, and on either side two stupid fake ferns frame the whole deliberately shitty, daytime public-access affair. Public access is funny. Galifianakis has all the wrong kinds of questions for his guests, which makes one wonder what makes the right kinds of questions right. He asks Bruce Willis if he ever worried that *The Whole Ten Yards* was going to be *too* good. Bitterness seeps through like the return of the repressed. There

is a willful wrongness, a revelatory dumbness, a thoughtful relishing of the finer shades of idiocy and absurdity in the psychology of everyday language.

GRAY, SPALDING

Spalding Gray's autobiographical monologues are epic, breathless recountings and sputtering rants. He sits at a table, leaning forward with a worn spiral notebook full of notes in his hands and a glass of water within reach (see Kasper's *On Moving and Motion*, 2011). Spuddy speaks directly to us; there is eye contact—gripping intimacy. In *Swimming to Cambodia*, a poster map hanging behind him signals the persistent possibility that this is a classroom scenario and we are the student body at a lecture on the narrativizing principle of consciousness. Instead of the contrived fictional dramatizations of theater from whence he was trained and came, Gray catharts self-analysis, self-absorption, confession, and ecstatic autobiography. A master storyteller, he condenses the drama of theater down to its concentrated essence of man monologuing himself, enacting humanity by amplifying his own particularities. He tested out the dark waters of confessional stand-up with trauma, neurosis, and just enough of the funny stuff to make the medicine go down. It was some downer of a stand-up routine.

Chronically gripped by hereditary depression, and having tried several previous suicide attempts, Gray took his life in 2004 at the age of sixty-two.

KAUFMAN, ANDY

Andy Kaufman, a devoted practitioner of transcendental meditation, asked the maharishi what the secret of comedy was. Silence, was the wise man's reply, and that told Kaufman everything he needed to know. He figured out how to perfectly detonate the nuclear thrill of brimming mutual awkwardness, discomfort, and upended expectation. He knew how to hold it, how to wait for it, how to wield maximum control over an audience with a minimum of gesture (see, as well, Dawn Kasper's *On Believing, or I Am Andy, You Are Andy and We All Have the Same Birthday, January 17th*, 2011). Kaufman dealt in baffled suspense, restraint, climax, release, and breathtaking flashes of transcendence at the Improvisation or on David Letterman's talk show. He wrestled women,

cocksure and crowing each time he won. As Tony Clifton, he put on a ruffled pink tux, moustache, sideburns, and sunglasses and ripped into the audience with belligerent slurs between aggressively off-key Vegas lounge numbers. His Elvis impersonation was the singer's favorite. When he incessantly chanted "I trusted you" over and over like some vengeful mantra, it crescendoed into a full-on screaming freak-out of existential rock proportions. And when he cried, defeated, into his congas, and his sobbing seamlessly morphed into rhythmic incantations, I thought to myself nothing could be better than this. Performing, in character, required his total commitment to the point of self-negation. He knew, in a profound sense, that failure and bombing are really, deeply, tragically funny. Jokes that aren't funny is funny. A bad comedian is funny as well, and maybe more so (just in a different way) than a good one. Genius that he was, Kaufman stepped back and went meta on the then still-nascent genre of stand-up. He was riddling and stretching the form even as he was inventing it.

KASPER, DAWN

Because of circum- and other kinds of identity-defining stance (artistic, ethical, biological), the artist really must insist on her presence. Kasper's approach to performance, dealing with visceral physicality and the (in)articulateness of direct address, is shot through with a certain aggression, which may also be frustration and most definitely is a deep emotional urgency. Overstated and performed presence compensates for an obsession with absence, or degrees of not-being (see Kasper's early *Evil Series*, 2001, and *Death Scenes*, 2007). So, she's emphatically here for the time being and the duration of the Biennial, using the public space of the museum as her studio because, for starters, she doesn't have anywhere else to go, and, put another way, she's been experimenting heavily with nomadism as of late. This makes the artist especially available, which is important because she wants to be able to look and to be looked at, flesh-to-flesh, eye-to-eye: direct address and intersubjective transmission are paramount (see her ongoing lecture-like performances from *Clues to the Meaning of Life*, 2007– , to her ongoing *Visual Poems: Studies in Time and Space, or The On Series*,

2008–). She's been known to bang on things in a manner just barely (if at all) musical. Sometimes the adrenalin is too much with all this eye-to-eye business, and she puts a paper bag over her head. Quite naked, she covers herself in glue. She plays dead.

You know, it wasn't until recovering from a near-death car accident that Garry Shandling found the nerve to do stand-up. And Dawn Kasper knows a thing or two about the catalytic potential of car accidents as galvanic performance (see *Repeater or Inertia and Anger*, 2009). That's how scary all this (living, art, standing up, performance, presence) can be—as scary as nearly dying or having nothing left to lose. Proper stand-up must act as though there were nothing left to lose, which makes me suspect that some art, like this art, may make for even better stand-up.

you, me, them, 2011. Performance, Los Angeles Contemporary Exhibitions (LACE), 2011

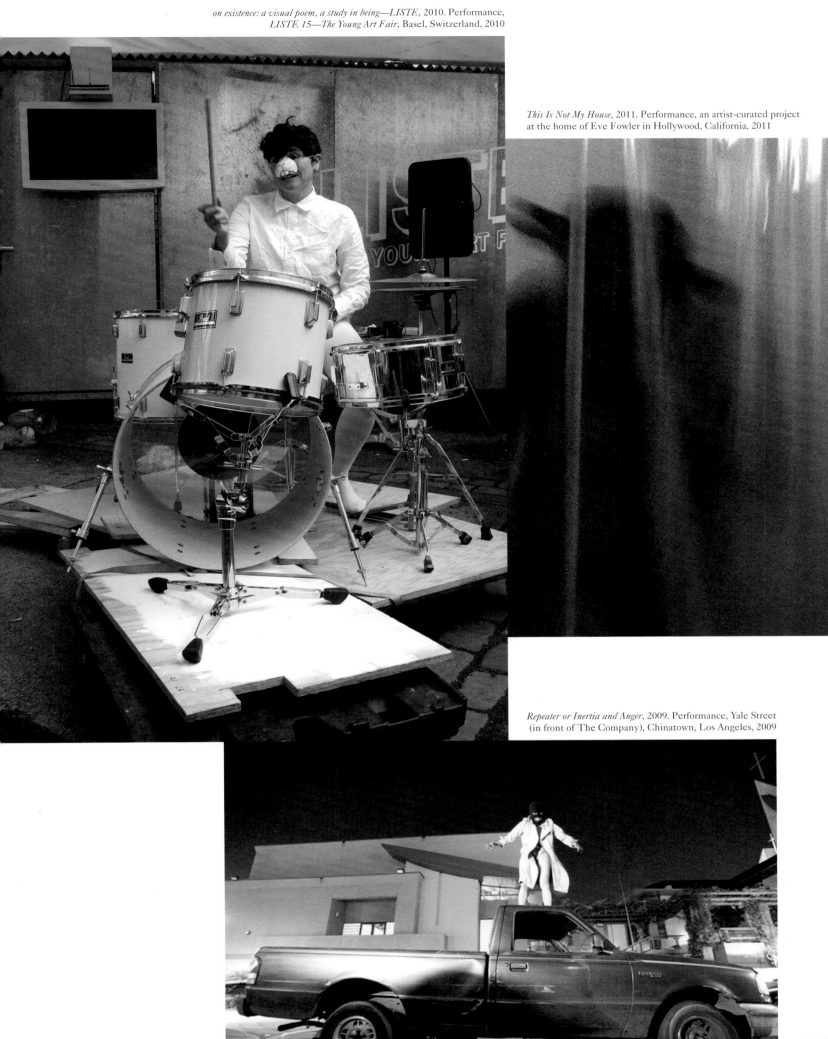

on existence: a visual poem, a study in being—LISTE, 2010. Performance, *LISTE 15—The Young Art Fair*, Basel, Switzerland, 2010

This Is Not My House, 2011. Performance, an artist-curated project at the home of Eve Fowler in Hollywood, California, 2011

Repeater or Inertia and Anger, 2009. Performance, Yale Street (in front of The Company), Chinatown, Los Angeles, 2009

157

Former Kelley Residence, Westland, Michigan, from the Mike Kelley series *Photo Show Portrays the Familiar*, 2001

Digital renderings of Mike Kelley's proposed *Mobile Homestead* project at the Museum of Contemporary Art, Detroit, Michigan, 2007: The reconstructed Kelley home on the MOCAD site in downtown Detroit; the *Mobile Homestead* being towed from the "Community Gallery" section of the project in order to perform community outreach

MIKE KELLEY *was born in 1954 in Detroit. He lives and works in Los Angeles.*

Digital rendering of Mike Kelley's proposed *Mobile Homestead* project at the Museum of Contemporary Art, Detroit, Michigan, including underground sections

Mobile Homestead

Mobile Homestead is a public sculpture conceived specifically for the Detroit area. The work was commissioned by Artangel, a London-based arts funding organization that specializes in site-specific works. Spearheaded by James Lingwood, *Mobile Homestead* is the first project produced by Artangel in the United States. At a certain point, Artangel partnered with the Museum of Contemporary Art (MOCAD) in downtown Detroit to co-produce the work.

Mobile Homestead is a full-scale replica of the house in which I was raised (a single-story ranch-style house), which still exists in the Detroit suburb of Westland, a working-class residential neighborhood. The replica will exist permanently on a grassy lot adjacent to MOCAD, where it will function as a community gallery— in concert with various local community groups. The facade of the structure is designed to be removable and is mounted on a chassis; it is "street legal" and close in size to a traditional mobile home so that it may be driven around the Detroit area to provide various sorts of public services. It is my wish that the community gallery will not simply be an outpost of MOCAD, but that it represent the cultural interests of the community that exists in proximity to it.

A complex basement area will be built beneath the house, mirroring the floor plan of the original Kelley family home. Though the floor plan of the underground zone is the same as the house, the rooms may not be entered directly one from the other. To accomplish this architectural effect, the subground section of the house will be constructed two levels deep so that visitors must travel labyrinthian hallways and climb

Stills from *Going West on Michigan Avenue from Downtown Detroit to Westland* and *Going East on Michigan Avenue from Westland to Downtown Detroit*, 2010–11. High-definition video, color, sound; 76:15 min. each

up and down ladders to reach the next space. The basement is being structured like this, specifically so that its floor plan is unrecognizable as the mirror of the house above. In this way, each room will take on a distinct cell-like quality. In contrast to the public orientation of the mobile section of the house and the community gallery/upper section, the lower levels are designed for private rites of an aesthetic nature. This section of the structure will be made available, on occasion, to individual artists or groups of my choosing. The underground zone will not be open to the public and the works produced there would have to be presented elsewhere, or not at all.

Mobile Homestead is also intended to have a parasitic relationship with Henry Ford's collection of structures associated with great American historical figures. Founded in 1929 by the automobile manufacturer in Dearborn, the Henry Ford Museum houses the industrialist's vast collection of machinery and technological items, period furnishings and Americana. Linked to the museum is Greenfield Village, a sprawling outdoor theme park made up of over eighty historical buildings, including Ford's birthplace, Thomas Edison's laboratory, and the Wright Brothers' workshop. The traveling portion of the house is intended to function as a somewhat ironic comment on such grandiose notions of history; it is an "every man's" home associated with Greenfield Village simply through proximity when it is driven into the parking lot where, on occasion, I plan to have it sit as long as legally possible.

Mobile Homestead's normal driving route would take it west down Michigan Avenue—starting at MOCAD downtown, continuing on to the "mother ship"—the original home in Westland—then heading east to Greenfield Village and back to MOCAD. As it goes it performs its social duty of useful public service, for example it could function as a blood mobile, food drop-off site, etc. The house is not intended as a monument to me or my family. It will not be designated as the "Kelley family home." It is simply a house typical of the area where I grew up. Yet even this aspect of the project is far from neutral. A replica of a typical house of the suburbs, it will look quite out of place in downtown Detroit. This fact itself points toward the complex racial and class-based issues that are representative of the Detroit area—for example, the "white flight" from the city after the Detroit race riots of 1967, which resulted in a city with a primarily African American population surrounded by white suburbs.

With this in mind, in 2010 I produced a video documentary that follows the route of the completed traveling section of *Mobile Homestead* from MOCAD's site in downtown Detroit to Westland and back. The documentary consists of two feature-length videos: the first follows the *Mobile Homestead* as it heads west to the original Kelley house; the second follows the vehicle's return east to downtown Detroit. The documentary traces a remarkable variety of urban and outlying areas, starting with the urban revitalization of the Woodward area and the urban blight that surrounds it and continuing through to the comparative wealth of Dearborn, the black slums of Inkster, and into the white working-class neighborhoods of Wayne and Westland.

A third video was made, documenting the September 25th, 2010, launch event of the mobile section that occurred on the site at MOCAD where the completed *Mobile Homestead* will eventually stand. It records an ode by local poet John Sinclair and the christening of the mobile section as well as the speeches delivered by local community leaders and representatives of Artangel and MOCAD. It also features an interview with the present owner of the Kelley family home and footage of a food drive that took place in the parking lot of Greenfield Village. Those attending the christening event were invited to form a caravan to follow the mobile section on its tour, during which locals were treated to a festival of live music made up of a variety of bands representing the rich cultural diversity of the Detroit area. These included soul, rock and punk, Polish polka, Irish, and Cuban bands and hip-hop deejays. Ironically, the driver of *Mobile Homestead* ran into the curb making the turn from Woodward onto Michigan Avenue—literally the first block of the tour. The scheduled tour was cancelled and the vehicle was not repaired until the end of the day, at which point it was driven back onto the MOCAD site just as the music concerts were ending. This video is edited in such a way as to give the impression that the event was successful. Only, at the end, is it revealed that *Mobile Homestead* never actually completed its route that day.

Luckily, the video documentation of the travel route of *Mobile Homestead*, which was shot before the actual opening event, went far more smoothly. I had scouted the route thoroughly while in Detroit for preproduction meetings. Priority sites were chosen, camera angles were fixed, and a shooting script was drawn up. Oren Goldenberg, a local filmmaker, was hired to shoot the tour and individual sites. Scott Benzel, who works with me in my studio in Los Angeles on sound, came to manage the production. Laura Sillars, who was sent from England by Artangel to help oversee the project, was essential in organizing the interviews even though she had never been to Detroit before. She, in essence, directed this aspect of the documentary.

As *Mobile Homestead* travels the Michigan Avenue loop in the two feature-length documentaries, there are cutaways to various homes and businesses where interviews are conducted. As I've already pointed out, the communities that *Mobile Homestead* passed through are incredibly varied with regard to ethnicity and economic scale. Some towns, such as Dearborn—home of the Ford Motor Company—are going through major social changes. Dearborn, once an enclave of white wealth, surrounded by black poverty, has become a thriving middle-class Arab American community. Interviewees included the workers and owners of shops, bars, and restaurants, a motorcycle gang, local citizens in their homes, strip-club dancers and street prostitutes, members and officials at a variety of churches (including a priest at St. Mary's Catholic Church and School in Wayne, which I attended as a child), social service organizations, as well as representatives of the Henry Ford Museum, Greenfield Village, and the Ford Motor Company at its corporate headquarters.

In 2011, I was invited to present the *Mobile Homestead* project at the 2012 Whitney Biennial in New York. The videos documenting the mobile unit's travel route and christening ceremony will be screened. But I consider the *Mobile Homestead* project to be a work in progress. The videos, on their own, do not convey the complex nature of the project as a whole, which will eventually include documentation of the exhibitions that will take place in the community gallery and the various social services that will be linked to the mobile section. Phase two of the project, the construction of the permanent structure next to MOCAD, is not yet even in production.

The *Mobile Homestead* project is my first sustained attempt to delve into the world of public art—something I have always shied away from in the past. I have a deep distrust of art that is foisted upon the public; I prefer that people go and see art if they choose to do so. (Of course, this stance does not apply to guerilla art—such as political protests or graffiti art, etc.—which is specifically intended to be transgressive. I mean, in this case, public art that is sanctioned by taxpayer dollars or public institutions.) This project developed in a way I would never have anticipated. Initially it was a secret project, designed for my own perverse amusement, situated in a lower-class suburb of Detroit. After this turned out to be impossible (because the current owner of the house I grew up in would not sell it to me, and because I became involved with the public institutions Artangel and later, MOCAD), I was forced to reconsider my intentions and change my approach in response to the work's new, public nature and its shift in location. Going public led to a nightmare of complexity, not only in the production of the work but also, personally, in its very meaning for me. As public art, intended to have some sort of positive effect on the community in proximity to it, it is a total failure. Detroit is a poor city, and I don't believe that the funding exists to organize the social programs associated with the project, or to even cover the operating costs of *Mobile Homestead*. The work could become just another ruin in a city full of ruins. Yet, in the beginning, I never intended the project to have any positive effect. Turning my childhood home into an "art gallery/community center" was simply a sign for social concern, performed in bad faith. The project, in its initial conception, expressed my true feelings about the milieu in which I was raised, and my belief that one always has to hide one's true desires and beliefs behind a facade of socially acceptable lies. But, perhaps, the failure of the *Mobile Homestead* project now, after being filtered through the institutions of the art world and community services, is successful as a model of my own belief that public art is always doomed to failure because of its basic passive/aggressive nature. Public art is a pleasure that is forced upon a public that, in most cases, finds no pleasure in it.

—Mike Kelley, 2011

161

The *Mobile Homestead* parked in front of the original Kelley home on Palmer Road in Westland, Michigan, 2010

The *Mobile Homestead* in front of the Kay Beard Building in Westland, formerly part of the Eloise Psychiatric Hospital and Poor House, 2010

The *Mobile Homestead* in front of the abandoned Detroit Central Train Station, 2010

The *Mobile Homestead* in front of the Henry Ford Museum, Dearborn, Michigan, 2010

:-)

JOHN KELSEY *lives and works in New York.*

JUTTA KOETHER *was born in 1958 in Cologne, Germany. She lives and works in New York.*

Garland. A line woven from other lines, freighted with objects, emblems, and fruit. Lines sprung from surfaces cut into segments, carried by arms. Catenary.

(Drawings for All) The Seasons, 2011.
Ten ink drawings on vellum, 9 x 12 in.
(22.9 x 30.5 cm) each. Collection of
the artist. Texts by David Joselit

what effect can paintings have?e
the effect of beauty
" " " " ? value
artistic ~~pleasure~~ presentations? value

Men + mallets
the ~~sight~~ of the seasons | 4 season + 1 Extra? | and one opening
| | | four period of crisis instability disputes

Waterfalls
life cycles
old testament
seasonal
activities | Spring | Landscape Apples / summer flowers * |
| | 1 |
~~market~~
~~retail~~ | (morning) greenish blue

fashion
Colors
Symbolism | Summer | [sketch] read large bearing sun → Race car drivers?
ages of men | (noon) afternoon yellow red | — Gold blob sunset?
Sport events | | maintain the illusion of win?
Krisen
~~passions~~ | Autumn | [sketch] 2 figures in a room after Bacon Dairy stuff w/ themselves but
| 3 |
~~autumn~~ leaves | brownish |
"behavioral"
painting | ~~autumn~~ ("combat 'seascape" Red
socialite | Winter [Deluge] | Large Dark painting | Blue tiled
watching it with different times of the day | 4 | Apocalyptic Massive still life? for and architecture read garland? |
Color curse | (night) |

Window. The elevator brings you up, but a window pulls you out: passage through space vanishes into wild passages of paint. Jutta Koether impersonates Nicolas Poussin's passage of seasons—Winter, Spring, Summer, Autumn. But four are not enough, so Koether insinuates more: hurricane season, flood season, or a season of hunger. She deposits a palimpsest for us to occupy: gridded space, painterly gesture, cycles of seasons. Their layers telescope, like a window onto a window.

Still from *Wild Night in El Reno*, 1977, from the *Weather Diaries*, 1977–2011. 16mm film, color, sound; 15 min. The Estate of George Kuchar

George Kuchar with Charles Bernstein on *Close Listening* (2009)

CHARLES BERNSTEIN: Welcome to *Close Listening*, PennSound's program of readings and conversations with poets and filmmakers, presented in collaboration with Art International Radio. My guest today for the first of three shows is George Kuchar, whose many films include *Hold Me While I'm Naked* (1966), *Pagan Rhapsody* (1970), *Devil's Cleavage* (1973), and in recent years a set of self-documenting filmed video journals and another remarkable series of films called the *Weather Diaries*. The IMDB database lists over 200 films of George Kuchar. He teaches at the San Francisco Art Institute. *It Came From Kuchar*, a documentary film of the life of George and his brother and collaborator Mike Kuchar, by Jennifer Kroot, was released this year. George—welcome to *Close Listening*.
GEORGE KUCHAR: Yeah, thank you. What's that "Penn"? Pennsylvania State?
Bernstein: University of Pennsylvania.
Kuchar: Okay.
Bernstein: That's where I teach. In Philadelphia.
Kuchar: I've been to Philadelphia. I like scrapple.
Bernstein: Penn is the oldest secular university in the United States, founded partly by Ben Franklin.
Kuchar: Oh wow. And the Liberty Bell is not too far away?
Bernstein: It is. Cracked.

Kuchar: Okay.
Bernstein: Did you ever read the autobiography of Ben Franklin, the self-made man?
Kuchar: No—I just know that he went to the Hellfire Club—a big sex club.
Bernstein: In London?
Kuchar: He was part of that.
Bernstein: He is known for doing everything himself, reinforced britches and all, that sort of self-inventing.
Kuchar: Okay. And then the thing with the lightening—very famous.
Bernstein: That's right.
Kuchar: I am interested in weather.
Bernstein: IMDB lists 200 or more films. How many films do you count?
Kuchar: Well, let's see, there are over two hundred videos—there is a whole pile of videos. Some French guy came over to the house, he wanted to have a big show in France and so I showed him a cabinet full of my videos and he changed the subject. I think there was too much to handle. So he left the house with no scheduling. That was the end of that show … Maybe there's forty or fifty movies—something like that. Somebody once did a compilation when they wrote the book. Me and my brother did a book, *Reflections from a Cinematic Cesspool*.
Bernstein: Yes—wonderful, funny, terrific book.
Kuchar: I'm glad you liked it. I did the first half,

Mike did the second. And then somebody did a documentation of how many pictures there were and that was a couple of years ago so the thing expanded. The editor of that book … her babysitter was the Blue Dahlia or was the Blue Dahlia black? I think the Blue Dahlia was black and she got murdered and so the woman … I forget her name but that's alright, she's forgettable anyway. Her son has a mental disorder where he forgets what happens, you know like in *Memento*?
Bernstein: I guess the key is distinguishing *The Black Dahlia* from the *Blue*. But back to the count. How about the switch that you made from one media to another? From when you and Mike started in 8mm and onward. How did you feel about each of the mediums you worked with and the differences that they allowed you?
Kuchar: Well you know I'm happy to jump mediums and in fact, it's kind of like the Frankenstein monster, sometimes you can make a movie …
Bernstein: The film is the Frankenstein monster and you're Dr. Frankenstein?
Kuchar: They can actually get a disease, they have that vinegar syndrome, and then in order to prevent that you have to have, like, a facelift. And so, you can now put it on digital—you can digitize all of your pictures. I guess in the old days they used to put the movies onto paper?
Bernstein: The earliest films …
Kuchar: The earliest films, you know? So now it gets digitized. I was always for that. I myself will probably deteriorate, like, rapidly …
Bernstein: As a human body … once you die …
Kuchar: As a human body, but people are more interested in the pictures so it doesn't matter.
Bernstein: The pictures will live on.
Kuchar: I can go—the hell with that.
Bernstein: Are there particular things working with 8mm versus 16 versus video that you liked? Let's just talk about those three.
Kuchar: Oh yeah, well with 8mm the image was small, my eyes were better. And so I was able to edit—even without a viewer.
Bernstein: You edited direct?
Kuchar: Yes.
Bernstein: On the film?
Kuchar: Oh, yeah, for sure.
Bernstein: That is tiny.
Kuchar: Very tiny and, of course, I wear glasses now. That may have helped—you know what I mean—my deterioration of the eyes. But anyway I used to work with that and I enjoyed it. And then you had a little chart when you bought the film and it said … if it was bright sun you put on F16 and then hazy you put on F8 and stuff, it gave you simple instructions. So I used to like the simple way you had to make a movie. And of course, the film I think was $2.65. So we had an allowance that we were able to make movies— my brother and I. My father gave us the allowance. And we had a camera that belonged to my aunt but my mother and aunt had a falling out, because of carnal activity with some of the other family members. And therefore, my mom got us our own camera, which was a Dejur. And we began making movies with that.

GEORGE KUCHAR *was born in 1942 in New York. He died in 2011 in San Francisco.*

Bernstein: How about when you moved to 16? Did you miss 8 when you went to 16?

Kuchar: Not at all. I began seeing the pictures that were done in 16mm because I was going to the underground movie shows. I saw you could see all the leaves on the trees. You know with 8mm you got an impression … We decided, oh, we were working now, we got jobs, so why not get a 16mm camera? So my brother bought one. Originally, he had bought a big fountain that looked like something from a book jacket by Isaac Asimov, one of the science-fiction things. It was a fountain and it dripped water. Then he realized that he spent five hundred bucks on that stupid thing. [*Phone rings.*] The phone is ringing but don't pay any attention to that.

Bernstein: Well, we planted that, that's part of … there's going to be a number of tests on this program to see how you react. That was a quick reaction …

Kuchar: Oh yeah, I'm excited. Whenever the phone rings, I get nervous. I just don't know what's on the other end. Answering machines are very important because then you don't have to be rude to the telemarketers. But in any case … my brother took the $500 and he bought a camera. It was a Bolex and we embarked in 16 mm. He started a picture *Corruption of the Damned*. Then he abandoned it because he wanted to make sort of a sci-fi picture, which had more of a Hercules feel to it. So he started *Sins of the Fleshapoids* and I took over *Corruption of the Damned*. That began our 16mm career. I liked 16mm: the frame was bigger but then I began buying equipment for editing …

Bernstein: Like a flatbed?

Kuchar: Yeah kind of like a flatbed but you just had cranks, it was better for the muscles. You know because you were turning the damn thing.

Bernstein: And you would cut on that thing? You could cut and splice by hand.

Kuchar: There were no work prints then. Actually, I did one work print once, but I realized how ridiculous it was because you had to edit the movie twice. It's hard enough editing once. Why do it twice? The first movie that I did in color, in 16mm, was *Hold Me While I'm Naked*. I tried to follow the instructions how to do it right, so I got a work print in black and white because it was cheaper. Then, when it came time to edit the color, I edited it completely different because the color dictated the cut.

Bernstein: So in films of that period, there's really only the original edited version—there's not a work print?

Kuchar: No, no work print.

Bernstein: Where is that film, for example—is that at Harvard now?

Kuchar: I hope so—it's out of my closet. You know San Francisco houses burn down and they make them out of wood to make it a little more earthquake proof. But then they burn down. There was a fire next to my house … the first thing I would do would be to grab the cats. I'm not going to grab the films. There are too many of them in the closet and they weight a ton.

Bernstein: Too many cats or too many films?

Kuchar: I've got two cats and there's like—fifty or sixty films? And a lot of them are in heavy cans so I realize, "Boy, I'm in trouble, the films are in trouble."

Bernstein: But all the films are now out and at the Harvard archives.

Kuchar: I got them all out of the house because all the labs closed down. The whole landscape has changed, much to the horror of people who went to film school and learned how to make movies.

Bernstein: Now a lot of filmmakers of your generation felt a kind of regret at the loss of the projected image in 16—going to digital. You don't seem to feel that way.

Kuchar: No, because you can project video now.

Bernstein: Yes.

Kuchar: People say you fall asleep in video. Maybe it's true, but it's healthier.

Bernstein: It's certainly a lot easier for you to edit video on your home set-up.

Kuchar: You have a ball. With the machines, you have now, I have this machine that wedding videographers like. You can get a lot of software with it.

Bernstein: What's the name of that?

Kuchar: The MacroSystem—they come out of Boulder, Colorado, so the people are nice. Because you go to Boulder and they got that Buddhist place and stuff. Anyway, mellow people. Then you have this machine: it doesn't do e-mail or anything else.

Bernstein: It's a dedicated editor.

Kuchar: It's a dedicated editor.

Bernstein: So you enjoy editing on this and making videos more than you did with 8mm and 16mm?

Kuchar: No, I loved 8 and 16 … I loved getting your hands on the picture and I loved editing. Then when that went out the door … alright that was fun—this is a new one and this is more fun too. You know what I mean? You don't touch it but you have to hit the buttons.

Bernstein: But there must be a number of things that you do in video that you don't do—that you couldn't do or didn't do—in 16, and vice versa.

Kuchar: Yeah, you know what? When people are looking in the wrong direction, you can flip them without the damn thing getting blurred. Because when you flip the film, the emulsion was on the wrong side. And also you can turn the stupid thing upside down … the image … and if people look particularly ugly, you can make them look uglier and therefore when people see them in person they look better. I once did an interview myself and I looked so hideous and I saw the footage and I decided to split the image in half and so my Adam's apple was up near my chin. It was horrible, like monster footage. But somehow it was more acceptable. So you can do all these different tricks. I think with the whole editing thing, if you get enough software, it's like a giant Band-Aid kit. You know where you can fix up images and stuff.

Bernstein: I think about your films in the context of the full history of Hollywood films, but

less so in terms of television. But now you are doing video. There must be a connection to TV. What is your sense about how you relate to TV in your work? There are a lot of times that TVs are on in your videos in a very eerie way. You have people, especially in those tornado/weather videos … you have a lone TV with an evangelist on or somebody watching it. The TVs are very desolate signals from some far-off place, very often unpleasant material on them. So you use televisions when you shoot stuff, but how about television as a way that you otherwise think about the video work that you do?

Kuchar: Well you know that my televisions are all black now because I didn't bother converting to digital signals—and what a relief! I grew up on television and I liked it you know, the shots were long and they had long talk shows. Tex [McCrary] and Jinx Falkenburg and stuff like that. I grew up on television—black and white. I never minded when pictures were colored because I would decolor them on my television, since I didn't get color television until way after it was invented. But television was important … I make these weather diaries and people say "I want to see twisters." Well, the only way you are going to see one is by looking at the screen where I am photographing a television, because you know those storms are kind of hard to get and once they're there, you have to head for a cellar. You don't want to become like a pin cushion, full of splinters and stuff.

Bernstein: What sort of TV shows stick in your mind from the 1940s and 1950s?

Kuchar: I like the talk shows that were in the morning. They were very long takes, and sometimes they sat out on patios with a pool in the background. And Tennessee Williams would be on and he would have his two dogs with him and they'd be slobbering and making all kinds of noises and so during the commercial break, which weren't too many, they would take the dogs away and you would see him sitting alone. I liked that and I also liked whenever they had a man come on—I forget his name but he used to stencil eyebrows onto people and I loved that idea—it was like an art project. You just stick a stencil onto your face and women would know what kind of eyebrow—they would just follow the lines. I enjoyed shows like that. Then I was envious of women who could stay home, they didn't have to go to work and could watch all these television shows. Then they used to have Yma Sumac on, and they were experimenting with color. And she would come on and you got to see that exotic woman singing. Then in the evening, of course, you had Milton Berle, the Texaco Star Theater. Television is important for growing up. Now I don't watch the damn thing because I am getting older and I'm going to drop dead soon, you know what I mean? I can't sit in front of the TV all the time, except when I go to a motel and I'm making these weather diaries. Then the TV is on because I get cable. I get, like, two or three weeks of cable and that's it.

Bernstein: While you are here in Provincetown, you are watching Fox News. What do you find interesting about Fox News?

175

Kuchar: Controversial—they are in your face and they got pretty anchor ladies … the lip-gloss. And Megyn Kelly, she did a whole thing on Fox. I watched it and then I was so flattered that there I was on Fox, like they had a poster from *Thundercrack!* Of course, I was an unwelcome segment because I was considered a pervert who was poisoning the cultural landscape. And that's fine. Because you know in the old days, if you ever you got a good review in the *New York Times* or another paper, it was a sign, "Uh oh, you are in trouble because your picture is bad."

Bernstein: Well it's odd that they picked *Thundercrack!* from 1975 to launch an attack on the NEA.

Kuchar: Yeah. They didn't want tax money going to … It wasn't about the movie because the movie wasn't done with tax money. It was a few students who got together and wanted to make a picture and they paid for it. They were the producers. But Fox was mad that a venue that was getting tax money was showcasing that kind of garbage. I was so delighted because the rumors of that picture still had impact after all these years. Plus, they quoted a line from the poster I designed: "Ecstasy so great that all heaven and hell become but one Shangri-la." And there I was, I was quoted on that show.

Bernstein: But at the same time, it's kind of frightening isn't it? The right wing attack …

Kuchar: No, the more the merrier … People want to see the picture, because it becomes a source of interest.

Bernstein: So you don't find Fox News, and this kind of right-wing attack on the values that you might have, disturbing?

Kuchar: No not at all. Because otherwise the values would have no value. In other words, you have to have a different kind of value system. And then there could be the clash of the values.

Bernstein: Do you think of your films as political? Do you think that *Thundercrack!*, which of course, is not your film alone, but you wrote the screenplay, as political?

Kuchar: No. They are mainly heartfelt or gut felt, some of them …

Bernstein: Your heart is a very different heart than the way we imagine hearts to be for more conventional film representations of …

Kuchar: Yeah, but I see a lot of conventional films. They are a jumping off point. And then you can put in things that you didn't see in pictures, like toilet bowls and turds …

Bernstein: So you don't find that your work offers a necessary alternative view to the way that reality is usually presented, say, on television?

Kuchar: Yeah, not necessary …

Bernstein: … yup, necessary was the key word there … [*Laughter.*]

Kuchar: You know you pay a price if you want to go in and see something. But, no, not necessary. Because sometimes the plots are … they are there, but I begin with an idea and then the plot may go off someplace else and, also, some of the characters you may not remember from previous scenes. I found that out in one movie. I had the same people in the movie and people didn't know it was the same people.

Bernstein: Your work creates a joyous and extremely funny view of ways of life that many people, in the United States anyway, consider immoral.

Kuchar: Yeah probably just because part of my life was a little bit off the tracks somewhere. I didn't mean it to go that way.

Bernstein: What do you think is off the track? You grew up as a Catholic? Certainly a lot of the things that you think now would not be in keeping with the religious views that surrounded you growing up?

Kuchar: You know the best things are to be thrown out of all these places. I always feel that it's kind of interesting if you get thrown out of places. It's a little more freedom.

Bernstein: Thrown out of places in what sense? Not being admitted into the company of …

Kuchar: Yeah … you really wouldn't be a welcome guest and that's sort of like … that's all right because I have other things to do. I can take a walk. I can make a picture and stuff. I don't have to be trapped somewhere. So I never minded that. And then if these organizations are there, that's fine, because they can throw you out. Then you can be freer.

Bernstein: They give a little structure or something to bounce off of?

Kuchar: Well, yeah, but then you always have a model and you can use that model and then make your version of it? Whatever becomes an obsession … I know I can go off the track but hopefully not for a major crash. Although major crashes do help in making other movies.

Bernstein: And yet part of your generation, especially in San Francisco but also in New York, is thought of as creating an alternative culture or counterculture. And there is some connection to what you do that gives a—I want to say voice because I'm on the radio—but gives eyes to something that's astonishing, something that's not otherwise presented. A range of possibilities for human interaction, human community …

Kuchar: Oh yeah, well that's your audience. You make movies and then eventually you find your audience. Some of them, you are completely ostracized from, even ones that are highfalutin …

Bernstein: Do you have a specific audience that you can identify? Who do you imagine to be the community that you speak to and for? Or do you not speak to and for any community that is in your mind?

Kuchar: Whoever comes into the theater. Whoever pays the money, you know? Once there was a showing of *Thundercrack!*, which is a porno picture, and it played in a museum. But they didn't bother to advertise it that it was a porno picture. So these two elderly ladies I saw buying tickets, and I was going to say, "Oh, do you have any idea that this is pornography?" And I expected them to go out, but no—they stayed through the entire picture, which gave them the opportunity to see a porno picture without anybody thinking they had gone into one.

Bernstein: Does identity politics plays an explicit part in the way that you imagine your work?

Kuchar: No, I don't think so because the identities are all—a lot of them are me. You know, different aspects of my personality—the people in the movies.

Bernstein: Do you have multiple identities as a filmmaker?

Kuchar: In the movies you make, you have your alter egos, and they'll come on and stuff. A lot of the diaries, of course, I'm in the diaries. I always want to be an actor. So, no alter ego intended. There's the real person. But then, of course, you have your face, because you have your real face. But, you know, it's like a burlesque show: if you take all your clothes off right away, who's interested? [*Laughter.*] You have to peel off a little bit at a time and then there has to be magic and mystery. Maybe you go behind a screen or something. So, it's the same way with movie image. I may appear on the picture, but that's not really the total me. The total me may be quite horrifying, in points. But there's always a mystery of the person and it should always be there.

Bernstein: You're part of a generation, and maybe the generation older than you, of North American filmmakers who transformed movies, creating a dwelling place for innovative, independently made film. What are some of the breakthroughs that you associate with some of your contemporaries and the generation before you in alternative and independent filmmaking? Who are the filmmakers that you feel closest to?

Kuchar: Well, you know, it's a weird community because nobody's that close. [*Laughter.*] They're all doing different work and stuff, then they get together once in a while and of course there are—

Bernstein: You don't feel that you and Michael Snow are doing exactly the same thing? [*Laughter.*]

Kuchar: No, but I like him. I enjoy his work. He used to come to the showings and, of course, I used him, he came to a class movie and he was playing a musical instrument. And then he and his ex-wife, Joyce Wieland … they made strange movies. I would go over to their loft and they were playing scientific films in 8mm that were showing how electrodes will activate a frog's leg and cause it to kick. And they were there with Hollis Frampton. I found their inspiration with these scientific 8mm movies so interesting. And then you go hear other people, I mean, I'm in school and I find out that commercials are actually activating the imagination of some of the students, that they like underwear commercials and stuff like that, and they want to incorporate that kind of style in their movies.

Bernstein: Well, vice-versa, of course.

Kuchar: Yeah, and then eventually it switches over because you see an underground movie and the cameras are moving in all kinds of crazy ways, and then you see it in commercials and other things. So, I love that kind of crossover of people getting inspired by everything else. And the underground filmmakers—I've known a few—and they're kind of interesting. Stan Brakhage, he was a big influence because whenever I got sick, he had so many illnesses that he would say, "Oh, this one ain't impor-

tant. There are worse things that you can go through." He was like an uncle. Ken Jacobs, I remember, he had a picture and he didn't bother cutting the ends off into the little, punch-holes, to show what kind of film it was on. I asked him about that—"How come you kept that in?"—and he said that he liked the way it looked. Then I realized, yeah, it did look good. So, when I was editing *Hold Me While I'm Naked*, I saw those holes and I liked it also. So, you know, things open you up. You just go to movies and then, in a way, you're a receptacle and then in your own digestive juices, you spill out something else, you know, incorporating a lot of stuff. It's a great tradition. One of the great, flattering things is if somebody has seen your picture and they are actually reproducing their version of a similar kind of thing. Because people kept telling me: "David Lynch, he stole your big lips thing. You know, putting lipstick on people. Aren't you mad?" And I would say, "No, I'm really flattered." I doubt if he got influenced by me. I think sometimes there's something in the air where people latch on to something. Because you find in a lot of inventions—sometimes they happen simultaneously. So, maybe that's it. Otherwise, I'm always flattered. Like, please, do take.

Bernstein: You're a remarkable sound editor. I wonder what you think about, well, let's talk about your recent films, for example, the *Weather Diaries*, and how you're using sound. Sometimes you're using movie music …

Kuchar: Yeah.

Bernstein: … that you have from LPs. You overdub and so on. How do you see the relation of sound and image, Mr. Kuchar?

Kuchar: Well, it's very important because sometimes a scene is on too long and you like it but it needs something else. So I found that if you just have music, it's not that good, but have a song with lyrics, then people are able to accept the long length. I once had an actress and she had very long pauses between her sentences, and it was just a little too long for the pacing of the movie. So, when she mentioned fog, I spliced in foghorns going, and stuff like that. So, sound is very important because it helps carry the image and keeps the rhythm of the movie. I never objected to music behind people either. People say … oh you know … But I say when you go to an opera, you don't say, can you please lower the music, I want to hear the voices. You know what I mean?

Bernstein: The balance, between the words and the music.

Kuchar: Yeah, like there's too much music in this opera! Plus, I enjoy music. A lot of times I play it when I'm washing dishes and when I'm editing and you can hear it in the background. I got a giant record collection, and music is very important.

Bernstein: So, all the music that you use, for example, in the *Weather Diaries*, is from your collection?

Kuchar: Yeah, from the collection. I have so much and that's going to be horrible when I try to move. In the early days, I had a boom box, and I had tapes and I would bring specific tapes along which had, you know, mood music. And I knew what mood I was going to shoot this particular scene in, so I would line up a tape and then when people were talking and it said something kind of sad or important, I put the music on and it would pipe into the room like a loudspeaker. Of course, it wasn't a loudspeaker because it came from a boom box, but it was loud enough and it had no fidelity, but it aided the mood that I wanted. Therefore I didn't have to edit music into the picture later, because it came actually from right there when you were shooting it live.

Bernstein: You are better known as a filmmaker than as a writer. Do you think of writing as a primary thing, or just something that contributes to the films that you're making?

Kuchar: It's another expression. In other words, I loved writing because actually you can compose, you know, when you're writing, it's composing the shot of the sentence. You can get the sentence rhythms and the repetition of sounds of the words. It's a lot of fun to move words around like in editing. And I love writing: it's cheaper, a hell of a lot cheaper than making a picture. And also, you get all these mental images and you try to convey what you've seen via words and get that whole mood. So, to me, it's a wonderful form of expression. I really liked it. And every once in a while I get the opportunity. Mainly now I write because people, students call up and they say, "Could you give me a recommendation?"

Bernstein: Yes, I have that, too: *The Collected Letters of Recommendation*.

Kuchar: Yeah, they come as a barrage. So, I've been writing them and I have now a whole collection of recommendations. And it's really a lot of fun because you think of the person, then you try and get the words that represent the basic feel of the person but also make it sound like a movie poster. Like these words blast out at you, and the talents that the person has.

Bernstein: And your titles themselves, the hundreds of titles that you created, are themselves a kind of poetic masterpiece, it seems to me.

Kuchar: Yeah, well, you know what you have to do, Charles? You have to think and break the ice. There's nothing more horrifying than you finish your picture, and now, what the hell is this title going to be? And so if you break the ice and just keep writing down things, even the most horrible titles … And the worst one I ever had was *Unstrap Me*. It was for a love story. [*Laughter.*] And I said I couldn't get that out of my head. It was the worst. So, I had to break the ice and I said, no, this is it. We're going to call it *Unstrap Me*. And so, it became that. You know, it hits you. Like, this is it. This is the title. Sometimes you get it and it's just a matter of rearranging the words in the previous examples when you were writing, and then you just rearrange it. And then, this is it, you know. But that's usually the final stage. I should save a lot of these, because sometimes I'm writing and I come across some good ones that don't quite fit the movie, then I throw away the whole list. I should save them for pictures to come.

Bernstein: You've been listening to George Kuchar on *Close Listening*. The program was recorded on August … what is today's date?

Kuchar: Well, let's see, I don't know, I leave in a couple of days but I …

Bernstein: August the 13th …

Kuchar: Okay—and it's not a Friday …

Bernstein: … 2009, in Provincetown, Massachusetts, with thanks to the Chaim and Renee Gross Family Foundation. For more information on this show, visit our web site: writing.upenn.edu/pennsound. I have a tendency to be Charles Bernstein. Lighting and costumes by … *Close Listening*.

Still from *Wild Night in El Reno*, 1977, from the *Weather Diaries*, 1977–2011. 16mm film, color, sound; 15 min. The Estate of George Kuchar

Production still from *My Tears Are Dry*, 2009. 16mm film, color, sound; 4 min.

LAIDA LERTXUNDI *was born in 1981 in Bilbao, Spain. She lives and works in Los Angeles.*

Still from *Cry When It Happens*, 2010. 16mm film, color, sound; 14 min.

Still from *Cry When It Happens*, 2010. 16mm film, color, sound; 14 min.

Still from *Cry When It Happens*, 2010. 16mm film, color, sound; 14 min.

Still from *A Lax Riddle Unit*, 2011. 16mm film, color, sound; 5 min.

Still from *A Lax Riddle Unit*, 2011. 16mm film, color, sound; 5 min.

KATE LEVANT *was born in 1983 in Chicago. She lives and works in Detroit.*

A crude skull is carved from wood. Its head is covered by a Sassanian helmet; the figure of a centipede is incised into the cheek; Chinese letters are inscribed onto the forehead. Greek meander ornaments adorn the base: "These heads are covered in motifs that testify to endless migrations" :

= Semiotic Modality of imprint or index = ←

*

There is no visual model for points of reference that would unite observation (in an ~~immobile~~ inertial class assignable to an immobile outside observer. What is consistency to this method of experiencing the world Nomadically?

187

SAM LEWITT *was born in 1981 in Los Angeles. He lives and works in New York.*

FLUID EMPLOYMENT

MATERIAL HISTORY

Ferrofluid is a magnetic fluid technology. It first appeared on the technological scene in the 1960s when a researcher at NASA tried to create a magnetic rocket fuel that could be manipulated under zero gravity by powerful magnets and fed into rocket engines. This did not work. The fluid was subsequently licensed by NASA to AVCO Corporation and went straight into private research and development. Commercialization began in 1968.

Against the backdrop of late 60s social unrest in factories and schools, struggles against Imperialism and widespread opposition to top down systems of rigid authority emerged this eminently adaptable substance. Ferrofluid's self-organizing magnetic properties act like a liquid workforce. It continuously adjusts to changing contextual demands when sealed into a magnetically regulated environment, providing frictionless performance in an ever widening range of applications with minimal risk of evaporation.*

The exquisite pliancy of Ferrofluid is caused by its invisible, erratic structural traits. The liquid is composed of randomly circulating ferromagnetic nanoparticles whose time derivative is everywhere infinite (Brownian motion). When used in conjunction with a strong magnet the ferric nanoparticles take the shape of the magnetic field, creating localized clusters that appear to the eye as spiky globules which are capable of continual modulation and re-composition.

Many possible applications have been envisioned for Ferrofluid and more are still to come. Loudspeaker technology was one of the first and continues to be one of the largest market segments, going into over 300 million speakers each year at over 300 different companies. Employment of this material has branched out into diverse sectors of industrial production. Its uses range from military optics to biomedical research, from the paint mixture on the stealth bomber to sports car hydraulics, from domain detection for media such as magnetic stripes and disks to manufacturing systems in need of hermetic sealing, from classrooms to consumer electronics or simply as conversation pieces for the office or home.

*Prolonged exposure to open air circulation causes evaporation to occur at accelerated rates.

Ferro Tec

industry ████ seals and vacuum rotary feedthroughs ████ quality performance ████ seals ████ seals ████ demanding applications, ████ optimize ████ intense performance requirements.

████ produce ████ optimized ████ demands ████ target ████cations. ████competitive products ████ high-precision ████

████ feedthrough »
████ seals and feedthroughs.

████ stand-alone ████

████ engineer ████ performance requirements ████ target ████ precision, performance ████ reliability ████

████ vacuum feedthrough ████ repair ████ upgrade ████ solution. ████ service.

████ existing ████ premium ████ product ████ optimized ████

Learn more »

Seals for Airborne Electro-Optical Systems

Airborne electro-optics ████ infrared devices ██ surveillance cameras ████ ever-growing ████ military, law enforcement, ██ civilian activities.

████

- Target acquisition and designation
- Weapons guidance
- Forward-looking infrared (FLIR) devices
- Reconnaissance and surveillance

████ electro-optical instruments ████ demanding airborne conditions. Hermetic seals ███ smooth, damped rotation ██ azimuth ██ elevation ████, constant pressure ████ optical pod. ████ integrate ████ bearing assemblies ███ customized interfaces ███ low-maintenance, highly integrated sealed gimbal systems ████ unlimited ████ diameters and sizes. Extremely low, consistent drag torque ████ servomotor power. ████ airborne enclosures ████ superior dynamic sealing █ critical█ optimum optical performance.

- True hermetic sealing
- High reliability
- Zero maintenance
- Low drag torque
- Wide thermal range
- Smooth operation
- Flexible configurations
- Compliance to military specifications and standards

9/1/1

Leak-Free ████

████ movable camera pods ███ single axis and gimbaled multiple axis. ████ sealed interior chamber ████ moisture-free gas. ████ system must maintain ██ internal environment ████ subjected to dust, rain, aircraft fuels, de-icing spray and normal maintenance fluids, ████ outside temperatures and altitudes.

████ hermetic sealing ████ smooth, low-power rotation. ████ elastomer lip seals ██ mechanical seals ████. Retrofitting ████ equipment operation.

Gimbal Style Optical Pods (multiple axis)

Multiple axis scanning pods ████ smooth optical tracking ████ azimuth ████ elevation. ████ under-wing ████ in the nose ████ forward-looking ████ applications ████ extremely low drag torque ████ temperature range.

Single Axis Optical Tracking Systems

████ under █ wing ███ lower fuselage surface ██ scan ████ single axis ████ target. ████ optical pod ████ interfaces ████ stationary mounting bracket. ████ internal passage█ cables, pressurization ██ optical path. ████ radial section, ████ precision ball ████ rotating ████ low-drag sealing ████ pressures exceeding one bar (14.5 psi).

████ leak-free ████ higher pressure capability █████, exotic lightweight ████ heating █ cooling ██ feedback █

Audio ████

████ global leader ████ audio speaker ████ speakers█ function ██ efficiently, ████ audio response ████ power ████ manufacturability ████ quality and higher ████ yields.

████ synthetic hydrocarbons ███ esters ██ oils ████ volatility ████ stability. ████ dictated ████ environmental ████ application

magnetic tapes, rigid ███ floppy disks, magneto-optical disks, crystalline and amorphous alloys, garnets, steels and geological rocks.

Commercial ██████ control recording media ███ identification ██ micro-defects ██ steel.

██████ magnetic tape, disk ███ specimen ██████ surface. ██ carrier liquid evaporates ██ particles congregate ██████ boundaries. ██████ dark lines ██ visible light ████████ microscope. ██████ magnetic field ██████ specimen ██████ contrast ███ pattern.

██████ water ██ mineral oil ██████. Domain detection ██████████ wetting agent ██ solvent ██████.

██████ audio and video tape manufacturers, TV a██ recording studios, forensic science laboratories ██ research institutions. A██ ██ water-based a██████.

Educational

███████ amazing ████████ visually ███████, exciting ███████ tool. ██ ███ mind, ██████ markets.

████████ maximize ██████ environments, a██████ exception.

visualize ██ magnetic patterns. Technical data ██████

██████ Adventure ██ patterns █████ thought ██████ ██████ supervision.

Bio-Medical

██████ diagnostic tests ███████ malignant masses ██ an assortment of lesions)██████ nanoparticles ██████ materials ██████ monomer ██ ██████ magnetic plastic). █ polymer ██████ shaped ██████ other ██████ are ██ micro-beads ██████ bio-active materials. beads ██ micro-spheres, ████████ antibodies, DNA ██ ██████ diagnostic process (immunoassay ██ molecular diagnostics - separation and amplification). ██████████ coat ██ treat ██████████████

site-specific delivery ██████ hyperthermia ██████ injected i██ a biological system, ████████ electromagnets ██████ tumor ██ lesion. ████████ infiltrate i██████ ██████ gradient, ████████████ interstitial pressure ██████ intravenous drug delivery. ██████ strong excitation of ██ particles. ██████████ heat, ██████ lesion, ██ killing ████████ tissues. ██████████ drug coated material.

██████ in-vivo human testing ██ therapeutic applications. ████████████

██ ████ bead manufacturers ██ research scientists - ████████ dry particles ██ █ performance characteristics ██████ optimized ████████ ██████ particle distribution. █ agglomerates ██████ consistent performance ██████ configurations, ██████ (10 nm nominal)██████ more information.

Applications

██████ R&D ████████ ██████ strategic partnerships ██████ material recycling, power and distribution transformers, quiet solenoids, sensors and switches.

Material Separation ██ Recycling

██████ apparent density ██ ██████ physical characteristic ██████ separate objects █ different density ██ floatation ██ sinking. ██ mining industries, ██████ economic advantage. ██████ ██████ commercialize ██ application. ██████ economic viability ██████ ██ patent-pending ██████ reclamation ██ reconstitution ██████ separation ██████ materials.

Electrical Transformers

██████████████ electrical power equipment, ██████ liquid-filled ██████████████ thermal and dielectric ██████

Good Job Skills

A Network of List of Good Jobs Skills, Jobs in Demand, Highest Paying Careers in 2011, Freelance Jobs Higher Sites

Home Backlinks List Of Job Skills Privacy Policy

15 Freelance Job Sites

June 12, 2011 by admin · Leave a Comment
Filed under: 15 Freelance Job Sites

Share/Bookmark

...Freelancing sites and ...mployment, pages, ...d ti... ...ntract prices, and ...uch n...

First http://jobs.37signals.com

...Freelance jobs are technical ...signals Forum 37. 9-5 regular jobs ...listed here and make sure that the lists of independent research.

2nd http://www.artypapers.com

...e a list of the best sites on t... ...find some simple tips

...e graphic desi... ...the answer. They can also res...

12th. http://www.writerlance.com

This site matches buyers with freelancers. There is no charge for this se... contract requires a payment of $ 3 or 3%, which is the largest.

13th http://www.freelancefree.com

...ndependent, not a free professional guidance easier and more attractive. You can get a good ...ob of different professions are looking for something a little different.

...4th http://freelance.geekinterview.com

...his is the place to find a job, regardless of income.

...5th http://www.teamprojectsonly.com

...he project team has been specially designed for independent developers. Technical writers ...d graphic designers can sometimes be able to find some good tracks here too.

...ags: 15 Freelance Job Sites, Collection of Freelance Job Sites, Freelance Job Sites 2011, ...reelance Jobs, List of Freelance Job Sites

CATEGORIES

10 Best Paid Jobs
100K Career Opportunities
100k Salary Jobs
101 Freelance Job Sites
15 Freelance Job Sites
20 Freelance Job Websites
5 Places to Find Freelance Jobs
65 Best Freelance Job Sites
Best Career Choice 2011
Best Careers For 2011
Best Careers For Women
Best Paying Jobs Without A Degree
Best Weekend Jobs
Dangerous Careers
Dangerous Jobs List
Dangerous Jobs that Pay Well
Future Of Jobs In America
Good Freelance Jobs Sites
Good Job Careers
Good Job Interview
Good Job Skills
...obs Skills Resume
...rt Time Job Sites
...Careers F...
...b Good
Search Sites
Lucrative Part Time Jobs
Most Stressful Jobs in America
Odd Jobs That Pay Well
Online Jobs for Teens
Part Time High Paying Jobs
Part Time Jobs for Moms
Part time Jobs For Students
Part Time Jobs for Teens

RECENT POSTS

Top 10 High Paying Jobs for 2011
Six Figure Jobs with a Bachelor's ...
Six Figure Jobs without Degree
101 Freelance Job Sites
...n Ten 10 Dangerous Jobs that P...

...E TRACE

...CONTROLER

Leonard Peltier (b. 1944), *Horse Nation*, 2011. Oil on canvas, 24 x 36 in. (61 x 91.4 cm). Collection of the artist

JOANNA MALINOWSKA *was born in 1972 in Gdynia, Poland. She lives and works in New York.*

Leonard Peltier, *AIM*, 2011. Oil on canvas, 12 x 9 in. (30.5 x 22.9 cm). Collection of the artist

Leonard Peltier, *Tatanka*, 2011. Oil on canvas, 24 x 36 in. (61 x 91.4 cm). Collection of the artist

Leonard Peltier, *Sturgis*, 2011. Oil on canvas, 22 x 28 in. (55.9 x 71.1 cm). Collection of the artist

Photograph of Leonard Peltier, date unknown

June 26, 2011

Hello my friends and relations,

I always try to come to you full of good spirit and vigor. But I cannot lie. There are days when the ugliness of my situation weighs me down. I swear I never thought this could happen. I never believed law enforcement and the government of this country would go so far for so long to keep their dirty laundry hidden away.

Over the years, you my dedicated friends and believers have kept a vision of justice alive. That really is something special. Because of you, we have learned of hidden evidence, coerced testimony, and outright lies by the FBI and prosecutors. Because of you we have been able to uncover thousands of documents the government wanted to stay secret. And yet they have been able to squirrel away thousands more pages of their biggest secrets about me, about the theft of Indian land, their motives behind murder, and their operations to silence people like me. I am living proof that my case is about squashing Indian rights and Indian sovereignty, otherwise why would I be serving a sentence so much longer than what is normal for my so-called conviction?

Those that believe in law and order should be the loudest voices calling for my release! The fact is the day I walk free is the day they are forced to deal with my innocence, and they are so very afraid of doing just that! No matter what they say, the dirty little secret underneath all of this is America's fear and loathing of Indian people. In over five hundred years, they have not yet learned how to deal honorably with us.

The burden is great sometimes, but the encouragement I get from you helps me to keep my faith that freedom will one day come my way. No matter what happens, on the day I draw my last breath I will be proud to have taken my place alongside my ancestors, knowing I did all I could do, and gave all I could for my people. For those FBI agents and prosecutors in my case, their last moments will include shame.

So remember all of you my friends and relations, this case is about much more than me. If you believe in truth, justice, honor, freedom, all of what is supposed to make America great, then help me open the door to my release. If you believe in Indian sovereignty, join my cause and in doing so help yourself. Take your place in the struggle and do all you can to eradicate injustice.

Thank you for your time. Thank you for your consideration. Thank you for your work. Thank you for your love.

Aho! Mitakuye Oyasin!

Doksha,

Leonard Peltier

89637-132
U.S.P. Lewisburg,
P.O. Box 1000,
Lewisburg, PA USA 17837

5165, 2009–10. Oil on canvas, 24 x 18 in. (61 x 45.7 cm). Collection of the artist

ANDREW MASULLO *was born in 1957 in Elizabeth, New Jersey. He lives and works in San Francisco.*

5170, 2008–09. Oil on canvas, 16 x 20 in. (40.6 x 50.8 cm). Private collection

5241, 2010. Oil on canvas, 30 x 24 in. (76.2 x 61 cm). Collection of Hillary and Jeremy N. Schwalbe

5030, 2008–10. Oil on canvas, 24 x 30 in. (61 x 76.2 cm). Collection of the artist

Left to right, top to bottom: *4498*, 2005–10; *5132*, 2009; *5147*, 2009–10; *5144*, 2009–10; *5143*, 2009–10; *5139*, 2009; *5271*, 2011; *5145*, 2009–10; *5302*, 2011; *5301*, 2011; *4962*, 2007–09; *4959*, 2006–11. Oil on canvas, 10 x 8 in. (25.4 x 20.3 cm) each. Collection of the artist

Left to right, top to bottom: *5142*, 2009; *5303*, 2011; *5133*, 2008–09 (Collection of Anne Doran); *5151*, 2009–10; *4986*, 2008–11; *5292*, 2011; *5265*, 2010–11; *5295*, 2011; *5131*, 2009 (Collection of Charles Lahti); *5263*, 2010; *5141*, 2009–10; *5251*, 2010 (Collection of Charles Lahti). Oil on canvas, 10 x 8 in. (25.4 x 20.3 cm) each. Collection of the artist (unless otherwise noted)

Don't Explain Yourself

E. told me how to build the model of a room I built in her dream. As she described it: just like that Claes Oldenburg installation with the plush and the zebra, except that the bed is covered in a grid of baguettes standing *en pointe* beneath a poster of the cover of *Tristes Tropiques*. "You still haven't made it?" she keeps asking me, incredulous.

The attempt to draw a relation between the present and the presence of something out-of-present (to show that presence persists) is generally misunderstood as too contingent, too undefined. Tracing this warped arc creates a space that can accommodate varying presences, ones in which different intensities can be orchestrated. Having spent my life moving among languages and places, I find myself constantly translating. I find myself revisiting encounters in the flourish of their disorder and tangents. I never wanted to make a claim over anything but to find a way to incorporate without assimilating, without forcing to conform.

The structure is generally this: one experience interrupted by the passage into another experience.

"Boredom is a warm gray fabric lined on the inside with the most lustrous and colorful of silks. In this fabric we wrap ourselves when we dream. We are at home then in the arabesques of its lining. But the sleeper looks bored and gray within his sheath. And when he later wakes and wants to tell of what he dreamed, he communicates by and large only this boredom. For who would be able at one stroke to turn the lining of time to the outside? Yet to narrate dreams signifies nothing else."[1]

This room is not a room, only a passage between spaces with functions. Now you can press on the velvet doors and get a facial, or a massage, or you can wait at the open "fourth wall" to have women in white lab coats whisper to you as they distribute cosmetics around the surface of your face. It was as an intervention into his gleaming interior scheme for the building on the Champs Élysées that Jean-Michel Frank commissioned this room from his frequent collaborator Christian Bérard, years before Frank took his own life in Manhattan and before his architecture was mutilated, sparing Bérard's room. "At the end of that afternoon or the following, the first visitors are my friends C. and J., in whose arms I weep: but a ladybug with seven spots spreads and gathers its elytra on C.'s naked shoulder."[2]

Awkward, unpeopled, Degas-colored, Bérard's "imaginary rooms" are free inventions rendered with just enough detail to give a semblance of decorated space, dashed off like autographs or thank-you notes. The rooms always seem too spacious, empty of purpose, but fully decked out, just entr'acte. "[In] the official annals of modern art, Bérard's name is missing. Or nearly so: sometimes he is mentioned in passing."[3]

In another world, Bérard's name does more than ring a bell, dispersing like a quickly spreading essence in whose swirling entire casts of other names clarify into many-tiered constellations: cinema, painting, couture, ballet, theater. With great generosity and promiscuity, Bérard applied his line to a storm of costume designs, fashion illustrations, frontispieces (to books such as *The Making of Americans*; *Ecoute, mon ami*; *If I Were You*), paintings, set designs, rugs, scarves, improvised stylings, and "looks" for legendary parties. The signature-like quality of his undulations and their clumsy "you-know-what-I-mean" abbreviations make him instantly familiar as the designer of a world seen affectionately and held in constant suspension. It is in this sure yet unsure style that Bérard expresses a "joy of living to the extent of perishing from that joy."[4]

If his life opens up like a door to a social history—people, sentiments, and convictions that interpenetrate and contradict one another so inconveniently that they've been edited in retrospect, or forgotten—then it is one so complex I can only appreciate it from the outside, as if it were a window display. This inevitable distancing allows me to internalize or to somehow accept Bérard's invitation to enter into the glyphs, emblems, facades, and interiors he proposes.

In his preface to the memoir compiled by Boris Kochno, Bérard's longtime companion, the chief art critic of the *New York Times*, John Russell, writes about Bérard's *On the Beach (Double Self-Portrait)* (1933) in the collection of the Museum of Modern Art, New York: "Where on earth could we fit such a painting into the didactic sequences of The Museum of Modern Art? And yet it speaks for a specific moment in the history of twentieth-century art, even if it is not one that at present has many admirers."[5]

"He draws elliptically, euphemistically," the film critic Frieda Grafe writes about René Gruau, isolating the quality so many others inherited, directly or indirectly, from Bérard.[6] Tracing the meander of influence, beginning with his particularly disarming quality of line, reveals an alternative, lacelike genealogy between and above distinctions and artistic categories and circles. How do Vuillard and Maurice Denis relate to Vertés, Schiaparelli, Beaton, Saint Laurent, Warhol? Liquid, loose, debauched, cowardly, refined, weak-willed, delicate, gentle, licentious.[7]

Bérard's room in the Institut Guerlain is a caricature, an interposition, an illustration, a frontispiece, an antechamber. In decoration, bodies make gestures around windows, beneath pediments, and carry expressions you wish people would make in real life. "That is all that is left—but how strong."[8]

"Bérard slowly returned to life while playing odd games of solitaire. He had replaced some of his playing cards, worn out and tattered, with the backs of cigarette packets on which he had painted fantastic numbers and figures in red and black ink: in this way he did not have to bother to turn over the cards to know their value or suit. The outcome of this game was unpredictable anyway, since in order to obtain the desired results, Bérard shuffled the cards about arbitrarily, without observing any of the rules of the game. On some days, abandoning the cards, he would decide to open his correspondence, which was often left to accumulate on the bedside table for days at a time. Or sometimes he would lose himself in detective novels, which he always began at the last chapter. Whenever the telephone rang and Marcel picked up the receiver, Bérard would listen to him as he asked loudly who was calling and would then invariably shout: 'I'm not here!'"[9]

NOTES
1. Walter Benjamin, *The Arcades Project* (Cambridge, MA: Harvard University Press, 2002), 106. 2. Pierre Guyotat, *Coma* (Los Angeles: Semiotext(e), 2010), 40. 3. Jean Clair, "… The Most Elegant Woman in the World…," in *Christian Bérard*, ed. Boris Kochno (London: Thames and Hudson, 1988), 81. 4. Jean-Louis Barrault, "Christian Bérard and the Theater," in *Christian Bérard*, 146. 5. John Russell, preface to *Christian Bérard*, 7. 6. Frieda Grafe, *Schnittstellen* (Berlin: Brinkmann & Bose, 2006), 49 (author's translation). 7. Words attached to a series of paintings by Ull Hohn taken from a list of adjectives describing homosexuality in early Christian texts that was collected by John Boswell in *Christianity, Social Tolerance, and Homosexuality* (Chicago: The University of Chicago Press, 1980). 8. Odile Fillion, "Christian Bérard, Decorator," in *Christian Bérard*, 229. 9. Boris Kochno, "My Years with Christian Bérard," in *Christian Bérard*, 48–49.

NICK MAUSS *was born in 1980 in New York. He lives and works in New York.*

Study for *Concern, Crush, Desire*, 2011. Cotton appliqué on velvet, brass doorknobs, and door stoppers, 131 x 94 x 115 in. (332.7 x 238.8 x 292.1 cm). Collection of the artist

LAST FIGHT

5 KNOCKED OUT.

acting in fights

lil homies I wanna show

Oh. liberal doesn't mean
 blunt.
 I know. I know

Kiss ideas

DVD player?

M: No need to ha
 to cry.

~~gonna die~~

✗ make a dec
 about B exit t
college form —

M: Nolls changes—
 scream

✡ ✡ ✡

last fight (old?)
lost intensity

5: Lazy in face
 cant see
 blood.

This goes out to th
 angels of th old

1. GRAY TEXAS A
2. MR BLOM A
3. ALLONS LAFAYETTE C

T: What's your earliest memo
B: Um... can't remember.
T: 70's? 60's?
B: probably 70's...
T: yeah. Doesn't it seem unpo
 far away?
B: yeah. yeah!
T: Right?
B: ~~yeah.~~ yep.
T: wrong, tho.

Scene to work

RICHARD MAXWELL was born in 1967 in West Fargo, North Dakota. He lives and works in New York.

RICHARD,

HERE IS THE UPDATE :

06/06	SOLD	35
	RESERVED	43
	BLOCKED	3
		= 151
07/06	SOLD	116
	RESERVED	55
	BLOCKED	18
		= 225
08/06	SOLD	154
	RESERVED	60
	BLOCKED	5
		= 223
05/06	SOLD	92
	RESERVED	108
	BLOCKED	8
		= 208

THE CAPACITY OF THE THEATRE IS 225.

Savitha

✓ Scene. S gets hired.
✓ Scene. A gets kidnapped
✓ Scene. mourning A
✓ Scene. S gets fired
✓ Scene. M gets hired
✓ Scene. J gets captured
✓* Scene. T kicks M out
✓* Scene. B takes M in
✓ Scene. M frees J
✓ Scene. T fires M
✓ Scene. B quits
✓ Scene. S + T defeat J + A

Brian's personal life
(unseen life)

Special thanks
Aaron Landsman
Tony Vazquez
michael schmelly
— desk for Stomping

12 - 6

12-1 talk thru
1-2 warm up
2-3 ~~block thru~~
3-4 lights
4-5 lunch
5-6 notes

I'M TIRED OF BEING
ANGRY.

The year of
the cat ?

Francesca Marcicconi ?

우put back

close back.

Here it is

〰〰〰〰〰〰〰〰〰
〰〰〰〰〰〰〰〰〰
〰〰〰〰〰〰〰〰〰

Kitty! What wrong

S: let her momenter late

□

W: Mommie! You found m

Kate, used to think
I thought I was
better than your
average man.
it turns out
I am everyman
All the hate
if you see it
they do too.
The self
Kate, let go
of me
Danny holds up
the building's
facade.

Danny she Vial
 Vile
ent

the whole
world of
hate
awaits
when you're
in bands

the world of snobs

3rd verse
A. using
 'idiot'
Ridersville
 dancing
B: crotch
series
pauses after
scuffle

[rifle + s]
A - hair - curls?
A lookzto
{E: welk
 A follow
 A/E
 listen;

A before of course
my brother is the

And then 1 day
she stopped
laughing. I
couldn't
Ever make her
smile. Something
went wrong.
Fucked around
couldn't get
anything done.

a. piano – takes guitars 3's
ends or high a

10

li-bass v. tuba ?

0/

Y: A m ?

19:05

start w/ profil in place.

narita start cue?
listening
loon noise
lights
?: digging root canal
out throwing wolfgang
time v/ otto – loud 2, angry

Please lend me eyes + ears
Then you give me presence here
I'll get it over my fear
Pls believe that I'm sincere
(pls) you'll understand
B
(they'll do it for you
they will
Have faith (Carl)

Here comes the moment please

It's breaking open now
Cutting across time now
How does the moment feel?
How will the rupture heal?

like wildcat blazes
The rapture amazes
o how awful it all is
How simple it is

Here comes the moment please now
and I want to pls you pls now
Pleas I entreat you pls
I'm down on my knees

Stolen time

Seguidas

1: (studies menu)
what's that?
2:
1: ~~whats that~~ ?
2: huh?
1: ~~what is this~~ what is this?
2: ~~this too~~
1:
2: Shut up
 motherfucker.

"fits in
w/ went.

going for yrs
w/out calling

on it. or

Iver expects

it?

maniac (term

of endearment –

old school)

□ Mo-fo

"just off 5th ave."

w/ chips or fruit or
soda

~~blow~~

Ice Cream cup 1.
 pops 2.

Top-left page

2. cut "don't pay attention". B- 'let's go.' I'm not coming back
3. end of Roma.
4. Gerlach sp. 1 + 1st crowd
5. university. pp 3
6. Gerlach get ready for his speech
 1st scene. W. follows.
7. worlds 4 people. pp 2 port you
8. b/x crowd- pickpocket bloch
9. are you gonna pay me
10. your always that - to H
11. place bar comfort
12. chas to Darrel/H - make out w
13. add sc B/H pull from bank
14. move forest sc.
15. cuts to boat.
16. cut to MT speed
17. move MT Song.
18. post card to Will
19. cut O she's back.
20. cuts to Ger B speech
21. gaff
22. tooth up Kay



☒ Minna to she wear scene?

R: enuff tash to la to whole 1st

— Block forest sc
→ W: go to town

Otto differen between & + anys

Otto put W fist - push out.

W: get letter @ steal
break up meeting -/ speech

N: ptd ?



AND NOW, A-1 Steak Sears

BEC INDUSTRIES IN CONDUCTION
EXECUTIVE DECISION MARKETING
ARE ASSEMBLING A TARGET
DEMOGRAPHIC IN THIS AREA—
TESTING A PROMOTIONAL STRATE
C/ PRICE WATERHOUSE. SPECIAL
PLEASE ENJOY ST MARKS CHURCH. PAID
PROMOTION THE PROGRAM



A-1 ROLLING STEAK HOUSE

different scenarios
for Toga.: subjects

 driving long distances
 places ive been
 different bands
 whos that girl/boy ?
 different drugs
 whats better: pot or co
 pot or b
 diamond sale @ DeBeers.
 contest (mail in)
 another contest.
"a few good movies.."

PHOSPHOGATE

- Early morning coffee
scene w/ Frances caffeinated.
burns — other 2 hours
later — burns out — back
where they started — coffee
has worn out.

I saw myself w/ broad hats
I saw French hustlers

Structure A ⟶ B

Cowboy outlaw scene

COWBOYS IN A CIRCUS

Cowboy argues about
what territory they're in.
"... This is Utah territory. Right
here you in Utah Territory."
"But can you see Utah territory
"What?! Look this is Utah territ

this is Utah territory. That
grass.

G⊛ Song - wait

an - ight.

opening present

J. offended

Horseboy

A. No - pat.

Voice

Sweet.

I divided space in
some scenes ??

- block opening ala '1st'

- Zone v lobby (what is
this place)

- maddog Introductions?

B

D

AND NOW, A-1 Steak Sauce

BEC INDUSTRIES IN CONJUCTION W/
EXECUTIVE DECISION MARKETING
ARE ASSEMBLING A TARGET
DEMOGRAPHIC IN THIS AREA —
TESTING PROMOTIONAL STRATEGY
c/ PRICEWATERHOUSE SPECIAL
PLEASE ENJOY THIS PAID
THE PROGRAM

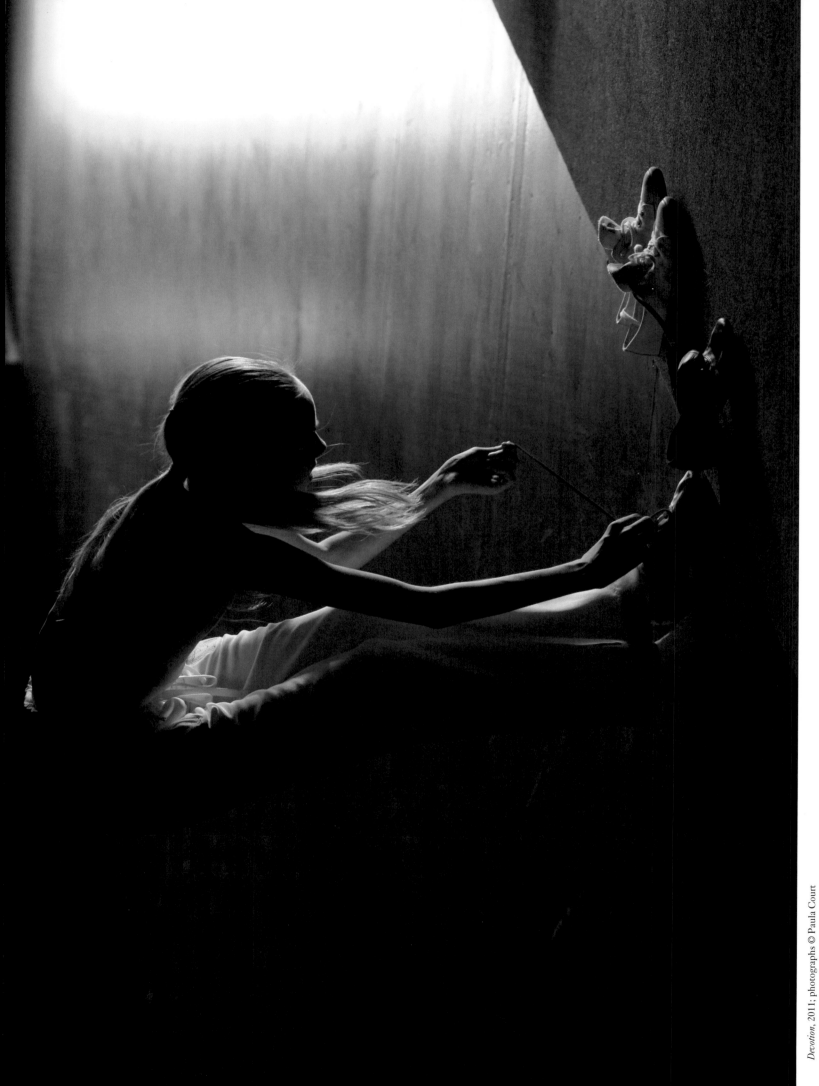

SARAH MICHELSON *was born in 1964 in Manchester, England. She lives and works in Brooklyn.*

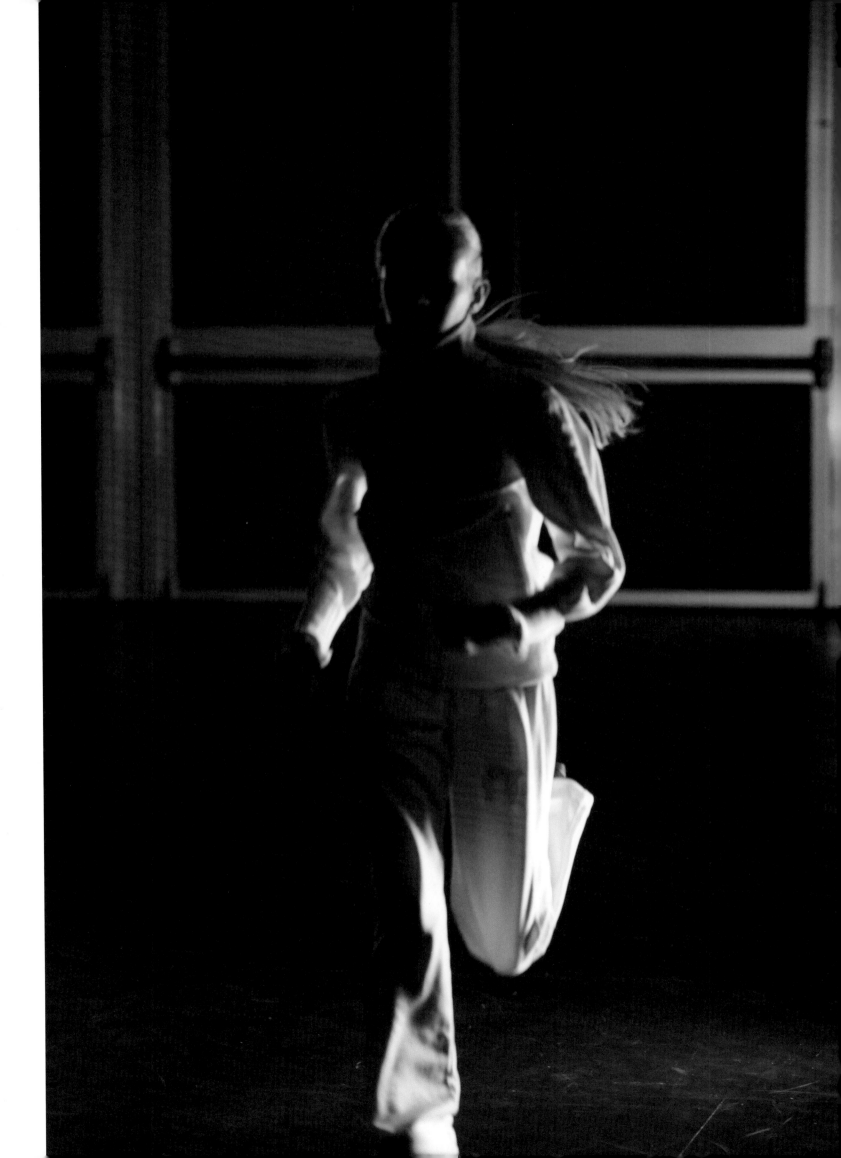

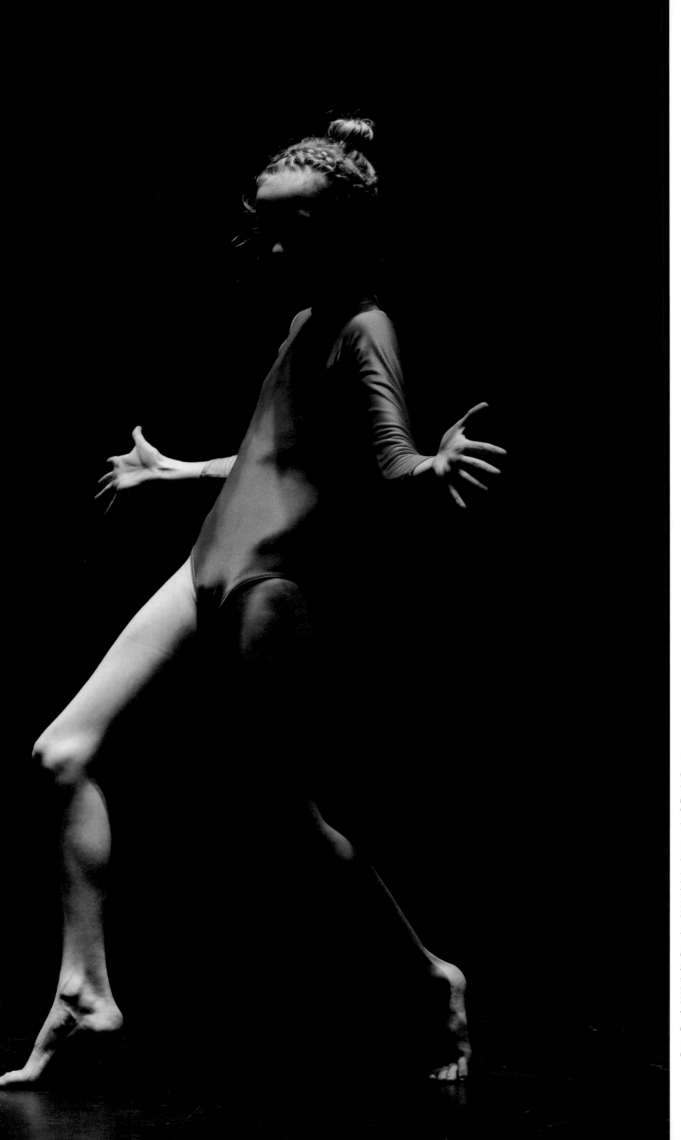

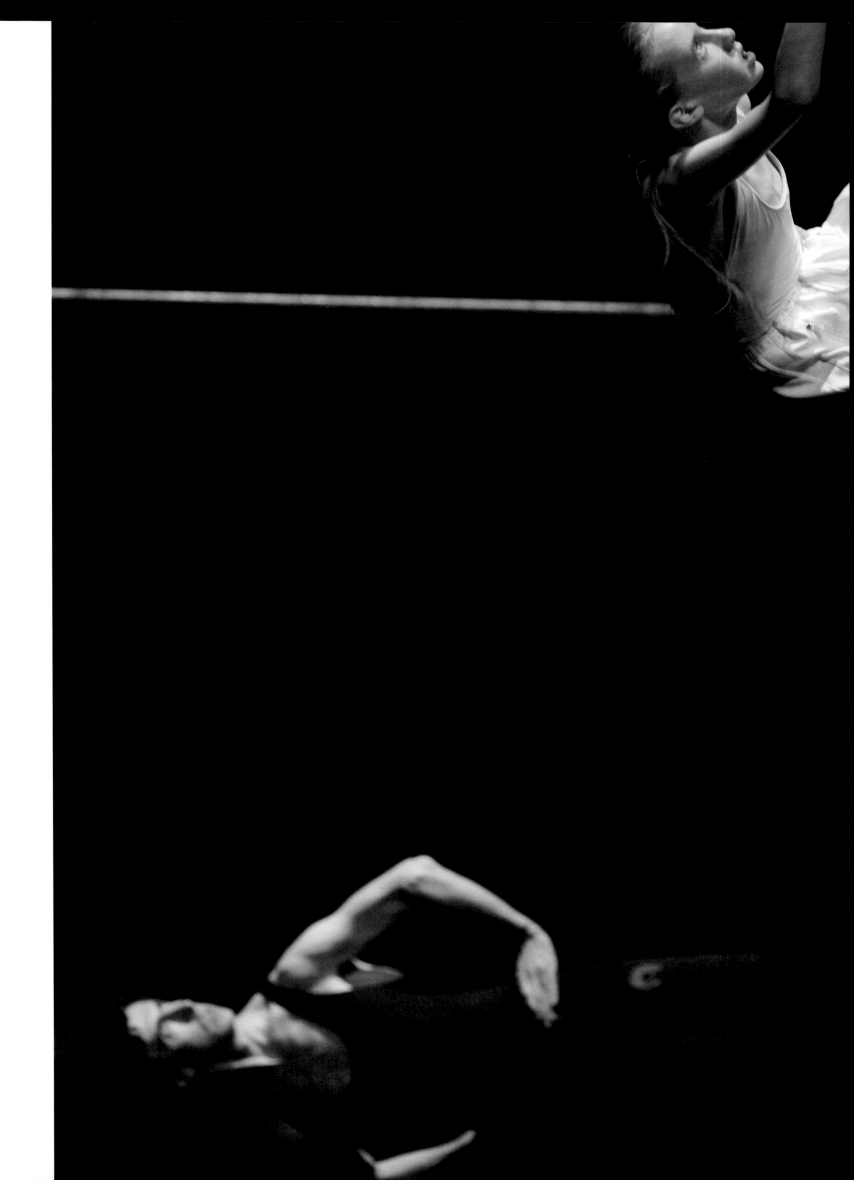

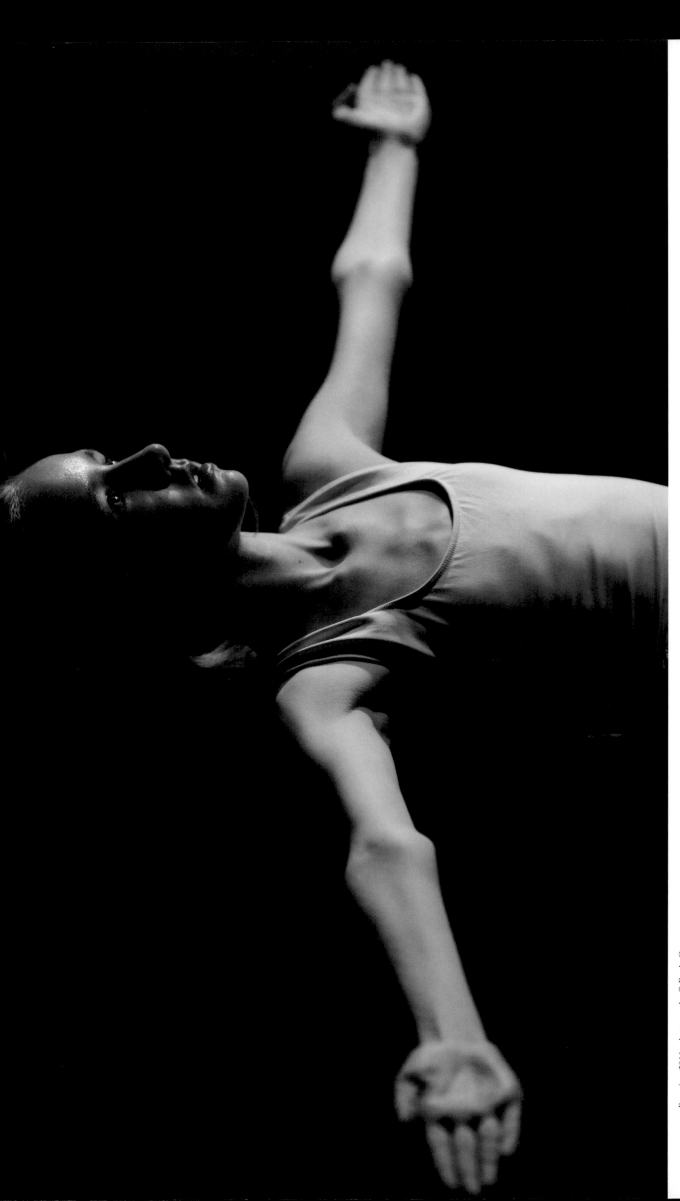

Inside Out with Alicia Moran

DAPHNE A. BROOKS

Mezzo-soprano Alicia Hall Moran uses suspense like a boxer, adroitly manipulating timing, remaining unpredictable, holding back one moment, flexing another. The presumption that a vocal artist will "attack" a song is now de rigueur. But beyond technical virtuosity, Hall Moran has gained attention for a body of distinctive performances that explore presumably familiar aesthetic territory with dexterous audacity, wicked humor, steadfast swagger, and gorgeously assured, beautifully crafted movement. Cutting and mixing musical concepts, aesthetics, and modes, she uses avant-garde musical praxis as a form of cultural excavation and (re)discovery.

Born in 1973, Hall Moran is a mediator and translator of multiple aesthetic languages for our modern age. As a black female vocalist, songwriter, arranger, actor, and public intellectual, she slips slyly into what Ralph Ellison (and so many others) might call "the breaks" of contemporary musical possibility and challenges us to hear the resonating mosaics in contemporary music culture.[1]

"SET ME FREE, WHY DON'T YOU BABE?"
The power of music reads across all lines when your head hasn't been filled with strange concepts of hierarchy. —AHM

But how will she dance the habanera? Hall Moran's "L'amour est un oiseau rebelle" from *Carmen* comes late in the set of the critically acclaimed *Motown Project*, her innovative exploration of the Berry Gordy canon by way of a lively conversation with a classical repertoire. By the time Bizet's aria crops up, it is clear that the singer will have her way with it. This is signature Alicia Hall Moran assuming the eloquently conceived role of a post–Civil Rights heroine chanteuse, a subversively complex musical persona.

As musicologist Guthrie Ramsey observes, "The idea of thinking about Motown recordings as a Schubertian song cycle winding through the stages and associated emotions of a love affair—from declamation, assurance, doubt, disappointment, to anger—[is] brilliant."[2]

Saucy and fancy, brooding and commanding, Hall Moran delivers high drama throughout the *Motown Project* as she finds the enthralling tenderness of Marvin Gaye and Tammi Terrell in the seduction song of Saint-Saëns's *Samson and Delilah*, the angst-ridden cries of Mozart's "Voi che sapete" in the love addiction that keeps the Supremes "hangin' on."

Toggling between affective registers, she locates desire and self-fulfillment, rebellion and commitment, freedom of movement and the joys of romantic stability. Hall Moran's *Motown Project* is akin to what the cultural critic Fred Moten describes as a "chromatic space." It is a site where excess and musical saturation flow and "overrun a normative musical matrix" so as to yield radically layered sounds. It insists that audiences recognize the complementary and mutually constitutive ways in which disparate traditions speak to and inform each other. Here in Hall Moran's luminous universe of antiphonal, intergeneric encounter, "opera and Motown reveal their deepest symmetries," writes Ramsey.[3]

Hall Moran's post-soul race woman is an anti-diva who conjures emotional common ground between the classical concert artists the singer has admired since childhood (think Marian Anderson, Leontyne Price, Jessye Norman, Shirley Verrett, and Kathleen Battle) and the jazz and pop artists on our play lists (consider Billie Holiday, Ella Fitzgerald, and Abbey Lincoln; Aretha Franklin, Valerie Simpson, and Diana Ross).[4] For Hall Moran, who came of age in New York City and Stamford, Connecticut, these artists mirrored modern black womanhood. They taught her that revelations can travel by sound and, likewise, that sound-travel can operate as a mode of cultural critique.

INSIDE OUT: POST-SOUL DREAMING & DRIVE
I grew up with systems and words going on at once. My dad could fly an airplane; he ski raced, rode a motorcycle, scuba dived, and he still captains a sailboat into open waters. He's a businessman and probably a mathematical genius. My mother is an editor and seems to live inside one big poem, ultimately driven by words.

Genealogies—spiritual, cultural, familial—still matter in our ever-evolving post-soul era. Hall Moran's cosmopolitanism is rooted in pre-millennial, pre-9/11, social and political agitation and liberation. Today we have decades' worth of articles, books, and documentary films that focus on the "Joshua generation," those individuals born in the wake of *Brown vs. the Board of Education*, Civil Rights legislation, and black power activism, and we know much about what these "soul babies" (as black studies critic Mark Anthony Neal calls them)[5] were bequeathed: unprecedented sociopolitical opportunity alongside persistent backlash in the bid to fulfill the dreams of previous generations. Into this tight-knit black cultural and intellectual community, Hall Moran fits, and to it, credits her drive and focus. Having absorbed it, she has, in many ways, used her career as a template to translate her milieu—into a musical meditation.

I concentrated in music and anthropology at Barnard, and if I learned anything there, it's that you got to get your paradigms in order!

In this way, one might liken her to fellow Barnard alumna Zora Neale Hurston, the noted anthropologist who recorded the sounds of fleeting folk cultures, archiving and then performing the sonic remnants of black America in transition during the Great Depression.[6] Like her, Hall Moran emerges in our millennial culture as a journey-woman exploring issues of identity and personal history with shrewd intelligence and empathy. The whimsical, mobile eccentricity of her performances attests to her inventive fluidity in the role.

I am kind of the most resourceful outsider. I can't think of anything I am really on the inside of except the INSIDE of things.

Diverse artists find Hall Moran's "inside/out" approach a perfect vehicle. Rich relationships with conceptualist Adam Pendleton and artists Whitfield Lovell, Deborah Willis, and Simone Leigh, for instance, inspired an ongoing series of site-specific performance and video work. Hall Moran has also found a welcome place in the densely ruminative realms of Bill T. Jones's dance company and of performance artist Joan Jonas. As Janet Wong, associate artistic director of the Bill T. Jones/Arnie Zane Dance Company, observes of Hall Moran's crucial role in the elegiac *Chapel/Chapter*: "In many ways, she was the anchor that centered the three interwoven narratives that made up the piece. We

thought we were looking for a singer, but we found a composer and a collaborator as well."[7]

An archness born of her inside/out viewpoint (art historian Huey Copeland alludes to it, referring to a style of "perfect inscrutability") enables her to cultivate a musical persona that is resolutely free, even within collaborative contexts. Her most frequent and beloved collaborator is Jason Moran, the acclaimed jazz pianist. The Morans have honed a multilingual approach to performing with one another that braids yet preserves each of their singular aesthetic voices as musicians.

OUTSIDE IN: THE BLACK WOMAN'S ART OF SONIC DIPLOMACY
My ability to "perform" classical in the contemporary context of most of my collaborations comes from this fact that I am on the outside of opera. If I were on the inside, I would not be able to look at it the way I do.

The roving career of Etta Moten Barnett, the early-twentieth-century black activist, stage and screen actress, singer, and African diaspora feminist, resonates closely with Hall Moran's multitasking.[8] Tactfully, skillfully, gracefully, such women subvert alienation with their sonic diplomacy.

That Etta Moten would play Gershwin's Bess, a woman way on the outside of Catfish Row in the 1940s Broadway revival of *Porgy and Bess*, and that Hall Moran would reimagine, understudy, and play this mythic figure in 2011 while performing in the new American Repertory Theatre production of *The Gershwin's Porgy and Bess*, points to a stunning convergence.

Situated between classical and musical theater, *Porgy and Bess*, as music critic Alex Ross contends, "perform[s] the monumental feat of reconciling the rigidity of Western notated music with the African-American principle of improvised variation."[9] The opera draws as much from the influences of Alban Berg as it does from the iconic choirs of Hall Moran's great-great uncle Hall Johnson, pioneer composer and arranger of Negro spirituals for the Harlem Renaissance generation.[10] How perfect, how fitting it is for Hall Moran to be invited to explore this territory and its timeless archetypes, inside out.

NOTES
1. Ralph Ellison, *Invisible Man* (New York: Vintage, 1995). See also and for instance, Albert Murray, "Improvisation and the Creative Process," in *The Jazz Cadence of American Culture*, ed. Robert O'Meally (New York: Columbia University Press, 1998), 111–13; and Fred Moten, *In the Break: The Aesthetics of the Black Radical Tradition* (Minneapolis, MN: University of Minnesota Press, 2003). 2. Guthrie P. Ramsey, "From Mozart to Motown: Alicia Hall Moran's Motor City Musings," *Dr. Guy's MusiQology*, http://musiqology.com/2011/01/08/from-mozart-to-motown-alicia-hall-moran's-motor-city-musings. 3. Ibid. 4. For more on "race women" in popular music culture, see Farah Jasmine Griffin, *If You Can't Be Free, Be a Mystery: In Search of Billie Holiday* (New York: One World/Ballantine, 2002); and Ruth Feldstein, "'I Don't Trust You Anymore': Nina Simone, Culture, and Black Activism in the 1960s," *The Journal of American History* 91, no. 4 (March 2005), 1349–79. 5. Mark Anthony Neal, *Soul Babies: Black Popular Culture and the Post-Soul Aesthetic* (New York: Routledge, 2002). See also Greg Tate, *Flyboy in the Buttermilk: Essays on Contemporary America* (New York: Simon & Schuster, 1992). 6. Daphne A. Brooks, "Sister, Can You Line It Out?: Zora Neale Hurston and the Sound of Angular Black Womanhood," *Amerikastudien/American Studies* 55 no. 4 (2010), 617–27. 7. Janet Wong, quoted at http://www.aliciahallmoran.com/press.html. 8. For more on Etta Moten Barnett, see her stunning interview in the "Black Women Oral History Project, 1976–1985," Sophia Smith Collection, Smith College, Northampton, MA. 9. Alex Ross, *The Rest Is Noise: Listening to the Twentieth Century* (New York: Picador, 2007), 163. 10. See Hall Johnson, *The Hall Johnson Collection* (Carl Fischer, 2003).

ALICIA HALL MORAN & JASON MORAN *Alicia Hall Moran was born in 1973 in Redwood City, California. She lives and works in New York.*

Out of Place and Out of Line: Jason Moran's Eclecticism as Critical Inquiry

GUTHRIE P. RAMSEY JR.

From the late nineteenth to the early twentieth centuries, African American musicians inhabited a world of hustle on ecumenical fronts. Long before our present-day ideas about genre had become stubborn, calcified categories, a more porous performance culture existed. And black musicians rarely "stayed in their place" but rather worked across invisible boundaries. Opera singer Sissieretta Jones, with a legendary career on the international concert stage, could find easy work on the minstrelsy circuit. The classically trained violinist Will Marion Cook unapologetically wrote, in collaboration with poet Paul Laurence Dunbar, the pioneering musical-comedy sketch *Clorindy; or, The Origin of the Cakewalk*, which premiered on Broadway in 1898. Scott Joplin, the ragtime pianist/composer who got American audiences dancing their way out of Victorianism, also composed the groundbreaking opera *Treemonisha* in 1911. You get the picture; it was all about stretching, as they say.

That tradition lives on in Jason Moran, the recipient of a MacArthur "genius" grant in 2010. A prodigious composer and pianist, he has reshaped our times artistically by challenging the very idea of category, aggressively pushing out at the edges of jazz's sometimes defensive palisade, crisscrossing artistic media, and turning this family of idioms on its head. Some would, indeed, call such audacious attitude, genius. In a mere ten years, he's built a highly visible and prolific career on an unusual endowment of technical facility through which he expresses something that audiences around the world, the moment they experience it, perceive as "universal," "timeless," or transcending. I'm dubious, however, that Moran himself is thinking about transcendence or, for that matter, a slippery term like *genius*.

I believe Moran uses the mechanics of delivery and his profound sense of social constitution—his knowledge of how musical codes "work"—to anchor listeners in a deep sense of the "present tense." Moreover, the way I see it, Moran's work, despite his reputation, is rarely a matter of isolated, rugged individualism. As Moran demonstrates time and again, it's more often a collaborative affair, one through which artistic communities in motion become, one by one, living models of thoughtful and meaningful social interaction—something that we all, I believe, are born to desire, and he was born to achieve.

How's he do it? Moran's artistic palette encompasses more than music. It interrogates how all of the arts—music, film, poetry, architecture, design, dance, and painting—can directly inform each other. Because of his ecumenical approach, his work has helped to expand not only the language but also the large possibilities of both the contemporary jazz scene and the visual art world.

Starting with his recordings as both leader and sideman, you can trace the development of an artist exploring new and eclectic sound worlds. In his performance rhetoric—one that is instantly recognizable—you can hear many of his wide affinities: the Southwest blues, traditional jazz, contemporary modal, and the influences of Berg, Monk, Webern, and more. I can think of no other young pianist on the jazz scene today who seems to be in perpetual artistic motion—constantly searching, forever challenging and chiding his muse. He has engaged in collaborations with museums, choreographers, art historians, poets, and performance artists, embracing the power derived from unusual juxtapositions. He is, arguably, the most critically engaged pianist to emerge on the jazz scene in years.

Recently, I witnessed Moran in an intimate live performance with his band of ten years, the Bandwagon. Surrounded by a clutter of written scores, they moved up something serious as they played an adventurous set of compositions from past projects and their latest CD, *Ten*. They opened with a powerful reading of an Alicia Hall Moran composition, "Blessing the Boats," which was packed with sly ostinato figures on the piano, pushy pop musical gestures, and sinewy melodies winding through tricky harmonic environments. The empathetic and telepathic virtuosity demonstrated between Moran and his colleagues (drummer Nasheet Waits and bassist Tarus Mateen) astounded. These very strong musical personalities are not simply a backdrop for Moran's musings: they are essential to the sonic mosaic that has become his vehicle in much the same way as Duke Ellington's orchestra was for his.

Throughout the set, Moran's performance rhetoric included full-voiced gospel-style chords in the right hand with single-note doublings with Mateen; Earl Hines's "trumpet style"; Bud Powell-esque bebop lines; Cecil Taylor-like passages of dissonant, florid pianism; and gutsy tremolo passages that sound like vocalized field hollers straight out of the ring-shout rituals of black expressive culture. His most intense solos move rapidly between arpeggios superimposed over dissonant harmonic structures and spirited scales. As Moran combines this rhetoric during the course of several songs, one experiences in real time a white-knuckled virtuosity awash in dizzying counterpoints of melodies, timbres, and polyrhythms that ebb and flow in apparent spontaneity.

His compositions are studies in the economic use of emotional momentum. Many move from precious, pithy statements into grand pronouncements and back again. Some leave you on the mountaintop, breathless. The Bandwagon achieves these in the context of grooves that, while infectious, are not easily digested. That is, one has to concentrate to perceive the large structures of their form. They are not built on smallish cyclic harmonic patterns but on larger-scale patterns of repetition. Moreover, because of their length, they can sound like seamless multimovement jazz suites. Their grooves take on many rhythm configurations: from soupy, down-home blues, hard bop swing, or rhythm rhetoric from rap and more contemporary sound worlds. Moran's occasional use of onstage pre-recorded sounds gives the effect of an installation art piece, where we in the audience are snapped out of our typical listening positions and drawn into a more intense listening and visual relationship with the band.

And speaking of art pieces, consider Moran's extraordinary collaboration with Adrian Piper in the commission *Milestone* for the Walker Art Center in 2005; with Kara Walker on her film *Six Miles from Springfield on the Franklin Road* (2009); and with Glenn Ligon on the film *The Death of Tom* (2008), recently installed at the Museum of Modern Art. Ligon also created a painting for Moran's multimedia *In My Mind: Monk at Town Hall 1959* (2007). Moran's compositional signature and improvisational rhetoric are forces now that stretch across the landscape of contemporary art. These and other examples, including Moran's scores for performance artist Joan Jonas and for Alonzo King's Lines Ballet, recall and extend black American musical cultures in the past, when creating together was a way to transgress boundaries, not reify them. In the decades leading up to high and heavy years of the Civil Rights and Black Consciousness movements, African American artists across the board believed that their work could collectively engage, interrogate, and challenge the status quo. A quote from the late poet Gwendolyn Brooks captures this energy:

> My husband and I knew writers, knew pianists and dancers and actresses, knew photographers galore. There were always weekend parties to be attended where we merry Bronzevillians could find each other and earnestly philosophize sometimes on into the dawn, over martinis and Scotch and coffee and an ample buffet. Great social decisions were reached. Great solutions for great problems were provided… Of course, in that time, it was believed, still, that society could be prettied, quieted, cradled, sweetened, if only people talked enough, glared at each other yearningly enough, waited enough.

I've attended a Moran house party and can testify that this kind of energy still thrives. There's more at stake in his circle than socializing and collaborating for the hell of it; it's even larger than making art objects for their own sake. Rather, the whole enterprise—the art, the music, the building of a collective—is about what art historian and curator Kellie Jones has recently called "community archive," a quest for a larger meaning through art. For her, the idea describes "how artistic communities—be they families of origin [or families by marriage], groups, movements, neighborhoods, and so on—create and theorize their pasts, illuminating the dialogic among individuals and the collectives to which they belong, and in which artistic meaning is derived." (But please don't think there's not good food and music, too!)

Jones was asked by *Artnews* back in 2007 to predict who the art world would be looking at 105 years hence. She said Jason Moran, and many of us agreed. Since that time, he's continued to experiment, traversing sonic, performance, literary, and visual art worlds, and then comes back to share what he's learned. Like his predecessors from well over a century ago, Moran with his approach obliterates boundaries, colors outside the lines, and poses a critical question: "Whose worlds are they anyway?"

Jason Moran was born in 1975 in Houston. He lives and works in New York.

Teamwork is a discipline. Here we found ways of using language—in this case jazz lingo—and instrumental/vocal technique to find deeper meaning and more specificity

in the work. An operatic vocal range can elevate the mundane, and Jason's jazz vocabularies lend cultural immediacy. Together, we generate a sort of retrofitted urbanity;

but even with classic musical forms, the goal is to keep the conversation in the here and now. —Alicia

Rehearsing for the premiere of *Slang* (Other Minds Festival of New Music, San Francisco, 2011). Video stills from a forthcoming documentary on Jason Moran by Gregg Conde and Radiclani Clytus

The Shape, The Scent, The Feel of Things *was my first collaboration with the storied performance artist Joan Jonas. I spent three months in the basement of Dia:Beacon with Joan and the ensemble, sculpting a live piano score. Joan's percussive response to one of the tunes evolved into a duet we called "Refraction." Later we recorded this song for my album* Artist in Residence *(Blue Note).* —Jason

Photograph © Paula Court

Joan Jonas, *The Shape, The Scent, The Feel of Things*, 2005–6. Performance, Dia:Beacon

Mary Lee Bendolph, *Mama's Song*, 2005. Cotton corduroy, 33 x 24 in. (83.8 x 61 cm). Collection of the Souls Grown Deep Foundation

The Philadelphia Museum of Art commissioned a response to their exhibition,
Gee's Bend: The Architecture of the Quilt *(2008) from Jason. He tapped me, the*
guitarist Bill Frisell, writer Asali Solomon, and the Bandwagon to realize compositions
he built in imitation of the geometric phrases suggested by certain quilts and the
expressivity of others. Time spent in Alabama with the artisans themselves in their studios
greatly informed the entire creative—and eventually, spiritual—process. —Alicia

The assignment was to gather a choir of voices, select soloists (Renee Neufville and Vaneese Thomas) and customize gospel arrangements for this artist, but the entire production was thrown for a loop when Alicia dropped out of the process to deliver our twin sons prematurely. The piece was rehearsed and premiered while she was up in the hospital, so there was nothing manufactured about the flood of spirit that erupted from the performers that night. The music delivered us. —Jason

Adam Pendleton, *The Revival*, 2007. Performance, PERFORMA07

Kara Walker's films depict racially motivated gang violence and sexual assault. Unlike her works based on fantasy, these films illustrate factual accounts. The challenge compositionally was to stay with Kara's characters, moment to moment, through horrendous circumstances. Jason favored sonic density and used my composition, The Field, *for the melody. —Alicia*

Kara Walker, video stills from *National Archives Microfilm Publication M999 Roll 34: Bureau of Refugees, Freedmen and Abandoned Lands: Six Miles from Springfield on the Franklin Road*, 2009. Digital video, color, sound; 13:22 min. With original music by Alicia Hall Moran and Jason Moran

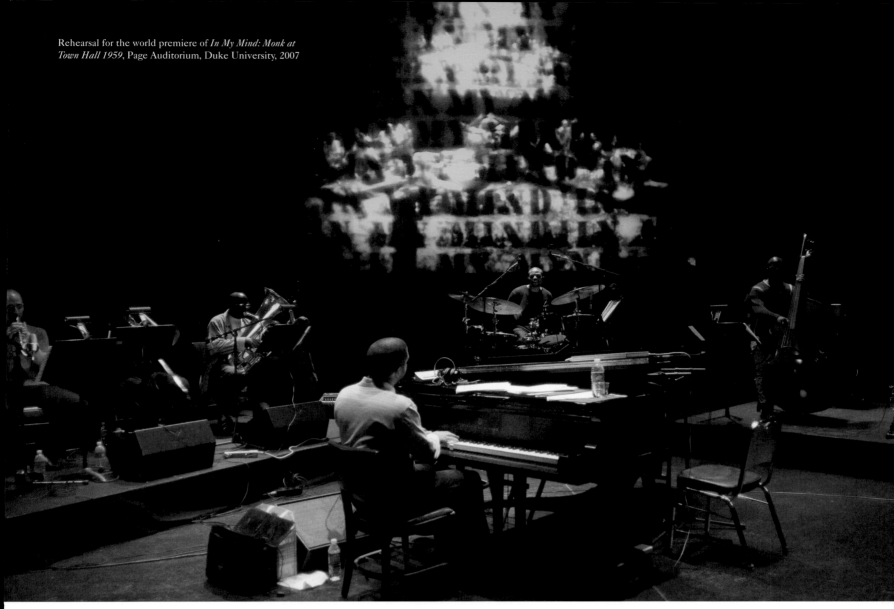

This is a concert work for big band commissioned by Duke University. I summoned musicians to investigate pianist Thelonious Monk's musical and personal histories via reimaginings of the classic arrangements of Monk's important 1959 concert at Town Hall. Video artist David Dempewolf, who traveled with me to film Monk's North Carolinian origins, and Glenn Ligon, whose painting we manipulated and projected on a large backdrop, supplied the visual narrative. —Jason

Liz Magic Laser and Simone Leigh in collaboration with Alicia Hall Moran, video stills from *Breakdown*, 2011. High-definition video, color, sound; 8 min.

This film by Simone Leigh and Liz Magic Laser manifests a deep interest in the expressive potentials of the voice. To elicit a "breakdown" in song, they flirted with performative stereotypes but were quick to reject them. The filming of this piece was wedged between some intense auditions for the role of Heyward/Gershwin's Bess (for the musical-theater version of Porgy & Bess, *directed by Diane Paulus) and a cabaret act I performed with Jason looking at Berg's Lulu and Hollaender's Lola Lola from* The Blue Angel *in one program. It was a season of general madness. —Alicia*

9/11 TRILOGY

Still from *Untitled Part III*, 2012 (in progress). High-definition video, color, sound

LAURA POITRAS *was born in 1964 in Boston. She lives in New York and works internationally.*

```
     16:52                    DOCUMENT FACILITY                      T2MX3401
TID=Z1WQ                TECS II - INCIDENT LOG REMARK               T2PX3406
INCIDENT REPORT NUMBER: 20084701001864
NAME: LAURA   POITRAS
```

█████████ International Terminal 4. February 12, 2008. Subject Poitras,
Laura, Female, DOB 020264. Flight RJ 261 from Jordan. ETA 1600. Gate Hard
Stand. ████████
 1625 - Report to Hard Stand Gate with CBPO ████████
 1637 - Flight RJ 261 arrived and blocked
 1641 - Poitras, Laura positively identified at Gate
 1650 - Pax referred by Primary to Full Primary by CBPO ████████
 1654 - CBPI Supervisor ████████ advised ████████
 1659 - Full Primary CBP Officer ████████ notified ████████
 ████████
 ████████ ████████
 1720 - ████CBPO ████████ authorized release of pax
 1725- 100% baggage inspection with negative results
 1734 - Pocket trash, literary and Passport pages copied with consent of pax
 1751 - Pax released without further incident

17:22:43 IO95 INSPECTION COMMENTS

+------------------- I N S P E C T I O N C O M M E N T S --------------------+
████████ SUBJECT STATES SHE IS DOCUMENTARY FILMMAKER
WHO IS WORKING ON PROJECT IN THE MIDDLE EAST. ████████
████████ SUBJECT ADM USC W/ CONCURRENCE OF DUTY SCBPO.

+---+

PAGE 1

(b) (2)

(b) (2)

(b) (2)

NAME: LAURA POITRAS

PAGE 1

+------------------- I N S P E C T I O N C O M M E N T S -------------------+

PAX MET AT GATE BY CBPO'S ███████ (b)(6)(b)(7)(c) ██████/PAX WAS A MATCH TO BOTH AN NCIC

(b)(2)(b)(7)(e) ████ (b)(6)(b)(7)(c) ████ (b)(2)(b)(7)(e) ████ OFFICER ████ (b)(6)(b)(7)(c) ████

(b)(6)(b)(7)(c) REQUESTED FULL SECONDARY,COPIES OF DOCS AND POCKET LITTER/ALL OF THAT REQ

UESTED INFO WAS OBTAINED ████ (b)(2)(b)(7)(e) ████ PAX'S CARRY O

BAG AND 2 CHECKED BAGS WERE SEARCHED 100% W/NEGATIVE RESULTS/ ████(b)(6)(b)(7)(c)██ ██(b)(2)(b)(7)(e)██

██(b)(2)(b)(7)(e)██ @1550HRS ████(b)(2)(b)(7)(e)████ PAX WAS OK TO RELEASE ██(b)(2)(b)(7)(e)██ ██(b)(6)(b)(7)(c)██ — ██(b)(2)(b)(7)(e)██

(b)(2)(b)(7)(e) ██████ PAX WAS COOPERATIVE TO AN EXTENT BUT TOOK N

OTES DURING EXAMINATION AND ASKED FOR THE NAMES OF THE OFFICERS PERFORMING SAID

EXAM/PAX WAS THANKED FOR HER COOPERATION AND ESCORTED THROUGH BAGGAGE AREA/██(b)(2)(b)(7)(e

██████ (b)(2)(b)(7)(e) ██████

+--+

(b) (2)

SUBJECT: POITRAS, Laura DOB:2/2/64 DATE: 8/24/08
1055hrs: ████ via ████ requested full secondary and copies of
docs and pocket litter, ████
1355hrs:CBPO's ████ and ████ to gate 6 to affect bypass of Subject.
1430hrs:Flight EK 201 from Dubai, UAE arrives at JFK Terminal 4/Gate 6.
1440hrs:Subject is met at gate and escorted by CBPO's to FIS area.
1450hrs:Subject is referred into Passport Control Secondary to begin exam.
1500hrs:Subject's docs are copied and the 5W's are ascertained.
1530hrs:Subject's two checked bags arrive and are brought to secondary office
1540hrs:Subject's bags are searched by CBPO ████ w/negative results.
1550hrs:A call is placed to JFK ████ and CBPO ████ states that ████
████ the Subject is cleared for release, ████
1555hrs:Subject is escorted through Baggage control area and thanked for her
cooperation.
Note:Subject was cooperative to an extent during this examination.The Subject
took frequent notes during exam and requested the names of the two officers
conducting the exam. The Subject also voiced dismay at going through this
process "every time" she travels and asked for a suggestion as to how she can
avoid this in the future. Subject was given comment card and repeatedly
thanked for her cooperation.

At Approx:

0822 CBPO (b)(6)(b)(7)(c) and CBPO (b)(6)(b)(7)(c) escorted pax LAURA POITRAS d.o.b. 02/02/ 1964 to PP Secondary. At 0827 CBPO (b)(6)(b)(7)(c) assisted pax Poitras in re treiving her checked baggage from the baggage claim. Pax Poitras two checked bags were brought into secondary for inspection. Pax Poitras also had one car ry on bag and one purse. At 0835 CBPO (b)(6)(b)(7)(c) started searching pa x Poitras baggage. During the baggage search Pax Poitras engaged in conversio n, stating that this was the 15th time she had been stopped and escorted from the flight and questioned. Pax Poitras stated that she was a film maker and made the documentary film "My Country" about the war in Iraq. Pax stated that since her film was released she has been getting escorted from the plane int o secondary every time she enters the US. Pax Poitras also stated that she ha s contacted Senator (b)(6) and other Government representatives about her be ing "flagged" and yet she still is stopped everytime she enters the US. At 08 49 the baggage search ended with negative results. PAU was notified and relea sed pax at 0902. Pax was released from the FIS w/o incident. Pax was offered a comment card but declined it.

U.S. Military Interrogation
Afghanistan, 2001

Still from *The Oath*, 2010. High-definition video, color, sound; 96 min.

NSA Data Storage Center (under construction)
Utah, 2011

Still from *Untitled Part III*, 2012 (in progress). High-definition video, color, sound

M.A.P.

Matt Porterfield and Matt Papich:
On *Putty Hill*, Contemporary Photography,
and Lifestyle

November 6, 2011

MATT PORTERFIELD: Thanks for spending your birthday with me. May I have a smoke?

MATT PAPICH: Of course.

So I want to start talking about where the movie starts, when the credits are coming in. There's that ambient moment, of all the ambient moments that are in the film, the one at the beginning, of the light on the wall. The other one I was remembering as I was writing these questions is the one after the tattoo is being done; there's a look up at the wall again—and maybe there's light again, and there's the sound. There are a bunch of examples. To me, those ambient moments are sometimes more dramatic than the dramatic moments in the movie, because they give the audience an opportunity to realize what's been transpiring and kind of, like, breathe into the movie, begin to relate to the movie, so they actually feel, *Here I am in the theater, watching this.* The kind of moment where you see the space, you know? That's how I see them being used. I wonder how you think of these moments, how they're interspersed, and how you think the audience interacts with them?

PORTERFIELD: I think if it's a film about absence, which it is—our protago-

nist is gone—*what's left?* I've always been interested in letting physical spaces speak, through ambient images, and sound, too, and music—which can all be used for a diegetic, nondiegetic, and mimetic effect. The opening credits allow us to explore the character immediately through his absence. He's represented—Cory, the dead kid—by the fading color field on the wall.

PAPICH: It's like the golden hour colors coming through.

PORTERFIELD: Yeah, and sped up a bit—a time lapse, so one can actually read it with the eye. But if, you know, absence or ambience is what's left when a person is gone, I think it makes sense that space and time then are filled with ambience, all that once surrounded the corporeal body. And narratively, I think, it's just interesting to discover characters through the spaces they inhabit. It opens things up. It's those things in between that are really more interesting than narrative or plot.

PAPICH: It lets you feel like you're actually looking around—or not actually looking around. It lets you just stare and *not* look around, you know? And that's what I feel like, in a more structural way, studs the narrative of the movie with these breaths, these openings.

MATT PORTERFIELD *was born in 1977 in Baltimore. He lives and works in Baltimore.*

PORTERFIELD: Cut-aways to trees and light—

PAPICH: But that are intertwined with the narrative, and the concept, and the story, also. Watching the movie, first in the theater and then again at home, I had this kind of feeling, like the way I'm interacting with this is different than other ambient movies, or ambient moments, because of the way that they're interjected and the way that they open up time, which opens up the experience—it takes me away from the screen for a moment.

PORTERFIELD: As an audience member, that's definitely a privilege I enjoy.

PAPICH: Well, I think it's necessary. And I also think that it allows the audience member this moment of kind of letting the movie be everyday for one second. You're back in the space that you're watching it in. I see a connection between that type of thing that goes on and the way that time is manipulated throughout the whole narrative, the way that people, in conversations with the camera, are always talking about how they knew Cory. How they got there. And those are also cut further, so that within the conversations it's not linear, and it collapses down this wormhole for a minute. You get a lot of informa-

tion and this back-story, and then a lot of times, shortly after that, it's followed by this moment of ambience. And then a forward motion, where you can exist again, in your own space, out of the story.

PORTERFIELD: And there are examples of whole scenes composed of pure ambience, like the swimming hole scene.

PAPICH: Well, the swimming hole's a good example, because that one has this thing that's so common: teenagers hanging out by the water, this natural setting, passing around some drugs, smoking cigarettes, beers—I like that there's this little bit of romance that you can see starting. And it's this kind of loitering thing that, to me, is part of being young and is also one of the main aspects of what is punk—which is wasting time. Because in a way it's saying that you're taking the time away from your job, you're taking the time away from the whole capitalist enterprise. But I don't think the whole movie's punk necessarily. I'm wondering what you think about that—how you see that relating and how you think of that in terms of the characters?

PORTERFIELD: I think if the film allows ambience to dominate in certain places, in a certain respect *that's* an act of wasting time.

PAPICH: Screen time.

PORTERFIELD: Taking away from the narrative, the plot. Or the will of the characters, the director. When we see it in movies, typically, I feel like leisure is depicted as the privilege of a certain class—the bourgeoisie, right? But in *Putty Hill*, we see a lot of characters who are unemployed or underemployed, so it is a fact of their economy that they have a lot of time. It's not because they have a lot of money, but when you don't have work, how do you fill your hours? And what they choose to do, I think, is interesting. And I find when I watch the film, what they're choosing to do is creative. They're skating, BMX-ing, making music, taking photographs. In a country, in a city, where there aren't a lot of jobs or where a lot of industry has left, these young people don't have the opportunities to work that they would have had, I don't know, when Bethlehem Steel was thriving, for example.

PAPICH: A lot of the places that we see people hanging out—even the skate park, where they're BMX-ing and skating— are these rural areas. Most of the film isn't in the city. Basically what I want to talk about here is what you think of this use of natural spaces? The woods: there's the walk

Joyce Kim, production stills for *Putty Hill*, 2011. Chromogenic prints, 20 x 24 in. (50.8 x 61 cm). Collection of the artist

through the woods. There's the hanging out at the water. There's the skate spot, which is made but built into this park. I'm interested in just what you think of how people find these places—as a person who grew up here, where the movie takes place—and why they find these places, as opposed to strictly hanging out in more urban settings, where there's potentially "more going on."

PORTERFIELD: I feel like these places outside of the urban centers grant access to a kind of spirituality. There's something potentially exalted about a walk in the woods. When the world opens up, everything's bigger in scale, we're hearing sounds, noticing sounds, that maybe we hear everyday but not in abundance. I think we're connected to life processes that are bigger than us when we go to remote places or parks. Maybe they're spots that are easily accessible, but the public spaces that take us away from our routines, our concerns of urban life, they give us a little more space to open up to the world in a way. And to ourselves. Those are the spaces sometimes that, if we listen, can speak more. I think the characters in the film are responding to that maybe. And I'm hoping the audience is, too.

PAPICH: That's where we get to see some of the more candid moments, where it's just the characters hanging out, seeing them interacting with other people who aren't a part of the story line, in a really natural way. It's also the kind of place where we see the main characters actually using drugs. But we hear talk about drugs the whole time in the movie, because of Cory. There's this distinction between drugs that we see being used or talked about in a casual way and this other kind of discussion that's more secretive, where people are more hesitant to really say a lot. I think it's these two currents that are running parallel in the film. I think this difference between what we see and what we hear is one of the main dynamics of the movie, because of the way it's built. And I wonder if you can talk a little more about that? If you could see that structurally working into the film, and how you think that extends into the actual real world.

PORTERFIELD: I'm definitely interested in the relationship between sound and image. There's this thing that the filmmaker Robert Bresson says: "If you give to the ear, give nothing or next to nothing to the eye." So it's a question of balancing the senses. The film is, again, about a central protagonist who is not there. We learn about him through the spaces he inhabits but also by what other people tell us about him. And then we learn, through a series of interviews, the answers to questions posed by an off-screen voice. We don't know who's asking these questions. *Whose voice is this?* So I do think [the relationship between what is seen and heard] is a central, *the* central, formal element of the film. It's interesting to discuss it in the context of drugs, because I think drugs are substances or tools we can use to expand our experience and make sense of the world, but at the same time, they have the power to take us towards a place of meaninglessness, a place beyond meaning. And meaninglessness, I guess, is another form of absence. Did you ever read *The Book of Laughter and Forgetting* by Milan Kundera?

PAPICH: No, I haven't.

PORTERFIELD: He talks about this physical border that exists; it's dusty, but through the repetition of action, it becomes visible. We walk it our whole lives, and on the far side is meaninglessness. I think drugs are sort of on that line, between what's physical, what we know to exist in the real world—objects, for example—and then everything that's sort of beyond meaning.

PAPICH: And they help to mediate that grey area in between those two.

PORTERFIELD: Yeah. And they're dangerous. We hear people talking about them, acknowledging their threat, and still, in practice, being open to their use. Maybe the unseen in the film is a threat. I don't know if that's consistent, but in a scene like the one in Double Rock Park, where the girls are walking—what we see is them, three friends in the woods, but what we hear is ominous: the sound of the ice cream truck and then the helicopter and radio, and then the police, who are slowly revealed, and the details of this bank-robbing man who's loose in the woods.

PAPICH: Which they laugh off.

PORTERFIELD: Right, yeah.

PAPICH: Partially because they see the ridiculousness of that threat. They make it ridiculous, you know? Although later on then, admitting that they are a little freaked out by that guy. But laughing about it, you know? And that, I think, relates to what you're talking about, too, with these natural spaces—where a threat like that can seem less pertinent because of the quality of space you're in. The scale of it, and the fact that it's a surreal threat. There's this man loose in the woods. Robs banks. And you're there also, you know? Surrealism is something that I don't think is huge in the movie, but I think

it's something that comes up a couple of times, in a few scenes. With humor, usually. The song has this element of being surreal.

PORTERFIELD: That Carol sings?

PAPICH: Yeah, with the guitar?

PORTERFIELD: Yeah.

PAPICH: Yeah, because of these different things going on simultaneously. And that's where the humor exists. The kid's coming home—he's just trying to get a soda or something, use the bathroom. The mom is trying to sing the song …

PORTERFIELD: About losing your mind, essentially. Looking for your brain.

PAPICH: Yeah, and it's one of my favorite scenes in the movie. That one, I think, has an element of being surreal. And the camera is just sitting there, too, right? The camera doesn't move.

PORTERFIELD: Right. It's one of my favorite scenes, too.

PAPICH: And that kind of stare you use sometimes—when the camera is really still—is almost like the ambient moments for me, because it's when I feel the most like I'm watching a movie on a screen. And I'm following it, I'm involved in it, but I'm not so raveled in it. And the humor helps to break through that, too. Especially in the theater,

when people laugh. Is surrealism ever a thing that you're thinking about? Or do you see that connection?

PORTERFIELD: I'm happy to hear you say it, because I'm interested in surrealism and its application in more traditional modes, narrative modes. And I'm interested in the potential for absurdity when combinations of forces in our lives come into play, combustably.

PAPICH: And there is that element of absurdity in that scene. That's what's funny. But the reason that I also think it's surreal is because it's serious simultaneously. And there's something sad about it, too. The way she's singing the song. And the other lady and the baby are listening, closely.

PORTERFIELD: Singing along.

PAPICH: But the boy isn't really. And that element, because it introduces these other feelings, makes you empathize with the singer.

PORTERFIELD: Carol's a real poet.

PAPICH: Is that her song?

PORTERFIELD: It's her song. I didn't know she wrote music. But when we came on location—we shot in her house; that's her home, those are her sons in the film, her grandchild—she was sitting there at the

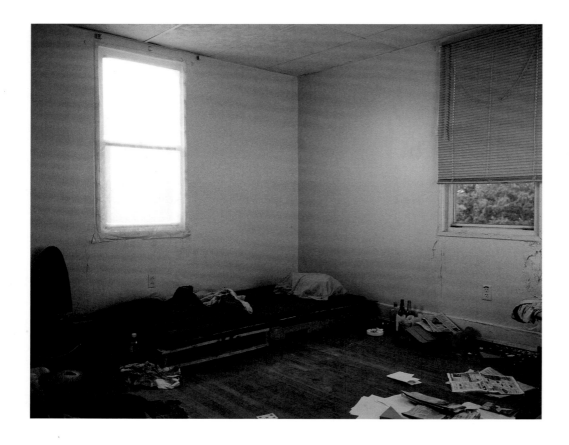

table, working on some original music, as if auditioning. Of course I had no choice but to invite her into the scene, and she was willing to participate. So in a way, the way it came about is sort of surreal.

PAPICH: Totally.

PORTERFIELD: One of the things I think we were able to achieve, or at least stay open to, is the potential for magic during production—which can be so rigid. You know, you're trying to do a certain thing, articulate a vision, whether it's fully scripted or just notes on paper. Often, you become myopic in that process. But because our construct was fairly open, we were able to allow for things like that, or the play of light on a wall.

PAPICH: There's this openness to the whole film in its final version and in how it's made.

PORTERFIELD: And the life around the film. And I think it's also important that the *process* is brought to the fore as well, for the audience, for the people involved, the actors—for me, as it's my voice offscreen. Because we're combining formal elements that are traditionally disparate—documentary tradition, traditions of fiction—I'd like to think that there are scenes in which the audience is aware of the life of the film, of the

narrative, but also of the film itself and the life beyond the film. So it's not just what's in frame, it's what's beyond the frame. What we don't see or hear.

PAPICH: Is that an ideology for you?

PORTERFIELD: I think so, yeah.

PAPICH: Like it could be a model for a society? An open way of everyone understanding and working together on different levels, but simultaneously.

PORTERFIELD: I'd like to think that. I mean, I don't think you're going too far. If you make a film, it's a representation of the world, but not an accurate one. It's really a representation of the way you and your collaborators see the world.

PAPICH: Exactly.

PORTERFIELD: So it's a *kind* of vision.

PAPICH: There's this John Cage interview, or conversation, where he's talking about a Glenn Branca piece. And he says something about the piece or the performance not representing a society that he would ever want to live in. And I love that question, essentially, and I try to ask it with most pieces of art. You know, *Is the way this is made and what it's ended up to be—is this or could this be a society that I would want to be a part of?*

PORTERFIELD: I think that's a great

way to approach art. I've never thought of that consciously, but I know that when I respond viscerally, sometimes inexplicably, to something—to a movie, a song, something hanging on a wall—I can't articulate it, but something about it repulses me. Maybe because of the ideology behind it or because it exists as a representation of a world that I wouldn't want to live in.

PAPICH: And as a possible threat to the world that you're trying to create, as an artist and a filmmaker.

PORTERFIELD: I guess I'm becoming more interested in how to articulate the experience of exalted daily life. We talked about leisure, how we spend our extra time. If our extra time is spent surrounded by things that move us in a spiritual way, it can play out in, I think, very banal, seemingly mundane environments and conditions. So we don't have to go to a place of worship in an official capacity to experience something spiritual, revelatory. We can be open to minor revelations, daily ones. And those are of particular interest to me—celebrating those and recognizing them.

PAPICH: Noticing them.

PORTERFIELD: The noticing is first. And when you take a photograph or make

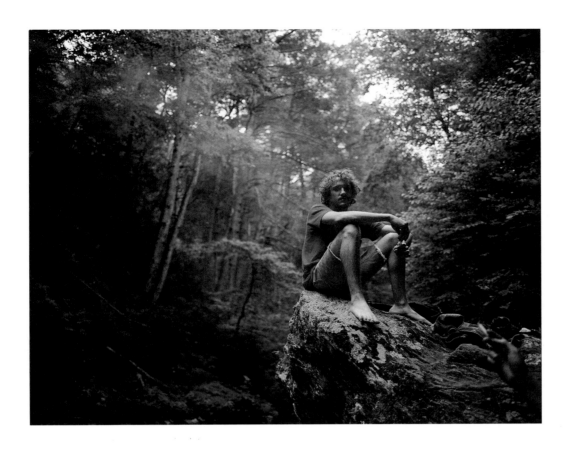

a film, I think you're creating an object that then exists in the world as a sort of signpost, or a little temple of its own to commemorate that moment.

PAPICH: And with your photos, as well as your film work, what you're kind of saying is that it's as much about taking the picture as the picture. More even. About noticing that this is a photo *opportunity* and seizing it, whether or not the photo, is like, a work of art in the end.

PORTERFIELD: Right—like aesthetically rigorous. Or accomplished. I mean, I see that in your work as well.

Papich: I think in most contemporary young photography. It's about people noticing the environments that they're in. Noticing moments that are magical and not being afraid of them. And not carrying this cynicism that would stop you from taking that picture. And I think it's a good place for young people, myself included, to be in. But then I also wonder—it's about this openness—what about that openness do you cling to and present as a stopping point, and then move on? Because I don't believe that it can actually always just *only* be about noticing. I think there has to be something else.

PORTERFIELD: In the work?

PAPICH: And in presenting it. It's not just about the gesture for me. And it's not just about the gesture for you. Because you present the photos, and you show them to people in galleries, and you make the films. We were talking about it earlier in terms of controlling the production. It's not just about the action; it's also about producing the thing, as a gesture in itself.

PORTERFIELD: Controlling the means of production. That's a political act.

PAPICH: It's a political act, too. But your work is not overtly political.

PORTERFIELD: No.

PAPICH: And what you're talking about is this kind of spiritual, open practice, noticing the *now* and trying to bring that through to the work, presenting something that's kind of an illustration, maybe, or a rendering of that concept—but that keeps on existing, with or without the exhibition, as a practice or as a lifestyle in the end.

PORTERFIELD: Yes. There's this theologian, a rabbi—Abraham Joshua Heschel. I used to teach at a Hebrew day school on the Upper West Side. And he had some really interesting texts, but there was this quote I remember really stuck out to me at the time, when I was in my early twenties and trying

to figure out how to live my life, and I didn't have a creative practice, like a regular practice of writing or filming or even photographing the world. But he said this thing: "Build your life as if it were a work of art." I think the decisions we make daily are just as important as the artistic practice we aspire to achieve. And I see you doing that. That's a lifestyle.

PAPICH: It is a lifestyle. I think it's important, and I also think that it's unavoidable if you're going to truly work as an artist. It's not necessarily something new, right? It's part of this long lineage. But we're talking about it now more than ever, it seems like—*focusing* on that in a way. I think that's interesting, in this conversation at least, talking more about the practice and the process, and about what those things mean, more than the …

PORTERFIELD: Than the product.

PAPICH: Than the product. And I think that says something about the ideology you have as an artist and a filmmaker. And I think it's contemporary because it's disavowing the product in a way. Seeing it for what it is.

PORTERFIELD: Thank you, Matt. I'm really honored that you would do this. And on your birthday.

PAPICH: I think we have a lot here. Thank you, Matt.

Meat, 1999. Handmade slide, 1 ½ x 1 ½ in. (3.8 x 3.8 cm). Collection of the artist

LUTHER PRICE *was born in 1962 in Marlboro, Massachusetts. He lives and works in Revere, Massachusetts.*

Refridgerator, 2006. Handmade slide, 1 ½ x 1 ½ in. (3.8 x 3.8 cm). Collection of the artist

Sally's Mouth, 1999. Handmade slide, 1 ½ x 1 ½ in. (3.8 x 3.8 cm). Collection of the artist

Luther in the Sky with Diamonds, 2000. Handmade slide, 1 ½ x 1 ½ in. (3.8 x 3.8 cm). Collection of the artist

Sprocket Infection, 1999. Handmade slide, 1 ½ x 1 ½ in. (3.8 x 3.8 cm). Collection of the artist

Patty-Cake Party, 2006. Handmade slide, 1 ½ x 1 ½ in. (3.8 x 3.8 cm). Collection of the artist

LUCY RAVEN *was born in 1977 in Tucson, Arizona. She lives and works in Oakland, California, and New York.*

Still from *RPx*, 2012 (in progress).
Video, color, sound. Collection of the artist

Notes Toward Not Shooting the Player Piano

SAM LIPSYTE

In 1952, Kurt Vonnegut published *Player Piano*, a dark humanist satire on the advent of a mechanized society. (Two years later it was published as a science-fiction paperback called *Utopia 14*, still seven years before *Catch-22*, another satire about people being crushed by machines—numbers are scary!) *Player Piano* was published sixteen years after Benjamin's "The Work of Art in the Age of Mechanical Reproduction," nine years before Eisenhower's warning about the "military-industrial complex," eight years before Jean Tinguely's *Homage to New York* and Truffaut's *Shoot the Piano Player*, fifty years before William Gaddis's posthumously published *Agapē Agape*, a post-humanist Bernhardian rant against the mechanization of art and society using the player piano, again, as a symbol, and twenty-five years before the birth of Lucy Raven.

What does all this mean? Perhaps not shit, not without Raven's framing. It's a motley chronology, some moments more associated than others, the numbers probably wrong. It's a string of thoughts about technology, the history of human tool-making, or the making of humans we might dismiss as "tools," a take on time ("Time will take you on," sang James Brown), a timeline of time signatures, a brief strip of punch holes to consider, some information to process, numbers to crunch, some tunes to shuffle.

Raven's connections, made not just through meaning but through the music itself, make us hear the song and the implications of its interpretations. We listen in joyous realization that the "natural," the "artistic," is coming to slimy life out of a vent in the counting machine! Gather the data, gather 'round, it's time to dance yourself clean—of sin, of toxins, of dumb reduction (mind/body? human/machine? disco/rock? jazz/disco-rock?)

"I don't believe I'm this wildly original individual," James Murphy has said. "I do believe I am a very good manipulator of sound." His manipulations, often on synthesizers, punch emotional code in us. His music reminds us of older music while becoming new music. This isn't rare. It's the basis for the popular form. Murphy's brain is the machine, as is Jason Moran's. Moran plays with the roll, expands it. Dyer's machine jabs the required holes. If it's all about the space between the notes, then it's also about the holes between the spaces.

> So go and dance yourself clean
> Go and dance yourself clean, yeah,
> You're blowing Marxism to pieces,
> Their little arguments to pieces.
>
> Show.
> It's your show.
>
> Put your little feet down and hang out.
> Every night's a different story,
> It's a thirty car pile-up with you.
> Everybody's getting younger …
> It's the end of an era—it's true.

The bourgeois individualists dance to an ecstatic and purgative state that frees them from the bonds of … Marxism? No longer quite the looming threat, those "little arguments" that can be obliterated by "little feet." Here is a sly slide in itself. Murphy chuckles with despair. Or despairs of his chuckling. Either way, he explodes into the ecstatic. The true dance experience in this context may look communal, all those asses shaking on the floor, but really it's about the individual's deliverance. There is no time to overthrow the machines if you are dancing yourself clean. Moran's interpretations interrupt this inexorability. We can't get so feverish with his versions. We sink into the beauty of his playing, of course, but suddenly we're thinking of, say, Scott Joplin, which places us in History. Motherfucker! I was almost clean! Moran's interpretations slow dance with Murphy. The piano (upright, after all, finally ready to be human) strides along with Moran.

We are consumers of music, yes, but we are also conduits of the art, the arguments, the communions, we seek. We are the machines, Raven might be saying, the player pianos playing ourselves. We slip the scrolls into some flesh notch. Please don't shoot us. "Nobody loses all the time," says Warren Oates, the unclean piano player in a movie about a pending decapitation. But that might not be true anymore, and if we do start to lose all the time, don't fault the machines, the soulless replacements of ancient holistic harmonies. Blame you and me for not building them well enough to protect ourselves from ourselves, or to leave ourselves behind (though we have plenty of technology that makes it seem we can). We put a man on the moon four decades ago, and yet we still die? That's pathetic. A real obscenity. No, machines are only good for one thing now. They can teach us how to feel.

Roll, Piano, Roll

ALEX ABRAMOVICH

Sam Lipsyte once referred to his friend James Murphy as "the only current Grammy nominee in his category able to quote freely from *The Recognitions*." I'm bringing that up today because I've been wondering, lately, about what the author of *The Recognitions* might have said about Lucy Raven's contribution to this year's Biennial.

William Gaddis spent fifty years working in fits and starts on a history of the player piano. He worked on it in the 1940s, when he was employed as one of the *New Yorker*'s fact-checkers. He worked on it in the 1950s ("I've written a history of the player piano," says an otherwise anonymous character in *The Recognitions*. "A whole history. It took me two years, it's got everything in it") and 1960s. (Portions of Gaddis's own unfinished history turned up in his 1975 novel, *JR*.) He gave up on it in the 1980s, deciding that he'd "overresearched." But he returned to it a few years before his death, in 1998, recasting his efforts, yet again, as fiction. Gaddis's fifth and final novel, *Agapē Agape*, is a Bernhardian riff on the instrument, which is also the through-line in a posthumous essay collection called *The Rush for Second Place*.

"I see the player piano as the grandfather of the computer, the ancestor of the entire nightmare we live in, the birth of the binary world where there is no option other than yes or no and where there is no refuge," Gaddis wrote, in a passage that turns up whenever you look him (or the player piano) up in any given search engine.

* * *

The player piano's actions are controlled by the holes a piano-roll puncher punches in a roll of paper. Joseph Marie Jacquard's loom, Charles Babbage's difference engine, and Herman Hollerith's tabulating machines are none-too-distant cousins. You could argue that com-

pact discs, which are encoded with very long series of zeroes and ones, have more in common with piano rolls than with vinyl records. And one small, satisfying irony of our post-industrial age is the fact that record stores that still sell vinyl records seem to have outlived Tower Records, HMV, and the Virgin Megastore. Weren't vinyl records supposed to have gone the way of the player piano? What happened instead is that, by transforming its products into very long series of zeroes and ones (all of which were totally indistinguishable from the zeroes and ones we could—and did—download from P2P networks, torrent sites, and MP3 blogs), the music industry we've known has rendered itself obsolete.

Ah, I love my records... I just wish they were smaller, more expensive, and illegal to share with my friends.

Bill Gaddis would have liked that.

* * *

The piano makers had something in common with the record companies in that they, too, came very close to putting their whole business out of business. I'm looking over the notes Gaddis assembled for his projected history:

1904
260,000 pianos built; 252,000 uprights; 7,000 grands; 1,000 players

1919
Players outnumber straight pianos, were 53 percent of industry output: 341,652 total.

1929
For 20 years the industry has been advertising, Why play the piano with your hands when you can pump it with your feet and hear the artist? In those years, a whole generation grew up which took them at their words and could not play with their hands. Consequently sales figures above, and the radio in 1926 which was recognized as a threat... Today the industry is constantly being bothered by inventors who present themselves with new "featherweight" player actions &c., the manufacturers know that if they started it again, the new generation which had grown up without players would go off their rockers with delight, as they did in 1912, but they are wiser after the way they paid for going on with their fad to such a degree that they came close to killing the whole piano industry.

And yet, here we are in 2012, listening to a player piano play three versions of "Dance Yrself Clean"—a song James Murphy wrote just a few years ago for his band, LCD Soundsystem, which appears on the band's third and final album, *This Is Happening*. What are we hearing, exactly?

At the most superficial (but also not-so-superficial) level, we're hearing one of three performances the composer and pianist Jason Moran programmed, via MIDI keyboard, in the spring of 2011. (Another small-but-satisfying irony? Programming piano rolls turns out to be one of the things that MIDI is still good for.) The longest performance, which synchs almost exactly to LCD Soundsystem's studio recording, is a straight transcription of "Dance Yrself Clean." The shortest, an interpretation for stride piano, plays the instrument's history, and sounds like something James P. Johnson might have programmed in the 1920s. In the third version, which falls somewhere in between, Moran plays his own highly personal interpretation of Murphy's composition.

Why Jason Moran?

It might have to do with Lucy Raven's appreciation of the pianist's 2002 solo album, *Modernistic*, which took its name from James P. Johnson's signature song, "You've Got to Be Modernistic," and included a radical (but instantly recognizable) reworking of Afrika Bambaataa's hip-hop touchstone, "Planet Rock." There, contra museum pieces like Ken Burns's *Jazz*, he showed us that jazz had not, in fact, gone the way of the player piano. Here, he shows us that even the player piano has not gone the way of the player piano. (The piano-roll puncher might be another story; Julian Dyer, the Englishman who punched these rolls, is one of six remaining piano-roll punchers in the world.)

Why "Dance Yrself Clean"?

Perhaps it's because one of the things we hear in LCD Soundsystem's recording is James Murphy's awareness of time's proverbial arrow: his way of setting elegiac lyrics against urgent beats; his insistence on present-tense pleasures as a way of resolving the tensions that ensue; finally, his awareness of the sustainability (or lack thereof) of the whole enterprise (which is also his own, human life). Or, it's because LCD Soundsystem, live, was a near-perfect approximation of a near-perfect machine, the sort of thing that wouldn't have been possible if drummers (Murphy started off as one) had never learned to play like (and, eventually, beyond) the drum machine.

Or, you might have entered the room when the piano wasn't playing anything at all and watched one of its human operators rewinding or setting up another roll. In which case you've seen a person do the kind of work we now associate with machines, while a machine geared up to do the kind work we've long associated with humans. This is the sort of thing that fucked Gaddis up, for five straight decades, as he worked, or tried to work, on something that was much more than a history of the player piano (even as it pretty much remained a history of the player piano).

"Gaddis wasn't merely displaying an elitist reaction to the democratization of the arts," the literary critic Steven Moore wrote in regards to that history.

> [I]nstead, he was concerned about the growing demand for immediate gratification and for the willingness to accept a mechanical reproduction over the real thing. It's the same trend towards the elimination of the human element that was going on in assembly-line production, whose growth took place concurrent with the heyday of the player piano. Mechanization of the arts ran parallel to the mechanization of people by means of efficiency studies, standardized testing, and various methods of measurement and evaluation more suited to machinery than people.

Moore goes on to note that Gaddis didn't read Walter Benjamin until very late in his career. ("Benjamin had already clearly, concisely, brilliant[ly] and briefly covered the ground," Gaddis wrote, in a 1992 letter about the player piano project.) And, of course, Benjamin's ghost is another thing you'll hear rattling around in Lucy Raven's piano. But if Raven's work is anything to go by, Benjamin was dead right about "the aura of the work of art" and less right about mechanical reproduction. Like Gaddis (and the rest of us), he was on the right and wrong track, and going around in circles.

Simpson/Meade, *If Now Then (Seeing Better)*, 2011

A MANIFESTO FOR THE RED KRAYOLA

The melting of historical relations "obliges the mind to go where it need not degrade itself." It may still fall to the work of art to assert what is barred to politics—resistance of some kind. But when we speak of "resistance," we know that the idea is inflected by modalities like "being hoped for" and "being just out of reach." We may also think that it has to be inflected by truculence. It is open to us under these circumstances to attempt the construction of forms of critical negativity that are not merely nostalgic.

What is needed is a resistant aesthetics that is also an aesthetics of resistance within the *Gesamtkunstwerk*—an aesthetics made in the form of essays—and a practice that can, inter alia, account for relevant aspects of European modernity as well as American critical modernism and the various forms of institutional critique that ensued, one able to act in relation to the fact that this is an artistic culture whose historiography has dissipated the negativity that lay in its origins. To this extent an aesthetics of resistance is an aesthetics of and in failure, an aesthetics fully awake to the fact that the culturally assimilated art product is exhausted by an adequate account of the material conditions of its production and alert to the characteristically degraded state of mind that follows knowing that, an aesthetics that recognizes that there is no automatically practical negativity. It will be a practical aesthetics—of guises, of false identities, of fictions and ghosts.

"Disguise is the first of the plotter's tasks." Of course, if you plot you will have to identify with both oppressed and oppressor—be a first-class chump. The Red Krayola supplies a dialectical scrutiny regarding the convention that, in the materiality of music production, the vocal performance of the singer and the craftsmanship of the musicians have been made marginal or irrelevant. It should not be assumed, however, that we stand for any mode-bounded authenticity. It is, rather, that the relation between the singer and the song in a Red Krayola

THE RED KRAYOLA *was founded in Texas in 1966.*

performance—indeed recording—is one that admits of a slippage that approaches fiction or a ghostly *hantise*. Ghosts and specters are not always fictional entities or the products of delusion. They can operate in and as cultural forms. They shift their shapes; they are identities as virtual as they are actual. They hate what they are and what they have done, even as they take pleasure in being praised for both. They shift their shapes and change their jackets. These latter can be, like music, straight or sporty, solemn or serious, stupid or ugly, ill fitting or neatly tailored.

What is clear is that The Red Krayola is one collaboration—or many—over time that answers, "Does it matter who is speaking?" with the statement, "Since you will never be able to know who is speaking (we'll try to make sure of that), it will matter a lot or a little according to your ability to make a fiction do its work, according to your taste in ghosts or musketeers, your taste regarding Ethos, Pathos, Bathos, and, of course, Dark Canyon."

Of course it does matter if you can play or write a lyric. In playing in a group, if you want to know the difference you make, stop playing and listen to others. While The Red Krayola and its collaborators are largely made of specters and other semifictional constructs, none is a victim of the postconceptual delusion that confuses entrepreneurial power with making or doing something like playing, writing, or singing. There are first-order skills in both writing and performance. We are specters who act on and in the work directly. We do not make our work out of the management and authorization of the skills of others. Our sense of that is our sense of collaboration, even though the distribution of labor within it must entail some form(s) of exploitation. Our sense of collaboration is based on the proposition that the solo artist is the sound or sight of the world plus one extracted from the world. What we suggest is some tightening of criteria. This is, however, a tightening that does not seek a return to a prelapsarian state. It is a tightening made after the fall by some of the fallen.

While The Red Krayola is fully implicated within the present *Gesamtkunstwerk,* we are nevertheless only "modern" in the

sense that we envisage its demolition. Our institutional culture is not suited to looking for the unlikely. The commodity is built out of plausibility. We must malinger, fearing and embracing passivity and death. We do not actively confront the corporate tumor fashioned by dispensations of the present with any sense of the virtue of our case; we do not claim that we have virtuously and heroically hidden an explosive charge in it, or even that we know exactly where such a charge may be laid.

We have constructed ourselves essayistically in music and art and in history as significantly virtual, in ways that bring destruction upon us. We are thus, qua musical performers and artists, users misusing the conventions of identity. The virtual truths of contemporary culture are highly instrumental and stable. The "who is speaking or singing or writing" in the practice of The Red Krayola and its collaborators is highly unstable. Our instability does not, however, go to a chaos of tasks and competences. The collaboration is represented by a dialectic of continuing. The voices and the noises of going on constitute an index of performables and performances that may be akin to a heuristic path or a set of heuristic paths. However, while lyric and musical performance are both conceivable as action types, they do not readily conform to a principle of differentiation implied where the finding of different structures by different heuristic paths are all instances of different works. The Red Krayola performances are double(d)-or-more works that are made out of structural and heuristic differences—contradictions—that are internal to them.

Let us add to this sense of paradox and confusion by saying that, in the limit, we are often formalist. Ours is a formalism that does not fear the naturalism that strives to match words and music. A formalistic mismatch may find itself juxtaposed to a moment of "naturalism." It is possible that in such a circumstance the former will displace the latter. A "naturalism" of voice may be, for example, more implausible than a disguise. A rant in the tune of Lounge Bossa is "unnatural," but in displacing a ranting tone a text is "rewritten" with all its menaces intact.

Perhaps in owning up to our being formalist, that we are not at all immune to formalistic observances, we may be suggesting that the work of The Red Krayola preserves some sense of genre. While the music is essayistic, there is no reason that it cannot lay claim to or hang on to a robust sense of genre—at least hypothetically—even as it is incorporated in to the tumor that is the *Gesamtkunstwerk*. It may be that this would be a sense of genre that is festooned with emergency conditionals: "It's a pop song just in case it might be an avant-garde art performance"; "It's a contribution to a conversation, just in case it's rock 'n' roll"; and so on. Such conditionals embody our kind of cultural insolence in the face of the *Gesamtkunstwerk*'s police.

The negative context of the work lies in a truthless negativity that is supplied by the emergency conditional, as with a malingering ghost who says to the institutional management, "You are indeed powerful, but you are blind." But who is doing the speaking? One of the most pervasive thoughts of Nietzsche is that there are no substantive selves. We imagine, then, that he didn't think that the fictional characters, specters, and ghosts possessed substantive selves. Leaving aside a few weird and modern Flaubertian excursions, a change in the history of a fictional character would entail a change in their identity. The norms of performance are both powerful and meaningless. They are either structures that go to distinct heuristic paths, as they are heuristic paths that go to different forms or structures, heuristic paths beset by sirens and distractions, by the effects of the emergency conditional, or there *are* forms and structures that change their shape for similar reasons. That would be heartening. The same song can shift genres by this means, and The Red Krayola shifts its shape. And this shift of shape is not at all analogous to versatility in performance, where the same singer may be able to perform a song in a number of styles. It is rather an instability of identity, a turning away from the question "Who is speaking (or playing or singing)?"

Stills from *Old Joy*, 2006. Super 16mm film, color, sound; 76 min.

KELLY REICHARDT *was born in 1964 in Miami. She lives and works in New York.*

Stills from *Wendy and Lucy*, 2008. Super 16mm film, color, sound; 80 min.

Stills from *Meek's Cutoff*, 2010. 35mm film, color, sound; 104 min.

The Searchers

DENNIS LIM

The characters in Kelly Reichardt's Oregon trilogy are all searchers. Two old friends look for a remote hot spring in *Old Joy*; a woman tries to find her missing dog in *Wendy and Lucy*; a wagon train of settlers traverses the unconquered American West in *Meek's Cutoff*. Tracing the anxious, hesitant steps of these wanderers, Reichardt brings urgency and nuance to central tensions nestled deep within the American psyche: between the individual and the collective, between freedom and responsibility, between founding myths and tough realities.

Because of her preference for compact, anecdotal plots and an uninflected visual style, Reichardt is often called a minimalist. And while it's true that silence speaks volumes in her films, that label understates the pictorial richness of her work and its thematic intricacy. Critics have positioned her at the forefront of an American neorealist movement, but it's important to note that her brand of social realism involves the deft manipulation and inversion of classic film genres. *Old Joy* is a western whose antagonists engage in a battle not of toughness but of openness; *Wendy and Lucy* is a road movie in which the heroine can't even get her car to start.

As was apparent even in her first feature, *River of Grass* (1994), a droll subversion of the outlaw caper that left the Bonnie and Clyde legend to wilt under the South Florida sun, Reichardt's metier is Americana—a designation that she strips of its nostalgic associations and imbues with fresh political meaning. *Old Joy* (2006), the movie that revived her career after a decade-plus hiatus from feature filmmaking (during which she made a number of short films), is the most Portland-specific of her films—a lament for the looming extinction of fringe lifestyles that is all the more acute for being pointedly set within a longtime haven of progressive values.

The friends in the film represent to each other the path not taken: Kurt (Will Oldham) is a stoner hippie who lives hand to mouth, and Mark (Daniel London) is a married father-to-be who blares Air America on his car radio almost as a security blanket. Reunited for a weekend, they embark on a hike in the woods, searching in vain for the tender, easy rapport they once shared. Relying less on words than on subtle shifts of mood and a telling use of close-ups and reaction shots, *Old Joy* shows how a gentler, more sensitive masculinity can circle back into passive-aggression.

The end of this friendship also signals the end of an era, or rather, the vanishing of utopian ideals, which the movie views both as a consequence of advancing age and a sign of the times. In the course of a long-winded story that Kurt tells Mark about a dream, he defines sorrow as "worn-out joy"—the idea that gives this film its title and abiding mood. Jonathan Raymond, the writer on whose novella the film is based and who is Reichardt's indispensable collaborator on all three Oregon films, has called it "a second-term kind of movie," evoking the passage of anger to ruefulness among deflated liberals during the George W. Bush years.

The fog of bad news that surrounds *Old Joy* takes on very tangible manifestations in *Wendy and Lucy* (2008), which more than ever seems like the emblematic film of recessionary America. A frontier heroine for exhausted times, Wendy (Michelle Williams) is making her way north to Alaska, hoping to find work at a fishing cannery. When she awakens in a Walgreens parking lot in a depressed Oregon town to find that her beat-up Honda has conked out, the indignities and strokes of bad luck start to mount with harrowing force: she pockets a tin of dog food for her beloved mutt, Lucy, and then is promptly arrested for shoplifting, only to return from the police station to find that Lucy is gone.

The movie's overall concreteness—its attention to the intractable details of economic hardship, to the daunting math of day-to-day survival—is political. As in *Old Joy*, Reichardt's concern is with the insidious judgments and matter-of-fact punishments that society has devised for those who flout its rules. Wendy experiences her downward spiral as a series of procedural hassles—she's inconvenienced and becomes an inconvenience to others—and is quickly forced to confront the dangerous fragility of her existence in a society that's not big on safety nets or second chances. Though it often feels like a one-woman show (Williams's performance is a master class in expressive restraint), *Wendy and Lucy* is very much a film about human interaction—or, more precisely, about how the social contract is broken or upheld in moments of stress and at the margins of society.

In *Meek's Cutoff* (2010), Reichardt's most explicit western, a genre that has lent itself to modification for decades undergoes one of its most comprehensive revisions: from male to female perspectives and from Manichean certainty to a creeping, all-but-deranging sense of doubt. Crossing the Oregon Trail in 1845, three families hire a guide (Bruce Greenwood) to take them through the desert. But as they continue to walk, and walk—perhaps in circles, or into terrible danger—the inevitable question arises of whether their leader knows what he is doing and where he is going, if he is "ignorant or just plain evil."

Like Reichardt's other films, *Meek's Cutoff* is grounded in the material reality of its characters, focused on physical toil and process, on the time and effort it takes to ford a river, build a fire, load a gun. Raymond's script is based on historical events, and the scenario will be queasily familiar to many Americans who lived through the Bush era, but this allegory of failed leadership and an illusory promised land resonates across political and historical contexts, and the collective unease, playing out against a stark backdrop that grows increasingly disorienting and void-like, is, above all, existential.

Reichardt's unerring sense of place has been especially evident in her Oregon films, which take place largely or entirely outdoors and make pointed use of landscapes and the natural world. The blur of Cascadian forest in *Old Joy*, as seen from a moving vehicle, suggests the irretrievability of the past. In *Wendy and Lucy*, nature is both a lush respite from the drabness of a dead-end American town and a source of danger, the great unknown. The characters in *Meek's Cutoff* are adrift in a vastness that comes to seem imprisoning (not least for being photographed in the boxy Academy ratio). Whether they are set in the present-day Pacific Northwest or the arid prairies of the mid-nineteenth-century American West, Reichardt's films have a deep contemporary resonance. In more ways than one, she makes movies about what it means to be at once trapped and lost in America.

Catullus, Poem 64

A wonderfully embroidered cloth sets forth the mythic deeds of various men of old. It illustrates the wave-loud coast of Naxos, where Theseus and his swift ship vanish from sight, and Ariadne, in most grave distress, awakes deserted on the lonely shore, and gazes after her uncaring lover. The graceful band is gone from her golden hair, her light dress hangs, her girdle slips from her breasts—all scatter, falling from her in the waves. Indifferent, the lost girl gazes after Theseus.

This warlike man had earlier gone to Crete, where Princess Ariadne, seeing him, had felt a flame burn down into her bones. And when bold Theseus went to fight the Minotaur, conquering the beast, and laying its body low, it was her wandering thread that showed to him the exit from the devious labyrinth. Then, when Ariadne chose the love of Theseus, he carried her by ship to Naxos's shore, only to abandon the princess while she slept.

Now in her grief she climbs the sudden cliffs, to view the vast ocean, calling out her plaint: "Theseus, in return for saving you from death, you leave me prey for angry beasts and birds. No shelter, no escape from the encircling waves, no means of flight, no hope."

But as these words pour from Ariadne's breast, and as she gazes after Theseus's ship, the cloth elsewhere portrays the young god Bacchus, racing amid a riot of spirits and satyrs, burning with love to give the Cretan girl.

A Wonderfully Embroidered Cloth, 2010 (detail). Pigmented inkjet print and hand embroidery on linen, 53 ½ x 37 in. (135.9 x 94 cm). Collection of the artist
Opposite: *Paint Me a Cavernous Waste Shore*, 2009–10 (detail). Tapestry, 118 x 107 in. (299.7 x 271.8 cm). Collection of the artist

ELAINE REICHEK *was born in 1943 in New York. She lives and works in New York.*

Midway in the journey of our life I came to myself in a dark wood, for the straight way was lost. Ah, how hard it is to tell the nature of that wood, savage and harsh—the very thought of it renews my fear!—Dante Alighieri, the Divine Comedy

Midway in the Journey, 2009 (detail). Digital and hand embroidery on linen, 30 x 28 in. (76.2 x 71.1 cm). Private collection; courtesy Shoshana Wayne Gallery, Santa Monica

Opposite: *If All the Way*, 2008 (detail). Hand embroidery on linen, 44 x 36 ¾ in. (111.8 x 93.3 cm). Private collection; courtesy Shoshana Wayne Gallery, Santa Monica

PABLO PICASSO THE KING OF THE MINOTAURS ELAINE REICHEK

If all the ways I have been along were marked on a
map and joined up in a line, it might represent a minotaur
— Pablo Picasso

G. DE CHIRICO/A. WARHOL

E. REICHEK

DRAMA OF NOONDAY SUN

THE PIGEONS SANG, LIKE ARIADNE SORROWING... —THE SUN, FRIENDS, BLACK, AND THE LONG SHADOWS RUN DRAMAS OVER THE CITY, I SAW THE

BEAUTIFUL, TRAGIC, TERRIBLE HOUSES: DEFEATED, EXHAUSTED, BEREFT OF LOVE AND OF HATRED, STRIPPED OF ALL NOSTALGIA, TRANQUIL, BOTH VIOLENCE

AND PASSION OVERCOME, LYING AT PEACE, CALM LIKE ARIADNE SLEEPING...

— ALBERTO SAVINIO

The Pigeons Sang, 2010 (detail). Pigmented inkjet print with digital appliqué and digital embroidery on linen, 51 ¾ x 46 ½ in. (131.4 x 118.1 cm). Collection of the artist
Opposite: *Ariadne's Lament*, 2009 (detail). Digital embroidery on linen, 27 ½ x 26 ½ in. (69.9 x 67.3 cm). Collection of the artist

Ariadne's Lament

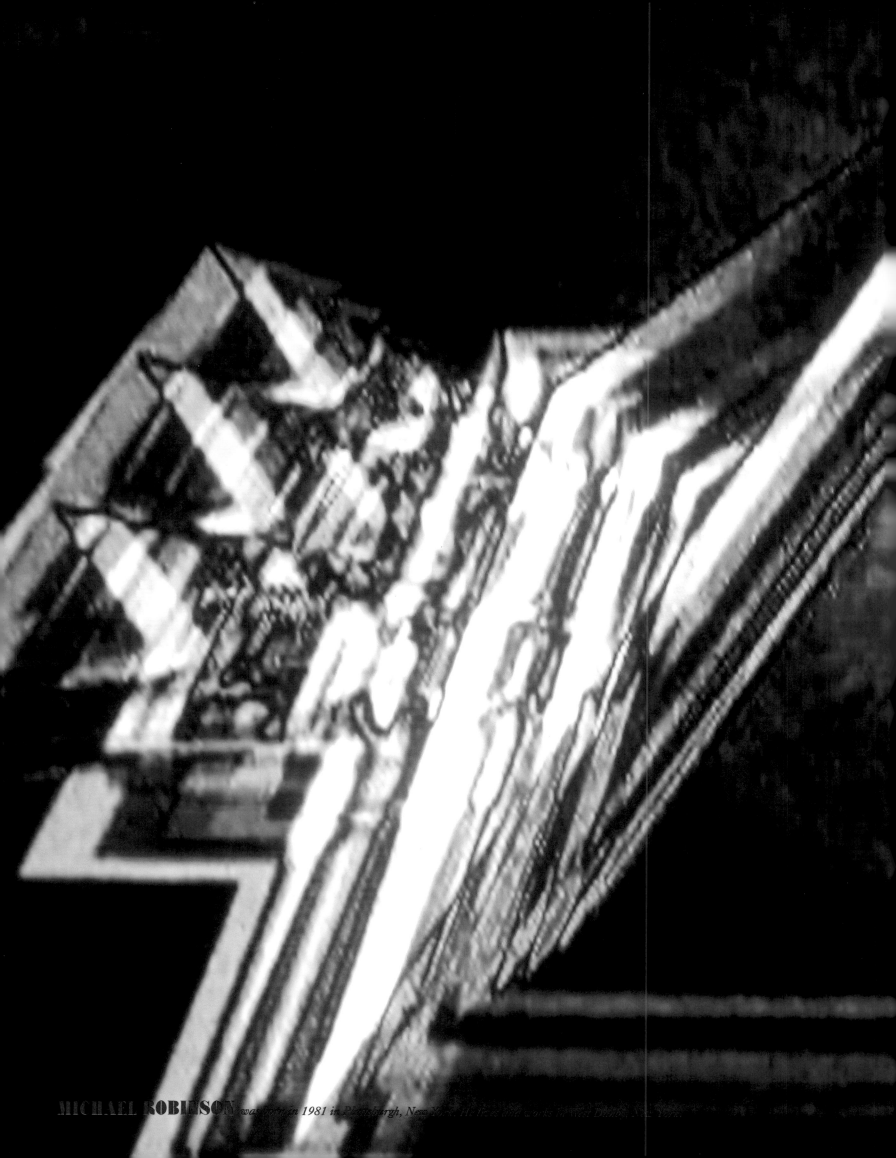

MICHAEL ROBINSON was born in 1981 in Plattsburgh, New York. He lives and works in West Berne, New York.

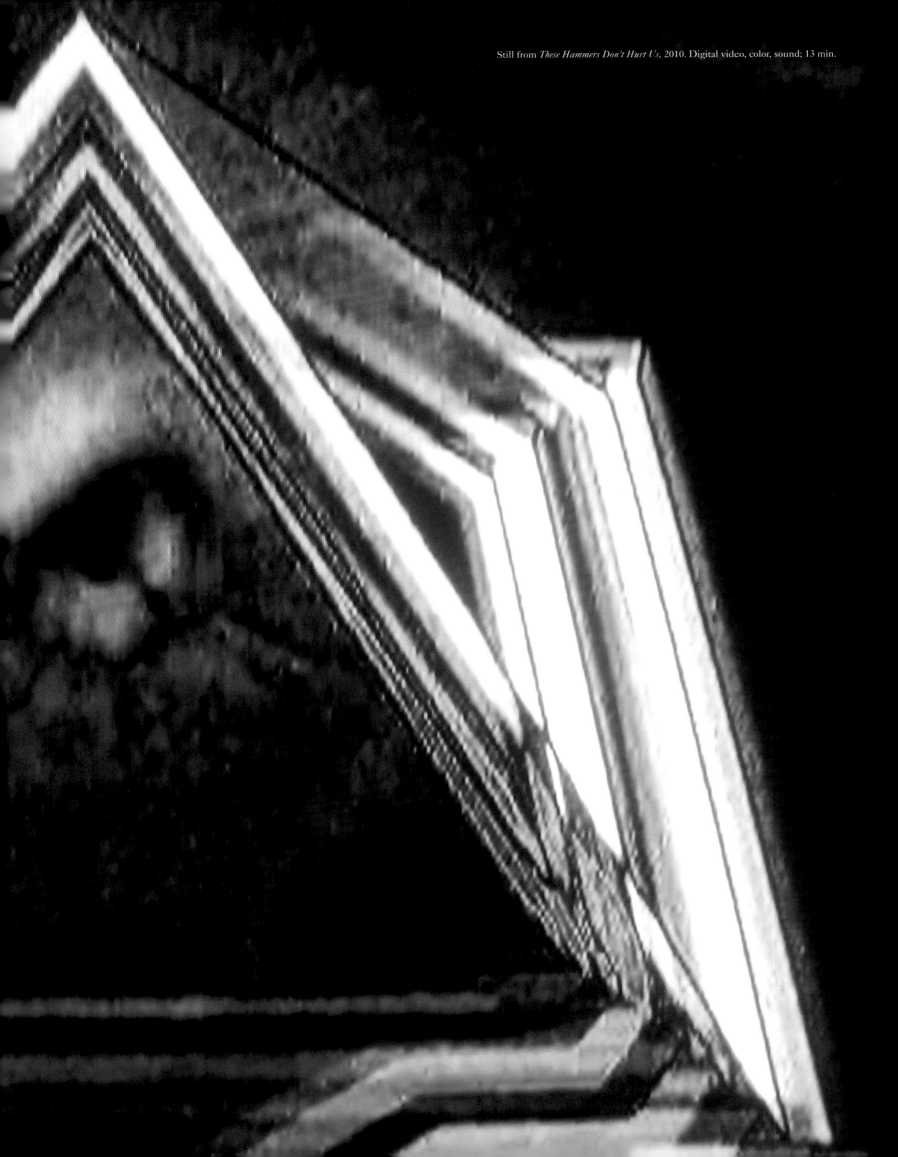

Still from *These Hammers Don't Hurt Us*, 2010. Digital video, color, sound; 13 min.

Extraterrestrial

BRUCE HAINLEY

… you know, *These Hammers Don't Hurt Us* just kills me. I can't think of many films that carry off such an uncanny, dizzying balance of gravity and light—of mourning somehow freaked with festivity—by way of the most improbable (to some!) material: Liz and "late" (in every sense) Michael Jackson. Seeing the film only days after Elizabeth Taylor's own passing, and during the still tremulous moment for liberty in Egypt, well, let's just say it's a good thing no one tried to trot out the meaningless term "camp" (consider the scare quotes like tweezers) in the Q&A after the screening, because I would have attacked him or her, physically. With my wand.

I can't really believe people still try to use that dull term. Has there ever been any word more evacuated of whatever dubious meaning it might never have even had? When *camp* is invoked, I know to prep myself for intellectual prison, not parole; someone's hedging bets, not ponying up.

Liz always ponied up, and she was always there to help others pony up, if they would allow themselves to. *National Velvet* to the rescue. She said she found Montgomery Clift his first lover. "He was tormented his whole life. I tried to explain to him that it wasn't awful. It was the way nature made him," she clarified, looking back "on Men, Money & Michael Jackson" for *Talk* magazine in 1999. Strange to think she was already looking back on MJ … then. I wonder if she found that "first" lover for Monty before or after holding his head together in one piece, sticking her hand into his maw to keep him from swallowing his own tongue, immediately after the late-night, post-party car accident that wrecked his face, and I wonder if, no naif, she meant "lover" in a strict and public sense, knowing there had been prior strangers more than just passing in the night of his life.

I assume she helped MJ in some similar manner, after some other kind of accident. In *These Hammers*, which is a movie about looking—across time, across dimensions, across borders of life and death, nature and supernature—you have Liz look at MJ in a way so similar to how she is able to look at Monty in *A Place in the Sun*, a way that I'm not sure either one of them was ever able to look at himself, or at her in return.

Some dolt declared, in one of the too many lousy, unrighteous obituaries for Liz, that, as an actress, she was merely fine, that "not one of Taylor's films [was] really necessary as anything other than one in a continuum of Hollywood movies." Kanye sings it exactly right about when we should be having a toast and to whom. After raising my glass, I'll let someone else deal with how *BUtterfield 8* or *Who's Afraid of Virginia Woolf?* might not exactly be quarantined by "continuum"; or how "Hollywood movies," especially when Liz was making them, aren't exactly inconsequential or mere affairs; and I won't begin to lay into what's to be gleaned about desire and its economies from Liz's desperate bark—"I. love. you. god. damn. it."—to Warren Beatty in *The Only Game in Town*, a flick supposedly about existential decline in the neon glare of the Strip, that, because of Liz's clout, was shot entirely in Monaco, for tax shelter, rather than Las Vegas; and I won't point out what's to be learned about generosity and performance from hearing her belch in *Secret Ceremony*, after Mia Farrow sates her hunger, or even suggest what's done to the notion of the pleasure principle once Liz blousily beds Susannah York, hot off *The Killing of Sister George*, in *X, Y and Zee*. I'll just note that, obviously, dbag's never really reckoned with Liz's going forth in *Boom!*, a boon of aesthetic delirium that, even if it did nothing else (and it did a lot else), helped John Waters and Divine come into their own.

About MJ … now is probably not the moment to conjecture if someone who idealized childhood so abreactively as a way of purging abuse—abuses—might remain, despite biochronological evidence to the contrary, a child, and therefore be incapable of even comprehending pedophilia, much less enacting it, or whether his life, its highs and lows, doesn't provide the oddest but most accurate mirror through which to see darkly America—say, for example, its fraught grappling with difference (racial, economic, and otherwise) or its two debacles in the Middle East, which, by some nightmare logic, adumbrate MJ's public humiliations, trials. His Abu Ghraib-ings.

Instead, you rightly focus on his own complicated self-portrait as a pharaonic trickster, his being, as music and magic, in fantasmatic contrast to Eddie Murphy's or Iman's or Magic Johnson's—swirling into grains of sand, and, rather than "ashes to ashes, dust to dust," becoming golden, an aspect of light, as if to burn always with this hard, gemlike flame, to maintain this ecstasy, were success in life. More and more his survival required a retreat into bejeweled armor and veils. When, finally, only shrouds could protect him from the hammering, then existence, already a neverland sarcophagus, became what he left behind for, let's hope, something better. Even Liz's surcease was not enough of a release.

Stills from *These Hammers Don't Hurt Us*, 2010. Digital video, color, sound; 13 min.

Life Forms/plastic bag and *Life Forms/candy*, 2011. Two chromogenic prints and paper clips on offset-printed book, dimensions variable. Collection of Andrew Rosh...

GEORGIA SAGRI *was born in 1979 in Athens, Greece. She lives and works in New York.*

Life Forms/condom box, 2011. Chromogenic print and paper clip on offset-printed book, dimensions variable. Collection of Andrew Roth

The Renaissance Legacy.

The Vanishing Point = Self-Effacement,
The Detached Observer.
No Involvement!

The viewer of Renaissance art is systematically
placed outside the frame of experience. A piazza
for everything and everything in its piazza.

The instantaneous world of electric informational
media involves all of us, all at once. No detachment
or frame is possible.

Info and *Life Forms*/MacBook, 2011. Ink on paper, printed receipt, chromogenic print, and paper clips on offset-printed book, dimensions variable. Collection of Andrew Roth.

She is Breaking the Door. She is Not Talking About it.

I think there is no trouble to the norm, only tiny explosions. I am going from Brooklyn GA to Bed Stuy GA, talking with a friend from the Bronk I met three days ago who is angry about the GA model. I am trying to find a way to be at as many places as possible. There are some disgusting power dynmaics with the Occupy Wall Street facilation working group. Process has become so rapidly a protocol for any GA that takes place in the whole country. Too much professional activism I guess, and too much commitment to the "cause".

Sounds like the struggle within the struggle. Professional activists are always teh first to put on the brakes.

Is it possible to push action that doesn't come out of ideology, radical symmetry and liberal monotone language? Is it possible for anyone to do more than just meetings and to go out on the streets and do his/ her own way?

The community is used to barricade and prevent threat to authority.

I am tired of empty critique, elitism, para-noia, fear, and all of those political experts who are certain that tehy know more and better than any other. These are our limitations and friendship is rare. I was too naive to think that friendship is a de facto and a stronger force than anything else.

Yours, G

She is Breaking the Door. She is Not Talking About it.

I think there is no trouble to the norm, only tiny explosions. I am going from Brooklyn GA to Bed Stuy GA, talking with a friend from the Bronk I met three days ago who is angry about the GA model. I am trying to find a way to be at as many places as possible. There are some disgusting power dynmaics with the Occupy Wall Street facilation working group. Process has become so rapidly a protocol for any GA that takes place in the whole country. Too much professional activism I guess, and too much commitment to the "cause".

Sounds like the struggle within the struggle. Professional activists are always teh first to put on the brakes.

Is it possible to push action that doesn't come out of ideology, radical symmetry and liberal monotone language? Is it possible for anyone to do more than just meetings and to go out on the streets and do his/ her own way?

The community is used to barricade and prevent threat to authority.

I am tired of empty critique, elitism, para-noia, fear, and all of those political experts who are certain that tehy know more and better than any other. These are our limitations and friendship is rare. I was too naive to think that friendship is a de facto and a stronger force than anything else.

Yours, G

MICHAEL E. SMITH *was born in 1977 in Detroit. He lives and works in Detroit.*

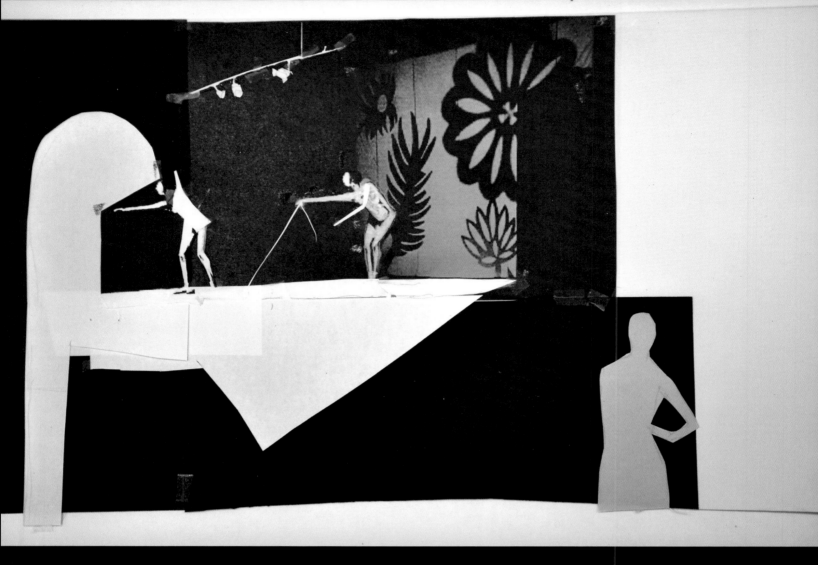

TOM THAYER *was born in 1970 in Chicago. He lives and works in New York.*

Stills from animated videos and images of the paper puppets, scenery, and notes used in their production

Production still from *WILDNESS*, 2012 (in progress).
High-definition video, color, sound

WU TSANG *was born in 1982 in Worcester, Massachusetts. He lives and works in Los Angeles.*

THERE IS A BAR CALLED THE SILVER PLATTER in the MacArthur Park neighborhood of Los Angeles that has been a safe space for a group of immigrant transgender women—to earn a living, create community, and to form a chosen family—for decades.

Or at least, that's the story I wanted to tell.

I came to know the Silver Platter through Wildness, a performance-party that I co-organized at the bar from 2008–10 with my friends Asma Maroof, Daniel Pineda, and Ashland Mines. In deciding to make a film about my experiences there, I was torn between my desire to "give voice" to an underrepresented movement (critical trans resistance) and the problems of represention itself—the burden of speaking on behalf of experiences that were not entirely my own. These negotiations were held in the balance by the daily challenges of doing the Wildness party, which strove to be a fun, entertaining, and critical space that was respectful and engaging of its site, and willfully *not* a site for any one group of people or form of creativity. I felt I needed to reach beyond the visual art audience, but still I wondered: who was I really making this film for, and why? The project became as much about the process (from within which I still write) as the product, a realization that led me to make my private artistic decisions public in the form of a blog called CLASS. Central to all this was an unresolved question. I'd set out to make a film about a safe space, but what did that mean? What is a "safe space," and can it ever be said to really exist?

According to the nonprofit GLBTQ organization Equality Network, the average lifespan of transgender people worldwide is <u>twenty-three</u>. Known causes of early death are suicide, murder, homelessness, criminalization, imprisonment, poverty, risky behavior—i.e., all the stuff that makes for the expected dramatic trans narrative. But there is also a more insidious violence: the violence weilded by the seemingly banal and neutral agencies of state administration—the DMV, parole officers, homeless shelters, criminal courts, the U.S. Immigration and Customs Enforcement, and departments of housing, unemployment, social security, and welfare, to name a few. Critical trans political resistance tries to expose how these entitites systematically exclude and collude against gender variant people, as well as poor people, immigrants, people with disbilities, and people of color. This kind of violence doesn't kill us outright; it shortens our lives through consistent exposure to violence, humiliation, and deprivation.

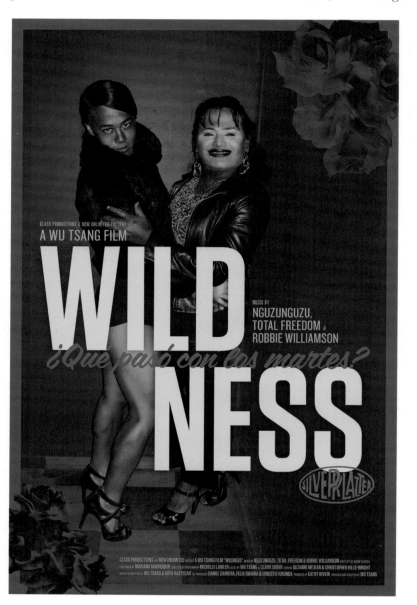

Living in Los Angeles today, in a social climate that is demonstrably and increasingly hostile to immigrants (as evidenced by the passage of SB 1070, H.R. 4437, and other anti-immigration laws), it is hard to imagine a more intense time and place to be poor and trans and undocumented. Without a doubt, the Silver Platter is a refuge, a place where we can live a kind of life made almost impossibe by contemporary conditions of oppression. It's a space not only were trans people "get by"; it's a place where we can party and make art, have friendships and drama—and really *live* life.

But is it a "safe space"?

I once asked Gonzalo Ramirez, the seventy-two-year-old owner of the Silver Platter, if he thought of the bar as such. His response was very matter of fact: "Yes, we have security guards every day." I struggled to communicate what I meant by "safe." I knew the bar had been around since the early 1960s, and I was digging for Stonewall-era stories. Did the place ever get shut down? Were there raids by the cops? Queens pumping their fists in the air? It turns out the bar has been gay on this block for forty-eight years, virtually without trouble. "Simply put, the city does not bother us at all," said Gonzalo. Except for people sometimes driving by and throwing eggs or insults, the Silver Platter has remained in peaceful coexistence with its surroundings.

I remember being a little confused by this first interview because it didn't fit with my idea of queer liberation. But I felt such a strong connection to the energy and to the scene that I was compelled to keep trying to put the pieces together. With the help of many participants, friends, and a documentary crew over a two-year period, we filmed more than thirty interviews and 150 hours of life at the bar. I thought that I'd already come to know the place inside and out, but the story of Silver Platter that emerged was far more singular, radical, and complex than I could ever imagine.

Many voices tell the story. The Silver Platter was founded in 1963 by Rogelio Ramirez (Roy for short). He was a handsome, charismatic guy, and wherever he opened shop, the gays would flock together. He had several bars around town, but this one remained the longest. Birthdays, dancing, fucking in the alleys; the guys with the *tejano* boots and leather jackets—the place was *alive*. It was packed by 6 p.m., full of people parading in and out. There was just a dance floor and a jukebox (no DJ); besides a few coats of paint, it looks exactly the same today. Roy was there every night—hosting, match-making,

dancing across the room and offering people soup to cure their hangovers. At the end of the night, he would holler, "You fucking queers, you get outta here right now and go suck dick in MacArthur Park. It's time to leave, bitches!" He worked a straight job during the day and ran the bar late into the night, sometimes until 4 or 5 a.m., inviting folks back to his apartment to make a morning of it. Everyone knew and adored him; all the bartenders were his boyfriends. He looked out for his little brother Gonzalo when times were tough: "Don't worry about being out of a job. Here's some money for your rent and to stock up your fridge. And next week we'll see what we can do." Everyone seems to remember those early years as happy and prosperous.

Then came the 1980s. Even as many of the regular crowd got sick and died, people were too scared to speak openly about AIDS. "We just kept them company and went to all their the funerals—," Gonzalo said. Roy died of AIDS in 1991, and he left the bar to two of his younger siblings, Gonzalo and Gloria, who were both gay. He said to Gonzalo: "Continue everything exactly as it is, as normal as possible. And to the person that helps you, or is good to you, if later on you want to pass it on to them, well then, so be it." That person turned out to be Gonzalo's long-time partner and best friend Koky Corral, who's been bartending there for over twenty-two years. Gonzalo said, "Now *he* is the owner of half of it. I already put it in a will. I'm prepared for everything." To this decree, Koky admitted, "Well, I feel some pressure … His brother passed this place down to him, and now he's giving it to me, and to keep this place running on track, to keep moving forward … We will do it as long as we can, God willing."

Gonzalo's other brother, Julio, and his wife, Nora, also feel a deep, special attachment to this place. Nora recalls being seventeen the first time she went to the bar in the late 1970s, and she was instantly captivated by the women—the *vestidas*—the ones who "dressed up." There weren't many in those days, because Roy didn't allow it. "If you want to come in, come as a man. You can dress up outside in the streets," he used to say. But Gonzalo and Gloria were more open and accepting of the newer generations, and things started to change after they took over. First came one, then two, then three, four, and now it's everyone. "The transformation has been substantial," says Nora. "They put on a dress, and they never want to take it off." Nicol, the doorwoman, confides that these little changes happen all the time: "Many people who come here realize it's ok to come dressed as a woman, and there are some people who have always had that fantasy … The next day they go buy themselves a wig, and there you go."

In recent decades the Silver Platter has become a beacon for trans youth migrating from Mexico and all over Central America: Guatemala, Honduras, El Salvador. The weekend belongs to them, *las chicas*, and their stories intertwine. "It feels almost just like the place where I came from," says Viki. "I've been coming here since I arrived seven months ago," says Griselda. It was the first place Yasenia came

when she arrived from Guatemala "exactly five years ago." "When they arrive they are struggling," Nora says. "They work in restaurants, as hairdressers, cleaning—El Pollo Loco, McDonalds—various jobs," says Gonzalo. "We have to show them the way," says another patron, Rosario. "For example, if they want to get into prostitution, then they need to protect themselves, watch out for this or that. Let's look for a job instead, that even if it's low paying, then you're doing something decent and will get ahead."

Like most everywhere else in Los Angeles (and in the country, for that matter), MacArthur Park is not safe at night if you're visibly trans. Morales, the director of the weekend drag show, says, "If I go out wearing my blond wigs trying to dominate outside, someone will walk by and they're going to break my mouth. But if I leave the bar normal and get into my car and go home, nothing is going to happen." Nicol, who lives full-time as a woman, has a different experience: "Even if we dress regularly, bad things happen to us." And, she adds, those outside prejudices still have a way of seeping into the bar: "To this day, whenever someone comes in here calling themselves 'straight,' they are always either violent or rude."

Such problems aren't confined to so-called outsiders. Regulars at the Silver Platter split off into cliques, factions; there's cattiness, back-stabbing, and, on occasion, an all-out fight. "Maybe because of what they have had to live through back in their countries, I feel that maybe that's the reason that they come here with that violence," says Rosario. "I think they no longer do it from a place of malice, but from instinct. They're constantly on the lookout to see who's giving them the wrong eye." There's plenty of alienation and loneliness at the Silver Platter, too. Venus, who's been coming for thirty years, says, "I've always

Production still from *WILDNESS*, 2012 (in progress). High-definition video, color, sound

sat in this corner. This is my favorite spot. So these girls now come to a scene that they believe is theirs … When they find me here, they start to make a mob in front of me, and I'm mortified by that. They don't greet me; they start waving their hair." Yasenia says knowingly, "You're ok as long as you don't have any problems with anyone else."

I wondered if "community" was just another form of coexistence, the simple fact of occupying space together. Yet it's hard to deny the magical, magnetic quality the Silver Platter exerts. People come back again and again, and they often become regulars over a long period of time. After twenty years, Betty says, "I won't ever leave, God willing." When Nora closes her eyes and pictures the outside of the bar, she sees the people who have died, lingering around this spot. It's as if they want to stay, even after they're gone.

So *is* the Silver Platter a refuge from a crazy, hateful world out there? Sometimes it definitely feels like it to me. On Fridays, I can never find parking nearby, so I have to run, teetering in too-tall heels or after too many drinks, until I make it safe inside. It's warmth is something I had never known before. But I also bring to it my own experiences: I am trans/feminine, yes, and a second generation immigrant, and like many of the women at the Silver Platter, I have

been running my whole life from an emotionally unsafe home. But I also have a college education, and as an artist I'm part of a socially mobile class; I myself may not have a lot of money, for example, but I recognize that I have tremendous access to wealth and resources through a network of artist friends and associates. I wrestled again with what "safe space" means. It seemed the definition could be slippery and shift depending on class and privilege. What is a safety net, and who has one?

Today, gentrification is encroaching MacArthur Park from all sides, particularly as downtown Los Angeles is undergoing massive redevelopment with its loft-driven "arts district." Artists are typically the harbingers of imminent "revitalization" of neighborhoods, and there was no denying the implications of our party vis-a-vis these larger forces at play. The press and attention surrounding Wildness erupted when the *LA Weekly* printed a exploitative review, portraying the women of the Silver Platter as essentially cum-thirsty nightcrawlers and describing the bar as "a place where a lady-boy can take a load off her feet and wipe a load off her skirt before getting back to buisness in the back of a Toyota." For a moment it seemed that our party was actual-

LGL (LETSGO LIBERACIÓN) mission statement on the back door of Imprenta

ly posing a critical threat to the very notion of the Silver Platter as a safe space. Some Wildness-goers started hating on us (tagging the outside of the bar with "OCCUPIED" stencils), saying we were exposing the Silver Platter to all kinds of unwanted attention. I felt existentially confused about whether Wildness belonged there, and whether we should stop.

Around that time, a storefront next door to the Silver Platter went up for rent. It seemed like an opportunity to address some of the underlying safety issues that affected many of the women at the bar in a more direct way. My feelings of protection and desire were what drew me to the Silver Platter in the first place; I thought if we were going to continue Wildness, then how could we broaden the "safety" or security afforded by the "safe space" of the bar? I wanted to connect the dots between many artist and actvist friends who were already enagaged in similar work. I had a fantasy of building a drop-in center *inside* the party, where you could drink and dance and also access legal services, under-the-counter hormones, body movement workshops, art projects, a radical library, and free internet. A group of us moved into the vacant storefront in December 2008. Dean Spade, a laywer and founder of the Sylvia Rivera Law Project, a nonprofit law collective that works to provide free legal services to trans people of color, introduced me to a dedicated group of lawyers and law students, and we started a free legal clinic. Thus, Imprenta was born; Wildness grew a mini-institutional appendage.

As we geared up our activities, we also partnered with a couple service providers, including an organization that I will call Good Services. GS had a conventional nonprofit hierarchy for a GLBTQ organization: the heads at the top were white men, the middle-management were gay men of color, and the lowest rung in the field

were trans women of color. We decided to coordinate HIV testing and needs assessment with GS, using Imprenta as a staging area next door to the Silver Platter. This would give the agency more reliable access to "the community," instead of having to depend on a mobile unit.

From the get-go, however, tensions seemed to arise between "effective" community organizing and accountiblity to the very community that Impreta was founded to serve. Those tensions became most evident to me one night when I saw the excitement of the GS workers after they "got a positive"—meaning someone that they tested had turned out to be HIV positive—which meant a "good" statistic from the standpoint of soliciting more funding. But how could it be good news to find out that a member of the Silver Platter scene has a dangerous illness? What kind of impact would it have on the highly vulnerable and precious communinty space that Imprenta was struggling to create to bring in this purportedly "helping" agency that was so concerned with its own funding—most of which paid inflated salaries to white senior employees of the organization? It disturbed me to see the GS workers treating my friends as a cold category of data collection, "TSM population" ("trans people who have sex with men"), yet it also made me question my own intentions and collaboration with them. In fact, there were many times when I utilized GS's network and methods for my own film production. What trade-offs had I made between community accountability and so-called effective organization in my own project?

As I became close with some of the trans women who were field workers at Good Services, people who all had amazing spirits and ideas, it frustrated me that no one ever put them in charge. Imprenta had been founded by and for trans people of color, and I wanted to make "by and for" governance a reality; I wanted these women, the underpaid field workers, to be the bosses! So we all started meeting together: lawyers, law students, field workers, activists, Silver Platter regulars, and Wildness-goers. We declared our "core" membership to be a hundred percent queer and trans, at least eighty percent people of color, and at least fifty percent low income (although we were a little off the mark with the low-income target, we pledged to meet it). We potlucked and smoked weed, enthusiastically plotting out all the dirty work to get the clinic going. We kept saying we needed to "get on the same page politically," and I was never really sure what that meant, but it was always on the meeting agenda. It seemed that behind it was a kind of nebulous idea that sharing an analysis could hold us together, could make us accountable to do the work. If we could just believe in the same criticisms of power, we could transform it.

We also renamed our ourselves LGL (LETSGO LIBERACIÓN) to honor the transformation from an organization managed by lawyers into a community-run collective. I wrote a mission statement on the back door of Imprenta, which faced the alley behind the Silver Platter, where all the queens go to piss.

But just as our agenda was beginning to coalese around something that we could articulate to the outside world, internal difficulties began to erode the organization from within: clashing communication styles, personalities, and power dynamics. Our biggest contention was the founding principle of being "by and for" the community and fulfilling our pledge to our core percentages. Seeking guidance, we turned to other activist manuals, such as the handbook for the Sylvia Rivera Law Project, with its intricate decision-making flowcharts, Incite! anthologies, and how-to worksheets, such as "how to be a white ally." (E.g., "A good ally understands that many one-down group members may be carrying 'cumulative impact' of a long series of negative treatment. If they seem irritated or unusually upset, the ally tries not to take it personally, but instead, tries to offer support to the one-down group member … ")

But the manuals and words were failing. We all tried so hard to wait, listen, and defer decision-making; our speech was measured by careful calibrations of our perceived privilege—and tensions grew. Personally, I felt caught between being a "one-up" member because of my educational privilege, and a "one-down" community member because I wasn't a lawyer and because I am a trans person of color. I felt paralyzed by not knowing when I was authorized to speak, and what my authentic position was in relation to the group.

At the legal clinic, the lawyers (who were disproportionately white non-trans people) also made me nervous, the way they would show up and expect to be provided clients through some hyper-efficient system that we often didn't have in place. We all felt pressure that their presence was a gift not to be wasted, as opposed to the other way around. Weren't they supposed to be there to support

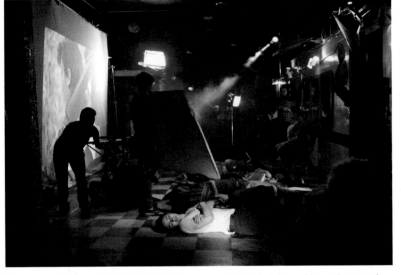

Production still from *WILDNESS*, 2012 (in progress). High-definition video, color, sound

us? Despite our efforts to the contrary, we were replicating the systems of valuation that surrounded our work—community members as unimportant volunteers, professionals as overvalued experts. In many ways, it seemed like we were utterly outside our initial aims of using services to build collective action for trans immigrants of color. On the other hand, the clinic was growing as a tangible resource; people from the community were seeking our services, and there was clearly *need* for this work. But the pressures of this need only further reinforced the fraught power dynamics between the lawyers and the community members, because there never seemed to be time to share skills or to go beyond our expected roles.

Eventually our core attendence dropped off sharply, a breakdown that was at least partially economic. For those of us getting some kind of "credit" in the straight world for this work, it was maintainable: the lawyers could clock pro-bono hours; the students could write dissertations; the artists could generate cultural capital, etc. But for many others, after the initial curiosity and desire wore off, Imprenta/LGL loomed as just another burn-out commitment at the end of a long workday, or a long-ass bus ride across town. Ultimately, with no structure in place for salaries or benefits (which we disavowed anyway), we

all found ourselves having to make those choices. It was truly a crisis of not knowing *what* was holding us together, if it wasn't just hanging out, getting laid, or even sharing a sense of connection. At this point, financial and other strains on maintaining the organization just imploded, and we had to give up the space and move out.

Imprenta/LGL lives on, however, though whether it will grow and thrive and endure as long as the Silver Platter, the enterprise that inspired it, remains to be seen. We decided to continue the clinic by making it mobile. No longer having a fixed address, a permanent physical place where community members can gather beyond the bar—it definitely challenges the notion of the expanded "safe space" we had originally envisioned. But it also opens up productive opportunies to continue exploring how "service providing" can be transformed into community organizing, and it provides us with a powerful analysis to build on as we move forward: to continue searching for ways to put the most vulnerable members of our communities at the center of our movements, instead of at the fringes. Our initial experiment, which is now slowly undergoing the process of reexamination and recommitment, is just part of a larger network of racial and economic justice efforts that is growing nationwide, including the Audre Lorde Project, FIERCE, SRLP, and the TGI Justice Project, as well as many others.

In the process of making *WILDNESS*, the film, I realized I had this fantasy of queer liberation that was based on documentation of past civil rights movements, on the recorded images and voices that were my only access to those historic moments. There was a nostalgia I felt for what I imagined were more "urgent" times, when demands were somehow more concrete, and the path to change was more connected to marching in the streets or rioting outside the bars. It was a fantasy that propelled me to pick up the camera and want to capture what was happening around me. But the material revealed truths that didn't necessarily fit with my ideas of what a "cohesive" resistance movement looked like (if ever there were such a thing), and these were sometimes hard to look at. The project grew into an unwieldly story, barely holding all the vibrant and conflicting pieces together, just like the bar itself.

Today the Silver Platter remains a safe space for a really special group of immigrant trans women. Wildness didn't end up blowing up its spot, as I sometimes feared it would. However, I anticipate that, because of its accessible format, the film *will* bring an unprecendented amount of attention to the bar. It will raise uncomfortable issues about exposure and exploitation (as a documentary inevitably does, because you are using people's lives to tell a story). But I'm ready for such confrontations and dialogs because my experiences taught me that real change comes through building coalitions, which are often painful and never safe. It's an endless process of reevaluation and struggle, which I hope continues to unfold as Wildness finds its way out into the world.

This essay is especially indebted to my ongoing conversations with Dean Spade, Roya Rastegar, and Mary Kelly.

OSCAR TUAZON *was born in 1975 in Seattle. He lives and works in Paris.*

Frederick Wiseman in Conversation with Kent Jones

KENT JONES: Do you have a problem looking at your older films?

FREDERICK WISEMAN: I don't look at them very often—only when I have to and I'm giving a talk. I tend to remember them. I've looked at them so often in the editing that I tend to remember the dialogue. But when I *do* look at an older film, particularly some of the earlier ones, it's painful sometimes because I see a lot of mistakes. If I live long enough to look at the recent ones, the same thing'll happen.

KJ: What kinds of mistakes?

FW: Well, either not the right coverage or an editing mistake.

KJ: Meaning you've gone to the wrong place or the rhythm is wrong?

FW: The rhythm isn't right, or I've intercut something that I shouldn't have intercut.

KJ: I'm not implying that you sit around and look at your older work, by the way.

FW: When I have Alzheimer's maybe I'll do that.

KJ: When you think of the films, do you think of them as they emerged or as they went through the shooting and editing process?

FW: Well, obviously I have strong memories of different aspects throughout the process. There are always a lot of funny experiences during the shooting and a lot of high and low moments during the editing.

KJ: How did you get interested in the subject of *Boxing Gym*? Is it because Zipporah [Wiseman's wife] spends so much time in Austin that you found your way to the gym?

FW: Actually, I started following boxing in the 1930s. Joe Louis was an early childhood sports idol, and I remember going to the newsreels on Saturday afternoon when I was six, seven, eight years old and seeing the highlights of the Louis fights. I remember the Louis-Baer fights; I remember the Louis-Schmeling fight, which was when I was *very* young. I boxed a little myself when I was thirteen, for all of two weeks. Many years later, before cable television covered the big matches, they used to project them at the Boston Garden on enormous screens, and I took my sons David and

Eric. We saw a lot of the big matches of the 1970s that way, including the Frazier-Ali fights. So, I was a big sports nut when I was a kid and am a moderate sports nut now, and I have a long history with boxing.

Actually, I heard about Lord's Gym when Zipporah and I were having dinner in Cambridge with one of her colleagues from the University of Texas. I told him that I'd always wanted to do a movie about boxing, and he said, "Have you ever been to Lord's Gym?" I said no, but the moment I heard it was called "Lord's" Gym, my large ears perked up. The next time I visited Austin I went over there, and I met and liked Richard Lord. He said okay right away, and I started shooting a few weeks later.

KJ: Did you spend any time figuring out which of the regulars you wanted to film?

FW: No. I spent exactly one morning in the gym before the shooting. That's usually the case. I've just come back from Japan, and I said about five thousand times in Japan that I don't do any research and that the research is the shooting of the film, and it has the charm of being true. Since none of the events are repeated and nothing is staged, I don't like to be around a place when something interesting might be going on and I'm not prepared to get it. Lord's

Gym is a very small place, so all I did there was walk around and then make an appointment to come back a couple of weeks later and start shooting.

KJ: You probably get the "research" question constantly, because for about the last ten or fifteen years that's become the standard idea of how documentaries are made: every documentarian supposedly has to spend at least a year with their subjects before presuming to pick up a camera.

FW: I would be very depressed if I were somewhere doing research and something spectacular went on and I wasn't prepared to *get* it. Maybe more spectacular things could be going on if I hung around for a year, but … I don't think there's any *right way* to do it; it's just the way that *I* do it. The whole "Las Vegas" aspect of it appeals to me enormously—I roll the dice all the way. For example, if I'd been at the hospital doing research when the doctor made the call to Miss Hightower, or when the young student who had taken an overdose of mescaline was given Ipecac and started to throw up, I would have been very unhappy to have missed that stuff, because it has terrific dialogue [*Hospital*, 1969]. Same with the fly-swatting sequence in *Essene* [1972]. If I'd been there observing the way the abbot interacted

Still from *Boxing Gym*, 2010. 16mm film, color, sound; 91 min.

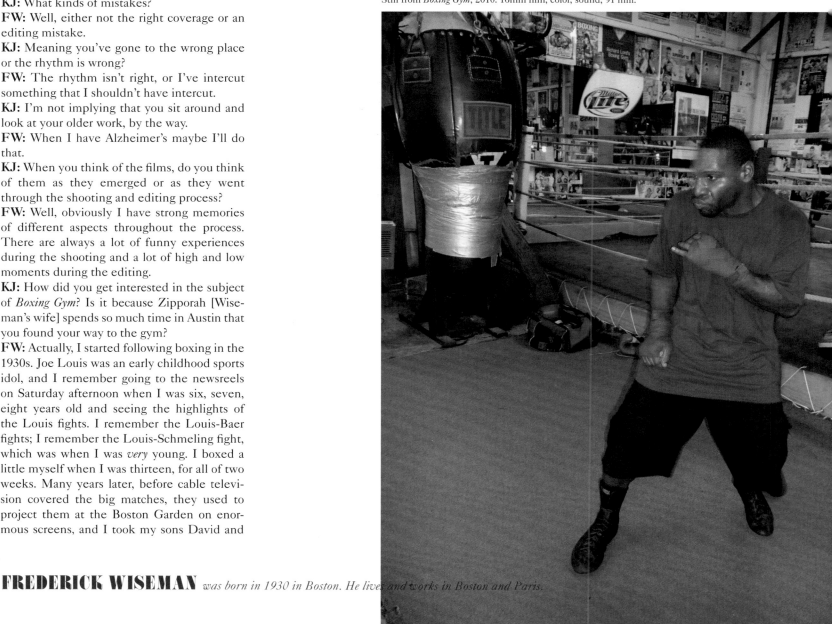

FREDERICK WISEMAN *was born in 1930 in Boston. He lives and works in Boston and Paris.*

with the monks on a one-to-one basis and the fly-swatting moment had happened, I would have been suicidal. When I'm not there, at least I don't know what I've missed. It doesn't mean equally or more spectacular things didn't happen. It's just that I don't know about it.

KJ: It occurs to me that when you spend research time, you might see something like the fly-swatting moment happen, mark it as typical, then look for something identical or at least similar, part of the same behavioral family—which inevitably leads to disappointment.

FW: *Or* you're going to feel forever unhappy; you're going to feel that the film wasn't as good as it might have been, because you missed that scene. There's also some pseudo-science attached to being there, some anthropological idea, which may or may not work. If the goal—as is *my* goal—is to make a narrative dramatic film, without any objective of touching all the

Still from *Boxing Gym*, 2010.
16mm film, color, sound; 91 min.

so-called bases, then … really what it boils down to is: I like this system, it works for me. It's obviously not the only way to do it, and I wouldn't criticize anybody who does it another way, but it's the way *I* do it.

KJ: Can you talk a little more about the "Las Vegas" aspect?

FW: The whole movie's a roll of the dice. You don't know what's going to happen. When you start one of these movies, chance is very important. The end result is a combination of instinct, judgment, and luck—in other words, chance.

KJ: In essence, you can't ever really come away from a shoot thinking, "Gee, I didn't get anything," because there's always something to get if you're paying attention.

FW: That's right. I don't know how to deal, and therefore don't get involved, in the issue of whether or not what I'm filming or have filmed is "representative." I just don't know how to do that, and the problem holds no interest for me. To the extent that I've thought about it, it seems to me insoluble. Or, you end up with some kind of bland statistical analysis that says, "These kinds of events happen ten

percent of the time and this kind two percent and others fifteen percent." But again, somebody else might do a terrific job with it.

KJ: But isn't the whole question of what is or isn't representative false to begin with?

FW: It's a false question because there's no answer.

KJ: It seems to me that the question of representative reality is at the root of all those questions you used to get about the presence of the camera affecting the reality of your subjects.

FW: *Aaarrggh* …

KJ: Do those questions persist?

FW: I just got back from Japan, and I got that question everywhere I went. There's no accurate way to measure whether the camera changes behavior. My experience is that it doesn't. I take as an extreme example the case of the scene in *Law and Order* [1969] where a policeman strangles a woman accused of prostitution. He does it in front of the camera. What she had previously done was knock an undercover cop down a flight of stairs after he arrested her. The police came and found her hiding under a pile of old furniture and dragged her out, and that's when the strangling occurred. After the first policeman lets her go, she complains to the second policeman who's holding her that the first policeman was trying to choke her, and the second policeman tells her that she was imagining it. Remember—you, the public, have just *seen* the first policeman strangling her. So the second policeman explains that if she wants to be a prostitute, that's okay, but she has to know how to play the game. Which is: if you get arrested, don't struggle, don't hit the police, go down to the police station, get fingerprinted, get your picture taken, pay your fine, and you're back on the street in thirty seconds. The policeman strangled her because she had assaulted another policeman. In other words, *he* thought that was a perfectly acceptable thing to do. I think this is an extreme example of what goes on all the time. We all think that what we do is okay. We don't see it the way other people see it. The same principle applies all the time. Obviously, that second policeman was neither showing off for the camera nor inhibited by it.

Another reason that I do not believe the camera changes behavior is that none of us are good enough actors. If we *were* skillful enough to change our behavior so rapidly and completely, the pool of actors for Broadway and Hollywood would be much larger than it is.

Another thing to consider is the wide variety of behavior recorded on film, in my films and in all the other thousands of films that have been made. The very diversity and range of experience that's been recorded on film can be employed as a general argument against the notion that the camera changes behavior. I don't know which of these factors predominate.

So, I will now make the same pretentious statement that I always make: the Heisenberg uncertainty principle doesn't apply to documentary filmmaking.

KJ: It seems to me that the worry about the camera changing people's behavior is based on the dream of a fundamentally just relationship between filmmaker and subject, a mistaken idea that they can reach some kind of mutual harmony.

FW: That's the phony sense of community, the implicit contract. In making *Welfare* [1975], some of the participants had no *idea* that a movie was being made, didn't look at the camera and went about their business. In the case of the happy couple at the beginning of the film, which is one of the funniest sequences in all of my films, I had never seen those people before, and I never saw them after. They were just going about their business, and some of the things they said were absolutely extraordinary. And, the man was lying.

KJ: This brings us back to the question of narrative. If you're thinking in narrative terms, you can allow yourself to see that sequence as funny. Which you can't do if you're worrying about whether you've achieved a just portrait of people applying for welfare.

FW: The notion that there is some kind of just relationship is a fantasy. It has to do with the whole idea of film and social change, and not accepting the world as it is.

KJ: The idea that there's *one* way to make a film that is morally and politically responsible.

FW: Exactly. The way that *I* frame that issue of responsibility is that I feel I have to be fair to the participants. Yet, like all other choices in

Still from *Law and Order*, 1969.
16mm film, black-and-white, sound; 81 min.

life, the choice of how I'm going to represent them is, finally, completely subjective. I won't change the order of events within a sequence, but I will place sequences out of the order in which they were shot. In other words, I might start the film with a sequence from the thirtieth day of shooting and end it with something from the first day. I won't change the order *within* a sequence, but I *will* compress that sequence from forty-five minutes to five.

KJ: Because you're creating a narrative arc.

FW: Yes, and in so doing I'm making a selection. I'm making choices in the service of creating the narrative arc.

KJ: How often do you find yourself in a situa-

tion where you see someone, they look interesting, and they refuse to be filmed?

FW: It happens *so* rarely, and on most films it doesn't even happen at all. I would say it's happened seven or eight times in forty-four years.

KJ: Why do you think that is?

FW: There are a number of possible explanations, but you can't underestimate the power of vanity.

KJ: *Boxing Gym* is a very compressed film—

self: "Now I'm going to do *physical* films." It's part of the daisy chain. Actually, *Boxing Gym* was shot before *La Danse* [2009], and then the opportunity came up to do *La Danse*, so I did that, and then because I was in Paris a lot, the idea for *Crazy Horse* [2011] occurred to me. It's not a matter of an overarching, systematic ten-year plan.

KJ: It never can be, I guess.

FW: Right. It depends on what pops up, what

values and experience of the viewer, as well as my capacity to provide enough information in the film to let the viewer know what's going on and therefore make some judgment about what *my* point of view is. The material is frequently ambiguous. The classic story from my point of view concerns Louise Day Hicks, who was a very conservative member of the Boston City Council and school committee for years. She saw *High School* [1968] at a screening in Boston just a short time after it came out. I was at the screening, and somebody introduced me to her after it was over, and she said, "Mr. Wiseman, that was a *wonderful* film, and I *wish* you could tell me how we could get high schools like that in Boston." So there it was. *High School* was a sad comedy, but she was on the other side of all the value issues. So what I thought were absurd moments—what I thought could easily be interpreted as a critique of the quality of the education that was being offered at Northeast High—she thought was wonderful! Now, you could say that's the fault of the film. Naturally I don't think that. I think it's a question of a difference in values.

KJ: I wanted to talk about the scene in *Crazy Horse* where the artistic director starts rhapsodizing about Josef von Sternberg and Michael Powell. On the one hand, he seems like an extremely grandiose person with a lavish sense of his own importance. On the other hand, he's expressing something very real about what we see in the film.

Still from *High School*, 1968. 16mm film, black-and-white, sound; 75 min.

there's a lot packed into ninety minutes, which is one of your shorter running times.

FW: As you know, I don't start editing with a running time in mind. The length of the film is a response to the experience of the editing. By that, I mean the nature of the material. To take a movie at the other extreme by way of contrast, *State Legislature* [2006] is a film that is very dependent on words and long discussions. There's no opportunity to cut to one-liners. Whereas in *Boxing Gym*, the rounds are short, you don't have to have *all* the rounds, and there isn't *that* much conversation. The subject matter allows—actually, it *demands*—quick cutting, given the nature of the sport, the nature of the activity, and the shortness of the conversations. In *State Legislature*, you have to allow time for the discussion to evolve, which enables you to present a complex version of an abstract issue, an issue that's filled with both ambiguity and ambivalence. So the editing style and the length of the film are therefore determined by the subject matter. On the other hand, *Zoo* [1993] was a relatively short film because fifty percent of the participants don't talk very clearly.

KJ: It does occur to me that the last few films you've made have been centered on the physical rather than the verbal.

FW: That's chance as well. I didn't say to my-

Still from *High School*, 1968. 16mm film, black-and-white, sound; 75 min.

interests me, what I get the money for. And it really depends on what subject I want to spend the next year of my time on.

KJ: I'd like to shift gears and talk about the instances, which I'm sure are numerous, when viewers characterize a scene from your film differently from the way you would characterize it. I'm guessing that this happens a lot.

FW: That's a complicated question, which is an illustration of the nature of this kind of filmmaking. In a sense, the real film happens where the mind of the individual spectator *meets* the film, so to some extent it's dependent on the

FW: That sequence serves a variety of purposes; it doesn't serve just one. The fact that the film references other films is true. And it's also the way he talks about it. Both things can happen. The scene is also an illustration of my particular way of making films. He *is* pretentious. And the review *does* have some kind of relationship to those films. It's the *form* of expression that's funny, not the effort to link *Crazy Horse* with those films. Although that might be funny, too, to the degree to which it succeeds or doesn't. In the review, as opposed to the film.

KJ: One of the things that struck me about

Production still from *Crazy Horse*, 2011.
High-definition video, color, sound; 134 min.

Crazy Horse is that you start *within* the spectacle rather than outside it, as you do in *La Danse*.

FW: Yeah, well, I don't think I'm beholden to any particular pattern. That's a choice related to the themes of the film. It is in *La Danse* as well; it's just a different theme.

KJ: Yeah, but I could also imagine *La Danse* starting with one of the dances.

FW: Well, of course—there are a million ways it could have started. It could have started with any one of the sequences that are in the film or in the rushes. But it wouldn't be saying the same thing. In my mind, there is a reason for the choice. Whether that reason is conveyed, or whether it's a good choice or not, isn't for me to say. It's just another illustration of the fact that I have to have a theory as to why each shot is where it is and what its relationship is to everything else. Otherwise I couldn't make the choices that create the structure.

KJ: A matter of instinct.

FW: A matter of instinct, or a matter of logic. The whole process is a combination of the rational and the nonrational. And when it doesn't work, the irrational.

KJ: Do you often find yourself getting to a certain point in the editing process and thinking, "I need to start somewhere else?"

FW: Yeah. It's the Yogi Berra response: "It's not over till it's over." It's subject to change till four o'clock in the morning the night before the mix.

KJ: Actually, can you talk about the mix a little? For different filmmakers, it means different things. In his book, Sidney Lumet confesses that it bores him silly. For other people, it's one of the most exciting parts of the process. What is it for you?

FW: I don't know that I would characterize it as exciting *or* boring. I take a much more practical approach to it. It's where I can try to make the sound exactly as I think is appropriate for the use that's being made of it. It's a question of being extremely attentive to sound levels and background noise. It's where you can clean up the track—these are obvious things, but they all make a big difference. For example, in *Boxing Gym*, since the sounds of the bells, the clock, and of boxing gloves hitting flesh or punching bags is the music of the film, I could do a lot with emphasis or changing the tone or extending the sound in ways that, I thought, added to the in-

terest of the track. That's true of all the films. There's the technical aspect of just cleaning up the sound, and there's also a more, for lack of a better word, *creative* aspect. If you somewhat over-modulate the sound in the recording, you can more or less correct that with digital sound editing. If the sound is too low, you can salvage it. You can determine the tone. And you can be very precise about the music cuts. If you have two different bits of music butting up against each other, it sounds terrible. But in the mix you can do the fade-ins and fade-outs, so that it sounds like one continuous piece of music, and you're less aware of the transition than you might have been otherwise—or perhaps unaware of it altogether. You could do it to some extent on an Avid. You couldn't *really* do it on a Steenbeck. In a mixing studio, where you have *total* control, you can make it appear smooth and contemporaneous.

KJ: I know that you've recently switched to digital editing and that you've shot your last two films on HD. Do you miss 16mm?

FW: I miss it because I prefer the look of film. Also, I edited on a Steenbeck for forty years, and at the risk of sounding pretentious, there was something artisanal about the handling of film. Some people think you have more choices on the Avid. I don't think you have any more *significant* choices. The old-fashioned way of editing with the Steenbeck—having to walk to the wall, take the roll down, and roll down to the point you wanted to get to, was not wasted time because you were reviewing the

film. I find that with the Avid, I'm somewhat removed from the material because I'm typing. I don't like that, but it may only be because I have forty years of doing it the other way. I remember there was a review of *State Legislature* by someone who didn't like it, and they said it would have been a much better film if it had been cut on the Avid because it would have been cut faster!

KJ: What the hell does *that* mean?

FW: It's an incredibly stupid remark, because the rhythm is determined by the editor and the subject matter, not by the machine. The editor—in that case, myself—was making the choices based on the material, *not* based on the ease with which I could make the cuts.

KJ: Do you miss the quality of the 16mm image?

FW: *Crazy Horse* was the first film that I shot on HD, and while I think that it looks quite nice—in the grading we tried to give it a film *look*—there were scenes during the shooting that I couldn't get. For example, with film I would've had more shots of the audience, because film would've worked better in low-light conditions. The HD camera I used, the Sony 900, was terrible in low light. There's a new camera, the Arri Alexa, that allows you to shoot in low light—the quality is as good as film because you're using 35mm lenses, which means the color reproduction and the possibility of getting good quality in low light is much better. I haven't tried it yet, but next time I make a movie, I probably will.

Production still from *La Danse*, 2009. Super 16mm film, color, sound; 158 min.

WORKS IN THE EXHIBITION

As of December 20, 2011

KAI ALTHOFF

There we will be buried, 2012
A play by Yair Oelbaum, featuring
Yedidya Oelbaum, Jessica Polaniecki,
Kai Althoff, Daniel Cowen, and
Alex Beth

Untitled, 2011
Oil, synthetic polymer, tempera, and
varnish on fabric and silk
Dimensions variable
Collection of the artist

Untitled, 2011
Oil, synthetic polymer, tempera, and
varnish on fabric and silk
Dimensions variable
Collection of the artist

Untitled, 2011
Wood, plexiglass, fabric, handwoven
panels by Travis Josef Meinolf, and
screenprinting
Dimensions variable
Collection of the artist

Untitled, 2011
Mixed media on iron and wood base
Dimensions variable
Collection of the artist

Untitled, 2011
Fabric
Dimensions variable
Collection of the artist

THOM ANDERSEN

Get Out of the Car, 2010
16mm film, color, sound; 35 min.
Courtesy the artist

Los Angeles Plays Itself, 2003
Beta SP video, black-and-white and
color, sound; 169 min.
Courtesy the artist

Rare Los Angeles Films, 2012
Film screening of *The Towers* by
William Hale (1955/2011; video, color,
sound; 13 min.); *Film Exercise #1 (Watts
Towers* by Baylis Glascock (1962; 16mm
film, color, sound; 5 min.); *Shoppers
Market* by John Vicario (1963, 16mm
film, color, sound; 22 min.); *Throbs*
by Fred Worden (1973; 16mm film,
color, sound; 7 min.); *Now, You Can Do
Anything* by Fred Worden and Chris
Langdon (1972; 16mm film, black-
and-white, sound; 6 min.); *Three/3:
In the Ocean, On Land* by Peter Bo
Rappmund (2010; video, color, sound;
5:30 min.); *Venusville* by Fred Worden
and Chris Langdon (1972; 16mm
film, color, sound; 12 min.); *999-BOY*
by Chris Langdon (1974; 16mm film,
black-and-white, sound; 5 min.); *Venice
Pier* by Gary Beydler (1976; 16mm
film, color, sound; 17 min.) *The Towers,
Film Exercise #1 (Watts Towers), Three/3*:
courtesy the artists; *Shoppers Market*:
courtesy Film-Makers' Cooperative;
Throbs and *Venusville* preserved by the

Academy Film Archive; prints courtesy
the Academy Film Archive and the
artists; *Now, You Can Do Anything* and
999-Boy: courtesy the Academy Film
Archive and the artists; *Venice Pier*:
courtesy Canyon Cinema

CHARLES ATLAS

Ocean, 2011
High-definition video, color, sound;
100 min.
Courtesy Cunningham Dance
Foundation and Walker Art Center

Atlas/Basinski, 2012
Live audio/visual improvisations with
William Basinski, with three laptop
computers, VDMX software, hardware
video mixer, four DVD players, video
camera, monitors, projector, and
video clips (loops),digitized analogue
tape loops, feedback loops, and
delay systems

LUTZ BACHER

What Are You Thinking, 2011
Single-channel video, black-and-white,
sound; 3 min.
Collection of the artist; courtesy
Ratio 3, San Francisco; Alex Zachary,
New York; and Cabinet, London
Commissioned by Frieze Film 2011,
Frieze Art Foundation

Baseballs II, 2011
Baseballs
Dimensions variable
Collection of the artist; courtesy
Ratio 3, San Francisco; Alex Zachary,
New York; and Cabinet, London

The Celestial Handbook, 2011
Eighty-four framed offset-printed
book pages
9 x 6 in. (22.9 x 15.2 cm) each
Collection of the artist; courtesy
Ratio 3, San Francisco; Alex Zachary,
New York; and Cabinet, London

Pipe Organs, 2009–11
Tin, paint, speakers, wire, and
Yamaha organ
Four pipes: 144 x 8 x 8 in. (365.8 x
20.3 x 20.3 cm) each; organ 40 x 48 x
24 in. (101.6 x 121.9 x 61 cm)
Courtesy the artist; Ratio 3,
San Francisco; Alex Zachary,
New York; and Cabinet, London

FORREST BESS

Complete Freedom, 1970
Oil on canvas
14 ½ x 19 in. (36.8 x 48.3 cm)
Private collection

Untitled, 1967
Oil on canvas
13 ⅞ x 14 in. (35.2 x 35.6 cm)
Private collection

The Noble Carbunkle, 1960
Oil on canvas
30 x 49 ½ in. (76.2 x 125.7 cm)
Private collection; courtesy Amy Wolf
Fine Art, New York

No. 6, 1959
Oil on canvas
17 x 26 in. (43.2 x 66 cm)
Private collection

Untitled No. 12a, 1957
Oil on canvas
12 x 18 in. (30.5 x 45.7 cm)
Collection of Andrew Masullo

The Hermaphrodite, 1957
Oil on canvas
8 x 11 in. (20.3 x 27.9 cm)
The Menil Collection, Houston;
gift of John Wilcox, in memory of
Frank Owen Wilson

Untitled No. 31, 1951
Oil on canvas
8 x 10 in. (20.3 x 25.4 cm)
Collection of Andrew Masullo

Bodies of Little Dead Children, 1949
Oil on canvas
5 ¾ x 7 ½ in. (14.6 x 19 cm)
The Menil Collection, Houston

Untitled (The Crown), 1949
Oil on canvas
8 x 10 in. (20.3 x 25.4 cm)
Whitney Museum of American Art,
New York; promised gift of Emily
Fisher Landau P.2010.35

Untitled (No. 5), 1949
Oil on canvas
10 x 12 ⅞ in. (25.4 x 32.7 cm)
The Cartin Collection

Ephemera
Installation photograph of Forrest
Bess's 1962 retrospective at the Betty
Parsons Gallery
Betty Parsons Gallery records and
personal papers, Archives of American
Art, Smithsonian Institution,
Washington, D.C.

John Money and Michael DePriest
article about Forrest Bess in
The Journal of Sex Research 12, no. 4,
November 1976
The Institute for the Advanced Study
of Human Sexuality

Lawrence Alloway article on Betty
Parsons in Vogue, October 1963
Betty Parsons Gallery records and
personal papers, Archives of American
Art, Smithsonian Institution,
Washington, D.C.

Letter from Forrest Bess to
President Dwight D. Eisenhower,
January 28, 1955
Meyer Schapiro papers, Archives of
American Art, Smithsonian Institution,
Washington, D.C.

Michael Ennis article on Forrest Bess
in *Texas Monthly*, June 1982

Pages from Forrest Bess's thesis found
in an undated letter to Meyer Schapiro
Meyer Schapiro papers, Archives of
American Art, Smithsonian Institution,
Washington, D.C.

Photograph of Betty Parsons in
her gallery
Betty Parsons Gallery records and
personal papers, Archives of American
Art, Smithsonian Institution,
Washington, D.C.

Photograph of Forrest Bess at
Chinquapin, October 1963
Betty Parsons Gallery records and
personal papers, Archives of American
Art, Smithsonian Institution,
Washington, D.C.

Polaroid by Forrest Bess of his self-
surgery that he sent to Betty Parsons
Betty Parsons Gallery records and
personal papers, Archives of American
Art, Smithsonian Institution,
Washington, D.C.

Polaroids by Forrest Bess of his
physical state before his surgeries that
he sent to Meyer Schapiro
Meyer Schapiro papers, Archives of
American Art, Smithsonian Institution,
Washington, D.C.

MICHAEL CLARK

W H O ' S Z O O, 2012
Performance
Commissioned by Michael Clark
Company, London; Modern Dance
Club, New York; and the Whitney
Museum of American Art, New York,
for the 2012 Whitney Biennial

DENNIS COOPER AND
GISÈLE VIENNE

LAST SPRING: A Prequel, 2011
Mixed-media installation; sound by
Peter Rehberg and Stephen O'Malley;
voices by Jonathan Capdevielle; wall
drawing design by Stephen O'Malley;
lighting by Patrick Riou
Dimensions variable
Collection of Gisèle Vienne and De
L'Autre Côté du Miroir (DACM)

CAMERON CRAWFORD

*Sick Sic Six Sic ((Not) Moving):
Seagullsssssssssssssssssssssssssssss.*, 2018
Monofilament, wood, hardware, and
textured tape
120 x 264 in. (304 x 670 cm)
New Capital Family Collection

*making water storage revolution making
water storage revolution*, 2012
Poplar, paste wax, plaster, wood filler,
oil on string, oil on organza, primed
brass, primed steel, graphite and
felt-tip pen on muslin, synthetic
polymer on paper, linen thread,
hardware, and hair
54 x 14 x 20 in. (137 x 36 x 51 cm)
Collection of the artist

*making water storage revolution making
water storage revolution*, 2012
Poplar, paste wax, plaster, wood filler,
oil on string, oil on organza, primed
brass, primed steel, graphite and
felt-tip pen on muslin, synthetic
polymer on paper, linen thread,
hardware, and hair
60 x 180 x 12 in. (152 x 457 x 30 cm)
Collection of the artist

MOYRA DAVEY

Les Goddesses, 2011
High-definition video, color, sound;
61 min.
Collection of the artist; courtesy
Murray Guy, New York

Mary, Marie, 2011
Twelve chromogenic prints, with tape,
stamps, postage, and ink
37 ¾ x 74 ⅜ in. (96 x 189 cm) overall
Collection of the artist; courtesy
Murray Guy, New York

*We Are Young And We Are Friends Of
Time*, 2011
Thirteen chromogenic prints, tape,
stamps, postage, and ink
37 ¾ x 110 ¼ (96 x 280 cm) overall
Collection of the artist; courtesy
Murray Guy, New York

LIZ DESCHENES

Untitled, 2011
Four silver-toned gelatin silver prints
Dimensions variable
Collection of the artist; courtesy
Campoli Presti, London, and Miguel
Abreu Gallery, New York

Untitled, 2011
Two silver-toned gelatin silver prints
Dimensions variable
Collection of the artist; courtesy
Campoli Presti, London, and Miguel
Abreu Gallery, New York

NATHANIEL DORKSY

The Return, 2011
16mm film, color, silent; 27 min.
Collection of the artist

Compline, 2010
16mm film, color, silent; 18:30 min.
Collection of the artist

Aubade, 2010
16mm film, color, silent; 11:30 min.
Collection of the artist

NICOLE EISENMAN

Breakup, 2011
Oil and mixed media on canvas
56 x 43 in. (142.2 x 109.2 cm)
Collection of Robert and Bonnie
Friedman; courtesy Leo Koenig Inc.,
New York, and Susanne Vielmetter
Los Angeles Projects

The Drawing Class, 2011
Oil and charcoal on canvas
82 x 65 in. (208.3 x 165.1 cm)
The Art Institute of Chicago

Tea Party, 2011
Oil on canvas
82 x 65 in. (208.3 x 165.1 cm)
Hort Family Collection; courtesy Leo
Koenig Inc., New York, and Suzanne
Vielmetter Los Angeles Projects

Untitled, 2011
Thirty-five mixed-media monotypes
24 ¾ x 19 ¾ in. (62.9 x 50.2 cm) each
The Hall Collection; courtesy Leo
Koenig Inc., New York

KEVIN JEROME EVERSON

Quality Control, 2011
16mm film, black-and-white, sound;
70 min.
Collection of the artist; courtesy
Trilobite-Arts-DAC and Picture
Palace Pictures

VINCENT FECTEAU

Untitled, 2011
Gypsum cement, resin clay, and
synthetic polymer paint
16 x 24 x 23 ½in. (40.6 x 61 x 60 cm)
Collection of the artist; courtesy
Galerie Buchholz, Berlin; greengrassi,
London; and Matthew Marks Gallery,
New York

Untitled, 2011
Gypsum cement, resin clay, and
synthetic polymer paint
15 ½ x 26 x 21 in. (39 x 66 x 53 cm)
Collection of the artist; courtesy
Galerie Buchholz, Berlin; greengrassi,
London; and Matthew Marks Gallery,
New York

Untitled, 2011
Gypsum cement, resin clay, and
synthetic polymer paint
14 ½ x 24 x 21 ½ in. (37 x 61 x 55 cm)
Collection of the artist; courtesy
Galerie Buchholz, Berlin; greengrassi,
London; and Matthew Marks Gallery,
New York

ANDREA FRASER

There's no place like home, 2011
Catalogue text
Collection of the artist; courtesy
Friedrich Petzel Gallery, New York

LATOYA RUBY FRAZIER

Statement
Health Care Not Wealth Care!
Grandma Ruby and U.P.M.C.
"Urban Pioneer"
Paper Magazine Ad
Where is Emergency Care?
Jenny Holzer's Truism
Broadway & Lafayette N.Y.C.
Race Based Class Based Healthcare
*Go Forth Where? We don't have horses in
Braddock!*
Undone
U.P.M.C. Global Health Care Exploitation
From the portfolio *Campaign for
Braddock Hospital (Save Our Community
Hospital)*, 2011
Twelve photolithographs and
screenprints
17 x 14 in. (43.2 x 35.6) each
Printed and published by Rob
Swainston, Prints of Darkness
Collection of the artist

Epilepsy Test, from the series *Landscape
of the Body*, 2011
Two gelatin silver prints
24 x 20 in. (61 x 50.8 cm) each
Collection of the artist

Corey Avenue, from the series *Landscape
of the Body*, 2011
Gelatin silver print
24 x 20 in. (61 x 50.8 cm)
Collection of the artist

Wrapped in Gramps' Blanket
In Grandma Ruby's Valor Bottoms
In Gramps' Pajamas
Covered in Gramps' Blanket
From the *Homebody* series, 2010
Gelatin silver prints
20 x 24 in. (50.8 x 61 cm) each
Collection of the artist

VINCENT GALLO

Promises Written in Water
75 min.

K8 HARDY

Untitled Runway Show, 2012
Performance

One Dimension #1–#7, 2011
Seven chromogenic prints with
photograms
10 x 20 in. (25.4 x 50.8 cm) each
Collection of the artist; courtesy Reena
Spaulings Fine Art, New York

Appurtenance A–G, 2011
Seven mixed-media sculptures
Dimensions variable
Collection of the artist; courtesy Reena
Spaulings Fine Art, New York

RICHARD HAWKINS

Salome Painting: Zacherley, 2011
Oil on canvas
24 x 20 in. (61 x 51 cm)
Private collection; courtesy Galerie
Buchholz, Berlin

Salome Painting: Locked up, 2011
Oil on canvas
30 x 25 in. (76 x 63.5 cm)
Private collection; courtesy Galerie
Buchholz, Berlin

Ankoku 1 through Ankoku 12, 2011
Collage
Twelve units, 13 ⅜ x 19 ⅔ in. (34 x 50
cm) each
Collection of the artist; courtesy
Greene Naftali, New York, and
Richard Telles Fine Art, Los Angeles

WERNER HERZOG

Hearsay of the Soul, 2012
Installation: four-channel digital
projection of twenty etchings by
Hercules Segers; music by Ernst
Reijseger (from the albums Requiem for
a Dying Planet [Winter & Winter, 2006]
and Cave of Forgotten Dreams [Winter
& Winter, 2011]); and an excerpt
from Herzog's film Ode to the Dawn of
Man (2011), featuring Ernst Reijseger
(cello) and Harmen Fraanje (organ)
Collection of the artist; courtesy Winter
& Winter, Munich; Rijksmuseum,
Amsterdam; Bibliothèque Nationale
de France, Paris; National Gallery
of Art, Washington D.C.; The State
Hermitage Museum, Saint Petersburg;
and Staatliche Museum, Berlin

JEROME HILER

Words of Mercury, 2011
16mm film, color, silent; 25 min.
Collection of the artist

MATT HOYT

Untitled (Group 64), 2011
Wood, mat board, and two mixed-
media constructions of materials
including clay, various putties, plastic,
pastel, and oil, synthetic polymer,
and tempera paints
¾ x 8 x 5 in. (1.9 x 20.3 x 12.7 cm)
Collection of the artist; courtesy
Bureau, New York

Untitled (Group 66), 2010–11
Wood, mat board, and five mixed-
media constructions of materials
including clay, fiberclay, plaster,
various putties, resin, pastel, glue,
plastic, and oil, synthetic polymer,
and tempera paints
4 x 18 x 11 ½ in. (10.2 x 45.7 x 29.2 cm)
Collection of the artist; courtesy
Bureau, New York

Untitled (Group 68), 2009–11
Wood, mat board, and four mixed-
media constructions of materials
including clay, various putties, resin,
pastel, monofilament string, Plasti
Dip, glue, and synthetic polymer
and tempera paints
1 x 16 ¼ x 9 in. (2.5 x 41.3 x 22.9 cm)
Collection of the artist; courtesy
Bureau, New York

Untitled (Group 62), 2009–11
Wood, mat board, and three mixed-
media constructions of materials
including clay, plastic, metal, resin,
various putties, glue, and synthetic
polymer and tempera paints
½ x 9 ¾ x 5 ½ in. (1.3 x 24.8 x 14 cm)
Collection of the artist; courtesy
Bureau, New York

Untitled (Group 58), 2009–11
Wood, mat board, and seven mixed-
media constructions of materials
including clay, various putties, wood,
metal, dye, Liquid Electrical Tape,
pastel, and oil, synthetic polymer,
and tempera paints
1 x 16 ¼ x 9 in. (2.5 x 41.3 x 22.9 cm)
Collection of the artist; courtesy
Bureau, New York

Untitled (Group 60), 2008–11
Wood, mat board, and two mixed-
media constructions of materials
including clay, putties, ABS plastic,
polyester resin, and pastel
1 x 8 ½ x 5 ½ in. (2.5 x 21.6 x 14 cm)
Collection of the artist; courtesy
Bureau, New York

DAWN KASPER

THIS COULD BE SOMETHING IF I
LET IT, 2012
Three-month durational performance
and multimedia installation
Dimensions variable
Collection of the artist

MIKE KELLEY

Going East on Michigan Avenue from
Westland to Downtown Detroit, 2010–11
High-definiton video, color,
sound; 76:17 min.
Courtesy the artist

Going West on Michigan Avenue from
Downtown Detroit to Westland, 2010–11
High-definition video, color, sound;
76:15 min.
Courtesy the artist

Mobile Homestead Christening Ceremony
and Launch, 2010–11
High-definition video, color, sound;
55:01 min.
Courtesy the artist

Mobile Homestead is commissioned by
Artangel with the support of Artangel
International Circle and the LUMA
Foundation in association with the
Museum of Contemporary Art
Detroit (MOCAD)

JOHN KELSEY

Untitled, 2012
Mixed media
Dimensions variable
Collection of the artist

JUTTA KOETHER

(Painting For All) The Seasons, 2011
Four oil-on-canvas paintings hung on
glass panels
67 x 86 ⅝ in. (170 x 220 cm) each
Collection of the artist; courtesy
Galerie Buchholz, Berlin

JOHN KNIGHT

Curb Appeal, a work in situ, 1966/2012
Whitney Museum of American Art

GEORGE KUCHAR

Hotspell, 2011, from the Weather Diaries,
1977–2011
Video, color, sound; 26 min.
The Estate of George Kuchar

Centennial, 2007, from the Weather
Diaries, 1977–2011
Video, color, sound; 13 min.
The Estate of George Kuchar

Heavenly Features, 2005, from the
Weather Diaries, 1977–2011
Video, color, sound; 10 min.
The Estate of George Kuchar

Supercell, 2004, from the Weather
Diaries, 1977–2011
Video, color, sound; 9:16 min.
The Estate of George Kuchar

Cyclone Alley Ceramics, 2000, from the
Weather Diaries, 1977–2011
Video, color, sound; 12 min.
The Estate of George Kuchar

Chigger Country, 1999, from the Weather
Diaries, 1977–2011
Video, color, sound; 24 min.
The Estate of George Kuchar

Weather Diary 3, 1998, from the Weather
Diaries, 1977–2011
Video, color, sound; 25 min.
The Estate of George Kuchar

The Inmate, 1997, from the Weather
Diaries, 1977–2011
Video, color, sound; 16 min.

Season of Sorrow, 1996, from the
Weather Diaries, 1977–2011
Video, color, sound; 13 min.
The Estate of George Kuchar

Weather Diary 6, 1990, from the Weather
Diaries, 1977–2011
Video, color, sound; 28:30 min.
The Estate of George Kuchar

Weather Diary #5, 1989, from the
Weather Diaries, 1977–2011
Video, color, sound; 38:17 min.
The Estate of George Kuchar

Weather Diary 1, 1986, from the Weather
Diaries, 1977–2011
Video, color, sound; 75 min.
The Estate of George Kuchar

Wild Night in El Reno, 1977, from the
Weather Diaries, 1977–2011
16mm film, color, sound; 15 min.
The Estate of George Kuchar

LAIDA LERTXUNDI

A Lax Riddle Unit, 2011
16mm film, color, sound; 5 min.
Collection of the artist

Llora Cuando Te Pase/Cry When It
Happens, 2010
16mm film, color, sound; 14 min.
Collection of the artist

My Tears Are Dry, 2009
16mm film, color, sound; 4 min.
Collection of the artist

Footnotes to a House of Love, 2007
16mm film, color, sound; 13 min.
Collection of the artist

KATE LEVANT

Untitled, 2006–11
Fabric
Dimensions variable
Collection of the artist; courtesy
Zach Feuer Gallery, New York, and
Susanne Hilberry Gallery, Detroit

SAM LEWITT

Fluid Employment, 2012
Ferromagnetic liquid poured bi-
weekly over plastic and magnetic
elements, fans
Dimensions variable
Collection of the artist; courtesy
Miguel Abreu Gallery, New York,
and Galerie Buchholz, Berlin

JOANNA MALINOWSKA

From the Canyons to the Stars, 2012
Shellacked plaster over Styrofoam
and artificial deer sinew
102 x 72 x 72 in. (259 x 183 x 183 cm)
Collection of the artist; courtesy
CANADA, New York

*His Worshipers Are Worshiping a
Phantom*, 2012
Video, plasma screen in wood,
and plexiglass
36 x 51 x 28 in. (91.4 x 129.5 x 71.1 cm)
Collection of the artist; courtesy
CANADA, New York

A Wall for Peltier, 2012
Sheetrock and a Leonard Peltier oil-
on-canvas painting
Approx. 153 x 76 x 4 ½ in. (388.6 x
193 x 11.4 cm) overall
Collection of the artist and Leonard
Peltier; courtesy Dorothy Ninham
and Leonard Peltier Defense Offense
Committee

ANDREW MASULLO

5303, 2011
Oil on canvas
10 x 8 in. (25.4 x 20.3 cm)
Collection of the artist; courtesy
Feature Inc., New York

5302, 2011
Oil on canvas
10 x 8 in. (25.4 x 20.3 cm)
Collection of the artist; courtesy
Feature Inc., New York

5301, 2011
Oil on canvas
10 x 8 in. (25.4 x 20.3 cm)
Collection of the artist; courtesy
Feature Inc., New York

5295, 2011
Oil on canvas
10 x 8 in. (25.4 x 20.3 cm)
Private collection; courtesy Steven
Zevitas Gallery, Boston

5292, 2011
Oil on canvas
10 x 8 in. (25.4 x 20.3 cm)
Collection of the artist; courtesy
Daniel Weinberg Gallery, Los Angeles

5271, 2011
Oil on canvas
10 x 8 in. (25.4 x 20.3 cm)
Collection of the artist; courtesy
Feature Inc., New York

5265, 2010–11
Oil on canvas
10 x 8 in. (25.4 x 20.3 cm)
Collection of the artist; courtesy
Daniel Weinberg Gallery, Los Angeles

5263, 2010
Oil on canvas
10 x 8 in. (25.4 x 20.3 cm)
Collection of the artist; courtesy
Daniel Weinberg Gallery, Los Angeles

5251, 2010
Oil on canvas
10 x 8 in. (25.4 x 20.3 cm)
Collection of the artist; courtesy
Feature Inc., New York

5244, 2010
Oil on canvas
22 x 28 in. (55.9 x 71.1 cm)
Collection of the artist; courtesy
Feature Inc., New York

5241, 2010
Oil on canvas
30 x 24 in. (76.2 x 61 cm)
Collection of Hillary and Jeremy N.
Schwalbe

5237, 2010
Oil on canvas
16 x 20 in. (40.6 x 50.8 cm)
Collection of Colombe Nicholas and
Leonard Rosenberg

5171, 2009–10
Oil on canvas
16 x 20 in. (40.6 x 50.8 cm)
Collection of the artist; courtesy
Daniel Weinberg Gallery, Los Angeles

5167, 2009–10
Oil on canvas
20 x 16 in. (50.8 x 40.6 cm)
Collection of the artist; courtesy
Daniel Weinberg Gallery, Los Angeles

5165, 2009–10
Oil on canvas
24 x 18 in. (61 x 45.7 cm)
Collection of the artist; courtesy
Feature Inc., New York

5151, 2009–10
Oil on canvas
10 x 8 in. (25.4 x 20.3 cm)
Collection of the artist; courtesy
Feature Inc., New York

5147, 2009–10
Oil on canvas
10 x 8 in. (25.4 x 20.3 cm)
Collection of the artist; courtesy
Daniel Weinberg Gallery, Los Angeles

5145, 2009–10
Oil on canvas
10 x 8 in. (25.4 x 20.3 cm)
Collection of the artist; courtesy
Daniel Weinberg Gallery, Los Angeles

5144, 2009–10
Oil on canvas
10 x 8 in. (25.4 x 20.3 cm)
Collection of the artist; courtesy
Daniel Weinberg Gallery, Los Angeles

5143, 2009–10
Oil on canvas
10 x 8 in. (25.4 x 20.3 cm)
Collection of the artist; courtesy
Feature Inc., New York

5142, 2009
Oil on canvas
10 x 8 in. (25.4 x 20.3 cm)
Collection of the artist; courtesy
Feature Inc., New York

5141, 2009–10
Oil on canvas
10 x 8 in. (25.4 x 20.3 cm)
Collection of the artist; courtesy
Daniel Weinberg Gallery, Los Angeles

5139, 2009
Oil on canvas
10 x 8 in. (25.4 x 20.3 cm)
Collection of the artist; courtesy
Feature Inc., New York

5133, 2008–09
Oil on canvas
10 x 8 in. (25.4 x 20.3 cm)
Collection of Anne Doran

5132, 2009
Oil on canvas
10 x 8 in. (25.4 x 20.3 cm)
Collection of the artist; courtesy
Daniel Weinberg Gallery, Los Angeles

5131, 2009
Oil on canvas
10 x 8 in. (25.4 x 20.3 cm)
Collection of Charles Lahti

5030, 2008–10
Oil on canvas
24 x 30 in. (61 x 76.2 cm)
Collection of the artist; courtesy
Daniel Weinberg Gallery, Los Angeles

5023, 2008
Oil on canvas
20 x 24 in. (50.8 x 61 cm)
Collection of the artist; courtesy
Feature Inc., New York

5017, 2008–09
Oil on canvas
16 x 20 in. (40.6 x 50.8 cm)
Collection of the artist; courtesy
Feature Inc., New York

4986, 2008–11
Oil on canvas
10 x 8 in. (25.4 x 20.3 cm)
Collection of the artist; courtesy
Steven Zevitas Gallery, Boston

4962, 2007–09
Oil on canvas
10 x 8 in. (25.4 x 20.3 cm)
Collection of the artist; courtesy
Daniel Weinberg Gallery, Los Angeles

4959, 2006–11
Oil on canvas
10 x 8 in. (25.4 x 20.3 cm)
Collection of the artist; courtesy
Feature Inc., New York

4498, 2005–10
Oil on canvas
10 x 8 in. (25.4 x 20.3 cm)
Collection of the artist; courtesy
Feature Inc., New York

3710, 2000–10
Oil on canvas
10 ½ x 13 ½ in. (26.7 x 34.3 cm)
Collection of the artist; courtesy
Feature Inc., New York

NICK MAUSS

Concern, Crush, Desire, 2011
Cotton appliqué on velvet, brass
doorknobs and doorstoppers
131 x 94 x 115 in. (332.7 x 238.8 x
292.1 cm)
Collection of the artist; courtesy 303
Gallery, New York, and Galerie
Neu, Berlin

Untitled, 2011
Eighty color 35mm slides and
projector, reverse projection
Collection of the artist; courtesy 303
Gallery, New York, and Galerie
Neu, Berlin

Garry Winogrand (1928–1984)
Beverly Hills, California, 1978, from
the portfolio *Women are better than
men. Not only have they survived,
they do prevail*, 1968–80
Gelatin silver print
8 ⅞ x 13 ⁵⁄₁₆ in. (22.5 x 33.8 cm)
Whitney Museum of American
Art, New York; gift of Mr. and Mrs.
Raymond W. Merritt 98.40.4

Andy Warhol (1928–1987)
Untitled (Cyclist), c. 1976
Four gelatin silver prints stitched
with thread
27 ⅜ x 21 ⅝ in. (69.5 x 54.9 cm)
Whitney Museum of American Art,
New York; gift of The Andy Warhol
Foundation for the Visual Arts
and purchase with funds from the
Photography Committee 94.125

May Wilson (1905–1986)
Untitled, c. 1973
Mixed media
9 ¼ x 15 x 7 in. (23.5 x 38.1 x 17.8 cm)
Whitney Museum of American Art,
New York; gift of Vince Aletti 2003.12

Ellsworth Kelly (b. 1923)
Locust, 1966
Lithograph on paper
24 ⅛ x 35 ⅜ in. (61.3 x 89.9 cm)
Whitney Museum of American Art,
New York; purchase 70.29

Marsden Hartley (1877–1943)
*Madawaska, Acadian Light-Heavy,
Third Arrangement*, 1940
Oil on masonite
27 ⅞ x 21 ½ in. (70.8 x 54.6cm)
Whitney Museum of American Art,
New York; gift of Nina and Herman
Schneider, Gertrude Vanderbilt
Whitney, and Dr. Meyer A. Pearlman
by exchange, purchase by exchange,
and purchase with funds from the
Director's Discretionary Fund 2005.89

Charles Demuth (1883–1935)
Eight O'Clock, 1917
Watercolor and graphite on paper
8 ⅟₁₆ x 10 ⁵⁄₁₆ in. (20.5 x 26.2 cm)
Whitney Museum of American Art,
New York; gift of Carl D. Lobell 93.108

Eyre de Lanux (1894–1996)
[Sketch for Consuelo], date unknown
Ink on paper, double-sided
10 ⅝ x 8 ¼ in. (27 x 21 cm)
Eyre de Lanux papers, 1905–1992,
Archives of American Art, Smithsonian
Institution, Washington, D.C.

Eyre de Lanux
[Sketches of women], date unknown
Ink on paper, double-sided
10 ⅝ x 8 ¼ in. (27 x 21 cm)
Eyre de Lanux papers, 1905–1992,
Archives of American Art, Smithsonian
Institution, Washington, D.C.

RICHARD MAXWELL

Untitled, 2012
Performance
Open rehearsals of a new play by
Richard Maxwell and New York City
Players
Commissioned by the Whitney
Museum of American Art, New York,
for the 2012 Whitney Biennial

SARAH MICHELSON

Untitled (as of 12/20/11), 2012
Performance
Collection of the artist
Commissioned by the Whitney
Museum of American Art, New York,
for the 2012 Whitney Biennial

ALICIA HALL MORAN AND
JASON MORAN

BLEED, 2012
Live music and mixed-media
installation
Dimensions variable
Collection of the artists
Commissioned by the Whitney
Museum of American Art, New York,
for the 2012 Whitney Biennial

Simone Leigh (b. 1968) and Liz Magic
Laser (b. 1981) in collaboration with
Alicia Hall Moran
Breakdown, 2011
High-definition video, color, sound;
8 min.
Courtesy the artists

Kara Walker (b. 1969)
*National Archives Microfilm Publication
M999 Roll 34: Bureau of Refugees,
Freedmen and Abandoned Lands: Six
Miles from Springfield on the Franklin
Road*, 2009
Digital video, color, sound; 13:22 min.
With original music by Alicia Hall
Moran and Jason Moran
Courtesy the artist and Sikkema
Jenkins & Co., New York

Joan Jonas (b. 1936)
Reading Dante III, 2008
Video, color, sound; 55 min.
With music by Jason Moran,
soundtrack by Joan Jonas, and
additional music by David Lang
Collection of the artist

Glenn Ligon (b. 1960)
The Death of Tom, 2008
16mm film transferred to video,
black-and-white, sound; 23 min.
With original music by Jason Moran
Courtesy the artist and Regen Projects,
Los Angeles

LAURA POITRAS

The Oath, 2010, from *9/11 Trilogy*
High-definition video, color, sound;
96 min.
Courtesy the artist and Zeitgeist Films

MATT PORTERFIELD

Putty Hill, 2011
High-definition video, color, sound;
87 min.
Courtesy Cinema Guild

LUTHER PRICE

Sorry – Walking the Cross "Quatch,"
2011, from *The Sorry Chapters*, 2010–
16mm film, black-and-white, sound;
approx. 8 min.
Collection of the artist

Sorry #1, 2010, from *The Sorry Chapters*,
2010–
16mm film, black-and-white, sound;
approx. 8 min.
Collection of the artist

Sorry #2, 2010, from *The Sorry Chapters*,
2010–
16mm film, black-and-white, sound;
approx. 8 min.
Collection of the artist

Sorry #3, 2011, from *The Sorry Chapters*,
2010–
16mm film, black-and-white, sound;
approx. 8 min.
Collection of the artist

After the Garden: Silking, 2010, from
After the Garden (decayed films), 2007–
16mm film, color, sound; approx. 5 min.
Collection of the artist

Bergen and Tonic, 2011–12, from *After
the Garden* (decayed films), 2007–
16mm film, black-and-white, sound;
approx. 8 min.
Collection of the artist

Inkblot #40: Sleep, 2011, from *Inkblots*
(painted films), 2007–
16mm film, color, sound; approx. 5 min.
Collection of the artist

Inkblot #41: Sal Mineo is Gay, 2011,
from *Inkblots* (painted films), 2007–
16mm film, color, sound; approx. 5 min.
Collection of the artist

Inkblot #44: Aqua Woman, 2009–11,
from *Inkblots* (painted films), 2007–
16mm film, color, sound; approx. 5 min.
Collection of the artist

Shelly Winters, 2010, from *Inkblots*
(painted films), 2007–
16mm film, black-and-white, sound;
approx. 8 min.
Collection of the artist

Untitled, 1999–
Handmade slides and carousel
projectors
Collection of the artist

LUCY RAVEN

RPx, 2012 (in progress)
Video, color, sound
Collection of the artist

*What Manchester Does Today, the Rest of
the World Does Tomorrow*, 2011
Performance
Player piano (pianola) and paper
music rolls
Featuring *Dance Yrself Clean*, 2010,
written by J. Murphy; published
by Guy with Head and Arms;
administered by Kobalt Songs Music
Publishing; arrangements by Jason
Moran; pianola rolls by Julian Dyer
Dimensions variable
Collection of the artist
Commissioned by Manchester
International Festival, Manchester
Art Gallery, and the International
Arts Festival RUHRTRIENNALE
2012–2014

THE RED KRAYOLA

Portal, 2012
Virtual presence with table,
chair, computer interface with
Skype, speakers
Collection of The Red Krayola

The Red Krayola in Concert I, 2012
Ensemble music performance
Collection of The Red Krayola

The Red Krayola in Concert II, 2012
Free-form freakout (performance)
Collection of The Red Krayola

*Scenes from Victorine: Act II, scene iii,
"Café 21"; III, ii, "Courbet's Studio"; III,
iv, "Manet's Studio (Olympia)*,*"* 2012
Opera
Collection of Art & Language and
Mayo Thompson

Art & Language (founded 1968)
Letters to the Jackson Pollock Bar VII, 2010
Oil on canvas with Teslin badges and
mixed media
15 ½ x 22 ¼ in. (39.5 x 57 cm)
Collection of Mulier Mulier Gallery,
Knokke-Zoute, Belgium

Art & Language
Letters to the Jackson Pollock Bar VIII, 2010
Oil on canvas with Teslin badges and
mixed media
15 ½ x 22 ¼ in. (39.5 x 57 cm)
Collection of Mulier Mulier Gallery,
Knokke-Zoute, Belgium

Art & Language
Letters to the Jackson Pollock Bar XX, 2010
Oil on canvas with Teslin badges and
mixed media
15 ½ x 22 ¼ in. (39.5 x 57 cm)
Collection of Mulier Mulier Gallery,
Knokke-Zoute, Belgium

Art & Language
Index: Incident in a Museum XIII, 1986
Oil on canvas
72 ½ x 113 in. (184.1 x 287 cm)
Marian Goodman Gallery, New York

KELLY REICHARDT

Meek's Cutoff, 2010
35mm film, color, sound; 104 min.

Wendy and Lucy, 2008
Super 16mm film, color, sound; 80 min.

Old Joy, 2006
Super 16mm film, color, sound; 76 min.

ELAINE REICHEK

There's No Need, 2011
Hand embroidery on linen
46 x 45 in. (116.8 x 114.3 cm)
Collection of the artist

Paint Me a Cavernous Waste Shore,
2009–10
Tapestry
118 x 107 in. (299.7 x 271.8 cm)
Collection of the artist

Midway in the Journey, 2009
Digital and hand embroidery on linen
30 x 28 in. (76.2 x 71.1 cm)
Private collection; courtesy Shoshana
Wayne Gallery, Santa Monica

Ariadne's Lament, 2009
Digital embroidery on linen
27 ½ x 26 ½ in. (69.9 x 67.3 cm)
Collection of the artist

We Construct a Narrative, 2008
Hand embroidery on linen
20 ½ x 16 in. (52.1 x 40.6 cm)
Collection of Isaac Julien and Mark
Nash; courtesy Shoshana Wayne
Gallery, Santa Monica

MICHAEL ROBINSON

Line Describing Your Mom, 2011
Digital video, color, sound; 5:50 min.
Collection of the artist

These Hammers Don't Hurt Us, 2010
Digital video, color, sound; 13 min.
Collection of the artist

If There Be Thorns, 2009
16mm film transferred to digital video,
color, sound; 13:20 min.
Collection of the artist

All Though the Night, 2008
Digital video, color, sound; 4:20 min.
Collection of the artist

Hold Me Now, 2008
Digital video, color, sound; 5 min.
Collection of the artist

Victory over the Sun, 2007
16mm film, color, sound; 12:30 min.
Collection of the artist

GEORGIA SAGRI

*Travailler Je ne travaille pas (working the
no work)* Δουλεύοντας τη μη δουλειά,
2011–12
Performance
Collection of the artist; courtesy
Anthony Reynolds Gallery, London;
AD Gallery, Athens; Andreas Melas &
Helena Papadopoulos, Athens; Real
Fine Arts, Brooklyn; and Formalist
Sidewalk Poetry Club, Miami Beach

MICHAEL E. SMITH

Untitled, 2012
Mixed media
Dimensions variable
Collection of the artist; courtesy
Clifton Benevento, New York; KOW,
Berlin; and Susanne Hilberry Gallery,
Detroit

TOM THAYER

Untitled Works, 2011
Mixed media, dimensions variable
Collection of the artist; courtesy Derek
Eller Gallery, New York

WU TSANG

WILDNESS, 2012
High-definition video, color, sound;
72 min.
Collection of the artist; courtesy Class
Productions and Now Unlimited

GREEN ROOM, 2012
Mixed media
Dimensions variable
Collection of the artist; courtesy
Clifton Benevento, New York

OSCAR TUAZON

For Hire, 2012
Mixed media
Dimensions variable
Collection of the artist

FREDERICK WISEMAN

Boxing Gym, 2010
16mm film, color, sound; 91 min.
Courtesy Zipporah Films, Inc.

ACKNOWLEDGMENTS

Every Biennial is an enormous undertaking and requires the hard work of many people both inside and outside of the Museum; the 2012 Biennial, with its fifty-one artists and wide-ranging performances and events, is no exception. First and foremost, we extend our sincere gratitude to the artists of the 2012 Biennial. Over the course of the last year and a half, they opened their studios and engaged in dialogue with us, challenging and inspiring us. We also appreciate the generosity of all the artists that we met with throughout our travels and research process. These were invaluable and illuminating conversations and we learned a great deal from them. The Biennial process is like no other, and to be in touch with so many artists nationwide has been our great fortune. We would like to thank Adam D. Weinberg, Alice Pratt Brown Director, for inviting us to organize the Whitney's signature exhibition and for his continued and enthusiastic support of our ambitious vision for the 2012 Biennial. We would also like to thank Donna De Salvo, chief curator and associate director for programs, for championing our concept of the Biennial and for providing always invaluable input, especially at crucial moments in the process. Emily Russell, acting curatorial manager, has been helpful at every turn. We are grateful to the Biennial team for their hard work and exchange of ideas. Esme Watanabe, Biennial coordinator, brilliantly stood up to the challenge and managed all aspects of the exhibition production and installation process with patience, diplomacy, and grace under pressure. Elisabeth Sherman, curatorial assistant, without whom this exhibition couldn't have taken place, was by our side from the very beginning of the curatorial process and has played an essential and invaluable role in every part of this exhibition's creation. Sophie Cavoulacos provided invaluable support, first as an intern and then as Biennial assistant, lending her skills in French and her interest in film. Greta Hartenstein, performance assistant, applied her unique interests and experience and helped us on the performance program. We would also like to thank Katherine Rochester, Julia Speed, and Rachel Valinsky, the Biennial interns.

We would like to recognize the work of Ed Halter and Thomas Beard, who curated the film and video program with intelligence and thoughtfulness, and who were important interlocutors, providing guidance and wise advice throughout our process. Likewise, we are grateful to Barry Esson and Bryony McIntyre (Arika) for their thoughtful survey of listening, and to Stefan Kalmár and Richard Birkett's (Artists Space) brilliant initiative to create a set of related programs.

This Biennial has truly reflected the synergy we see between the visual and the performing arts. We are especially indebted to Bentley Meeker, who worked as an artistic collaborator on the performance series and made our vision of the Biennial as a festival come to life. The performance series would have been impossible without the help and support of Branislav Henselmann, Chloe Seddon, and the entire staff and board of the Michael Clark Dance Company; Christopher Müller and Daniel Buchholz; Matthew Marks; and Barbara Bryan, Zack Tinkelman, and all of Sarah Michelson's team. We are also thankful for the assistance provided by Stonie Darling at the Brooklyn Academy of Music, Boo Froebel at Lincoln Center, Capucine Perrot at Tate Modern, Jess Edkins and Sherri Kronfeld at PS122, and Jason McCullough and Eric Winston at Site Fabrication & Design Shop. Joe Melillo, Debra Singer, and Limor Tomer were especially instrumental as we learned from our peer institutions with performing arts programs and reconnected with the Whitney's own history of showing live work.

We are grateful to Beth Huseman, interim head of publications, and Beth Turk, associate editor, who oversaw the publication of this volume. In particular, Beth Turk deftly managed all aspects of this complex and fast-moving publication. Joseph Logan created a visionary design for the catalogue and worked closely with each artist to brilliantly realize its fullest potential. Jason Best went above and beyond his duties as editor, organizing and shaping our curatorial text from rough transcripts to its current form, for which we are most grateful. Writers David Joselit, Andrea Fraser, and John Kelsey contributed thoughtful and illuminating essays in spite of tight deadlines. And Eric Banks conducted a thought-provoking conversation with Adam D. Weinberg that serves as the foreword to this volume. We are thankful to all the writers for the catalogue, the artists themselves or their chosen authors or contributors: Alex Abramovich, Andrew Berardini, Charles Bernstein, Nellie Bridge, Daphne A. Brooks, Dennis Cooper, Lia Gangitano, Bruce Hainley, Kent Jones, David Joselit, Sarah Lehrer-Graiwer, Dennis Lim, Sam Lipsyte, Dave Miko, Jed Oelbaum, Matthew Papich, Leonard Peltier, Guthrie P. Ramsey Jr., Ariana Reines, Martha Rosler, Simpson/Meade, Laurie Weeks, and Matthew S. Witkovsky.

The Biennial inevitably involves the efforts of every department within the Museum. We would like to thank the entire Whitney's staff, in particular: Jay Abu-Hamda, projectionist; Rachel Arteaga, assistant director of special events; John Balestrieri, director of security; Wendy Barbee-Lowell, manager of visitor services; Jeffrey Bergstrom, audio visual coordinator; Caitlin Bermingham, assistant head preparator; Richard Bloes, senior technician; Cara Bonewitz, design and construction assistant; Melissa Cohen, associate registrar; Kristen Denner, director of membership and annual fund; Anita Duquette, manager, rights and reproductions; Delano Dunn, facilities department manager; Rich Flood, marketing and community affairs officer; Seth Fogelman, senior registrar; Carter Foster, curator and curator of drawings; Rebecca Gimenez, head of graphic design; Francesca Grassi, senior designer; Peter Guss, director of information technology; Barbara Haskell, Curator; Jennifer Heslin,

director of retail operations; Nicholas S. Holmes, general counsel; Sarah Hromack, digital content manager; Chrissie Iles, Anne and Joel Ehrenkranz Curator; David Kiehl, curator and curator of prints; Jen Leventhal, administrative coordinator, director's office; Jeffrey Levine, chief marketing and communications officer; Kelley Loftus, paper preparator; Gene McHugh, Kress Interpretation Fellow; Graham Miles, art handler, supervisor; Dana Miller, curator, permanent collection; Nora Nagy, conservator of three-dimensional works of art; Kathryn Potts, associate director, Helena Rubinstein Chair of Education; Christy Putnam, associate director for exhibitions and collections management; Gina Rogak, director of special events; Justin Romeo, executive assistant to the director; Joshua Rosenblatt, head preparator; Amy Roth, director of corporate partnerships; Scott Rothkopf, curator; Lynn Schatz, exhibitions coordinator; Gretchen Scott, marketing manager; Kasey Sherrick, senior coordinator of corporate partnerships; Stephen Soba, communications officer; Barbi Spieler, senior registrar; John S. Stanley, chief operating officer; Mark Steigelman, manager, design and construction; Mary Anne Talotta, director of major gifts; Ray Vega, carpenter, supervisor; Margie Weinstein, manager of education initiatives; Alexandra Wheeler, deputy director for development.

We would also like to acknowledge the following individuals who generously offered advice, expertise, perspective, and support throughout the process: Vito Acconci, Rich Aldrich, Cecilia Alemani, Vince Aletti, Domenick Ammirati, Rhea Anastas, David Armstrong, Bill Arning, Naomi Beckwith, Dodie Bellamy, Bill Berkson, Charles Bernstein, Philip Bither, Hazel Blake, Michael Bracewell, Sabine Breitwieser, Craig Buckley, Carly Busta, Don Byron, Emanuele Carcano, Ben Carlson, Valerie Cassel Oliver, Paul Chan, Jeff Chang, Rebecca Cleman, Keith Connolly, Tony Conrad, Huey Copeland, John Corbett, Diego Cortez, Simon Critchley, Luis Croquer, Michael Darling, Mónica de la Torre, Clayton Deutsch, Diedrich Diederichsen, Apsara DiQuinzio, Lisa Dorin, Nancy Douthey, Steven Duble, Anita Durst, Craig Dworkin, E. J. Farhood, Bob Gersh, Thelma Golden, Kenny Goldsmith, Ann Goldstein, Sue Graze, Carol Greene, Tim Griffin, Bruce Hainley, Kathy Halbreich, Clay Hapaz, Lena Herzog, Matthew Higgs, Susanne Hilberry, Frances Horn, Alex Hubbard, Fredericka Hunter, David Joselit, Branden Joseph, Steve K, John Kelsey, Michele Gerber Klein, Kevin Killian, Alex Kitnick, Sabu Kohso, Jacob Korczynski, Liz Kotz, Michael Krebber, Tina Kukielski, Rachel Kushner, Andy Lampert, Ed Leffingwell, Fred Leen, Steven Leiber, Connie Lewallen, Alan Licht, Amy Lien, James Lingwood, David Little, Cary Loren, Sylvère Lotringer, Greil Marcus, Mara McCarthy, Tommy McCutchon, Martin McGeown, Fernando Mesta, Dave Miko, Akiko Miyake, Aram Moshayedi, Yasufumi Nakamori, Linda Norden, Annie Ochmanek, Jim O'Rourke, Andrew Perchuk, Chris Perez, Jon Pestoni, Glenn Phillips, Kye Potter, Bill Powers, Armelle Pradalier, Stephen Prina, Jacob Proctor, Sam Pulitzer, R. H. Quaytman, Yvonne Quirmbach, Jon Raymond, Emma Reeves, Larry Rinder, Julie Rodrigues Widholm, Anne Rorimer, David Ross, Andrew Roth, André Rottmann, Leo Rubinfien, Allen Ruppersberg, Alex Sainsbury, Yuzo Sakuramoto, Michael Sanchez, Michelle Saylor, Alexandra Schwartz, Olivia Shao, Ira Silverberg, Clint Simonson, Bennett Simpson, Rani Singh, Mike Smith, Kevin Spencer, Valerie Steele, Josef Strau, Ali Subotnick, Herb Sussman, Eva Svennung, Alex Tuttle, Dean Valentine, Michael Vasquez, Philippe Vergne, Ethan Wagner, Antek Walczak, Thea Westreich, Martha Wilson, Christian Xatrec, Linda Yablonsky, Matvei Yankelevich, and John Zorn.

Additionally, the following individuals, groups, and organizations provided critical assistance in the production of individual artist projects: Ei Arakawa; William Basinski; Lindsay Bosch, Video Data Bank, Chicago; Cindy Burlingham, Hammer Museum; Michael Jude Caputo; Matthew Patterson Curry; Susan de Cary, Archives of American Art; Cinema Guild; Taco Dibbits, Rijksmuseum; Nicholas Elliot and all at New York City Players; Todd Fouser and all at Face Design + Fabrication; May Haduong, The Academy Film Archive; Becky Kinder; Karen Konicek, Zipporah Films; Mike Kuchar; Travis Joseph Meinolf; Madeleine Molyneaux, Picture Palace Pictures; Takashi Morishita (Tatsumi Hijikata Archive) along with Sen Uesaki, and the staff of the RCAAA, Keio University; Yair Oelbaum; Jon Santos, Common Space; Anish Savjani, filmscience; Anne-Cécile Sibué and the team at Bureau Cassiopée; Mary-Clare Stevens and all at Mike Kelley Studio; Takumi Watanabe; Stefan Winter, Winter and Winter; Taka Yamamoto; and Zeitgeist Films.

Finally, we are delighted to acknowledge the support and generosity of the following galleries whose commitment to their artists helped make the Biennial possible: 303 Gallery, New York; Miguel Abreu Gallery, New York; AD Gallery, Athens; ADA Gallery, Richmond, Virginia; Gallery Paule Anglim, San Francisco; Balice Hertling, Paris; Galerie Daniel Buchholz, Cologne and Berlin; Bureau, New York; Cabinet, London; CANADA, New York; Clifton Benevento, New York; Derek Eller Gallery, New York; Formalist Sidewalk Poetry Club, Miami Beach; Feature, Inc., New York; Zach Feuer, New York; Gagosian, New York; Gladstone Gallery, New York; Vilma Gold, London; Marian Goodman Gallery, New York; Greene Naftali, New York; greengrassi, London; Murray Guy, New York; Susanne Hilberry Gallery, Detroit; Nicole Klagsbrun, New York; KOW, Berlin; Leo Koenig, New York; Luhring Augustine, New York; Maccarone Inc., New York; Matthew Marks Gallery, New York; Andreas Melas & Helena Papadopoulos, Athens; Mulier Mulier Gallery, Knokke-Zoute, Belgium; Galerie Neu, Berlin; Friedrich Petzel Gallery, New York; Campoli Presti, London and Paris; Ratio 3, San Francisco; Real Fine Arts, Brooklyn; Anthony Reynolds Gallery, London; Reena Spaulings Fine Art, New York; Richard Telles Fine Art, Los Angeles; Susanne Vielmetter Los Angeles Projects; Shoshana Wayne Gallery, Santa Monica; Daniel Weinberg Gallery, Los Angeles; Alex Zachary, New York; Steven Zevitas, Boston.

—Elisabeth Sussman and Jay Sanders

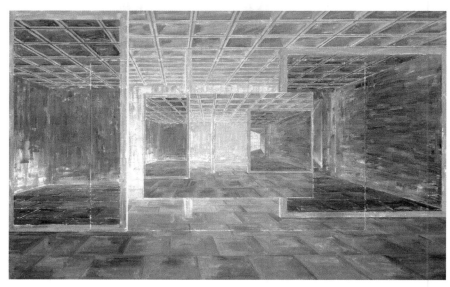

Art & Language (founded 1968), *Index: Incident in a Museum* XIII, 1986.
Oil on canvas, 72 ½ x 113 in. (184.1 x 287 cm). Marian Goodman Gallery, New York

This catalogue was produced by the publications department at the Whitney Museum of American Art, New York:
Beth A. Huseman, interim head of publications and editor; Beth Turk, associate editor; Anita Duquette, manager, rights
and reproductions; Kiowa Hammons, rights and reproductions assistant; and Brian Reese, publications assistant.

Project manager and copy editor: Beth Turk
Editor: Jason Best
Catalogue design: Joseph Logan

Production: The Production Department
Separations and printing: GHP, West Haven, CT
This book is typeset primarily in Fat Face and Caslon, and is printed on Mohawk Knightkote 118 gsm.